Padovano, Anthony.

NB
1170
.P25

The process of
sculpture

THE PROCESS OF SCULPTURE

Anthony Padovano

THE PROCESS
OF
SCULPTURE

1981

DOUBLEDAY & COMPANY, INC., GARDEN CITY, NEW YORK

Unless otherwise credited, photographs and line illustrations are by the author.

Library of Congress Cataloging in Publication Data

Padovano, Anthony.
 The process of sculpture.

 Bibliography: p. 309
 Includes index.
 1. Sculpture—Technique. I. Title.
NB1170.P25 731.4
 ISBN: 0-385-14142-4
Library of Congress Catalog Card Number 78–22345

ACKNOWLEDGMENTS

The idea for writing this book came to me about five years ago when I began to feel the need and desire to record my experiences with the various techniques I was using. This idea was reinforced by my students, who wanted technical (and aesthetic) knowledge at their fingertips. Of course no amount of recorded knowledge can substitute for practical experience, but few if any books on contemporary sculpture techniques were available. The good ones were outdated and I wanted to present technical and aesthetic knowledge in relationship to some of the best contemporary sculpture. I could not include every sculptor of importance because it was impossible to get photographs of their work, or because there were limitations of space. I've also included several excellent young and unknown sculptors whose work is relevant to the text.

Special thanks are to be given to Nina Seidenfeld. Without her encouragement and drive, this book might not have been published. Her constant belief in me and this book overcame many difficult obstacles. I would also like to thank Elsa van Bergen, Nan Grubbs, and Ann Sleeper for their editorial work and encouragement.

Anthony Padovano
New York
June 1980

CONTENTS

Sculpture is one of the earliest known and practiced forms of artistic expression. It is my purpose in this book to present the wide range of materials and techniques available to today's artist. Clay modeling, the simplest and perhaps most widely practiced form of sculpture, begins our book and in its chapter we discuss the new tools and techniques that have made it possible for the sculptor to create forms not feasible in earlier times. This holds true for each following chapter. Each of the various sculpture materials has its advantages and disadvantages and no attempt is made to consider one material as better than another. It is hoped that the student of sculpture will experiment and enjoy the experience of working with several different materials. Experimentation is encouraged as a source of growth and discovery, but so is discipline and technique. Discipline and technique must ultimately be self-imposed and self-discovered and not become merely academic. The most self-disciplined academician, however, must learn to give full rein to his imagination; otherwise he will remain predictable and boring as an artist. He cannot express the awe and wonder of the universe if he is always involved with technique alone.

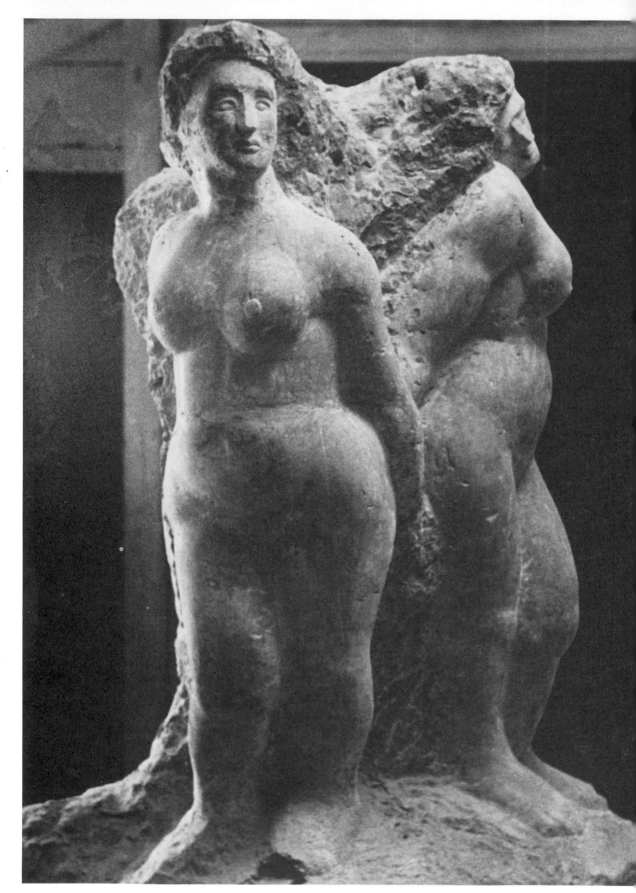

1. "The Sisters" by author. An image is hewn from stone.

INTRODUCTION

In the beginning there was matter. Matter solidified into infinite forms of astounding beauty and size. Man first climbed over rocks, over mountains, learned the ways of water; he became aware of the three-dimensional world. He fashioned stones and wood into images which he offered to the gods. Sometimes these images protected him from evil spirits. From the basic human or superhuman desire to know himself, man created sculpture. Man's images in sculpture changed as his idea of himself and God changed. Sometimes the image was serene and full, sometimes disturbing and fragmentary. This was the direct experience and expression of awe. Awe and wonder are things man experiences in direct confrontation with nature. Hurricanes, thunder, the ocean, the stars, still inspire man to awe, and in the best of sculpture, man expresses this wonder of the universe.

Art was discovered many centuries later. As an activity separate and different from other activities, art came into being when man thought about beauty as separate from religion and God. Art then became involved with daily life. Schools of sculpture were developed, styles were formed, academies flourished, and direct experience of nature was almost lost. Experience of beauty came as a learned process via the institutions of art. With the machine age, experience of wonder and awe was replaced by experience via a machine. Man learned much about the world through cameras, telescopes, airplanes, and the like.

The experience of wonder and beauty became lost in a world of technology where experience was secondhand or thirdhand. We experience, for example, the marvels of the depth of the ocean via the modern underwater film, but we rarely experience this marvel of nature directly. Modern technology has made us lazy and complacent and, worst of all, dependent on

others. While we are dependent upon the advances of modern medicine, we should not surrender our individual experience of wonder. I personally believe that the experience we feel when we are alone in the presence of flowers, clouds, trees, a sun-filled sky, leads to health, both spiritual and physical. The tragedy of our times is that we have lost this childlike experience of nature because of technology. A true experience of simply watching a single raindrop by ourselves is worth an hour-long feature film of underwater sea life. What I am saying is that many of us have lost the ability to experience for ourselves. Many have become boring and unimaginative. It is easier to go to the movies than to find something you enjoy doing for yourself. In short, we are prisoners of other people's way of seeing reality. We must return, even in small ways, to experiencing joy for ourselves. Finding an interesting stone or piece of wood, for example, can be such an experience. Fashioning it to clarify an idea or vision is something personal and doesn't depend on anything else. We must try to see the world new again as a child does every day. Imagination is the one quality we have built in and do not have to purchase, but we have surrendered it. We try to fill in the gap with *things* like automobiles, television, and all sorts of appliances in our environment, but we still remain bored.

Involvement in sculpture is one way to return to basic independence. We can work at our own level and speed. This book offers how-to advice on many levels of accomplishment, whether you are a beginner just curious about clay, or a professional sculptor seeking advice about a particular material.

I have read many fine books on sculpture materials and techniques, but in the end it is my personal experience as a sculptor that I am offering in these pages. I spent years as an adolescent apprenticed to professional sculptors and carvers such as Oronzio Maldarelli, Robert Baillie, and William Zorach and have worked for Theodore Roszak as a welder. What was more important to me was not so much the technique of sculpture, but the attitude of dedication, love, and seriousness these sculptors all had in common. Although each of these sculptors differed as artists, they were all dedicated professionals. They all spent many years learning their skills as students and apprentices, or from a family tradition, as in the case of Robert Baillie, who came from a tradition of stone carvers and monument workers. Others, like Maldarelli and Zorach spent additional years finding their personal vision. Let me emphasize the fact that "imagination," is more important than knowing the process of ceramic shell casting. Technique should grow out of *personal need*. This is how technique is developed in the first place. Many students have asked me "how to do something" in sculpture. They may not have had the slightest hint of an idea or vision of their own to pursue. When students do have something personal to express, they

magically find a way of going about it and if persistent enough, they will develop their own technique.

My aim is not to offer you formulas the way a cookbook offers recipes, but to offer you possibilities in your particular medium. This book offers you the traditional methods of sculpture as I learned them and worked with them, plus the contemporary approach which I invented as I went along, solving all kinds of problems in sculpture. I hold no secrets about anything and only hope my experience can aid you in your development. As a young student apprentice, I encountered a world of "secrets." Few were willing to share their techniques; I would often be shown little or nothing. This was particularly true of the stone carvers' union as well as the decorative modelers' union in New York. Both of these groups died, as did their "secrets." There are no secrets in art, there are only *possibilities*. There is no one way to do anything in sculpture, there are many ways to sculpt even in the same material. You may invent a few new ways yourself. Basically, you must have the courage to experiment. Try—and if you fail, refer to the relevant pages or chapter. Not every answer can be given in this book, but most situations are covered and can hint at your particular problem's solution.

THE PROCESS OF SCULPTURE

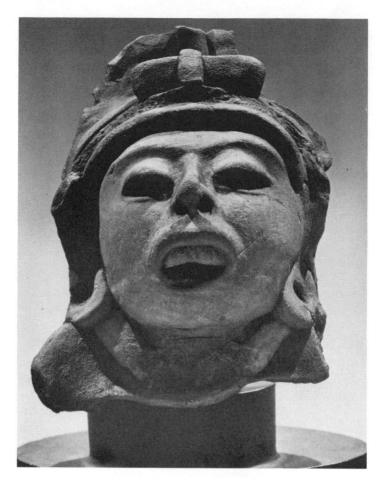

**2. Laughing Head, Vera Cruz. Powerful
human emotion is expressed through this
amazing head in fired clay.** *Courtesy
American Museum of Natural History.*

ONE

CLAY SCULPTURING

Clay, in the hands of a gifted sculptor, is by far the most versatile of all sculpturing media. The process between thought and act is the shortest possible, and resembles drawing or painting in this respect. Carving, welding, or casting all require much time, patience, and technique from the original idea to its execution, but with clay the idea is immediately shaped. A clay sculpture can be formed as fast or even faster than an oil sketch on canvas. No wonder Rodin found clay the perfect medium to capture and express the attitudes and movements of the models walking around his studio. Since clay is fluid, sculpting it is similar to drawing.

Clay is the medium which reveals the "hand" and hopefully the "soul" of the artist. The hand is literally imprinted into the clay. No hand is like any other. A sculpture which is built and modeled in clay is unique.

Our discussion of clay sculpture will, of necessity, be confined to modeling in clay (fired or castwork) and will not include ceramics and pottery, which are vast subjects in themselves. I will therefore avoid discussing glazes and other ceramic finishes. Much has been written about them already, and such information can easily be found in most public libraries. My intention here is to direct the interested reader toward the concepts and techniques of clay *sculpturing*.

Thoughts About the Use of Clay

Clay is one of the oldest materials used by mankind and ranks with wood and stone in its antiquity. Early man found that this mudlike substance dried into a solid mass in the heat of the sun, and could be used as mortar to cement together leaves and branches. It was out of such materials that many

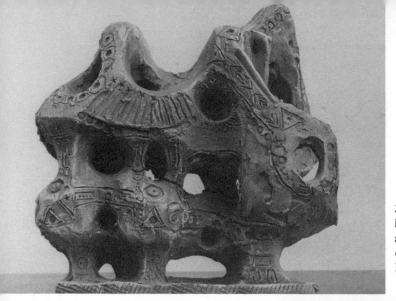

3. "Roman Ruins" by author. The firing of the clay here resulted in shrinkage, which cracked the clay. The cracks, however, are expressive of the Roman ruins.

4. Drawing of Roman ruins by author. Drawing for sculpture came after many studies of ancient Roman architecture.

primitive shelters were built. When it was discovered that baking clay in a hot fire or oven transformed it into a hard, durable material, it was then used for vessels, utensils, architectural ornamentation, and any number of utilitarian or artistic purposes. The pre-Columbian peoples of North and South America and the ancient Chinese all developed clay sculpturing to a highly sophisticated degree. The Etruscans were adept at constructing large works in terra-cotta and they built large kilns or ovens for firing these works. During the late Gothic and High Renaissance periods, clay was used as a transitional material toward casting into bronze, or for preliminary studies of subjects which would later be executed in stone. Luca della Robbia worked directly in glazed terra-cotta during the fifteenth century, while Donatello, Ghiberti, and Jacopo della Quercia used clay to cast into

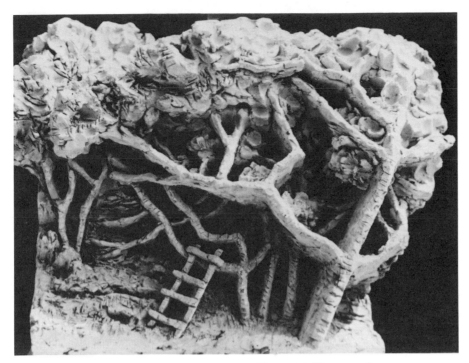

5. Terra-cotta by Evert Lindfors. Lindfors works
directly from nature, achieving an intense earthly
quality. His works are fired in his own handmade
kiln. *Photo by Turin.*

bronze or to make models in preparation for their stone sculpture. Clay be-
came a "thinking" medium for the sculptor who would draw a sketch on
paper then transfer his ideas into a clay model. In this century, Jacques
Lipchitz continued the tradition, as Henry Moore still does today.

For a sculptor confronted with a ten-ton block of hard stone, doesn't it
make sense to make many clay studies to satisfy some idea of what is to be
carved? Rather than going directly into the hard stone and then later trying
to resolve the hundreds of changes that may be necessary, a few hours
working in clay may save months of carving.

It is relatively easy to become three dimensional with clay, whereas in
carving, it takes much courage to go deeply into the stone. This is doubly
true when the design or idea has not been worked out beforehand. Mi-
chelangelo in his maturity and old age could carve stone directly because he
was highly trained in marble pointing from models, but even in his old age
he made full-scale clay models to work from, although he did not "point
them off." "Pointing off" in marble is an ancient measuring technique that
employs a sliding needle that measures the depth of the forms inside a stone.
Such "pointing machines" are still sold today in sculpture supply houses.

The idea of truth to material is therefore a contemporary notion which
has only relative validity and only limited practicality. Abstract art of
course is the perfect expression of this idea. For all the ideas of organic

form and internal space, abstract sculpture is generally concerned with the outward form. The concept of the egg, as originated by Brancusi, has directed most contemporary sculpture toward the surface. The major sculptors of our times—Arp, Moore, Lipchitz, Smith, and others—have been concerned with forms which are conceived from the outside. In their later works, Moore and Lipchitz returned to the idea of internal energy and structure. Their later works however really are a compromise *between* their earlier sculptures, which were outwardly conceived, and the idea of inward form as expressed by Rodin. The pent-up energy of Rodin, Michelangelo, or the Greeks is a forgotten idea that has been relegated to the past. When and if this idea of internal energy is revived, we may see a return to clay as a transitional material.

When referring to Rodin, Brancusi said he didn't like to make "beef-steak" sculpture, he didn't realize that he was turning sculpture into soft omelets. Given a choice between steak and eggs, I still choose the meat. The mystique about the egg form is due for a reevaluation. There is much to be admired in contemporary sculpture. However, unless the image is intended, I do not admire the soft mushrooming forms that ooze and creep taffylike into the homes and museums of the world. These bloblike creatures in marble, wood, and bronze, like the ocean jellyfish, have no skeletal structure. They are soft forms derived from the egg. No doubt, Brancusi would eat his words if he saw the results of his own pronouncements.

7. "Metamorphic Form" by Mikhail Zakin. This porcelain work is remarkable for its sensitivity to form and texture. *Photo by artist.*

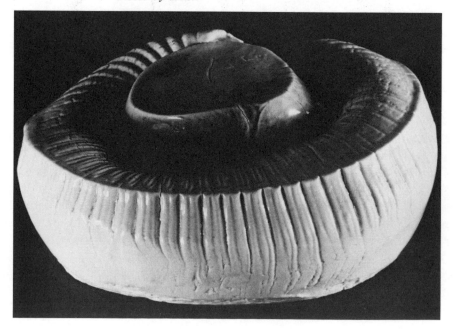

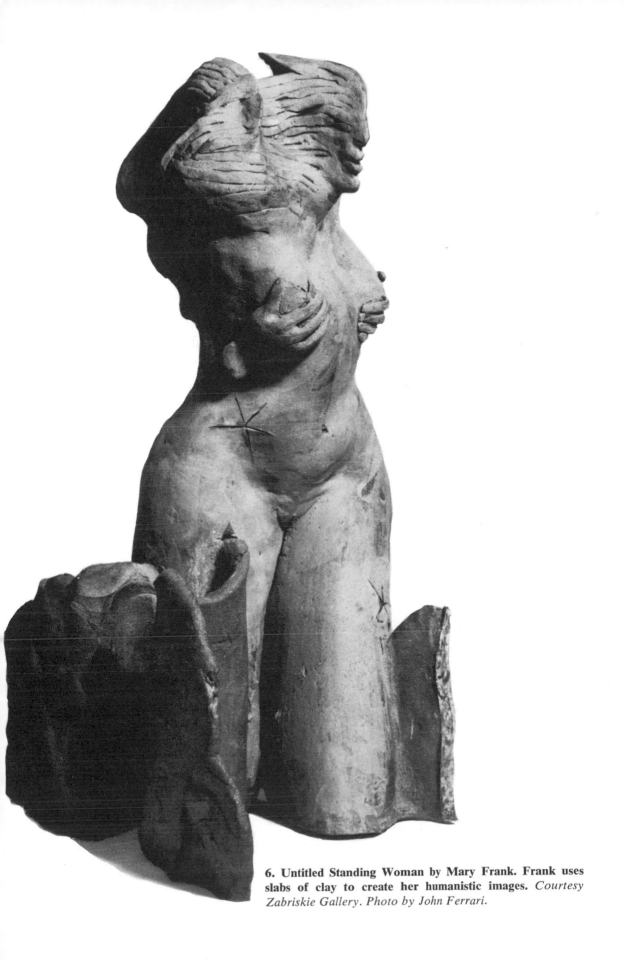

6. Untitled Standing Woman by Mary Frank. Frank uses slabs of clay to create her humanistic images. *Courtesy Zabriskie Gallery. Photo by John Ferrari.*

While it is true that a certain architecture is necessary in sculpture (I prefer to use the idea of structure), I am no admirer of the other extreme in art of cold, bloodless designs. This school of thought, deriving its philosophy from the machine aesthetic, is equally devoid of spirit. At present, this school is enjoying a certain snob appeal (which may be over by the time this writing is published), but its emotional and spiritual content is meager and, like a shallow well, will dry up. In both the egg school and architectonic school, the human element is absent or limited. The human element deals with the spirit, or what is called content. There is no formula for expressing human content, but if the artist does not feel it originally, he certainly cannot express it.

Although clay is used today mostly for ceramics and pottery, a few contemporary sculptors (Bruno Lucchesi, Richard Miller, Peter Voulkos, and Mary Frank—to name a few) use it as their major art medium. Although most contemporary sculptors work directly in materials such as bronze, steel, stone, and wood, I believe that as our infatuation with technology grows old, more artists will return to clay and other more natural materials.

In the nineteenth century it was realized that the "thinking process" or rough clay studies were valid works of art in themselves. Rodin and Degas used clay (or wax) to advance their understanding of movement and gesture observed in the human figure. Degas's waxes, done as movement studies and ñot intended for bronze reproduction, were cast posthumously and are now owned by major museums throughout the world. Brancusi used clay for accurate anatomical studies and many painters used it to explore their understanding of volumes and planes. In the nineteenth century both paint and clay were important mediums. The Impressionistic surfaces and dramatic contrasts of light and dark found in the work of sculptors like Rodin, Bourdelle, and Carpeaux had much in common with the qualities found in the paintings of Delacroix, Géricault, Manet, Monet, and Cézanne. The bronze works of Rodin share a common sensibility with the paintings of Paul Cézanne.

The reason clay is so important in our times is that it brings us back to the earth element. There is little technique to be concerned with (as compared to welding or plastics for example), and the feeling of warm elemental life can come flowing through the artist into the clay. From the earth the greatest monuments have their roots.

Clay—The Material

Clay is found in the earth near rivers, wetlands, and hills. Aluminum silicates are the main ingredient in clay, which is produced by the deposit of fine rock particles in water. Kaolin is a fine white clay used for making porcelain but is not used by sculptors to any great degree. Terra-cotta, wet

modeling clay, and stoneware clay are chiefly used by sculptors. All these clays are similar because they are natural and have a water base. Plastelene, an oily synthetic clay, is used by many sculptors and has the advantage of not drying, but it does not have the great flexibility of wet clay. The water-based clays can be used in forms ranging from extremely hard consistencies (carved clay) to a creamlike consistency applied with a palette knife. Soft and hard clays can be used in the same sculpture, as Rodin often did. The water-based clays must be carefully wrapped in plastic sheets to prevent their drying out while work on a sculpture continues over a long period of

8. "Italian Woman" by Bruno Lucchesi. A virtuoso with clay modeling. *Photo by Bolotsky.*

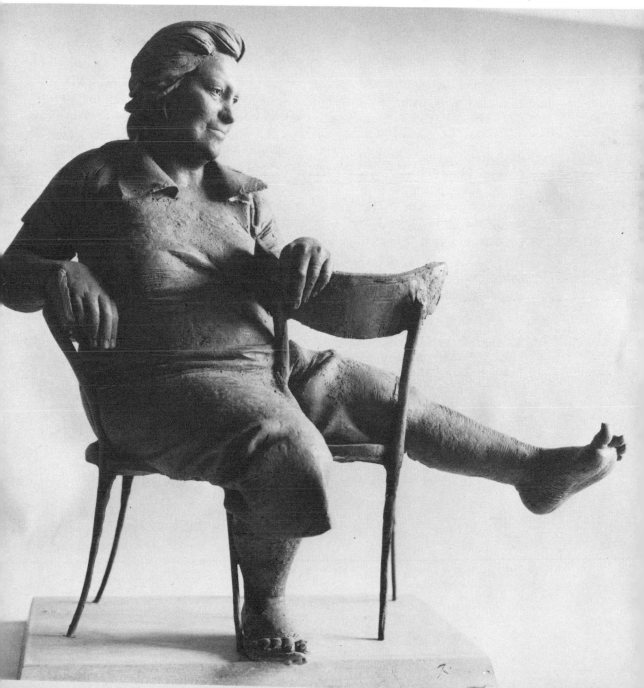

time. If properly stored in a plastic sheet and wet cloths, clay can be kept moist for months—and even years.

When clay is dug from the ground, it must be cleaned and made into an even consistency. It is dried, crushed, screened, and soaked in water, where it resumes its normal consistency. Other clay bodies, or grog (fired clay that has been crushed), are sometimes added, depending upon the intended use of the clay. Grog adds strength, stiffness, and texture to clay. Grog is made by firing clay at a high temperature; the clay is then pounded and crushed into an assortment of coarse and fine grades. If a heavily textured surface is desired, the addition of a coarse grog will achieve this end. Fine-grade grogs can be used in delicate modeling such as portraiture. During the firing process in the kiln, grog reduces the amount of shrinkage and cuts down on the possibility of cracking or explosion of the work. Clay can be purchased with grog already added, or grog can be added to the clay as desired.

Clay can be purchased in powder form in sacks and sprinkled into water. It should soak overnight and excess water should be drained off the next day. The clay should be allowed to dry out for twenty-four hours or longer, depending on moisture in the air. The clay must then be wedged or beaten on a slab of plaster of paris (it is still very wet). Spread an even ½" thickness of clay over the entire surface of the wedging table or plaster slab. Allow the clay to stand for half an hour. This will allow the water in the clay to be absorbed by the plaster tabletop. Pick up a large handful of clay and proceed to knead and wedge the clay, never using more than ten pounds at a time. When the clay no longer sticks to your fingers, it is ready for use. The prepared clay can be stored in plastic bags or galvanized drums, or used immediately. Grog can be added during the wedging process to give stiffness to the clay. The procedure of preparing clay is very impor-

9. The plaster of paris welding table must be strongly built to withstand the heavy pounding of wet clay. *Illustrations 9–15 by Margaret Worth.*

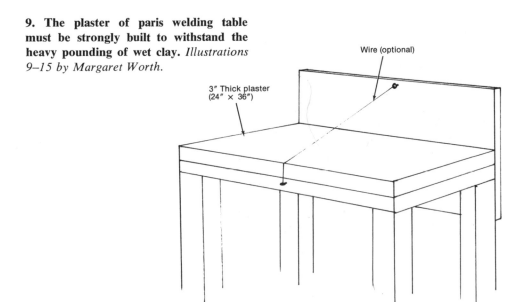

Wire (optional)

3" Thick plaster
(24" × 36")

tant because it establishes the mood of work much in the same manner as the painter's preparation of his palette.

It is a good idea to keep one bin of clay with a stiff consistency. This can be achieved by either adding more grog to the mixture, or by allowing it to dry further. Stiff clay can be used to construct more open-form sculptures, or as a support for softer clay. Always use the same type of clay in a sculpture. Do not mix gray clay with red or brown. The only variable in clay should be the *amount* of grog in the mixture; use only one *grade* of grog and keep the amount uniform for each structure. If you have a substructure of heavily grogged clay covered with sparsely grogged clay, cracks can develop during the firing due to the difference in the shrinkage rate. It would be better to use a stiffer consistency of clay by allowing it to dry more. Use about a 20 percent amount of grog in substructure clay for works to be fired.

Clay preparation is more important for sculptures to be fired in the kiln than it is when clay will be cast into plaster. The firing process makes careful preparation necessary. In the kiln, the temperature will reach between 1,800 and 2,200 degrees. Weaknesses in the clay, such as faulty kneading and improper attachments, will show in the form of cracks, holes, or separa-

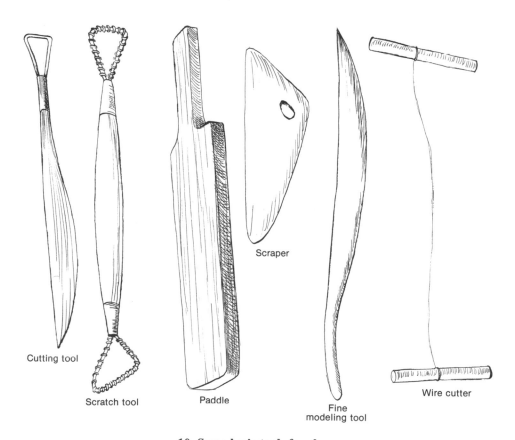

Cutting tool

Scratch tool

Paddle

Scraper

Fine modeling tool

Wire cutter

10. Some basic tools for clay.

tions. Air holes and foreign matter can also cause damage to the clay. A piece of wood or metal in the clay, for example, will expand during firing and cause a small explosion in the clay.

Using the Tools

The fingers and especially the thumbs are the main tools for forming clay shapes. Large masses are formed with your hands first and it is only when you are ready to "block out" or establish the major planes that you would use a tool. This is usually achieved with a paddle or block of wood measuring 12″ long by 2″ wide (see illustration 10). The clay is struck with the paddle to form a flat surface. Give the forms a front, sides, and a back. A head for example, in its initial stage, should look blocklike. Smaller planes are likewise established by paddling and also be adding more clay onto the general mass. A nose, for instance, would be added by attaching a wedge-like shape. The scraper is then used to define the smaller transitional planes between the nose and eye socket, cheekbones and upper mouth. At each stage however, you would still be using your finger and thumb along with the tool.

Smaller forms such as eyes, nostrils, lips, and the mouth are formed with the aid of the cutting tool. Little bits of clay are added for parts such as eye-lids, lips, etc., and are pressed into the mass with the fingers, and are sharpened with either end of the cutting tool.

When the sculpture is formed generally, the masses and details are unified by the use of the scratch tool (see illustration 10). This is similar to a fine raking process where the divisions of planes and broken surfaces are pulled together into a unified whole.

The finishing stage consists of using the fine modeling tool to give accents to certain details such as the eyes and mouth. A certain amount of smoothness or plane definition is reestablished by using the scraper or paddle again in a gentle manner. For a very smooth finished surface, the entire sculpture must be patiently tooled or rubbed with the fine modeling tool.

We will thoroughly study clay modeling later in this chapter.

Hollowing Out Clay

If you intend to fire your sculpture in a kiln, you must hollow it out. A head, for example, is allowed to become "leather hard" so that you can move it without danger of distortion. When it is leather hard, roll it over on a pillow or soft surface.

Generally, most clay sculpture is hollowed out from underneath. Ideally, the clay should be hollowed out to an even consistency and be no more than ½″ in thickness. This is, however, generally difficult if not impossible to

achieve. Do not worry, however, about the unevenness of a hollowed-out work, because in ninety-nine out of one hundred cases, the sculpture will fire well as long as it has been well dried.

Using your cutting tool, cut away the clay located at the most central part of the neck. You will notice that the clay there is much softer than the outer surface. Carve away the clay just as though you were making a tunnel from the bottom of the neck to the top of the head. Be careful not to penetrate the outer surface. If you do, add more clay where you went through and re-tool the finished surface. If you cannot reach to the inner parts of the head, cut off the top of the head with the wire cutter (see illustration 10). Care-fully place the cut-off top section on a soft surface and hollow out both sec-tions. To reattach the top section, use the scratch tool on the edges of both sections and rough them up evenly. Wet down these two surfaces with water and gently attach the top section to the main mass. Gently press them into position and retool the outer surface. If you can, retool the inner surface also to ensure proper attachment for firing. If it is done carefully, there should be no division seams where you cut off the top of the head. The clay sculpture should then be allowed to dry slowly for at least one week. Keep a loose plastic covering over the work if you do not have a drying cabinet. Be sure to keep the work away from hot areas such as radiators or boilers, at least until it feels dry to the touch.

Clay must be thoroughly dried before firing. The slightest amount of moisture inside the clay can cause severe cracks. Usually works are stored on top or near the kiln just prior to firing. Because sculpture is usually heavier and thicker than pottery, more care is needed in drying and firing it. The kiln door should be left slightly open during the first thirty minutes of firing. This will dry out the kiln and sculpture. After locking the kiln door, leave the kiln on the "low" position for at least six hours before raising the temperature.

I have fired solid life-sized heads perfectly, although I do not recommend this as a general practice. I used a $\frac{1}{16}''$ thick rod of steel sharpened to a point and pushed the steel entirely through the clay while it was still soft. These tiny holes should be made in inconspicuous places, and you should make as many of them as you can. This is a good practice even for hollowed-out works, which may have thick areas because of unevenness. These small holes allow the clay to dry out more thoroughly.

The Use of Fillers and Supports

A filler, such as vermiculite, can be mixed in with the clay. When fired, the vermiculite, which consists of small air-filled plastic bubbles, will dis-solve, leaving the clay very open and grainy. Ashes, as well as sawdust, can also be used in this manner. The principle at work here is that the filler is

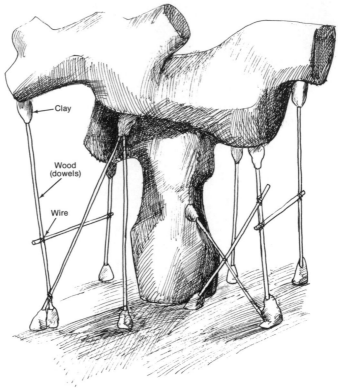

Clay

Wood
(dowels)

Wire

11. Temporary supports.

burned away leaving the clay porous. On the other hand, fillers such as grog
which give strength and weight to the clay can be added. Fiber glass can
also be added to clay, giving great strength to the clay after firing. The fiber
glass is added in the form of strands, like hair, to the clay. The firing proc-
ess turns the fiber glass to a glasslike substance. Extended parts of the sculp-
ture, such as arms and legs, can be projected much more when using fiber
glass as a strengthening agent.

For standing figures or vertical thin forms, you can make a temporary ar-
mature or support. A temporary armature is one which is removed from the
clay during the drying period. Wooden dowels, wires, or whatever is used to
support clay can become an armature. First seal the wooden dowels with
shellac or paint to prevent the wood from swelling due to the moisture in
the clay. Dowels should also be oiled or Vaseline-treated before coming into
contact with clay. Often, thick lengths of stiff clay are used to support the
sculpture and are later removed (as are the dowels) when the sculpture
hardens and is self-supporting.

12. "Torso" by author. This early work was built by the coil method.

The Coil Method

An ancient way of building clay sculpture is the coil method. A form is built with a series of clay strips which are laid one on top of the other (see illustration 13). This method requires patience and craftsmanship.

The clay is usually rolled out on a plaster table. A rolling pin is excellent for spreading out the clay to an even thickness. The size of the sculpture will determine the thickness of the clay wall. A life-sized head, for example, can be from ½″ to 1″ in thickness. On large works, the bottom coils can be thicker, as well as a little stiffer in consistency.

After the clay is carefully rolled out to the desired thickness, it must be sliced into strips. Use a steel-edged ruler or yardstick as a guide for cutting. A sharp wooden tool or knife can be used for the cutting. Make a simple diagrammatic drawing of the sculpture you want to do and plan how you would construct the coils to form the shape you want (see illustration 14).

For building a life-sized head, for example, you would wind the coils

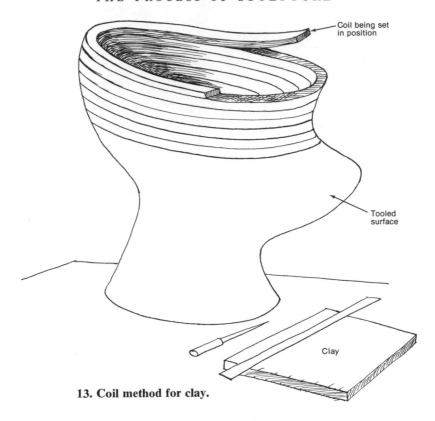

Coil being set
in position

Tooled
surface

Clay

13. Coil method for clay.

around in a circular fashion to start the neck. If one coil (or strip) is not enough to complete the circle, you can add another coil or part of one to the short length. Be sure to score or scratch each edge coming together and add water or slip to these edges. (For slip, use the same clay as for the head but mix it in water to give it a creamy consistency.) When the first layer of coils has completed the circle, you can then build the next layer on top of the first. The bottom edge of the second layer must be placed on top of the top edge of the bottom layer. Be sure to score the edges all around on each coil, use water or slip on the edges, and carefully place the second layer on top of the first one. Gently press the top layer down onto the first until you see the wet clay or slip ooze out along the seam. If the coils or strips are too soft, they will warp and you will have difficulty controlling the cylindrical shape of the neck. The clay must be firm enough not to collapse, yet not hard enough to cause surface cracks. Most times, a section of a sculpture (the neck for example) is made and left to stand for hardening. The lower coils must be firm enough to support the upper coils, and this determines how long the clay section must stand. Obviously, the neck would have to be quite strong (stiff) to support the great mass of the head. The chin and back of the head project further out into space than the neck, which adds further stress to the neck. In building the chin and back of the

15. Use of template.

Template
(masonite, plywood)

Clay
sculpture

14. General planes of the head.

head sections, you may not be able to add more than two or three coils in a few hours. These must be stiff enough to .support themselves as well as the upper coils added to them later. Remember to score or scratch the edges that come together as well as adding water or slip to these edges. It may also be necessary to support the chin temporarily until it becomes firm enough to be self-supporting. If you work slowly and carefully, allowing the lower coils to become firm enough to support the upper ones, you should have no trouble constructing a simple life-sized head. The features of the face can be added or modeled onto the general mass of the head. Since these details are relatively thin and small, they need not be hollow for the firing in the kiln.

As previously explained, you can push a thin steel wire or rod (like a hat-pin) through the thick sections of the clay when the head is complete. This will ensure that these sections will thoroughly dry out for firing. In a form like a life-sized head, it would be advisable to add about 20 percent of fine grog to the clay body. The outer details (nose, eyes, etc.) can have no grog, or a small amount (5 percent) of fine grog. The grog will help to prevent shrinkage when the head dries and is baked in the kiln. It also helps while you're building the coils because it adds stiffness to the clay.

Other Methods of Using Clay

In addition to the coil method of building clay, there is the solid clay technique. Basically, no supporting armature, or a very simple armature, is used to support a large mass of clay. The clay is usually self-supporting. You must know beforehand whether you intend to fire or cast into plaster your final sculpture. If you intend to fire the finished work in a kiln, you cannot use an armature unless it can be easily removed from the clay while it is still pliable. You must also consider that the clay must be hollowed out for firing.

If the work is to be cast into plaster, a supporting armature can be used and you need not concern yourself about hollowing out. The armature remains inside the clay sculpture while the outer plaster mold is made on the clay surface. This difference between firing and casting is the difference in approach between clay used as a finished product and clay used as a transitional medium to another material such as plaster or bronze. Solid clay sculpture is used on a small scale only, simply because it is impractical to form masses of clay over fifty pounds. Sculptors do not, for example, model clay sculptures of life-sized figures or animals without a supporting armature. Those sculptors who make large clay sculptures do so because of a highly developed technique for controlling clay. Usually, they control the clay with temporary supports and armatures, or the works are made in sections and are carefully assembled.

Another method related to the latter-mentioned technique is to create many clay shapes and forms which are fired and then joined by cement, epoxy, or fiber glass. This method, practiced by many sculptors, allows great flexibility and versatility in approach, and is similar to making a three-dimensional collage. The joining element (cement, epoxy, etc.) is either visible and considered part of the sculpture, or is invisible, in which case the clay parts must be carefully matched where they join. The matching is of course done before firing takes place.

Clay can be rolled into large flat slabs on a plaster table and cut into shapes. These shapes can be folded and twisted into exciting free forms. They are then allowed to harden and dry thoroughly for firing. While wet, however, two or more can be joined into a composition. The crucial principle in this method is to fold the clay at the correct thickness and the desired stiffness. If the clay is too thick or too soft, the folding will be faulty. If too stiff, the clay will develop many cracks. The addition of fine grog into the clay body can help firm up the clay and give a beautiful texture after firing.

There are several types of cements, or bonding cements, that are better than epoxy for out-of-door sculpture. Epoxies, polyesters, and plastics in general will break down in weather much faster than baked clay, especially high-fired clay such as stoneware. New products such as vinyl-concrete or ferro cement will last as long as the baked clay itself.

16. Metamorphic form by Mikhail Zakin. A beautiful example of salt glazing. *Photo by artist.*

Finishing Clay

Fired clay is one of the most beautiful of all materials. Glazes are not generally employed for sculptural works, although they have been used with great success. A stain is often used as a coloring agent which soaks deeply into the clay and does not remain on the surface, as does glaze. Stains are usually powdered chemicals mixed into the clay or painted on the surface of the work just prior to firing.

The finishing of clay starts when the clay is still wet. Clay can be left with a rough and textured finish or made smooth by using sponges to rub down the surface. Slip, a form of liquid clay, can be dripped, thrown, or painted onto the surface and left to dry; a rough texture results. Dry clay can be sanded with sandpaper, or scratched into with a sharp tool to make a drawing. A low bas-relief can be cut into the dry clay or modeled in the wet clay. In short, there are numerous ways of attaining a beautiful finish on clay, even without glazing or stains. As mentioned previously, glazing and ceramics are a subject not discussed in this book because of the vast and special nature of ceramics and pottery. Salt glazing, however, is very appropriate and beautiful for clay sculpture. This consists of throwing salt (rock salt is used) into the kiln through a special opening as the sculpture is baking. This creates a chemical reaction which coats the clay. The kiln must be cleaned after salt firings because of residue.

Clay which has been fired but is unglazed is called bisque. "Bisque firing" refers to baking raw clay without glaze. The bisque surface is used in sculpture because of its honest and earthy quality. When the sculpture has been well done, the raw clay needs no further embellishment.

Study of the Figure

For an inexperienced student, it is a mistake to use a live model to learn and work from. The confrontation of a living person having arms, legs, and an assortment of bumps, lumps, and muscles (or fat) is usually too much to handle at first. Some groundwork in the human figure should be done before using a live model. Reference material (there is a list of suggested reading at the back of this book) is more helpful than the live model at this point. Plaster casts, anatomy books and charts, and especially demonstrations by an instructor give a student an idea by which to study this complicated subject. The purpose of figure modeling should not be to reproduce an actual figure but to understand figure construction.

The first thing is to note and understand the figure's proportion. The accompanying diagram should be studied and memorized. Note that the body is divided into four major proportions. Draw this diagram exactly and memorize the natural S curve of the body. Simple as this curve may seem, it is

17. *To the right.* **Richard McDermott Miller carefully articulates movement and anatomy in this over-life-sized figure, "The Space Walker," bronze.** *Photo by artist.*

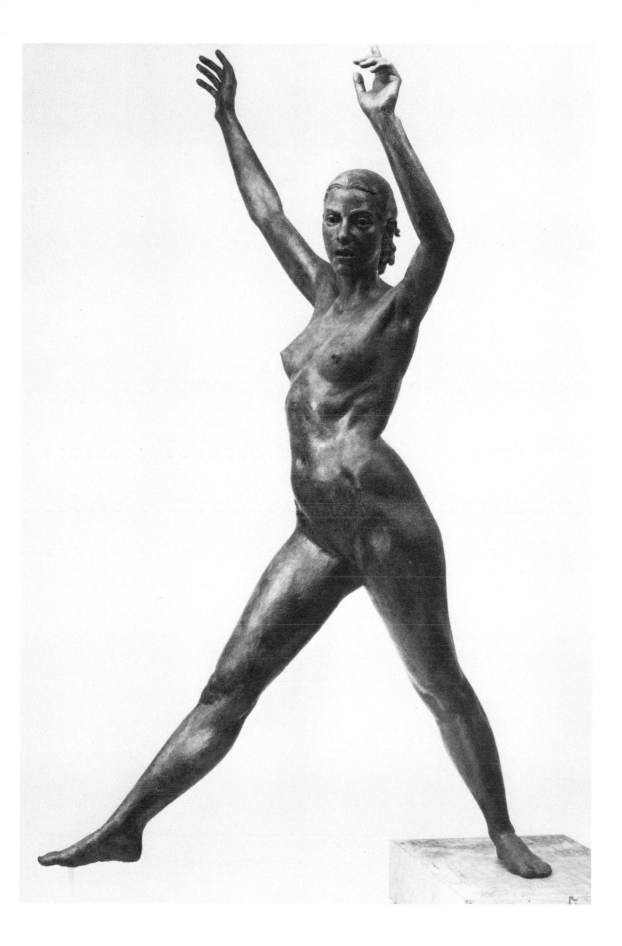

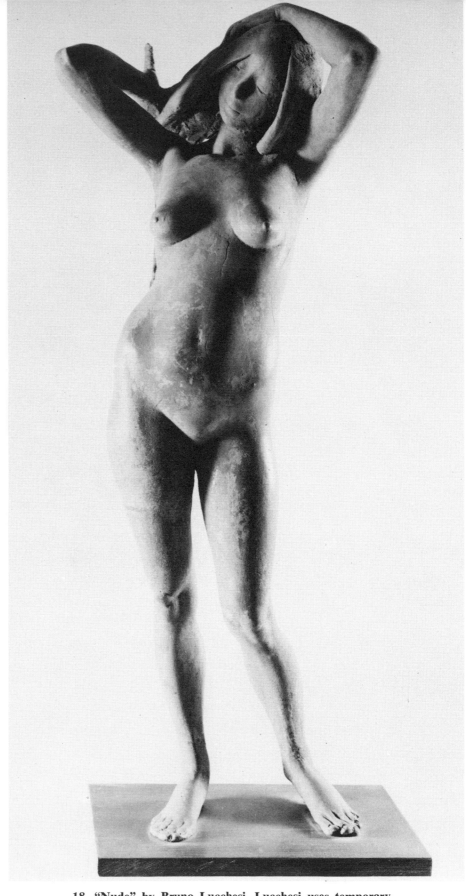

18. "Nude" by Bruno Lucchesi. Lucchesi uses temporary supports in modeling the figure. *Photo by Bolotsky.*

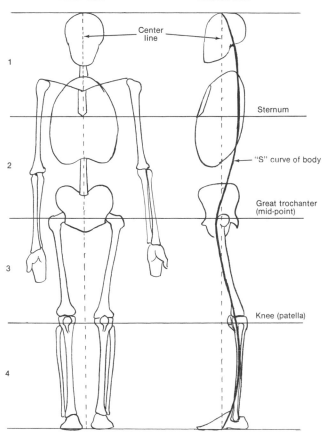

FRONT VIEW PROFILE VIEW

Center line

Sternum

"S" curve of body

Great trochanter (mid-point)

Knee (patella)

1

2

3

4

19. Human proportions.

quite complex, and the entire foundation of the human figure rests upon thoroughly understanding this natural S curve. Note that the S curve intersects the center line at the midpoint which is where the great trochanter is located. The great trochanter is the pivotal point of the figure. From this point, the leg can move in an arc and the upper spine can move in its own arc. This understanding will help later when you're trying to represent figures in movement. Note also that the first division on the chart marks where the sternum (or breastbone) ends, and that the last division locates the position of the knees (patellae). If you measure off the head in relation to the body, you will find that there are about eight head lengths to the length of the figure when the muscles and flesh are finally added.

These observations are general laws of the body which help in the understanding and construction of any particular figure that may deviate from the general principles. The body, like the head or portrait study, reveals the character and personality within. A body of a dancer will be obviously different from that of a laborer because one's profession affects his anatomy over a long period of time. The perceptive eye of the artist will pick out those revealing parts and proportions which emphasize the personality

Mid-point

20. Pivotal study of upper and lower figure.

of the sitter. This approach to figure modeling will naturally lead into the fascinating study of anatomy. Human anatomy cannot be mastered in one week, one month, or even one year. Many years of study are required to gain an understanding of the human machine.

Drawing and modeling from an actual human skeleton is essential. The copying of bones is important because it is the foundation structure for the body. Bones are also beautiful in form and shape; understanding them will add to your form vocabulary. It will take months before you memorize and understand the skeleton. When you think you really know the skeleton, give yourself a test by modeling it in three dimensions. If you reconstruct it 75 percent correctly, you can begin with the superficial muscle structure. The other 25 percent will become correct over the period of time you are spending on the muscles. This is so because as you study muscle origins and insertions, you will notice these seemingly unimportant details. All bumps and hollows on the bones all there for very good reasons. Generally, muscles are attached to these protuberances and depressions.

Concepts of Figure Modeling

You can start working from the live model when you understand the proportions of the body. Before we look at the actual modeling process, let us consider the principles which will come into play.

In sculpture, volume proportions are as important as length proportions. It is essential to understand the thickness of the torso in proportion to its length, for example. This will give a feeling of solidity and volume to your figure. Simplify the volumes of the torso, head, neck, and extremities to near geometric forms. The head, for example, can become egglike in form while the torso can become a wedge-shaped box (see illustrations 19 and 20). The arms and legs can be reduced to cones and cylinders. This process will make the figure appear a bit like a mannequin or robot, but then you must carefully "draw" the beautiful lines and shapes of the body as you observe them in the live model. All the silhouettes of the figure must be worked over so that from any angle, the sculpture looks beautiful. Volumes are then defined by shaping planes. Planes are surfaces which define the front, back, and sides of a particular volume. The head, for example, which starts as an egg, then becomes squared off (see illustration 19). The front face is formed into two large diagonal planes, while the side face is flattened into one large plane as is the back into two planes. The features of eyes, nose, and mouth are constructed as smaller planes. The development and use of planes is a system of modeling which is hinted at in nature but is not explicitly obvious. Planes are in relationship to modeling what perspective is to painting and drawing. Students have complained that they do not see planes on the live model. It is only after it is realized that planes are a system of construction that planes become apparent in nature. A blind man cannot see color and an untrained student does not see planes. Many Renaissance artists did not work from live models, yet made superb figurative works. The painter Mantegna is one example.

The study of planes at first should be done without the live model. Force yourself to give strong planes to all forms. As previously described, use a paddle, a flat piece of wood approximately 12″ long by 2″ wide, to pound the clay into planes. Planes need not be flat and straight. They can curve, bend, and become concave as well as convex. Like solid geometry, planes exist in three-dimensional space, and on solid forms such as spheres and pyramids. Like a rough diamond, the cut planes capture light and dark with all the subtle nuances of grays. In highly finished works, the intersecting edges of the planes are softened so that we are only aware of the light and dark patterns and not the planes. This is the essential difference between a cast from life and the art of modeling. A life or death mask cast off of a human face looks frozen like death itself, while a work constructed in planes has life and vitality. *The point is not how lifelike you can get, but*

how much life you can bring to your work. The former attitude is literal while the latter is imaginative.

The Process of Figure Modeling

To begin any project you would first need to prepare about fifty pounds of clay as described in the section "Clay—The Material."

To model the figure in clay, there are basically two approaches. Both however rely upon a general principle, which is to construct the figure within a geometric framework. Try to fit the figure into a pyramid, rectangle, sphere, or whatever geometric, even asymmetric, shape form, which the pose, design, or movement of the figure suggests. A sitting pose for example would probably fit well into a pyramid, wheras a standing pose would fit well into a rectangle. It is best to first work without an armature, which means that your figures should be compact and should not have many extended parts. Later, when you achieve a certain amount of dexterity, you can use stiffer clay for extended figures.

One approach would be to make a solid geometric form in clay and then carve away from this basic form. Use the cutting tool to find the large relationships (torso, legs, arms, etc.) within the solid geometric volume. Take the clay and actually make a cube, rectangle, or sphere, and carve the figure within that shape. You can always add parts on if it seems necessary, but if you do add on, try to keep the geometric form intact.

The other process is to add the basic figurative parts together which will fit into a geometric scheme. The two approaches are very similar, but the former is a carver's approach, the latter is a constructivist method. The important point is that a general geometric form or plan keeps the figure organized. Parts are constantly considered and observed in relationship to the whole. In the latter approach, model the general shape of the torso, legs, arms, etc., and fit them together. Check that the legs and arms are in correct relationship to the torso. Be aware of the size of the head in relationship to the entire figure. If it seems wrong, cut the form down or build it up. When you have established the general proportions correctly, you can slowly add onto the forms a fuller volume as well as contrast between bone and flesh. You must always check that the figure is balanced and does not look as though it could fall over or not hold the pose comfortably. Strenuous poses should be avoided, at least for beginners. Every bit of clay that is added must be deliberate and for a reason. Avoid piling up clay for its own sake, or with the intention of cutting it down later. Every cut that removes clay should also be well considered, otherwise a confused carved surface would result. Even if you do not know the figure or form that you want to create, a deliberate approach will finally develop into a strong statement later on.

Try to see the figure in its entirety, and not in isolated parts. Always con-

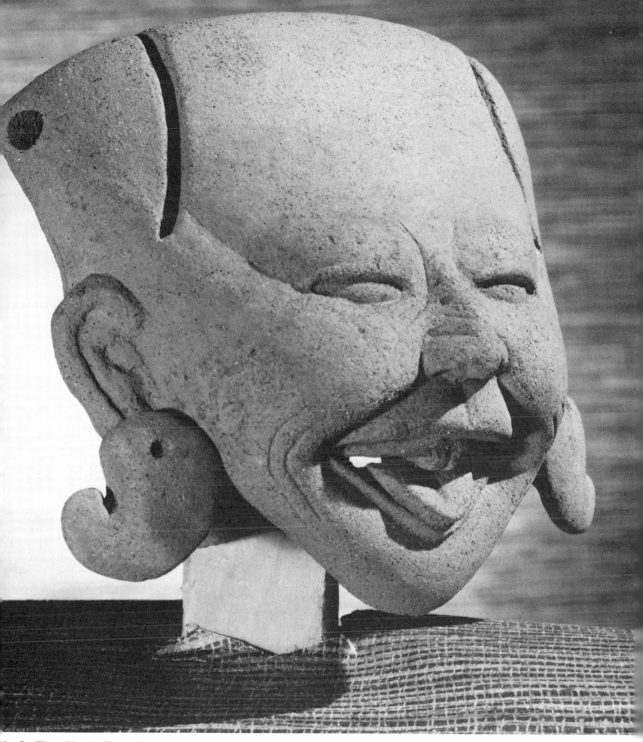

1. Smiling Head, Vera Cruz. Simple, bold planes. *Courtesy American Museum of Natural History.*

sider the general geometric shape that the figure seems to fit into, and then work within that shape. You must constantly turn the work so that you see the volumes from all sides. One student made a short leg because he was viewing the leg from a foreshortened point of view. As soon as he walked around the other side of the model, he discovered that the outstretched leg

was very long, and not short as he had made it. Foreshortening does not exist in three-dimensional sculpture. You must begin to think three-dimensionally.

Your first figures in clay will probably be stiff and flat. Move the clay around as you would a wooden mannequin. You will surprise yourself by the amount of life that can be expressed by this activity. Be more daring than usual and add a lot more volume; the advantage of clay modeling is that you can add and subtract endlessly until you get it right. At this stage, you are learning to "block in" a figure, that is, to represent in actual form the correct proportions and movements of the live model. To block in is to see the figure totally—the parts in relation to the whole.

After you are able to "block in" a figure well, you must then be able to give a sense of inner structure. Try to express the feeling of internal bones underneath the planes. Dig deep into the knee area and shape the bones of the femur, tibia, and patella. You will be amazed at the sense of inner anatomy expressed. Apply this principle to the entire figure by digging out all of the bony areas such as elbows, wrists, ankles, breastbone, cheeks, etc. Try to express the sense of the rib cage underneath the muscles and the fact that it expands and contracts with life. From a robotlike figure of planes and volumes, you can give your figures a sense of realistic life and vitality. As you learn and master the placement of planes on the figure, you will be able to give dramatic light and dark patterns to your sculpture.

This kind of study and work must continue for several years for those who want to make figurative sculpture. Henry Moore, Archipenko, Lipchitz, Brancusi, Noguchi, and others long studied the figure in this manner.

Working with an Armature

After modeling compact figures without an armature, you can then start to work on a 2' high "skeleton" or armature. You can make your own armature by buying the following at a hardware store:

> 5' of ¼" soft aluminum wire
> 1 roll (15') of No. 14 soft aluminum wire
> 12" length of ½" steel pipe threaded on both ends
> 1 steel flange ½" with flathead wood screws
> ½" steel pipe elbow
> 6" length of ½" steel pipe
> Board of plywood 24"×15"×¾"
> ½" T-joint

The following diagram will help you in putting this armature together:

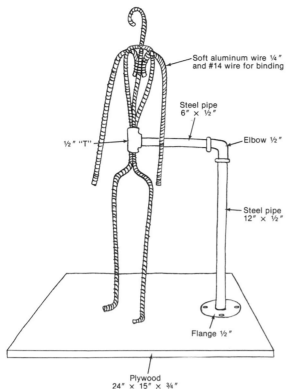

Soft aluminum wire ¼"
and #14 wire for binding

Steel pipe
6" × ½"

½" "T"

Elbow ½"

Steel pipe
12" × ½"

Flange ½"

Plywood
24" × 15" × ¾"

22. Figure armature.

The armature should be well made, so make sure that all the fittings are secure and that the flange is snugly screwed down. Remember that the armature must support thirty to forty pounds of clay. The plywood top should be painted with an oil-based paint or shellac. A formica-covered piece of plywood is ideal. This will prevent the plywood from absorbing water from the clay and becoming warped. Paint the steel pipe also, as this will prevent rusting.

The soft aluminum wire figure should be flexible so that you can bend it easily into a variety of poses. Be very free and daring with the wire figure because if you do not bend it to express movement, your figures will be stiff and dull. A certain amount of emphasis and exaggeration is necessary to express movement. If you are sculpting a live model, position the armature into a simple standing pose. Look for the leg where the weight falls, and for shifts in the hips, waist, shoulders, and head. Bend the wire figure to approximate the live model. Do not be anxious to put clay on the armature until the wire figure expresses the movement of the live model. At this stage, the wire figure should look a little like a well-executed line drawing of movement.

If you are satisfied with the wire figure, first model some clay for a base. The base should be about 1" thick, and the wire feet should be held secure by the clay base (see photo). The clay can then be added to cover the whole figure. Keep the movement of the pose as you apply the clay. It is very easy to lose the movement. Clay should be an extension of the armature (and therefore of movement) and not simply material to cover the ar-

mature. Do not put on too much clay because this will result in loss of movement, and in heavy masses without form. You must study proportion and shapes, and try to form this in the clay. Figure modeling in clay must be repeated over and over many times, the way a pianist practices the piano. Do not expect to make masterful figures, nor should you get discouraged with your first efforts. Progress depends upon effort, and you will have to work for a long time before you are able to make convincing figures.

The figure is a lifetime involvement. Today, if an artist acquires the rudimentary training with the figure, he will most likely feel qualified to work "abstractly." There seems to be the feeling that somehow the figurative approach and the abstract approach have nothing to do with each other. Indeed, students are encouraged to "break away" and forget their figurative training if they get that training at all. They are encouraged to become original, and this jump into the abstract is supposed to make them so.

While I believe breaking away from your traditional training is beneficial, I am doubtful that you will become more "original," whatever that means. Originality means something new, never before seen, without reference, etc.

23–28. Steps in modeling on an armature.

Anyone who has visited graduate art departments around the country will be struck by the hundreds of art students who think they are original. There is a sameness about most of this work, and very few of these students actually pursue a career in the arts. The only ones who seem to have a chance at being an artist are those who work very well figuratively.

The argument that the figure has been done well during the Renaissance and is now a dead issue is not a valid one. Abstract art is now about seventy years old, and one can use the same argument against abstraction. The past is part of us whether we are influenced by art which is seventy years old, or three hundred years old. We are not being more original by working as Brancusi did in 1920. The past is to be studied, assimilated, and then put into proper perspective. If your natural inclination is to be figurative, you may be made a more original artist by being influenced by past figurative art. All art is both realistic and abstract because nature is profoundly diverse and complex. There are thousands of forms and shapes in nature, and we as people live with these "abstractions." It is not inconceivable that the figure can be worked in an abstract environment even today.

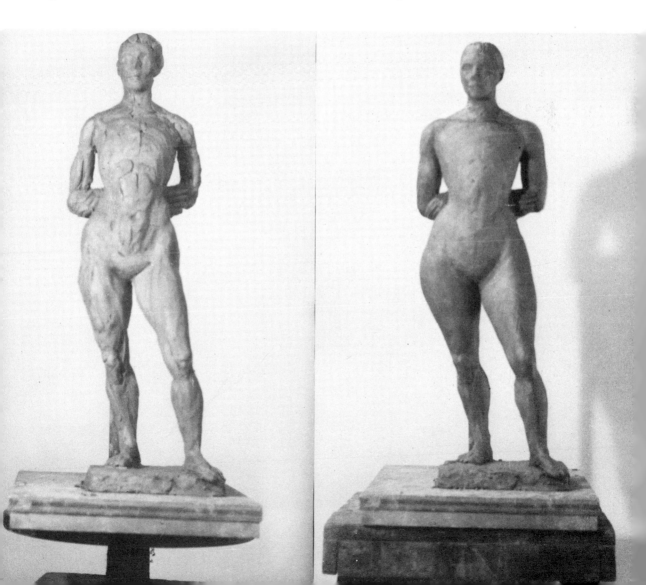

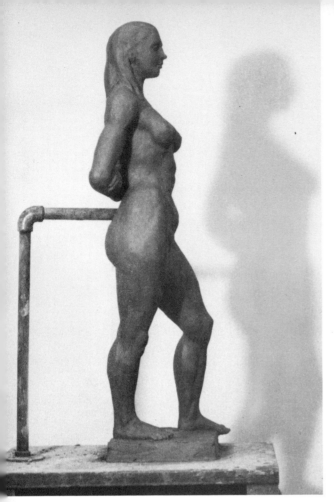

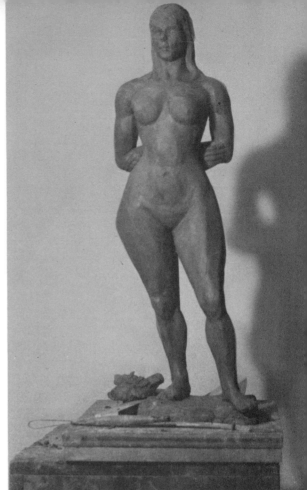

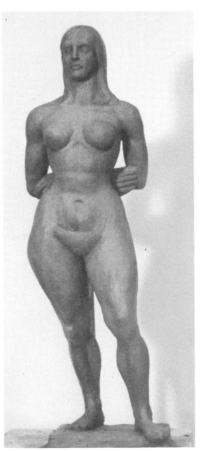

29. Figure completed.

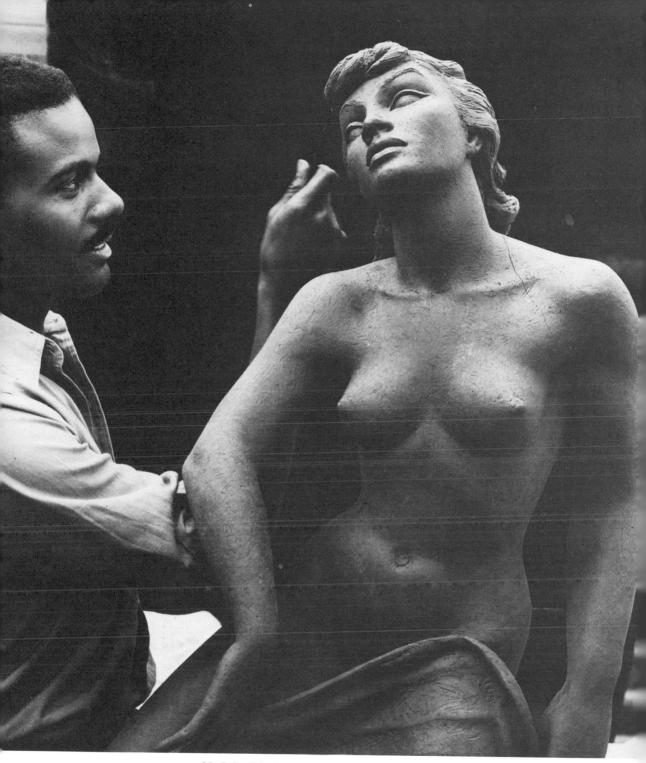

30. John Rhoden modeling a clay figure.

THE AUTHOR MODELS A HEAD

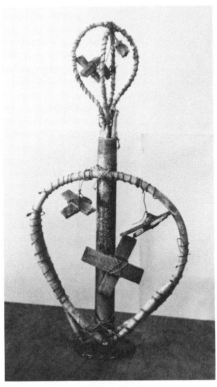

31. View of bust armature. Note details of the flange screwed down to shellacked plywood board. The heavy aluminum wire to support the shoulders is wired with "butterflies," which are simply crossed pieces of wood. Butterflies are included into armatures where there will be a heavy mass of clay to support.

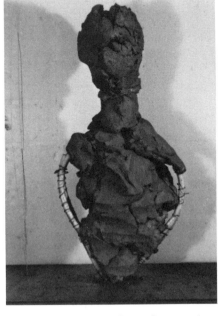

32. View of application of clay. Note how the armature easily supports the clay, here weighing about forty pounds.

33. Development of the basic masses, planes, and skeletal structure. Note that the nose has not yet been added, but that the feeling for the forehead, cheeks, chin, and lower jaw have been suggested. Further notice that the entire sculpture is being developed simultaneously.

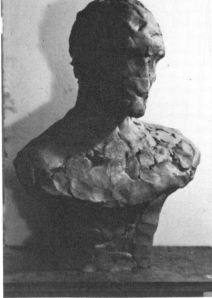

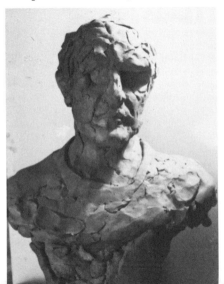

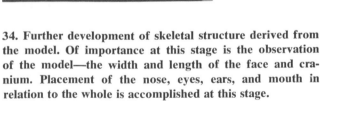

34. Further development of skeletal structure derived from the model. Of importance at this stage is the observation of the model—the width and length of the face and cranium. Placement of the nose, eyes, ears, and mouth in relation to the whole is accomplished at this stage.

Making a Waste Mold

Students and professional sculptors should know how to make their own casts. The most important mold to make for oneself is the "waste mold." As the name implies, the mold is used once and is destroyed in the process of casting. The principle of mold making is to have pieces of the mold pull away or easily separate from a sculpted form. The ideal sculpture to cast, for example, would be an egg form, for it has no protuberances to complicate the separation of mold from form. If each half of the egg was covered by a mold section, there would be nothing on the surface to prevent the pieces of the mold from coming away easily. If, however, instead of the egg form you were casting a portrait head, forms such as the nose, ear, chin, etc., would make the mold difficult to separate from the clay form. Often, separate pieces are made in the mold for these undercuts (areas of indentation) or protruding parts. This is especially important in the piece mold or slip mold for ceramics so that the ceramic clay does not distort while the pieces of the mold are removed. In complex sculptures, rubber molds are now generally used instead of piece molds, which are time consuming to make.

In the waste mold, thin metal shims are used to make the various sections of the mold. The shims are pressed into the soft clay edgewise to create an even vertical wall of metal. In the egg form for example, the shims would divide the egg into two equal halves. The shims would all be the same width

35. Step One: Finished clay portrait *Photo by Margaret Worth.*

36. Step Two: Cutting shims. *Photo by Margaret Worth.*

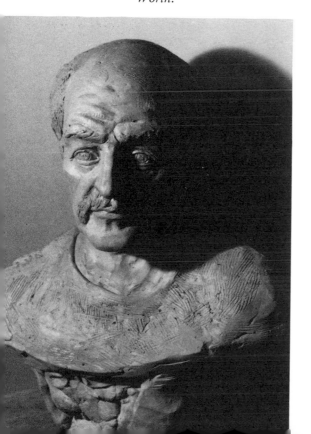

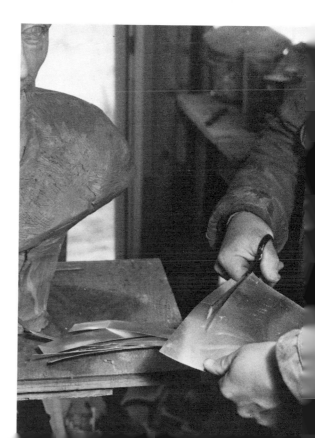

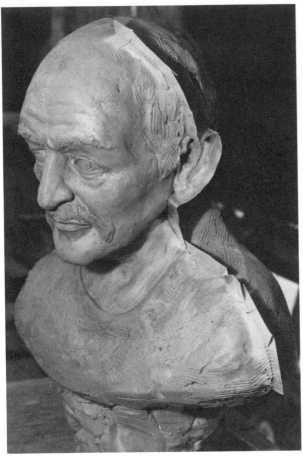

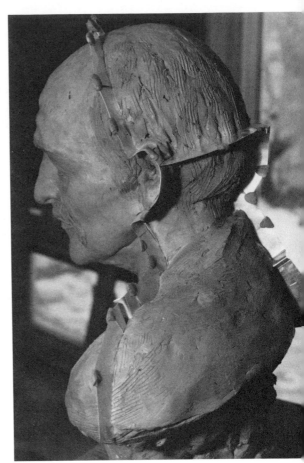

37. **Step Three: Inserting shims.** *Photo by Margaret Worth.*

38. **Step Four: Division of mold pieces.** *Photo by Margaret Worth.*

39. **Step Five: Applying "blue coat."** *Photo by Margaret Worth.*

40. **Step Six: Completed blue coat is ¼″ thick.** *Photo by Margaret Worth.*

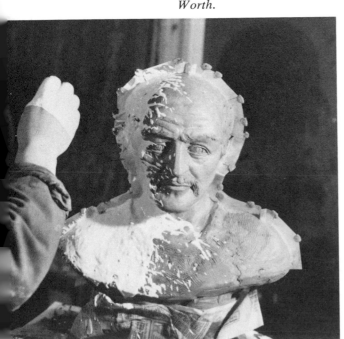

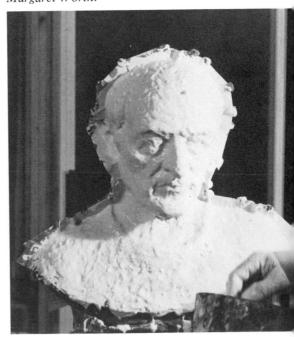

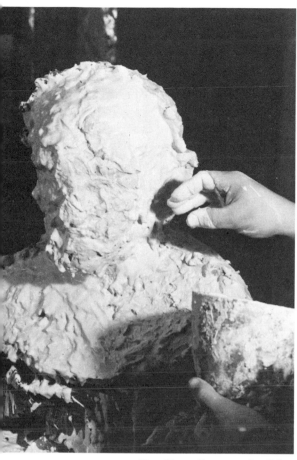

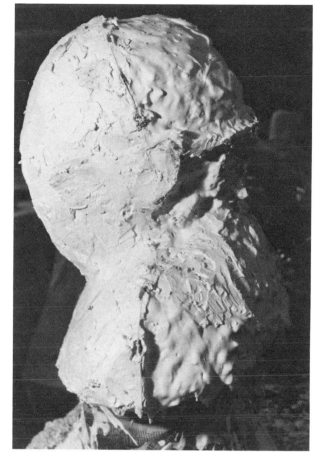

41. Step Seven: Applying white coat of plaster over blue coat. *Photo by Margaret Worth.*

42. Step Eight: Note back section of mold not yet thick enough. *Photo by Margaret Worth.*

43. Step Nine: Completed mold. *Photo by Margaret Worth.*

44. Step Ten: Addition of reinforcing irons. *Photo by Margaret Worth.*

to ensure evenness. I often fold two or three shims into a V shape to "register" the mold sections. This prevents the mold from slipping around when it is being reassembled.

After shimming, a "blue" coat of plaster is first put on the clay form. Liquid laundry bluing (without whitener or ammonia) is used to color the plaster. Pour two ounces of it into the water before you sprinkle it in the plaster. Do not use ink or paint as a coloring agent as this may prevent setting of the plaster. Food dyes can be used, but if unsure of anything you want to use, make a test on a small amount of plaster.

The blue coat is thrown onto the clay with a flicking motion. The plaster should not be too watery or too thick. It should be about as consistent as heavy cream. In applying the blue coat to the clay form, do not attempt to put all of the plaster on the form at once. Plaster takes about fifteen minutes to set and your first application of plaster should be thin, taking only five minutes to apply. As the plaster thickens, you can apply more plaster without it running off. Learn to work with plaster as it sets. Many beginners pour all the plaster onto their clay quickly, and most of it winds up on the floor. Make sure that the entire clay surface is covered with the blue coat, which should be built up to a thickness of ¼". Keep the edges of the shim visible. They will get covered with plaster, but you must clean them off with a knife or scraper. Do not clean off the sides of the shims, only the top edge.

After the blue coat has been completed, you can immediately put on the white coat of plaster. It is not necessary for the blue coat to be thoroughly dry. This is sometimes referred to as the reinforcing coat, and is usually two or three times thicker than the blue coat. Depending upon your casting skill and experience, you can make a thick or thin mold. The shims, however, should determine the thickness of the mold. If the shims protrude ¾" from the clay, that is how thick the mold should be. I like to make thin molds which are reinforced with iron or steel rods and burlap. Heavy molds are wasteful of plaster and time, and they are unwieldy when casting.

Build up the white reinforcing coat to be as thick as the shims are high. As mentioned before, the shim edges must be kept visible. When the reinforcing coat has been complete, you can add the iron rods, which must be bent to conform to the shape of the mold. Be sure not to span over two separate pieces of mold. Cut the burlap into long strips about 2" by 10". Soak these in plaster and use them to attach the rods to the mold. When you have attached all of the irons, allow the mold to set thoroughly. This will take no more than one hour under normal circumstances. Check that the shims are visible all around the mold.

To open the mold, you must first have small wooden wedges and a strong knife. Tap in the wood wedges all around the seams of the mold created by the shims. Pour water along the edge and gently pry with the knife to open the seam. Use more water than force because the water will break the suc-

45. Opening the mold. *Photo by Margaret Worth.*

46. Clay head being dug out from the mold. *Photo by Margaret Worth.*

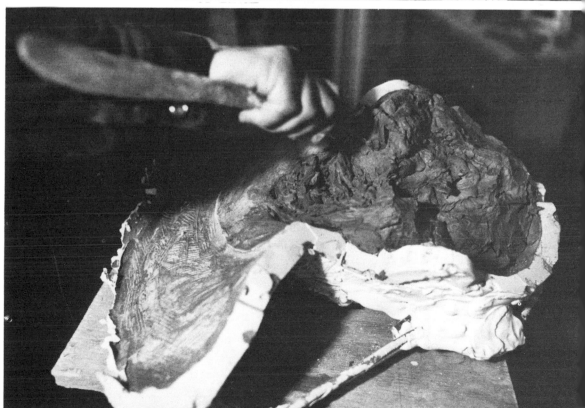

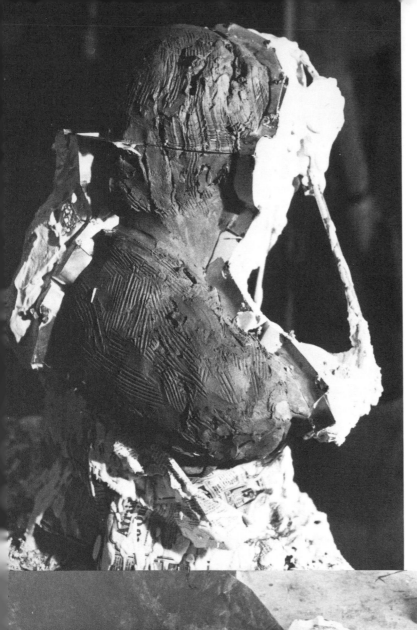

47. Removing the mold from clay model. Note the division of mold sections. *Photo by Margaret Worth.*

48. The mold laid out and washed. *Photo by Michael Sabatelle.*

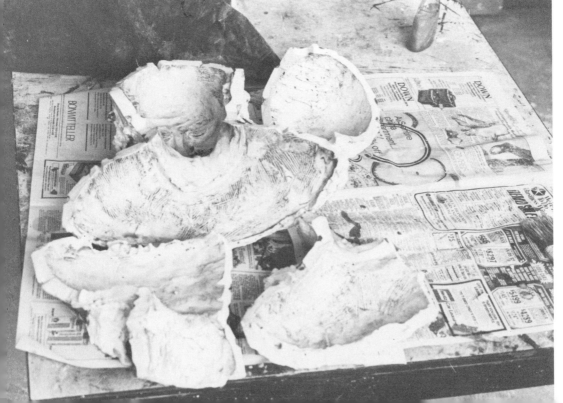

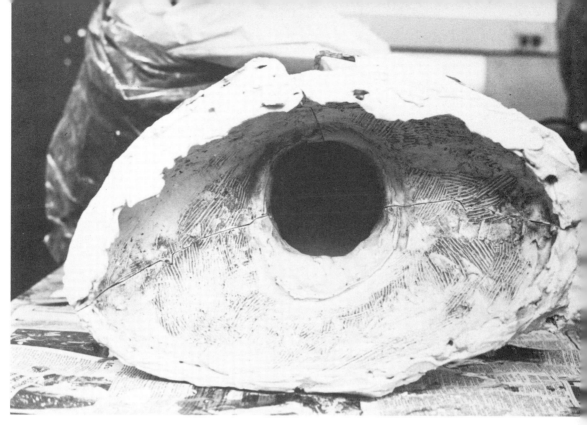

49. The closed mold should fit together tightly. Note how the seams match. *Photo by Michael Sabatelle.*

50. Plastering the mold together. Use burlap squares soaked with plaster to join each section. *Photo by Michael Sabatelle.*

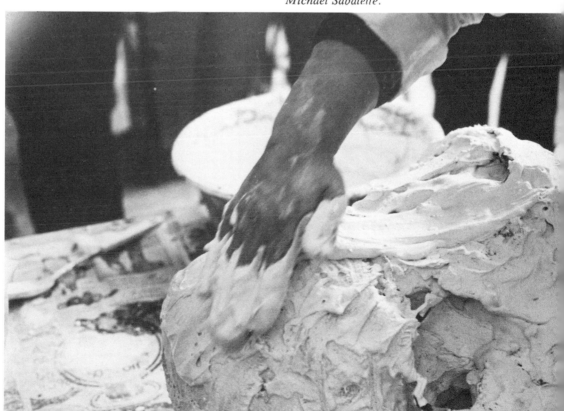

51. Filling the mold. Note hollow cast made by "slush" casting. *Photo by Michael Sabatelle.*

52. Chipping the mold. Use lightweight hammer. *Photo by Michael Sabatelle.*

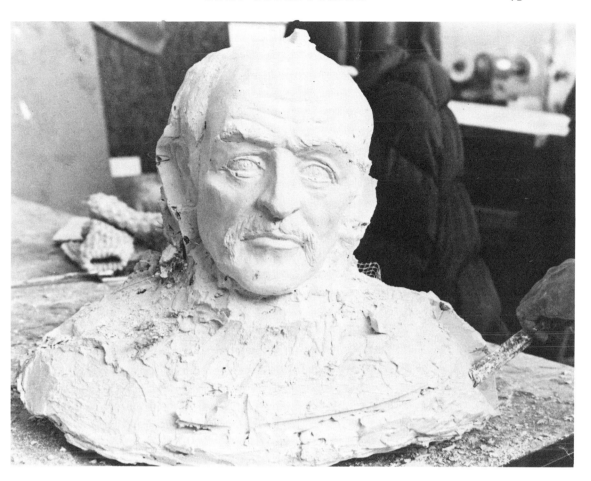

53. Cast of face emerges from the mold. *Photo by Michael Sabatelle.*

tion, whereas the knife would break the mold. The mold will finally open, with enough water. In some instances, the clay must be dug out after the first mold section is removed. The face, for example, may be lodged inside the mold and if the back section of the mold is off, the face can be dug out from behind.

When the mold has been removed from the clay form, it must be thoroughly washed with water. Use a bristle brush and check that the clay is removed from any undercuts and details. The inside of the mold must then be prepared with a mold separator such as tincture of green soap. This can be purchased in a drugstore or sculpture supply house. I have even used an inexpensive shampoo successfully. The green soap should be poured into each separate section of mold and allowed to soak for twenty minutes. Brush the green soap around the mold, including the edges made by the shims. The

shims should be cleaned off and saved for future use. After the green soap has been soaking into the mold for twenty minutes, it must be wiped out with a cloth towel. Do not leave puddles of green soap. The inside of the mold should look dry and not soapy. Some casters also apply a light coat of olive oil. Other oils, such as corn oil or vegetable oil, do not work. The olive oil is an extra precaution for mold separation.

The mold is then reassembled and plastered together with plaster-soaked burlap strips. Make sure all the seams are perfectly matched and that there are no separations where the plaster could escape. Holes can be plugged with clay or plastelene. The entrance to the mold is, of course, where the plaster meets your working surface, usually at the bottom.

When the mold is ready for pouring, mix enough plaster to fill the mold. A large mold may require two buckets. As you become more proficient with experience, you should make your casts hollow instead of solid. If properly done, a hollow cast is stronger. Many commercial castings, however, are too thin. A life-sized head, for example, should be about 1″ thick and reinforced inside with plaster-impregnated burlap squares that form an interior skin. Lift the mold off of the working surface and invert it so that the entrance faces up. Pour about one third of the necessary plaster into the mold, and gently revolve the mold so that the plaster covers the entire inside surface. This is called "slush" casting. In solid casting, however, you can pour in the remaining plaster and fill the mold. Vibrate the mold gently without spilling the plaster. This will cause the air bubbles to rise and break. The plaster should set and remain for about forty-five minutes.

You are now ready to chip off the mold. This is the reason for the term "waste mold." Using a light hammer and carpenter's chisel, first remove the irons and burlap. Next, chip off a section of the white coat until you see the blue plaster underneath. You are now next to the cast inside. Gently chip off the blue section until you see the white cast inside. Repeat this process over the entire mold until the cast is finally out. In some sections, the mold will come off safely in larger pieces. Do not, however, try to remove very large sections on a detailed work such as a portrait, because it is easy to break off an ear or nose.

Most casts need retouching and cleaning up after casting. Chisel marks and chips can be filled with fresh plaster and water.

Some Do's and Don'ts:

A mold which has been stored and is dry should first be soaked in water before preparation for casting. A dry mold will absorb water from the wet plaster and thereby weaken the cast. Green soap should not be left overnight in the mold. It will dry and lose its separating power. Do not chip a dry mold because the cast inside can easily crack. Soak the mold with water first before chipping.

A Look at the Future

Clay techniques will no doubt become more complex and versatile as technology develops. This development has and will continue to challenge the artist into redefining his art as well as himself. Technology will, however, remain technique and not content, and it will remain for the artist to clarify this dichotomy. There are those who believe that technology will become art because of its tremendous influence, power, and perfection. Perhaps this may come true, but if it does, it will be because a human being is behind the machine. I personally feel that a machine will never replace a human being, especially in the arts. Art curators and critics are glorifying technology to such an extent it may be centuries before we recognize what art is. Art has always been an individual idea or expression, more often than not ignored or misunderstood during its time. In an age such as ours, when marvels in technology have been achieved, Picasso, Matisse, De Kooning, Henry Moore, and many others are actually antitechnical in their work and aims. They remain human and their strong personalities come through in their work, even while technology was developing computers that would replace humans. I believe it will remain this way even in the future. That is, art will prevail as a basically human activity, while technology will remain outside of this preoccupation. It will take longer, however, to recognize art because preoccupation with technology will make us temporarily forget the values of art. This is already happening. There is much admiration for art that eliminates the "hand" of the artist. This in itself would not be so bad if it didn't eliminate the soul as well. If there is coordination between mind and hand, or between perception and act, there is unique art. Computers can turn out interesting patterns if programmed well, but they cannot initiate inspiration or action. No doubt, engineers will develop computers that will feel "emotion," but they will be limited compared to humans. Why invent these crude imitations of human beings? Imitations are always several steps behind originals. No computer will ever be developed to model clay as Rodin did. Artists are rebels and it would be dangerous to have a computer programmed to be rebellious.

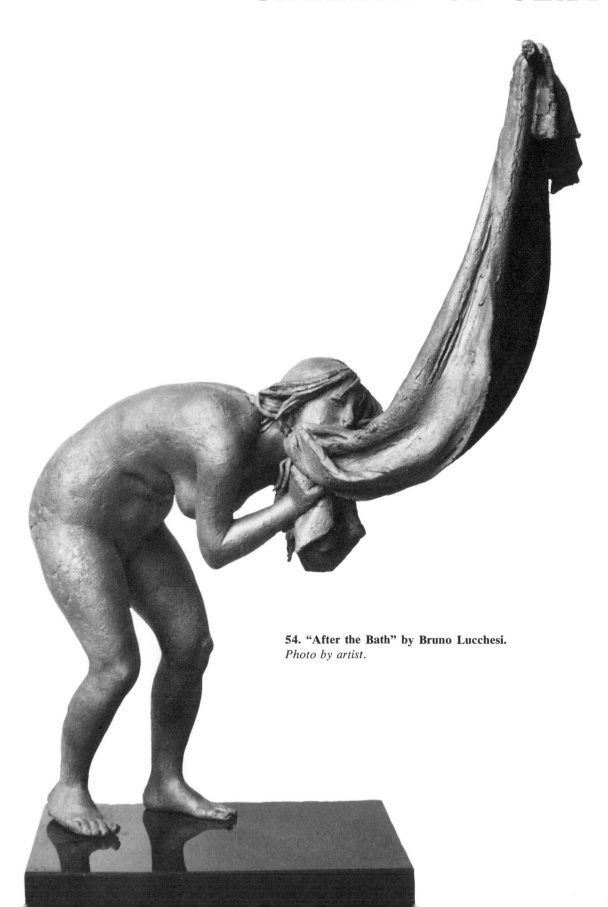

54. "After the Bath" by Bruno Lucchesi. *Photo by artist.*

SCULPTURE

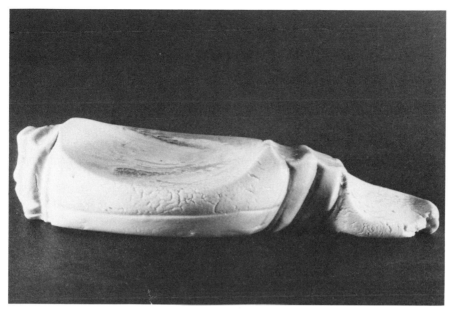

**55. "Metamorphic Form" by Mikhail Zakin.
Porcelain—12″ × 4″ × 5″.** *Photo by artist.*

**56. "Metamorphic Form" by Mikhail Zakin.
Stoneware—18″ × 9″ × 9″.** *Photo by artist.*

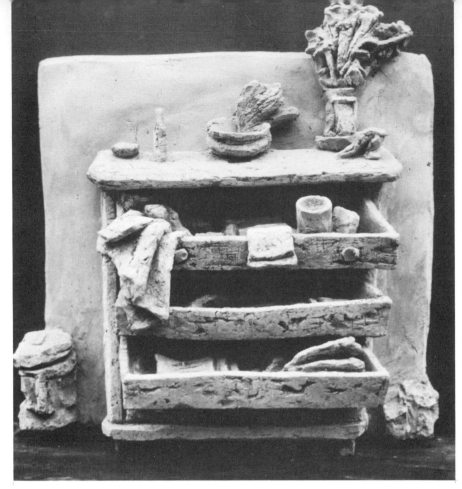

**57. Terra-Cotta by Evert Lindfors.
24″×24″.** *Photo by Turin.*

**58. Terra-Cotta Landscape by Evert
Lindfors. 16″×24″.** *Photo by Turin.*

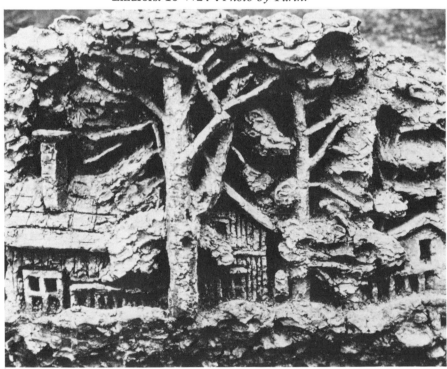

59. Terra-Cotta Still Life by Evert Lindfors. 24″×18″. *Photo by Turin.*

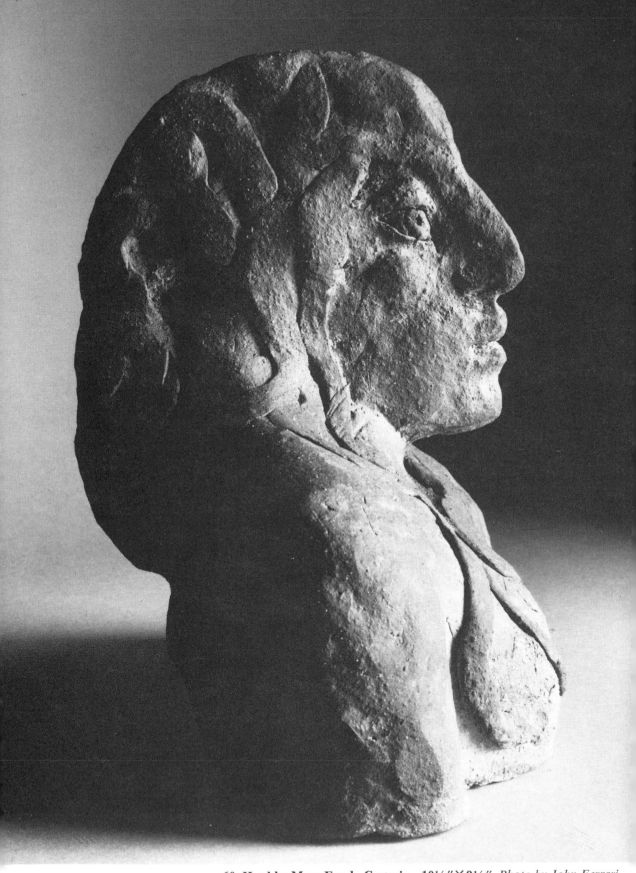

60. Head by Mary Frank. Ceramic—10½″ × 9½″. *Photo by John Ferrari.*

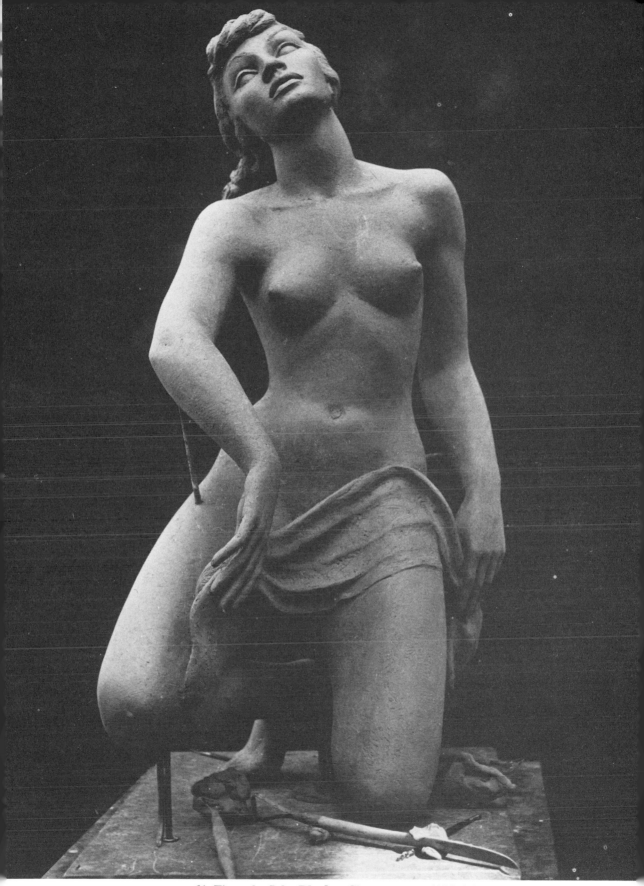

61. Figure by John Rhoden. Clay—approx. 48″ height.

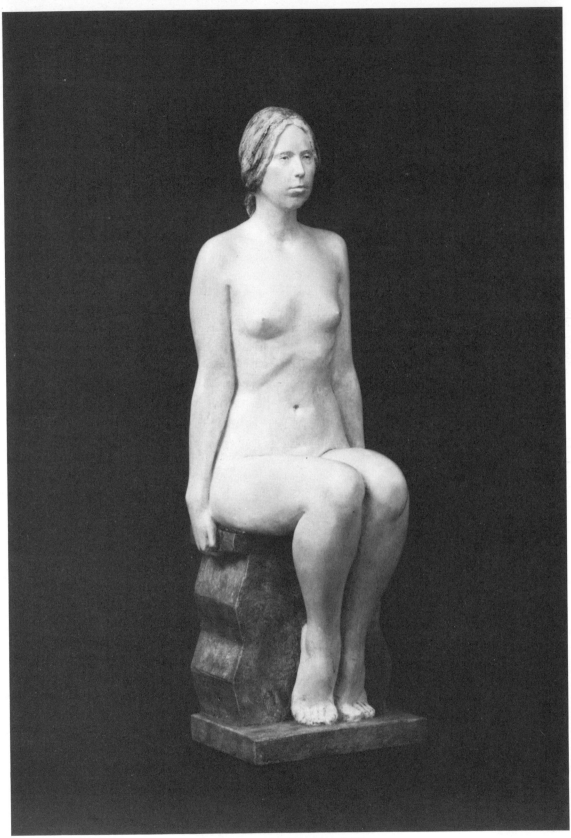

62. "Gayle Posing" by Lloyd Glasson.
Cast stone—21″ height. *Photo by David Allison.*

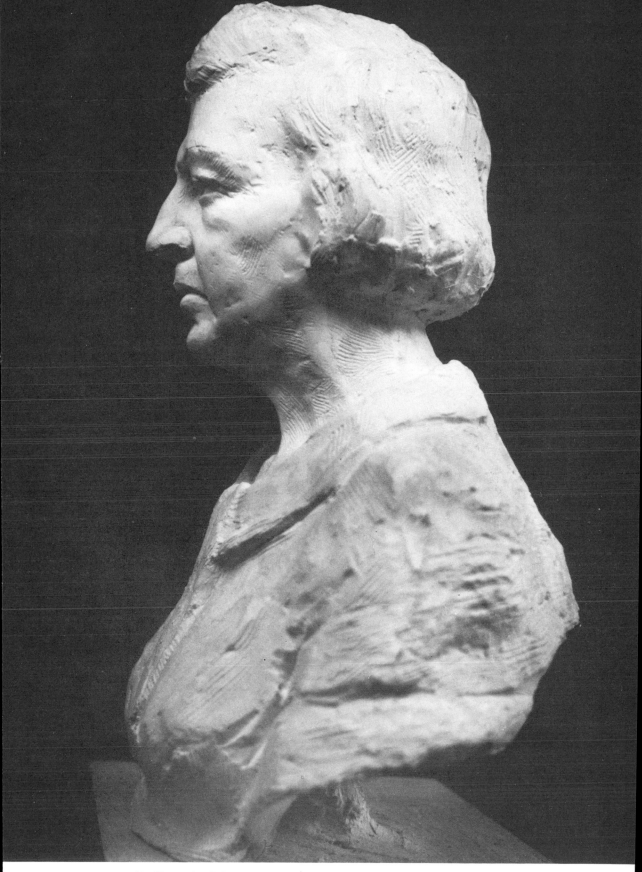

63. "Portrait of the Artist's Mother" by author. Plaster—life-sized.

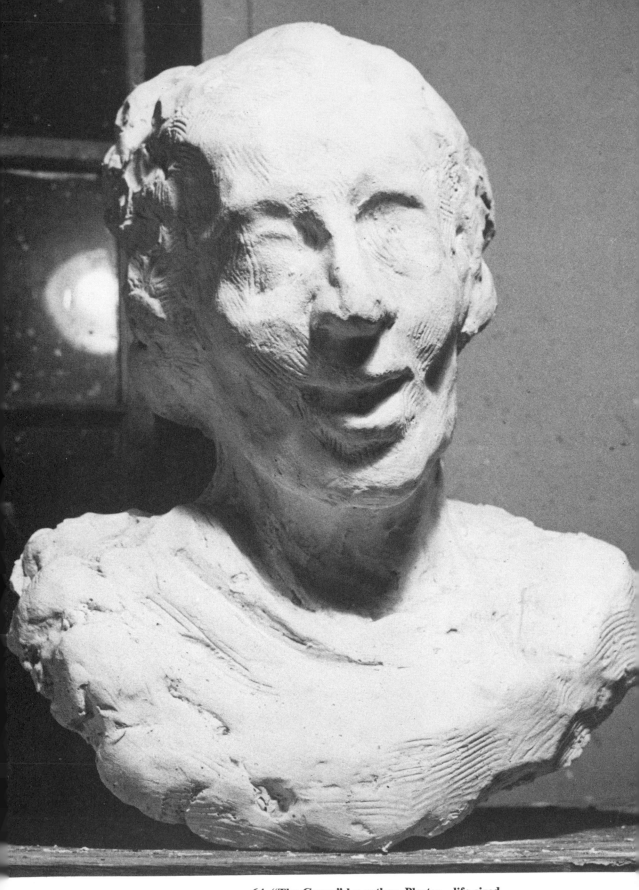

64. "The Gypsy" by author. Plaster—life-sized.

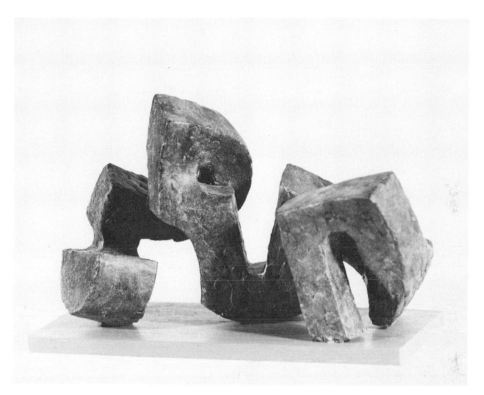

65. "Rambling" by author. Ceramic—6″ × 8″.

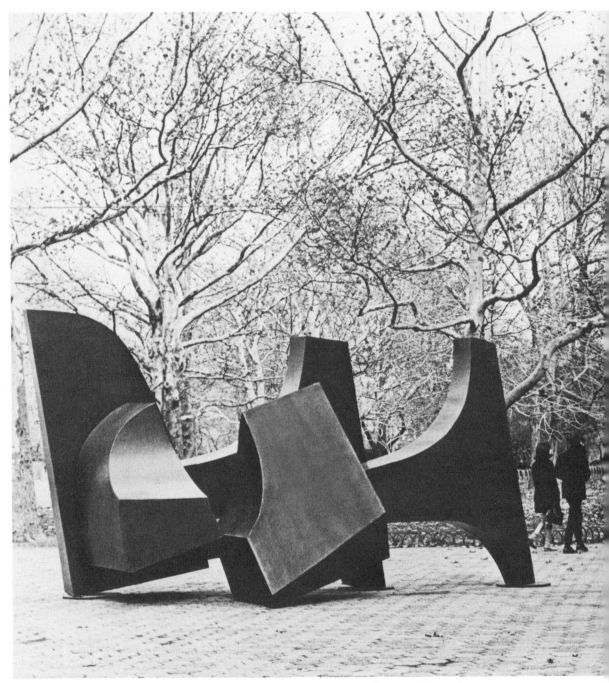

66. "New York I" by author. Plywood, masonite, paint, 1968—22′ × 12′ × 6′. Large sculpture was made of plywood as a mock-up for steel.

TWO

WOOD CARVING AND CONSTRUCTION

Wood, like clay, is one of the oldest materials used by man. It has been used for the construction of shelters, temples, ships, bridges, as well as for sculptural expression. Some of the greatest wood constructions known to man were the ancient Chinese temples. They were enormous architectural structures, most of which have been destroyed by fire. Today, large forest preserves and technology have greatly expanded our knowledge and use of wood. Large and small mills cut trees into lumber which is used for construction and many related fields. There are literally dozens of machines available for woodworking, but before embarking upon setting up your own mill, it would be best for you, as a beginner, to carve with wood chisels (gouges) and a mallet. Learning to carve and finish wood by hand is the basic training needed for using power machinery later.

The Structure of Wood

All wood is fibrous material having graining which is beautiful and durable when finished. Trees, or logs, have an outer core and an inner one called the heart. Generally, the outer core is of a lighter color and is usually softer. There are many varieties of hardwoods and softwoods which can be carved, drilled, and worked in a number of ways. Certain woods are better for carving, while others are more useful for construction. Pine and fir, while not suitable for carving, are ideal for construction. Nails and screws can be driven through pine and fir, but it is very difficult to drive them through oak, chestnut, ash, maple, or other hardwoods. Hardwoods are better for carving than softwoods because they finish better. They can be carved *across* the grain without tearing the wood. You should never carve *against*

the grain whether you are carving softwoods or hardwoods because this can ruin the chisel and splinter the wood.

The grain of wood is similar to the straws of a broom squeezed tightly together. The end of the broom which does the sweeping is called the "end grain" on a piece of wood. The sides where the straws run parallel is called the "face." Saws which cut across the grain are called "crosscut saws" while "ripsaws" cut wood lengthwise with the grain. Learning to carve wood depends upon learning to carve with or across the grain. For example, if you wanted to carve a deep concavity or a hole through wood, the chisel must start at the outer perimeter and work toward the center. Never try to start from the center of a concavity and work toward the perimeter. You will quickly learn this as soon as you start carving wood. Wood carves smoothly and easily when carved with the grain. Against the grain, you will experience difficulty and tearing of wood.

End grain

67. End grain is similar to the fibrous straws of a broom squeezed tightly together.

Carve from outer perimeter toward center

68. Carve from outer perimeter toward center (see illustrations 67 and 72).

Carving Techniques

Logs are more exciting to carve than blocks because the forms and twists in a log can be the starting point for a sculptural idea. Gnarled tree trunks have powerful forms which can be utilized in the form concept. The same is true of certain blocks of stone if they are not squared off on all sides. Technically, carving wood is similar to carving stone. Stone is generally harder, but some woods can equal stone in toughness.

Start with a deep gouge and heavy mallet. An adz or hatchet can also be used on large logs. (See illustration 71.) The work is slow and hard, but as

your body adjusts to the physical exertion, you will feel stimulated. Try to conceive of the fibrous graining of the wood as growing out from the inner core of the wood. This is the greatest difference in structure between wood and stone. Stone has a crystalline structure which is dense, compact, and hard, while wood is organic, fibrous, and more fluid in feeling.

Wood carving, technically speaking, is a simple technique. A wooden mallet is used to strike a chisel (or gouge) which cuts into the wood and removes the wood in strands. A deep gouge, usually ¾″ wide by ½″ deep, is first used to start or rough out a log or wood block. Wood is plentiful and relatively inexpensive. If you are just beginning wood carving, you need not buy seasoned hardwoods, which are expensive, especially the imported varieties. You can get wood from tree cutters, park departments, lumber mills and lumberyards, beaches, old barns, as well as from sculpture and wood suppliers.

Try to get a piece of wood that is seasoned for at least one year, or that has been kiln-dried. Most sculptors, however, like to work in large pieces of wood, which are difficult if not impossible to find already seasoned. A wet piece of wood (one which has recently been cut down) is called "green," and will dry rapidly when brought indoors and develop cracks due to shrinkage. Sculptors, Henry Moore among them, have carved huge logs of wood while they were still green, but controlled the drying rate (and thus the shrinkage also) by sealing the wood while they were carving it. Shellac or polyurethane varnish is painted over the outer carving to seal the wood.

69. Logs ready for carving.

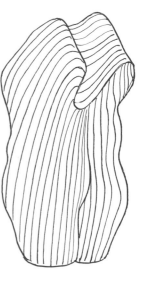

70. Log suggests form.

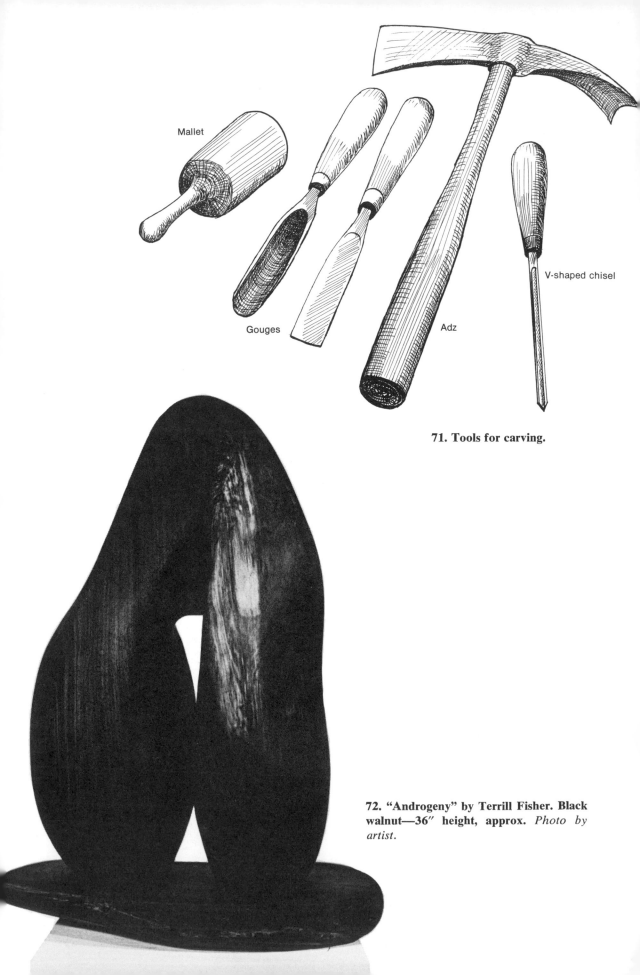

Mallet

Gouges

Adz

V-shaped chisel

71. Tools for carving.

72. "Androgeny" by Terrill Fisher. Black walnut—36″ height, approx. *Photo by artist.*

This is done each day on those sections which have been carved, thus sealing the log.

As mentioned, the deep gouge is used to carve away the large sections of wood. Carving in this manner is a slow process. Do not drive the chisel so deeply into the wood that you cannot easily remove it. (You can break the chisel in this manner.) Carve in the direction of the grain and remove the wood in layers or planes. If the wood is green, it will be easy to carve. If it is seasoned, it will be more difficult, but cracking is less likely to occur. You can try carving across the grain, but if the wood begins to tear or come apart, discontinue working across grain. Usually, the seasoned hardwoods are good enough to carve across grain without tearing. Develop the sculpture with a sense of planes working generally all over the wood. We saw this principle in the first chapter, on modeling a head or figure. Carving, of course, is a removal method instead of an additive one, but the principle of developing the major planes remains constant. To hold the work stationary or firmly in place, use a woodworking vise on a heavy worktable. If you do not have a vise, you can use either a hydraulic arm, (purchased at a sculpture supplier—a few are listed at the end of the book), or you can screw the wood down to a heavy board which is clamped to a worktable. A corner frame made of 2″ by 4″s can also be nailed on top of a worktable to simply stop the wood from rolling or moving.

After you have developed the sculpture with the deep gouge, you can further refine the planes and carve details with a shallow gouge (see illustration). The shallow gouge is usually ½″ wide by ⅛″ deep. The use of the shallow gouge will greatly smooth out the wood so that the grain will be more apparent.

At this point, you can finish the wood in either one of two ways: by leaving the chisel marks and later burnishing and waxing the wood, or by rasping the surfaces to a smooth finish. After rasping, sandpaper and finally varnish or oil finish the wood. If you decide on this finish, be sure to use a sharp rasp that will remove all the gouge marks. After rasping, start with a coarse sandpaper (one from No. 24 to No. 36), removing all the rasping marks. Then use the medium sandpapers (from No. 60 to No. 80). Cut the sandpaper into small squares about the size of your hand. You can use a sanding block (a gadget that holds sandpaper) for large simple forms.

For final sanding, use fine sandpaper, No. 100 to No. 180. On some extremely hard dense woods, you can go to No. 220 and No. 280 sandpapers. The V-chisel (see illustration) is used to sharpen or emphasize details such as eyes, lips, nostrils, hair, etc.

If however, a textured finish is desired instead of the smooth varnished look, use a small gouge (¼″ wide by ⅛″ deep) and carefully carve all over the surface of the wood. The great German sculptor Ernst Barlach often completed his figures with a textured finish.

Like all tools, wood chisels must be sharpened when they become dull. An oil slipstone or water slipstone is used. These can be purchased in almost all hardware stores, sculpture suppliers, or even stores which deal in cutlery. Oil or water is used as a lubricant when the chisel edge is ground on the stone. Slipstones have a rough side and a smooth side and are made of Carborundum. When sharpening the chisel edge, be sure to sharpen only the angled surface, keeping the angle intact. Do not round off this angle. Do not use a bench grinder to sharpen chisels because the chisel will overheat rapidly and burn the steel. Chisels can also be sharpened professionally by commercial firms.

Wood Quality

The following is a list of domestic woods:

DOMESTIC WOOD TYPE (Partial List)	CARVING QUALITY
Apple	Good
Ash	Good
Aspen	Good
Basswood	Good
Beech wood	Fair
Birch	Fair
Black Walnut	Excellent
Boxwood	Good
Cedar	Poor
Cherry wood	Good–Excellent
Chestnut	Good
Cypress	Fair
Elm	Fair
Fir	Poor
Hemlock	Poor
Hickory	Good
Linden	Good
Maple (Rock, or Sugar)	Good–Excellent
Oak	Good
Pear	Good
Pine (White and Yellow)	Poor–Fair
Plumwood	Good
Poplar	Good
Redwood	Fair
Sycamore	Good
Tulipwood	Good
Walnut	Excellent
Willow	Poor

Imported woods are generally better for carving, many of them coming from Mexico, Australia, South America, and Europe. They are as follows:

TYPE OF WOOD (Partial List)	CARVING QUALITY
Cocobola	Excellent
Ebony	Excellent
Gum	Poor
Jarrah	Good
Karri	Good
Lignum vitae	Fair
Mahogany (African and Philippine)	Excellent
Mulga	Good
Rosewood	Excellent
Teak	Good
Vermillion (African padauk)	Good

Seasoning Wood

Wood must be dried before it can be used for carving or construction. There are two methods for drying wood; one is by air and the other is by kiln. Because of the demand for dry lumber in the construction industry, most lumber is kiln-dried in huge kilns. These kilns are perfectly controlled in temperature and moisture content for each type of wood. Drying wood, whether by air or kiln, must be a slow and gradual process; otherwise cracks, or "checks" develop along the radial lines on the end grain. In general, it takes about six months to a year to dry an inch of wood by air. A log 12″ in diameter would take between five and twelve years according to conditions and type of wood. The log must be stored indoors off the ground (usually on 2″ by 4″s), and the bark must be removed. Both ends of the log must be sealed with either wax, polyurethane, or several coats of an oil-based paint. Logs should be stored in a dry, cool place, not a heated area. If they are stacked outside, a roof cover must be provided. Do not cover logs with plastic sheet because this will keep moisture in and also cause mold and decay. Rain and snow should be kept away from the wood.

Seasoning wood will cause moisture to evaporate and a certain amount of shrinkage to occur. Different woods will shrink at various rates, but if seasoned wood is used, shrinking and "checking" can be minimized. No guarantees against checking are possible with even seasoned woods. A change of environment or climatic conditions can cause a seasoned piece of wood to check. Wood will absorb and evaporate moisture depending upon environment. Frequently, a finished carving will check during an exhibition

because most art galleries and museums are warmer than sculptors' studios. To counteract this tendency, finished wood carving can be saturated with boiled linseed oil. The wood will absorb the oil, thereby preventing moisture from escaping or being absorbed too quickly. To saturate a large wood carving may require several days. The linseed oil should be painted on with a brush and allowed to soak in. Very small carvings can be submerged in linseed oil in a deep bucket.

Another sealant for wood is one of the clear polyurethanes. These come in satin and glossy finishes and will completely seal wood with several coats. Wood-Life is a wood preservative which is chemically treated to prevent wood decay. Color can be added to Wood-Life, a popular practice in house construction. Wood preservatives are sold commercially under various trade names such as Wood-Life. These sealants and preservatives give a beautiful finish to the wood grain. Wood polish and wax can be applied to give a luster. A metal burnisher is sometimes used to bring a glossy surface to the wood.

Stains

Many commercial stains are available to color wood, but aesthetically this is not recommended. If the wood is scratched, the natural color will show through the stain. It is better to choose the wood you want rather than change its color. Wood will naturally change color with age. Some stains are made with water-soluble materials, while most are made with oil vehicles. Stains raise the grain of the wood, which must then be refinished with fine sandpaper or steel wool.

Color Change Through Fumigation

A wood carving in a light-colored wood such as white pine, oak, ash, etc., can be darkened by the following method:

1. Raise carving on two pieces of wood to allow a dish or pan to be placed under the work.
2. Wet down the wood with water, using a sponge.
3. Fill the pan with a solution of ammonia (ammonium hydroxide).
4. Cover the carving and the pan with an airtight box or a plastic sheet stretched over a wire cage.
5. Leave encased for twenty-four hours. The fumes from the ammonia will react with the wood, thereby darkening the grain.
6. Remove covering (after twenty-four hours) and sand or steel wool the raised grain of the wood. Clear wood preservatives or sealants can be applied, or boiled linseed oil can be used for finishing. Wood wax, furniture polish, or burnishing can be used finally to give a glossy finish.

Wood is not recommended as a permanent material. Cedar is best for out-of-door wear, especially if treated with creosote. Telephone poles are made of cedar which has been pressurized with creosote. With periodic treatment (painting, varnishing, oil, wax), wood can last for a very long time, but it does not have the durability of the hard stones.

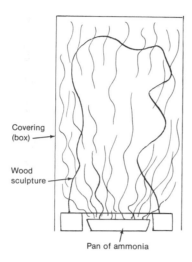

73. **Fumigating wood.**

RALPH BANEY CARVING WOOD

Photos by Isaac Jones, Jr.

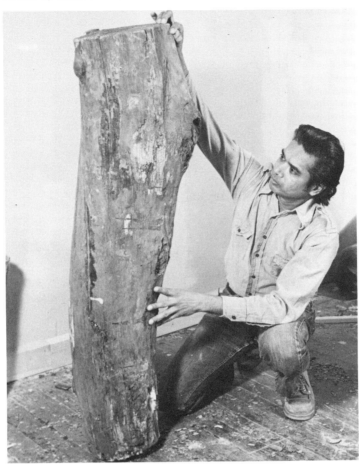

74. Studying a walnut log.

75. Removing the wood in layers.

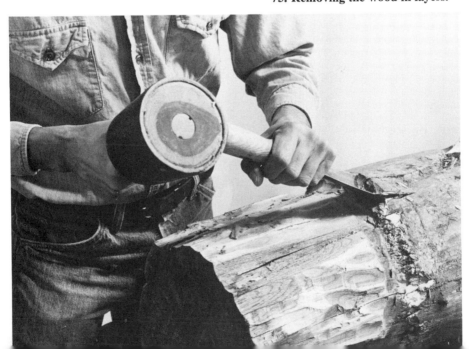

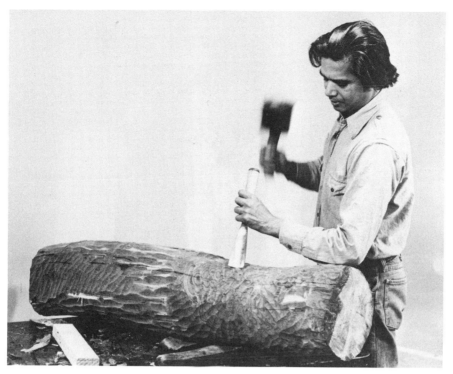

76. Using the large gouge to cut across the grain of the wood.

77. A bent gouge is used for concave areas. Note that the direction of the gouge marks follow the form. They are also determined by the grain of the wood. The objective is to make clean cuts without tearing or ripping the wood. The concavity or hole is being carved from perimeter to center.

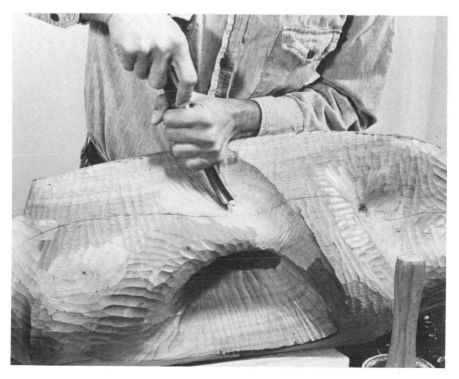

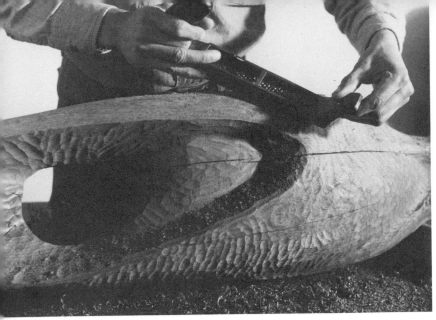

78. The Shur-form rasp is used to remove the gouge marks and to pull the surface together.

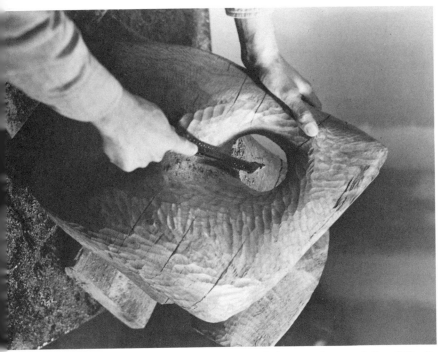

79. The round rasp is used for openings and for difficult-to-get-at areas.

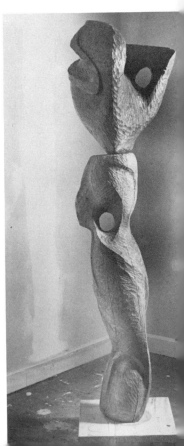

80. Finishing stage.

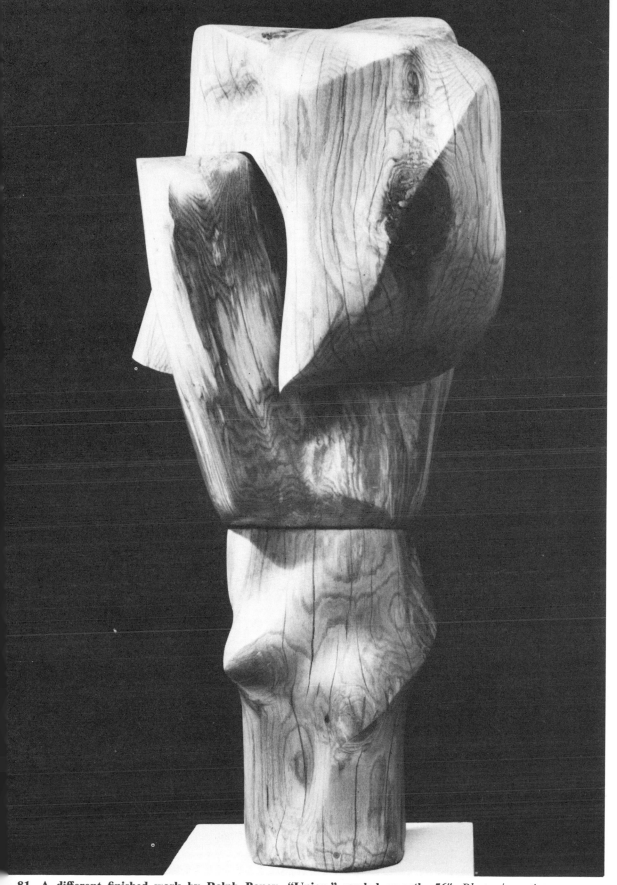

81. A different finished work by Ralph Baney, "Union," sanded smooth, 56″. *Photo by artist.*

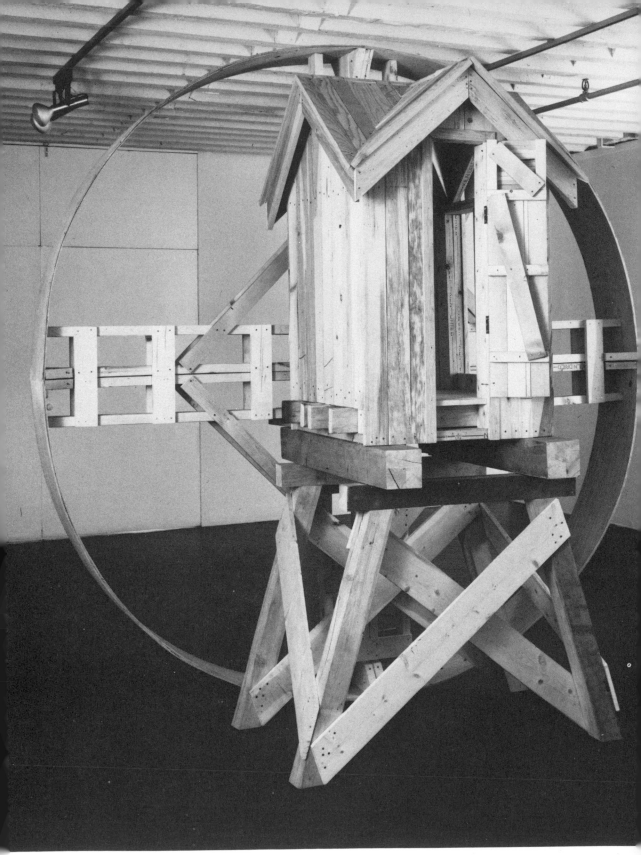

82. Untitled (Medieval Wheel House) by Alice Aycock. Wood, 1978—House: approx. 4′ × 4′ × 8′; wheel: approx. 8′ diameter. *Courtesy John Weber Gallery, N.Y. Photo by John Ferrari.*

Wood Construction—Contemporary Approaches

Wood can be joined (laminated), glued, bolted, screwed, doweled, notched, or nailed. Today, power tools can cut, drill, and sand wood quickly. Wood can also be bent by steam pressure. Contemporary sculptors often use large industrial wood blocks (railroad ties) and join them with bolts, metal plates, or notching; the current taste is for roughly natural or aged woods with the joining elements made visible. Large constructions must be put together by using a chain hoist, crane, or other lifting machine to position each form. New industrial glues and adhesives make it possible to join wood into strong joints.

The chain saw is a marvelous tool for the contemporary sculptor. Not only can wood be cut into pieces, but with experience and practice, a log can be roughed out with a chain saw. Beginners should be extremely careful handling a chain saw. A "kickback" can occur causing serious bodily harm. The left arm should be locked into position so that if the chain saw does kickback, it will be held in check. The teeth on a chain saw must be kept sharp. Most chain saws have an automatic oil flow to lubricate the cut. Chain saws are powered by electricity or gas. For inside studio work, the electric chain saw is preferable. Gas chain saws are used for downing trees in the field or forest. There are various lengths to a chain saw bar. It is best to have two saws, a 12" bar and a 16" one for large work. After a log is roughed out with a chain saw, wood chisels or an adz can be used to further develop the forms.

Drilling holes through hard wood can be extremely difficult work, especially when very thick wood is used. High-speed blade drill bits are best and can be used with extension attachments. Electricians use a flexible extension attachment which is 3' long. Drill bits dull quickly when used on oak, maple, ash, and other hardwoods, and resharpening is essential. Be sure to lubricate the drill bit when drilling. A reversible electric drill is best for drilling through thick wood because if it jams, the drill can be rotated in the reversed position and backed out. If smoke appears when you're drilling, stop until the bit has cooled. Many beams are made of oak which is difficult to drill through or nail into.

83. Holding chain saw, keep left arm locked straight.

Plywood is a good material for sculptural purposes. It can be purchased in 8' or 10' lengths. Plywood 1" thick is very strong and ¼" or ⅛" thicknesses can be bent over a wooden frame. Successive layers of thin plywood can be laminated one over the other up to any desired thickness, giving great strength. For out-of-door works, a waterproof glue is important for lamination. Plywood can also be laminated into a block and carved. Finishing a plywood form with sandpaper will show the beautiful layer of the wood. Many plywood bowls were turned on a lathe and use the layering as part of the design.

Many sculptors prefer laminating thick boards into blocks for carving rather than using logs. The advantage is that boards are usually better seasoned. Be sure, however, that the boards are perfectly flat; otherwise the lamination will be faulty. Boards can be milled flat by a local carpenter. Extended parts of a sculpture can be laminated separately, and carved and joined later. Wooden dowels can also be used for joining wood but are not recommended for extended parts bearing great weight. Steel dowels can be used instead. The difficulty with doweling through two separate forms is in trying to maintain alignment. The slightest deviation in alignment will make it impossible to pass a dowel through. The two forms must be set up perfectly and held securely in place before drilling starts. An extension bit is necessary to go through forms over 6" thick. A threaded rod can be used with a nut and washer on both ends to squeeze the forms together. The nut and washer can be countersunk beneath the surface of the wood, and a ratchet wrench may be used to tighten the nut. The hole can be plugged and finished with the same wood if desired. Wood dowels even 1" thick would break on heavy forms.

The ancient Orientals used wooden plugs to prevent wood from checking wide open or to stop further checking. If already cracked or checked, sometimes the wood can be squeezed back with clamps, and a wedgelike shape can be carved from the surface overlapping the crack. A separate piece of wood is then carefully fitted into the wedge shape and glued into position. This method holds the fibers of the wood together.

84. Plywood bowl.

85. Wood plug was used by ancient Orientals to prevent checking.

Wood Techniques in the Twentieth Century

Cubist formalism has had a great effect on modern sculpture. Early cubist works by Picasso, Lipchitz, and Archipenko were often done in wood. Lipchitz also used wood for models later executed in stone and bronze. Constructions and collages were made of cut-offs from a power saw; this approach is closer to the carpenter's technique of using wood than to the traditional carving approach. Wood construction today has reached a highly sophisticated level of technique since the early days of the cubists. The contemporary sculptor's studio may resemble a carpenter's shop. Indeed, power tools such as the band saw, radial saw, circular saw, sander, and drill press are necessary for the sculptor using this approach. Using industrial tools on industrial forms (beams, 2″ by 4″s, etc.) often results in an impersonal statement, especially when the cubist aesthetic is followed.

The emphasis on form has made it easier to concentrate on technique. The sculptor can approach the making of a work as the carpenter approaches making a table. Emotional involvement is at a minimum, although

86. "The X" by Ronald Bladen. Painted wood mockup used as model for aluminum sculpture, 1968—22′ × 14′ × 24′. *Courtesy Sculpture Now, Inc.*

there is pleasure in the craft. Content, which is emotional involvement and expression, complicates art greatly. Art historians, at least those who like to categorize artists, get upset by profoundly emotional works. This kind of work, which comes from the heart rather than the head, is generally more personal. The achievements of such contemporary wood sculpture are of a technical nature, and more time will be needed before we can develop (or assess) this art. Often an involvement with content necessitates the restriction of technique. Modern film, for example, has achieved this. Some of the best films are made on small budgets with unknown actors, even though the film industry has achieved monumental technical know-how. The great science fiction spectacles such as *Star Wars, King Kong,* etc., are mainly contentless and emphasize dazzling technique. When a film maker wants to express an emotion about human reality, it is the emotion that counts, with the technique playing a secondary role. The danger with technique is that it can become mindless and eventually boring. The expression of art is often a quiet experience requiring a gentle reception to take place. A smiling Buddha stone head requires sensitivity to be appreciated, whereas a multimedia work with light and sound (and whatever else) may be simply noise if content is not considered. Consider this in using these power tools, for wood or any material.

Wood is a warm and organic material especially adapted to humanistic ideas and feeling. Most people love to touch wood, though they may not want to touch steel, for example. Wood is easy to live with. A sculpture in wood if done in aluminum would be entirely different. Yet wood is not considered very valuable among art collectors and connoisseurs. Bronze and stone are more highly prized, and often a mediocre work in bronze will fetch a higher price than a superior work in wood. Wood has the great advantage of being plentiful and relatively inexpensive. Sculptors I know of will stockpile dozens of logs and carve three or four of them simultaneously. This method of working develops ideas as connected concepts rather than as individual unrelated thoughts.

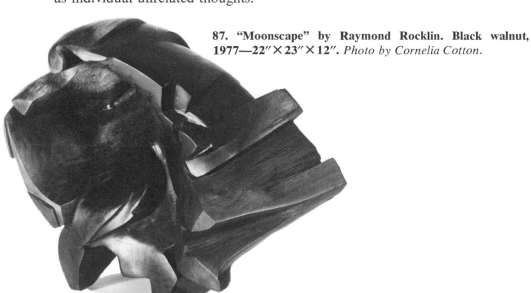

87. "Moonscape" by Raymond Rocklin. Black walnut, 1977—22″ × 23″ × 12″. *Photo by Cornelia Cotton.*

GALLERY OF WOOD
SCULPTURE

88. "Niagara Dance" by Robert Stackhouse. Wood and rock, 1977—112′ × 9′ × 16′ (width). *Photo by Mary Beth Edelson.*

89. "Running Animals—Reindeer Way" by Robert Stackhouse. Wood, 1976—144′ height × 66′ × 72″. *Courtesy Sculpture Now, Inc.*

90. "Ithaca" by Charles Ginnever. Wood and steel, 1959–60—12′ × 15′ × 25′. *Courtesy Sculpture Now, Inc.*

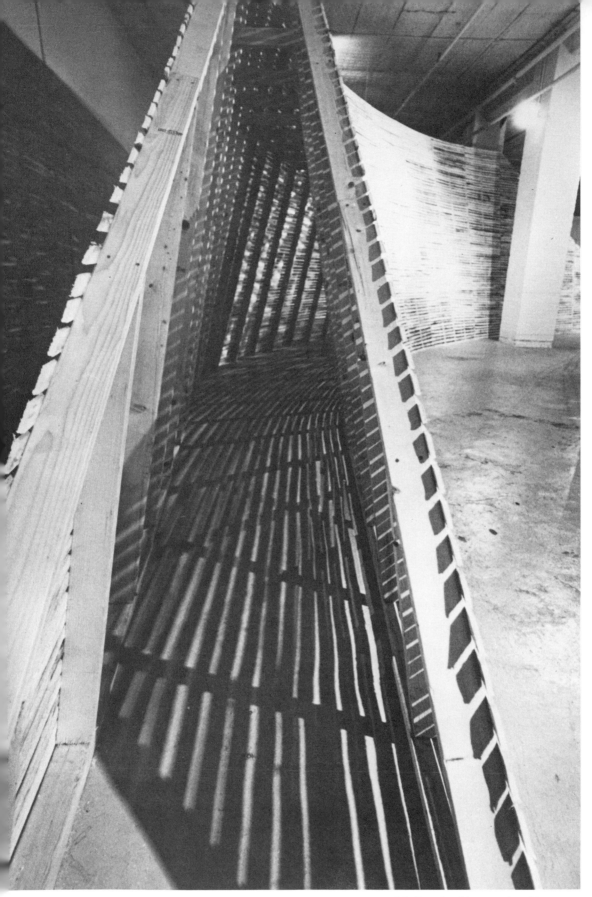

91. Detail of illustration 89.

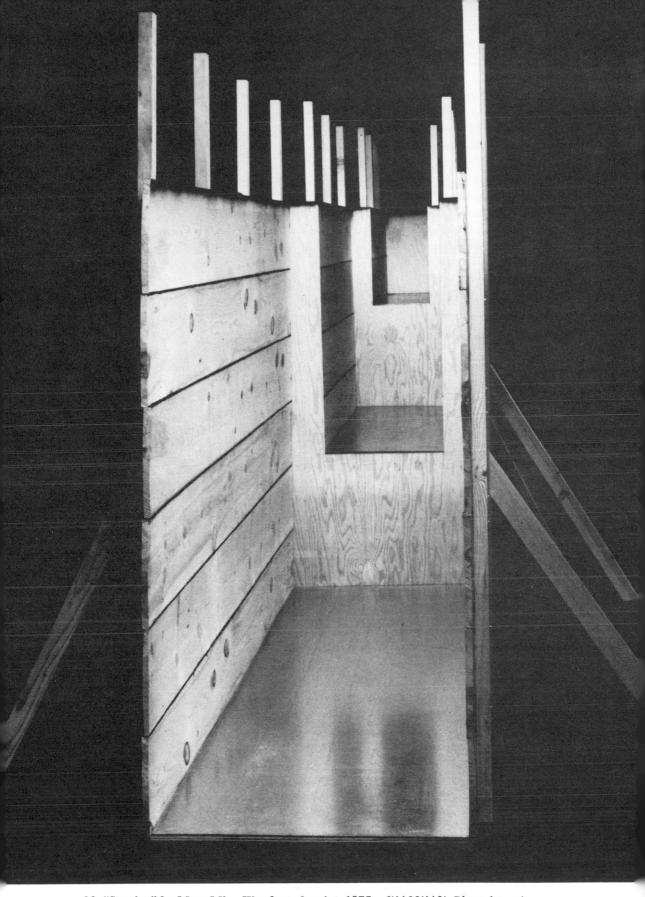

92. "Sapping" by Mary Miss. Wood, steel, paint, 1975—6′ × 22′ × 3′. *Photo by artist.*

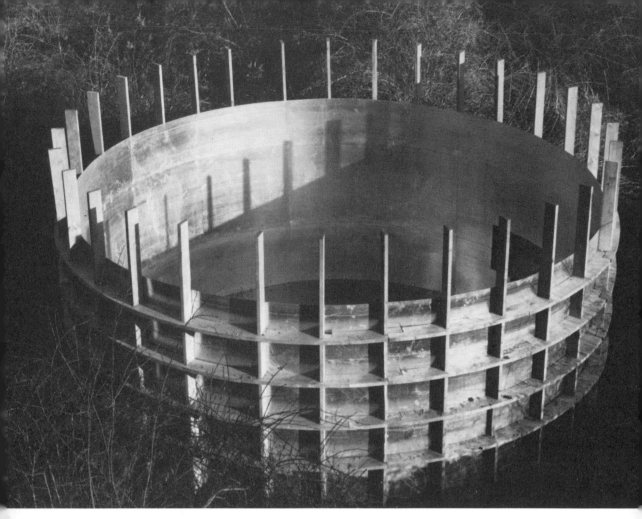

93. "Sunken Pool" by Mary Miss. Wood, steel, water, 1974—13′ height inside, 10′ height outside, 20′ diameter. *Photo by artist.*

94. Wood Sculpture by Moulton Andrus. Redwood— 4′ × 12′. *Photo by artist.*

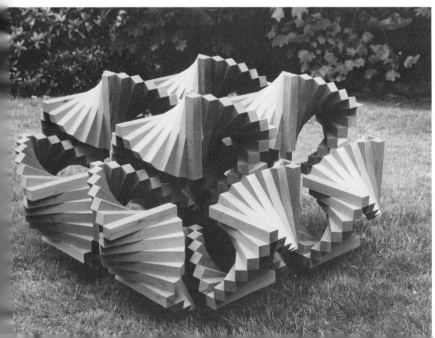

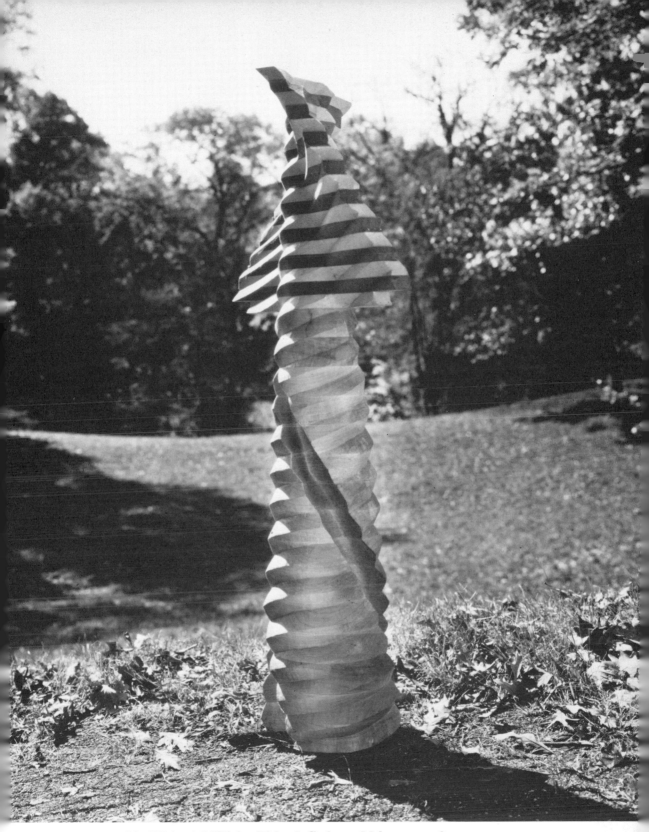

95. "Gaines' Mill" by Richard Graham. Mahogany and maple, 1977—40½″ × 12″ × 13″. *Courtesy, Minneapolis College of Art and Design. Photo by Nick Felice.*

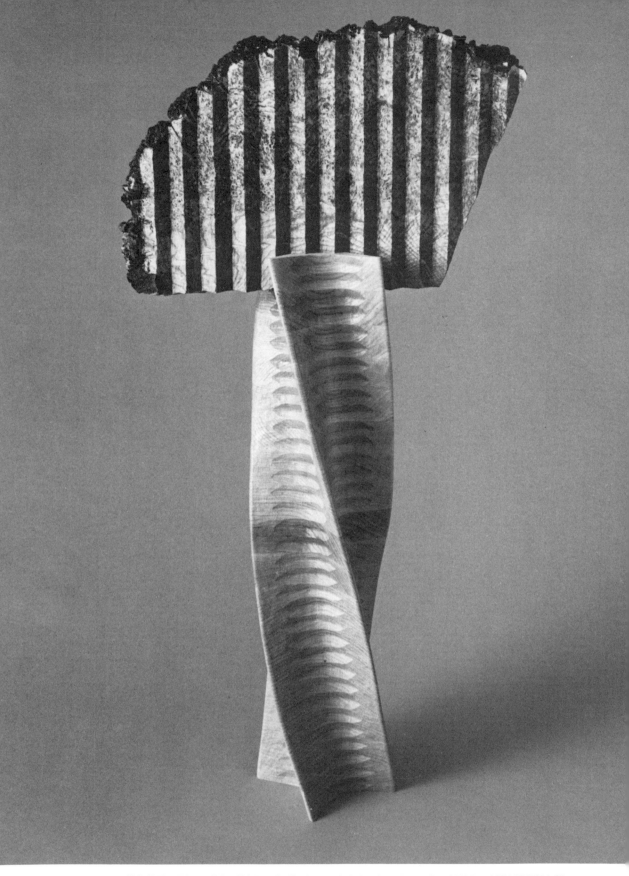

96. "The Pinola" by Richard Graham. Ash burl and maple, 1976—42″×21″×6″.
Courtesy, Minneapolis College of Art and Design. Photo by Nick Felice.

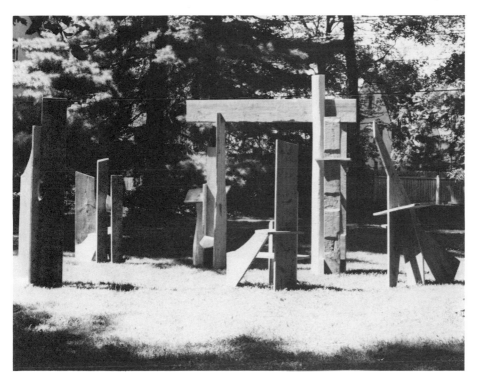

97. "Temenos" by Jane Teller. Wood. A group of five ritual sculptures: Porta—96″×90″×54″; Luna—78″× 25″×19″; Astraea—74″×36″×36″; Casseopeia—60″× 39″×36″; Selene—54″×36″×36″. *Photo by artist.*

98. "Zanesville Bridge" by Tom Doyle. Wood, 1976— 38″×24″×5′5″. *Courtesy Sculpture Now, Inc.*

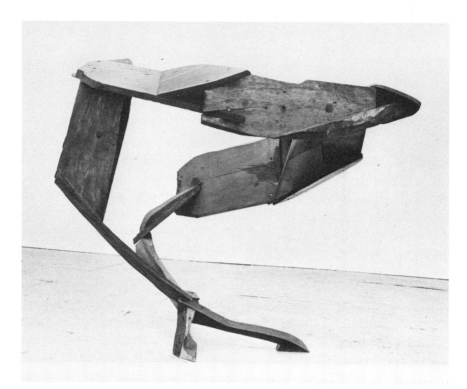

99. "Franklin" by Tom Doyle. Wood, 1959—4′×3′11″× 4′10″. *Courtesy Sculpture Now, Inc.*

100. "298 Circles" by Bernard Kirschenbaum. Painted upon board, steel weights, stainless steel, cable, 1977— 30½″×⅜″ each. *Photo by Julio Ravello, courtesy Sculpture Now, Inc.*

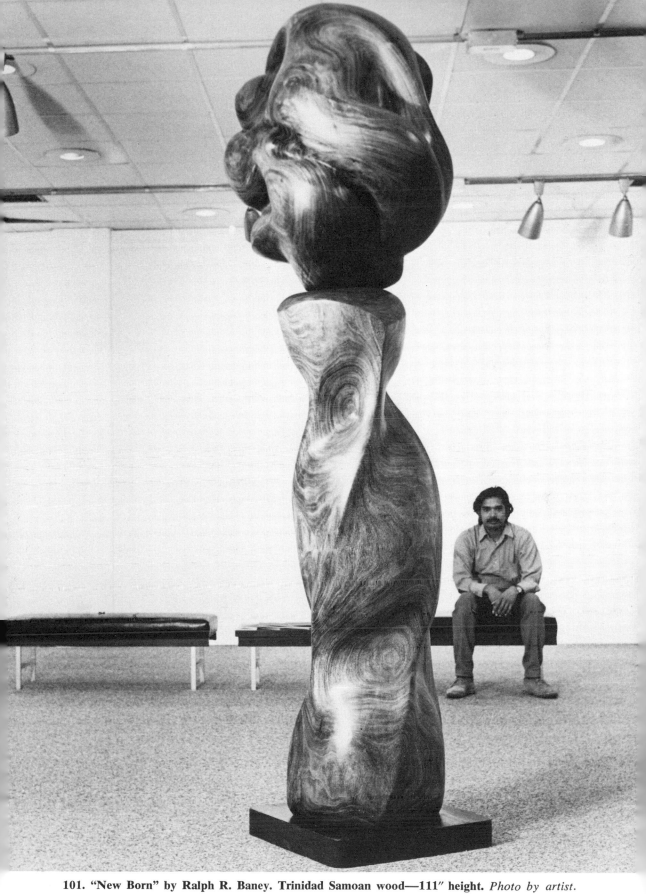

101. "New Born" by Ralph R. Baney. Trinidad Samoan wood—111″ height. *Photo by artist.*

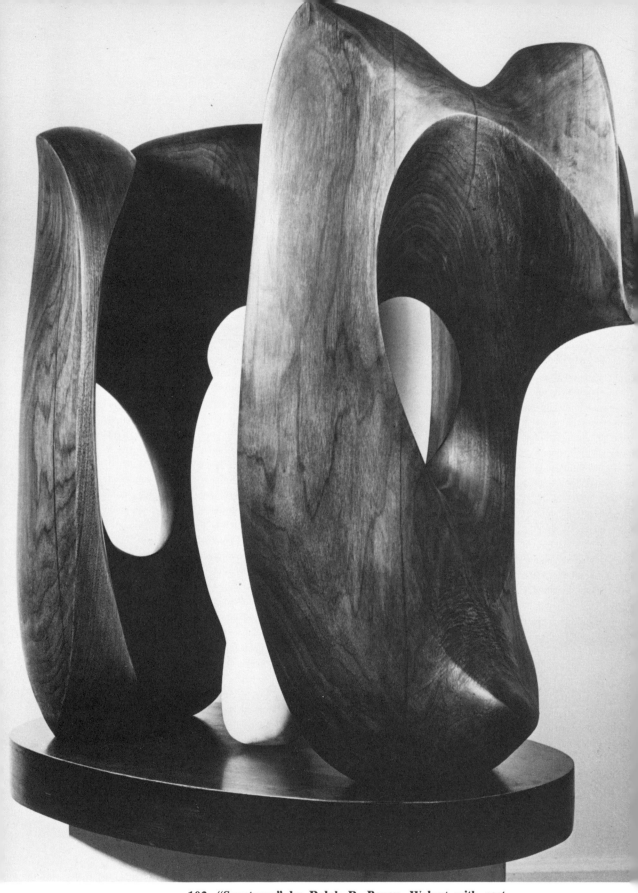

102. "Sanctuary" by Ralph R. Baney. Walnut with cast stone centerpiece—39″ height. *Photo by artist.*

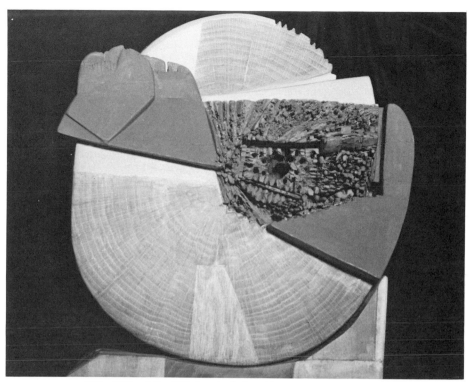

103. "Mandala II" by Wörden Day. Wood and mixed media—12¾″ × 11¾″. *Photo by artist.*

106. "I Ching Series ⅝5" by Dorothy Dehner. Painted and natural wood—4′ × 4′ relief. *Photo by Walter Russell.*

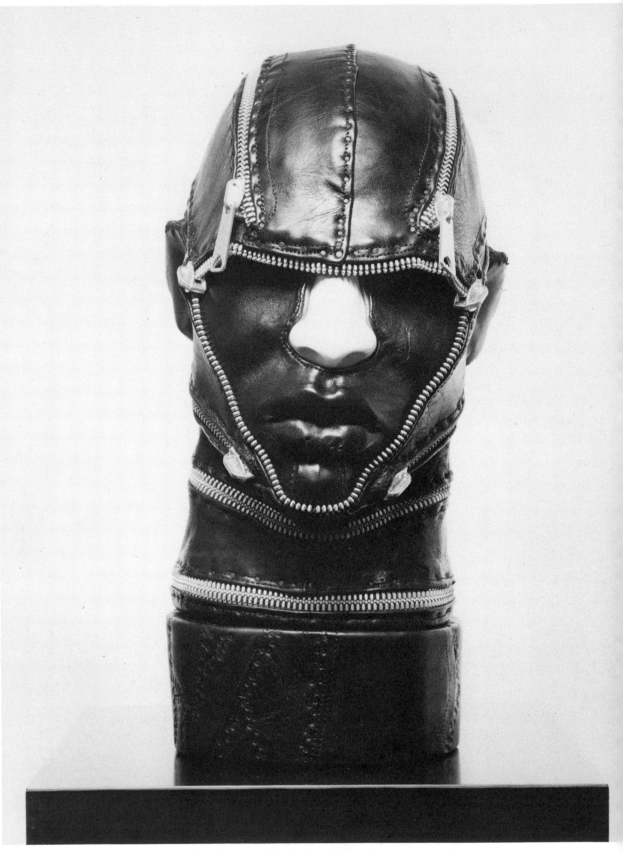

104. "Leather Head" by Nancy Grossman. Leather over carved wood, 1971—16¼″ height. *Courtesy Cordier & Ekstrom, Inc., Photo by Geoffrey Clements.*

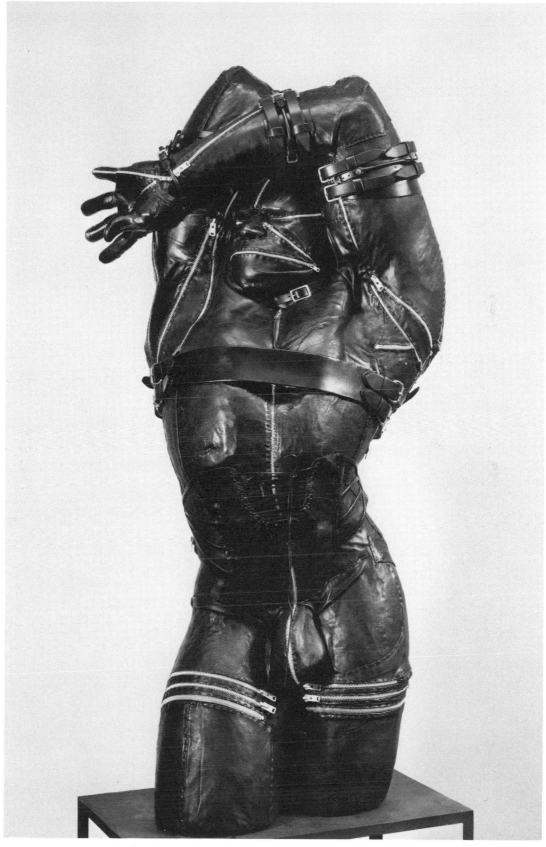

105. **"Male Figure Sculpture" by Nancy Grossman.**
Leather over carved wood, 1971—68″ height. *Courtesy*
Fogg Art Museum.

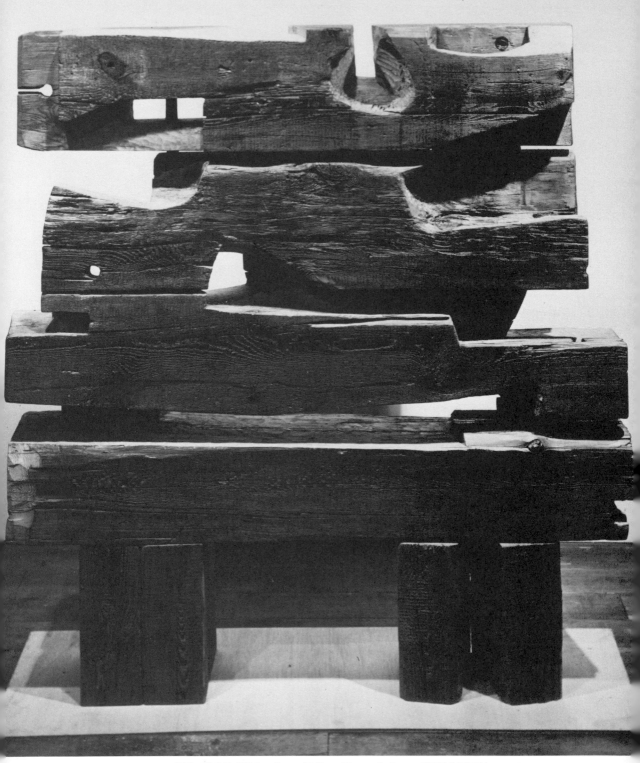

107. "Wall II" by Jane Teller. Barn timber—3′7″ × 4′3″ × 10″. *Photo by Werner Goodwin.*

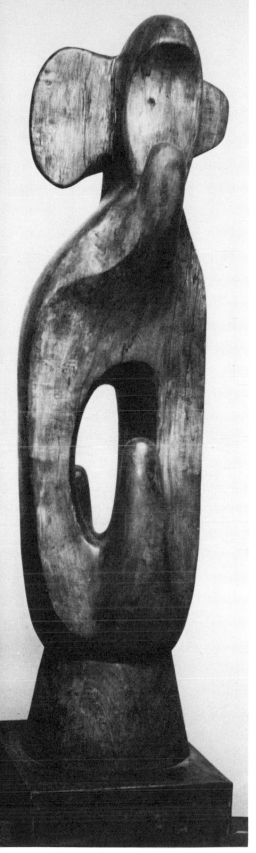

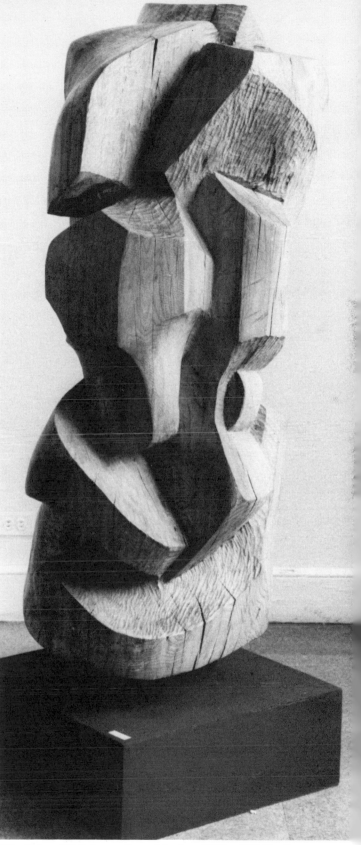

108. "Idol" by author. Wood (fumigated), 1959—5′ height.

109. "Monolith" by author. Maple, 1975—6′×3′. *Courtesy Graham Gallery.*

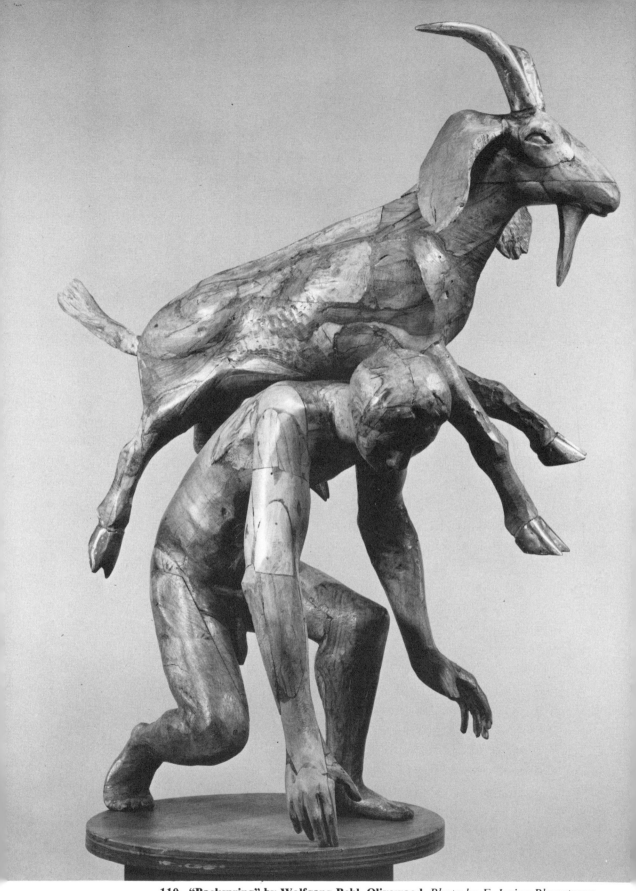

110. **"Backspring" by Wolfgang Behl. Olivewood.** *Photo by E. Irving Blomstrann.*

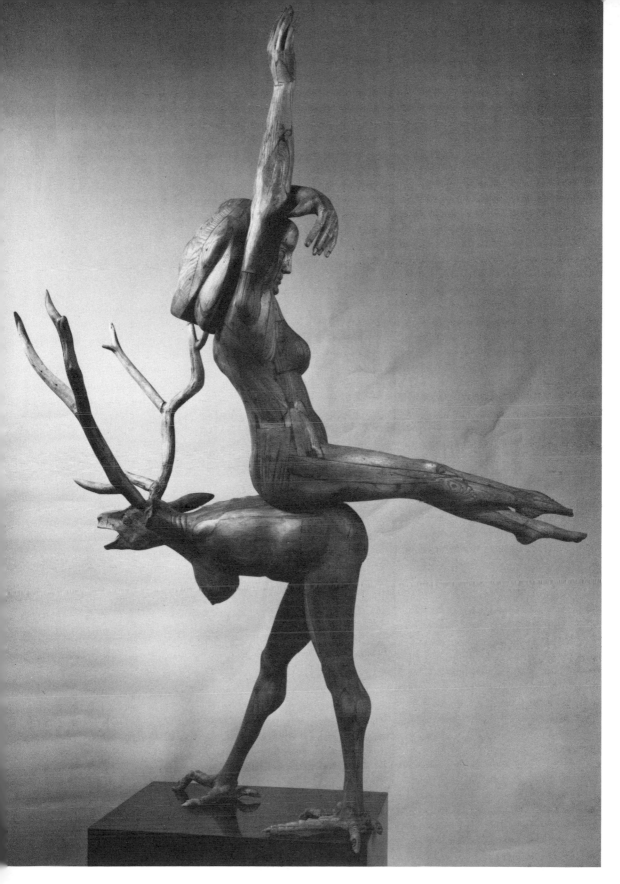

111. "Two Faces of Eve" by Wolfgang Behl. Cherry and chestnut—approx. 7′ height. *Photo by E. Irving Blom-strann.*

112. Roughed-out torso by author. French limestone, 1978, life-sized. *Photo by Jean-Pierre Cannelle.*

THREE

STONE CARVING

Carving as an activity has remained unchanged since man first started hewing away at a stone to fashion his image. The process is to take away from the stone until an image or form is judged satisfactory by its creator. This is as true today as it was in 5000 B.C. There have been only two or three techniques added, to hasten the process or to subject that process to copying, such as the pointing technique developed during the Renaissance. Carving can be practiced by anyone. You do not have to possess superhuman strength. Carving takes no more strength than golf, tennis, or swimming. Strength and skill develop over a period of time as one carves. Some of my students who thought the carving hammer was too heavy the first day could in a short time work for several hours.

Exploring Stone Sculpture

For anyone carving for the first time, it is better to work directly in the stone without trying to follow a model rigidly. Experimentation is most important and mistakes must be made in the learning process. You need not even have "an idea" before you start. I would in fact let the stone suggest a form to you. Even if this should fail, I would start by knocking off large chunks from the edges. A shape will suggest itself and you can develop it from there. Do not start with a hard stone, either. A piece of soft limestone, alabaster, soapstone, or even soft marble would be fine. I wouldn't start with granite, bluestone, hard marble, or sandstone; all these are marvelous stones for the more experienced carver.

Starting with a very small stone is not a good idea: you will have difficulty holding it stationary while you work. I will, however, go into this

113. "Margarita" by author. Marble, 1953, life-sized. *Photo by Dennis Purse.*

later in the section on "Selecting a Stone." Your first stones should be inexpensive, and adapting an attitude of adventure would be far more beneficial than trying to create a "masterpiece." Finding out how the stone feels and what the tools can do is as important as the form you are trying to create.

Looking at sculpture, especially carved stone sculpture, is invaluable. Having good models or high standards to follow can give you a direction. Your individual temperament will force you to return to looking at a certain kind of work. Just as Van Gogh learned from Rembrandt, or Degas from Ingres, or Rodin from Michelangelo, you will learn from someone you admire. This doesn't mean that you will not eventually break from the past, but your roots will have at least been developed and you can move onto newer ground with more authority. Ultimately, all art means taking a chance, but you must first learn how to gamble. All the great artists experimented well after they had become thoroughly trained. Study the early work of Michelangelo and Leonardo, and even Matisse and Picasso, and you will find work which is highly controlled and studied. It takes years to loosen up and experiment and finally to express yourself in an original way.

Sculpture, and especially carving, calls for a very patient and loving tem-

114. "Socrates," Roman portrait. Marble, life-sized. *Capitoline Museums.*

perament. You cannot rush a stone to completion, nor should you want to. Finishing should be as rewarding as beginning. Many sculptors use mechanical aids such as the air compressor, but I know good sculptors in this country and Europe who still prefer working by hand alone. Like love, sculpture is a physical activity in which the pleasure eventually deepens with time and experience; and as with love, you must commit your entire physical and spiritual self to it. Giving your sculpture to someone else to do is like giving your lover away. Why do sculpture? What about making a living? The only reason to do sculpture is because you really love to. I certainly could not recommend sculpture as a good way to make a living. Sculpture has enjoyed something of a revival in our times, but it is far from the kind of activity it was in ancient Eygpt, Africa, China, Greece, or in Renaissance Europe. Until sculpture becomes more integrated into the established institutions of society, it will remain a highly precarious occupation. It is not enough for the superstars such as Calder or Henry Moore to survive. Great sculpture exists on facades of cathedrals, temples, and buildings, which are unsigned. Until our society can reach this achievement again, sculpture will remain on the perimeter of society's activity. Let us begin, however, with the basic essentials relating to carving.

Stone Carving Tools

As a beginner, you will find it easiest to purchase your tools from a sculpture or stone-tool supplier. Most of these companies have catalogs you can send for if you are not in their area. Once you know what tools you need,

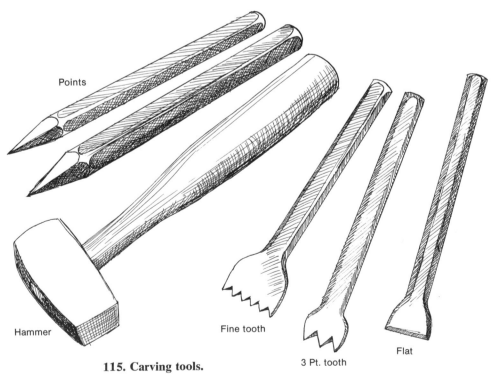

115. Carving tools.

you can also have a local blacksmith make your tools. Basically, two point chisels, two tooth chisels, and one flat chisel, in addition to a carving hammer (about one and a half to two pounds) are what you need to start carving. Rasps are used to smooth the stone and remove the chisel marks. Cabinet rasps, rifflers, and combination rasps are used on stone, but they wear out fairly quickly on hard stones such as marble and must be reordered.

Beginners may benefit by starting with a very soft stone such as steatite (soapstone). Soapstone can be carved with an ordinary carpenter's chisel, a light hammer, and rasps. This is an advantage for those who want to find out if they like stone enough to invest in stone-carving chisels. Other soft stones can be carved with an ordinary carpenter's chisel, but this is not highly recommended. There are a great variety of alabasters, such as white alabaster, coral alabaster, pink alabaster, crystal, and many others. Alabaster is slightly harder and more dense than steatite, and this slight difference makes working with a carpenter's chisel impractical. The steel of the chisel would dull quickly and it would be better to purchase the stone carving chisels from a sculpture supplier. The rasps and rifflers work very well on steatite and alabaster. These stones can be finished with sandpaper and highly polished later with wax.

Although beginners may find it convenient to start carving steatite with an ordinary carpenter's chisel, this practice should be only temporary. This technique used with a carpenter's chisel cannot be used for the harder stones. Carving marble, for example, requires certain tools used in a specific way.

The tools for stone carving are simple. When choosing a hammer and chisels, select tools which feel comfortable and not heavy. In this way you will have a certain amount of control over your hands and tools, and as you strengthen, your technique and control will develop. In the sports of golf, tennis, and baseball, the players select clubs, rackets, and bats with this principle in mind.

After some months of carving, you will probably buy another hammer that is heavier. It is never a waste to have more than one hammer, since stones, size, and other factors vary and you will have the choice of selecting the tool which best fits the requirements.

I myself have six favorite hammers and I use them according to which stone I am working. The same is true of chisels and other tools as well as the other materials and equipment.

Tools can be made as well as purchased; I believe a sculptor should know how to make his own tools. Man first fashioned stone with other stones that were harder and sharper. You could still do this today. If, for example, you wanted to carve soapstone or alabaster, you could use sharp pieces of bluestone or flintstone to chip away the softer stone. A simple hammer could be made from a small granite boulder and a wooden handle. To fashion tools

of steel requires some basic skill, but from tool-steel stock, which can be purchased from a steel distributor in almost any city in the United States, you can form the three or four basic tools for carving limestone, sandstone, and marble. In addition to the tool steel, a sculptor's studio should include the following:

> Anvil (or 3″×3″×12″ piece of steel)
> Small forge (either gas- or coal-fed) with a blower
> Tongs and blacksmith's hammer
> Grindstone and files
> Vise
> Bucket of water (with salt)
> Fans
> Benches
> Crowbar
> Dolly
> Dust mask or face respirator
> Riffler rasps (two-sided knife-shaped rasps)
> Sandpapers and emery cloths

Making Tools for Carving Marble and Limestone

You must first purchase tool steel, which is available in an assortment of thicknesses and lengths. Most chisels you would be using would range in thickness from ¼″ to ⅞″, but the ½″ and the ⅝″ are best for most carving. The steel stock is square or octagonal in form and both forms are used by stone carvers.

Cut the steel into lengths of 10″, using a metal hacksaw. Fire up your forge and place four or five bars of steel into the fire with only 2″ to 3″ of the tips in the flame. The tips should become bright red in a few minutes. Use your tongs to remove one bar of steel and hammer the tip into a point chisel on your anvil. Hammer the point by flattening four sides and putting the bar back into the forge when the steel cools and turns black. You must continue hammering the bar until you arrive at the approximate pointed shape you want. Have a good idea of the chisels you want to make before you try to fashion them. It is a good idea to make a drawing of each chisel before working. For the tooth chisel, you can cut the individual teeth with a V-shaped metal file after you have fashioned the flat shape. Use a vise to hold the bar while you file (after the steel is cool). It takes some time, patience, and practice to make tools, so do not become discouraged if your first efforts are not satisfactory. After making tools for some time, you will become proficient at it and save time and money over many years.

After shaping your tools with the hammer and file, you now sharpen

them on a grindstone. Do not make the tip of the point chisel too long and narrow or it will break on a hard stone. Each tool must be sharpened well so that it will bite into the stone and not slide over it. Tools must be sharpened very often, even after an hour's use sometimes. Keeping your tools sharp will give you great pleasure in carving, while dull tools are discouraging.

After you have sharpened your tools satisfactorily, you must temper, or harden, the cutting tip. An untempered tool will become dull or even break very rapidly. Place the tips of your tools back into the forge and heat them until they become cherry red, not bright red. Have a pail of cold, salted water nearby (use rock salt) and remove a tool with your tongs, placing the tip of the tool into the water for a few seconds only. Clean the tip half of the tool with a metal file and look for a band of colors moving toward the tip. The colors will be blue and straw color. When the straw color reaches

116. Marble carving set.

the tip, plunge the tool into the water until completely cool. The tool is now tempered. Some sculptors quench the tool when the blue color reaches the tip. You can decide for yourself after trying the particular stone you are using.

When you resharpen your tools, use a bench grinder with a Carborundum stone wheel. Most bench grinders have two wheels, one rough stone and one finer stone. If your tool needs a lot of sharpening, use the rough wheel. Always dip the tip of the tool into cold water so that you do not overheat the tool and lose the temper. Wear eye goggles when using a bench grinder. If you do not have a bench grinder, you can send your tools out to a commercial sharpener.

The Studio

Your studio should have a strong floor, if you are carving stone, and should be well ventilated. An industrial window fan is necessary to blow out stone dust when you are grinding stone. A face respirator is also necessary, especially if you are carving granite, soapstone, or sandstone. These stones contain silica and talc, which if breathed in, will lodge in your lungs. If you

breathe in enough silica or talc, you can develop silicosis, which is very dangerous and can even cause death. If you have a respiratory problem, granite, soapstone, and sandstone are not for you.

A heavy workbench with a turntable is also necessary, but if you work on large stones, this becomes impractical because the weight of the stone could weaken the table. When working on stones weighing over five hundred pounds, in place of a table you should use a fifth wheel, which is made of metal and can support great amounts of weight. Timbers can be stacked on top of the fifth wheel to bring the working surface (the timbers themselves, on which the stone is placed) to the desired height.

You should never try to lift a heavy stone onto a worktable. Many sculptors have hurt their backs permanently doing this. Use either a chain hoist or a hydraulic-lift table. If you must lift a stone, make sure to keep your legs together and use your entire body while lifting.

Learn to use a crowbar or pinch bar to raise an edge of a stone. Place a piece of wood (2″ by 2″) 2 to 3″ from the bottom edge of your stone. Get the edge of your crowbar under the edge of the stone and pry downward against the wood. This will raise the edge of even a heavy stone very easily. Have someone place a length of wood under the raised edge. Do the same on the opposite side. In this way you can "block-up" a stone to the desired height. This technique is an ancient one and is advantageous where there is no chain hoist available. Simple leverage, properly used, can move the heaviest of stones. I have blocked-up stones weighing two or three tons. You must of course have the experience to do this.

Desirable tools in a stone carving studio would include a dolly for wheeling stones from one place to another. You can also move a stone by picking it up on one edge and putting a round dowel under it. You can thus roll a stone 2 or 3′ at a time by always putting another round dowel in front of it. I've also used 1″ pipe for rollers.

**117. Stacked timbers supporting
a large stone.**

118. Using a chain hoist. *Photo by Margaret Worth.*

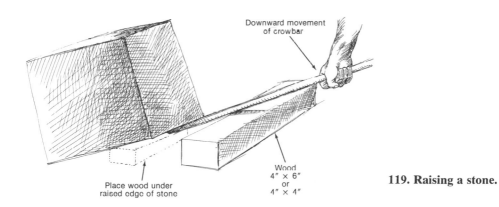

Downward movement
of crowbar

Place wood under
raised edge of stone

Wood
4″ × 6″
or
4″ × 4″

119. Raising a stone.

The hydraulic-lift table is desirable for moving heavy stones. The one disadvantage is that this piece of equipment takes up floor space, whereas if you have an overhead chain hoist that runs on a track, you can save your floor space and still move objects around.

Getting rid of stone chips can present problems, especially in a city. You will probably have to hire a private cartage firm to do this. A garbage pail full of stone chips can weigh five hundred pounds. In the country, you can make a stone pile which you can use later for all sorts of purposes.

You will need a strong shovel and bristle push broom to pick up stone

chips. An industrial vacuum is good for getting to stone dust that is hidden in corners. If you work out of doors, a strong rake and wheelbarrow are necessary to move stone chips away.

These are the basic tools you will need to carve stone. I leave for later the use of the pneumatic air tool.

Selecting a Stone

Having made the commitment to carving stone, you should not think of getting one stone. Start with at least three. In this way you will not be afraid of ruining one. The best place to get stone is from a quarry. If this is not practical, you will have to go to a stone supplier or sculpture supplier. As a student, I got stone from building foundations where old buildings were being demolished. I even went to a graveyard where I was given several blocks of blue and white marble. If you do this, simply check the stone for weathering and make sure the stone has no major cracks and does not crumble. If there are cracks, leave the stone alone. To check for crumbling, rap the stone with a hammer, and if it sounds solid and "rings," the chances are that it is fine.

There are many stone quarries throughout the United States. Granite, marble, limestone, and alabaster are in plentiful supply. There is also a large supply of bluestone and sandstone, but these are very difficult to carve because of their sedimentary nature. Granite, of course, is very hard, but it is probably the best of stones for finish, durability, and beauty. It also comes in a great variety of colors and textures, ranging from red to black. It is relatively inexpensive compared to marble, although the carbide tools needed to work granite cost much more than marble tools. I suggest buying your carbide tools instead of making them since these tools are manufactured by means not practical for a sculptor to use. Some tool suppliers are listed at the end of the book.

There are quarries in Vermont for marble and granite. The Vermont Marble Company* will supply just about every kind of marble there is because they import marble from around the world. The Barre Guild, which is made up of dozens of granite companies, will supply any kind of granite you may need. There is also marble and granite in Georgia, Wisconsin, Tennessee, Minnesota, New York, and Maine. Indiana supplies a very fine limestone which is excellent for carving. There is a gray and off-white limestone there. In upstate New York, bluestone is in large supply if you care to tackle a difficult stone. Colorado supplies a beautiful pink and white alabaster. There is a list of stone suppliers at the end of the book.

Stone is plentiful in Europe and is much cheaper there than in the United States. Marble is still plentiful in Italy, while France supplies a soft lime-

* Recently acquired by Gawet Marble Co., Rutland, Vermont.

stone. Granite is plentiful in both countries as well as throughout Europe. Black Belgian marble is getting scarce and is very expensive. There are a variety of limestones in England.

After you've made your supplier contact, order at least three stones of different shapes. Very small stones are just as difficult to work as extremely large ones. They move while you're working, and you must either nail a corner frame on a workbench to work against, or work in a sand box, or plaster the stone down to a flat, larger slate or stone. A stone which is over a cubic foot is best since it will not move easily while you're carving and when you're finished, you can move it yourself.

Place your stone on a strong and heavy wooden workbench where the stone is not higher than your chest. While carving you must keep your arms raised and much energy can be saved by keeping your arms at a comfortable height. Large stones should be placed on blocks of wood like 6″ by 6″s or 12″ by 12″s. A fifth wheel can be used in small quarters to turn the stone around if you cannot walk around the work. A fifth wheel can be purchased from Sculpture Associates or Sculpture House in New York, or made by a blacksmith.

120. **Fifth wheel.**

General Steps in Carving

Most stones are roughed out with the point chisel. You can, in fact, begin and finish a stone with just the point chisel. Some sculptors knock off the edges from a stone if the stone is rectangular with a pitching tool or just their hammers. This process takes off large pieces of stone very quickly, but once this has been done, the pitch or hammer cannot be used in this way again on that surface. Pitching requires a 90 degree angle in the stone, and

Pitching tool

121. **Using the pitch tool.**

once you've done it, you've changed the angle of one surface to the other. You must then work with the point chisel. Use your heavier point chisel to begin. Carve off the stone in a series of planes or flat levels, keeping the strokes of the chisel flat and parallel to each other. The stone should have a "combed" or "raked" look.

Avoid carving in a haphazard manner. The carving should develop slowly, logically, and with a feeling for the material and form. The stone should not look chopped up and confused even in the first stages of carving.

122. The stone should have a "raked" or "combed" appearance.

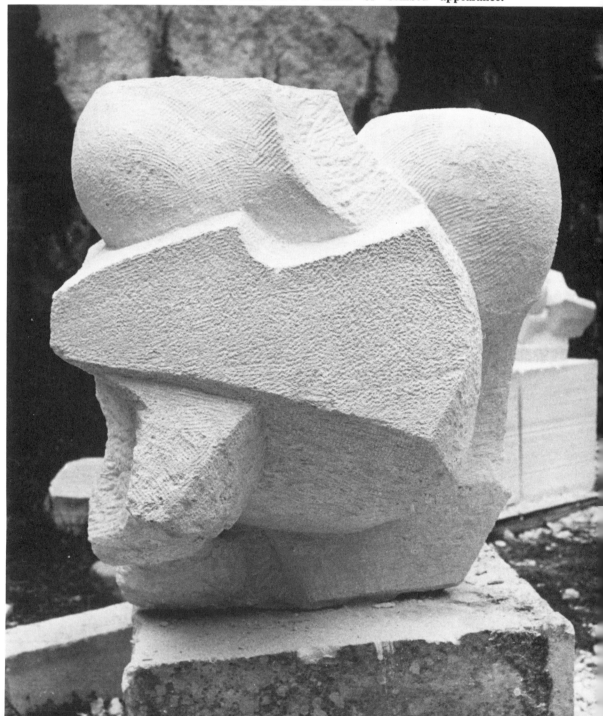

With the point chisel, rough out the planes from all around the stone. Work generally and avoid working on only one area. This is called "massing" the forms. At any point during the first stage of massing, the sculpture could be considered finished. Finish should not mean smoothness or polish. Relationship of forms and planes is more essential than surface finish. When carving, consider planes as surfaces which tilt inward toward an imaginary center line in the middle of the stone. If you can do this, you can avoid thinking on the surface. Do not let the stone's surface texture, cracks, color, etc., deter you from your goal, which is to establish forms three-dimensionally throughout the entire mass of stone. Carving and sculpture in general call for an aggressive approach in which *you* must control the material.

After the planes are generally established in the stone, you can then use your tooth chisel. This tool is used to further define and clarify the planes. In effect, the tooth chisel is a combined unison of three or four point chisels.

The tooth chisel pulls the forms together as the planes are defined. As you carve, try to draw with the tooth chisel. Draw around the form—not lengthwise, but in a cross-contour manner. Carving is similar to peeling off the layers of an onion or artichoke. In general, the coarse outer layers are cut away with the point chisel while the inner layers are carved with a tooth chisel. The final surfaces are cleaned up with a flat chisel. The flat chisel can have a square cutting edge or a round one. The round one is invaluable for concave surfaces as well as for complex organic forms. Be sure that as you go from the point chisel to the tooth, and from the tooth to the flat chisel, each mark from the preceding tool is carved away. "Stun marks," as these are called, are thus removed, which makes sanding and polishing much easier. This is especially important for marble and alabaster. Stun marks are white in appearance and disturb a polished surface. Do not try to sand out stun marks. Use either a flat chisel or a sharp rasp to remove the unpleasant white marks. I've seen many students sand for hours trying to remove a stun mark, while it takes only minutes to use your flat chisel or rasp.

Finishing and Polishing Stone

As mentioned above, a finished sculpture can be very textured, but if you are intending to give a smooth polished surface to your stone, you must follow some further steps. After you have cleaned up your sculpture thoroughly with the flat chisel, you must then proceed to rasp down the surfaces. Use as large a rasp as possible where you can. In small, hard-to-get-to places, a variety of riffler rasps will do the job. The forms, even though set at the rasping stage, can be further developed. Rasping should not mean simply smoothing. Much can happen within the ⅛″ of the final surface, especially in highly polished sculpture. After you have rasped the entire sculp-

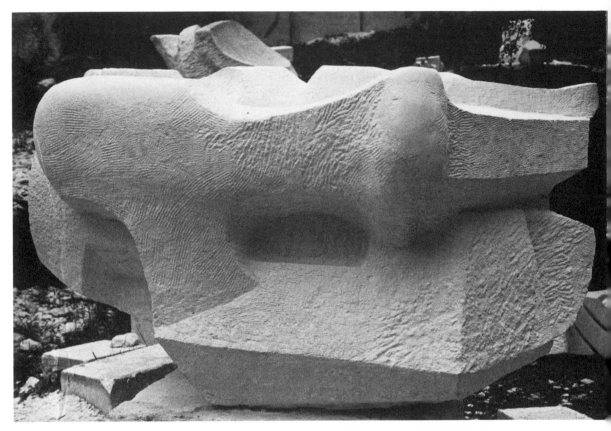

123. "Luberon" by author. French limestone, 1976—approx. 8′ × 4¼′ × 4′.
Stone was carved directly by hand without a model.

ture, you then start with the abrasive sandpapers, emery cloths, and wet-or-dry sandpapers. Start sanding with the coarse grits such as No. 60 or 80 and work toward the fine grit such as No. 150. You can use either sandpaper or emery cloths. Try both and see which you like better and decide which is more economical for you.

After you have sanded the stone down to the finest grit, you then start with the wet-or-dry sandpapers. You start with grit No. 180, using water kept nearby in a pail. Wet the stone with a sponge and sand into the wet area. The surface will become pasty from the stone dust mixing with the water. Simply wash off the surface with the sponge and examine the stone for scratches. You must proceed from area to area on your sculpture in this manner. Needless to say, this can be a very tedious operation, but it must be done and the results will delight you when you are finished. After using grit No. 180, you will then go into using the finer grits such as Nos. 220, 280, 320, 380, 400, and 500. Some sculptors go to grit No. 600 and then use pumice powder or tin oxide with a damp felt pad to rub the stone to a polish. This takes much patience and time, but the results can be incredibly beautiful. For a high luster, use marble polish or clear white wax on the stone. Several coats of wax rubbed on with a soft cloth will bring out the beauty of the stone.

The sense of delight and satisfaction of having created a fine work, through labor and even pain, is one of the rare experiences on this earth. You and others can delight in a work of unique beauty, warm and precious and, above all, personal. You will probably be fired to start another stone carving. The process starts all over again, but each sculpture is different. Each sculpture is a new life, and new problems will arise that you have not anticipated. As you work, you deepen and change, you try to bring a sense of mystery to your carving. Contemplation is as important as action and both are mutually dependent for an artist. We must dream, and then we must act. The closer the work resembles the dream, the more personal the art becomes. Each person's dreams are uniquely his. Originality is not necessarily something created outside of all reference to everything else, but can be the pure experience of an individual expressed directly.

A Contemporary Approach to Stone

In the preceding pages, I explained the working and selecting of stone in a traditional manner. This method is still exciting and vital and probably always will be, but in the technological world of the twentieth century, it is possible to do a few things with stone that were not possible a century ago. I am referring to the entire industry of stone cutting, polishing, joining, and construction, which has gone through as radical a change as steel technology did in its development. With the newer cutting tools, today we can cut

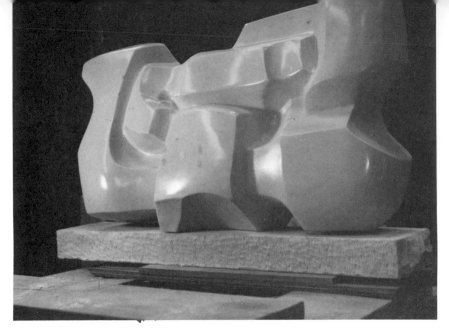

124. Horizontal Composition by author. Marble, 1978—44″ × 28″ × 10″. *Collection: Kingsborough Community College, Brooklyn, New York.*

stone faster, larger, or thinner, can polish it brighter, construct it further into space, and in general, do things with stone not generally done before. Modern engineering has produced bridges, dams, and buildings of astounding beauty and immensity. The contemporary sculptor can laminate stones together or combine stone with other materials in the same way that the engineer does.

Large or small circles, spheres, and curves can be cut at the various granite companies in Barre, Vermont, as well as in other sections of the country.* Circles and curves are cut with a wire saw that usually runs around or through the plant for 400–500′. The wire is fed with a flow of water and Carborundum grit while the stone is turned slowly to make the circular cut. A 3′ thick stone will cut at about one foot every two hours within a radius of ten feet. This is an average time which can vary according to the hardness of the stone and use of the wire.

Another way of cutting stone is with a torch. At the quarries in Vermont, a device that resembles an oxyacetylene torch is used to cut deep into the granite. This saves much time in quarrying compared to the older method of drilling. The flame is fed with a combination of fuel (oil) and oxygen. Some sculptors have used such a flame-cutting method to block out their works. Before you embark on such a venture, do your research well with the experts. Find out exactly how this works.

Another contemporary cutting technique utilizes a diamond saw. Very large circular saws with diamond teeth can cost as much as $10,000. Chain saws with diamond teeth were used by Italian masons to save Egyptian monuments from the rise of the Nile River. The large stone figures were cut

* Refer to the list of granite quarries at the end of the book. Much stone cutting is done also in Pietrasanta, Italy.

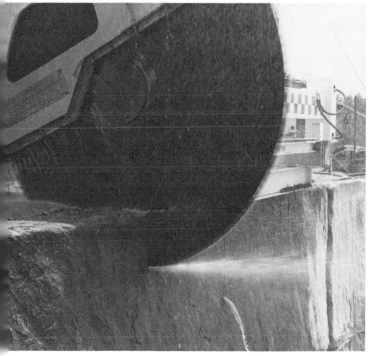

125. Use of wire saw, granulated Carborundum, and water to cut through granite. Six or more wires like these are spaced 1½″ apart in a parallel manner for slicing facing for building material. *Photo by Everett Saggus.*

126. Diamond saw with 6′ diameter cutting through granite. The saw is water-fed for cooling. *Photo by Everett Saggus.*

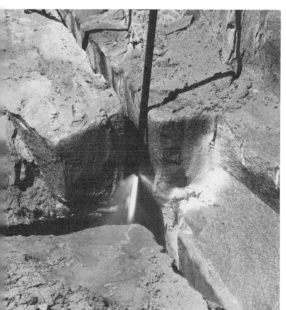

127. Flame cutting through granite. *Photo by Everett Saggus.*

up into pieces like a giant jigsaw puzzle and then put back together again. You may not be able to afford diamond-toothed saws, but you can use the facilities of a company employing these techniques.

Carving stone has been greatly speeded up as a result of the pneumatic hammer, also called the air hammer. This technique is commonly used by sculptors working in stone. A compressor which is either electrically or gas driven is used to power a tubular air hammer. Tools are inserted into the air hammer, which drives them into the stone, delivering more than three hundred blows per minute. It is within the means of most professional sculptors to purchase this equipment. The most expensive piece of equipment is the air compressor. If you are working in a studio, buy the electrical compressor. This kind of compressor will run only to build up enough air pressure to use your pneumatic air hammer. A two horsepower compressor would be satisfactory to drive a medium-sized air hammer. Once the pressure is built up, it will automatically shut off. When the pressure drops, it will automatically start up again. What this means to you in a studio is a certain time of relative quiet. A gas-driven compressor, on the other hand, constantly runs and stops only when you turn it off. The noise of a gas compressor is much louder and is constant. Fumes from the gas-driven compressor make it impractical to use indoors. It also costs more to use a gas-driven compressor. On a granite monumental sculpture I did in Nebraska, I used as much as twenty gallons of gas per day running an eighteen horsepower compressor.

The one great advantage of the gas compressor is that it can be used in the field: Without an electrical outlet close-by, there is no way to use an electrical compressor. In the field, the fumes and noise are bearable. If you are a sculptor who works out of doors most of the time, then the gas-driven compressor is probably for you.

Air hoses are fed off the compressor and are attached through the use of fittings and couplings. Just below the air hammer (sometimes referred to as the air gun), there should be a shut-off or control lever. This will control the amount of air that drives the air hammer. You can work very lightly or very forcefully, according to how much you turn up the lever. Most air compressors have an automatic shut-off valve on the compressor itself. This is to ensure that it doesn't explode. Check the safety features of any compressor you intend to use.

With the air compressor, you can drill holes as well as carve. You can also use a sandblasting gun or a paint sprayer. Finally, you can use the air to dust yourself off from all the stone dust.

Joining stones is a common contemporary technique. The epoxy stone cements can hold stones together. The technique is very similar to wood lamination. The surfaces of the stones must be true and flat. Compression must be used between each pair of stones while the epoxy cement is setting. It is also desirable to use bolts or rods between the stones to ensure further

strength. This is simply doweling with metal into stone instead of with wood dowels into wood. Dovetailing in stone is very difficult and impractical but can be used in special instances.

Notching stones to fit into each other is an ancient technique and is still used today, but in contemporary sculpture, the notching itself becomes part of the design. In the past, "Roman joints," or notched stones, were mainly meant to be hidden. Arms and legs of marble sculpture were joined to the body so that the joints were invisible.

Weathering of Stones and Maintenance

Technically, all stones weather when left out of doors, but obviously a sculptor has to know which stones will better withstand the onslaught of ice, rain, wind, temperature change, and, in our modern world, air pollutants or smog. In general, the very soft stones will break down in a time span of one to seven years if left out of doors in the Northeastern United States, Canada, or Northern Europe. The harder stones will last very much longer, while the granites, basalts, and diorites will last many centuries. Indiana limestone as well as bluestone and sandstone will also weather very well in these areas. The hard marbles will, in a shorter time, develop discoloration as a result of air pollutants, but they will have a life-span lasting two hundred years or so, depending on environmental factors. Even Michelangelo's "David," in Florence, Italy had to be taken indoors, while a copy was made for the out-of-doors setting for which the original was intended. Today, with certain chemicals and machines, it is possible to keep stones from corroding. Chemicals such as silicone will prevent water from sinking into the stone and cracking it by freezing.

Sandblasting can be used to clean off badly discolored stones, but this technique must be used with extreme caution. On very finely detailed sculpture, one should probably not sandblast, since the surface of the stone will actually be worn away through the action of the pressurized sand. You would not sandblast the delicate surface of a Brancusi sculpture, for example. Sandblasting is desirable on large architectural forms and should be done as lightly as possible. Cleaning of stones is also accomplished with acids such as oxalic acid, and even with strong detergents. I've used nitrate acid to clean grease spots off stone, but you must be careful handling acids. Always wear eye goggles and rubber gloves, as well as protective work clothes. After cleaning with acids or detergents, rinse the stone well with water.

Another method of cleaning stone is with steam. You must contact a firm that uses steam-cleaning machines for building facades or automobile engines, or any other specialty company using this method. Steam is probably more advantageous than sandblasting in certain cases, especially where deli-

cate surfaces are involved. There are dangers, however, because an over-heated stone surface can chip apart or crack. Make sure that whoever is doing the cleaning knows something about the stone he is working on.

No matter what modern technology develops, all sculpture must finally be maintained with care. Most sculpture requires cleaning or maintenance every four or five years, which is not difficult and can be accomplished usually very quickly.

Laminating Stone

As is true in wood lamination, the surfaces to be laminated in stone must be flat and level. For best results, use surfaces which have been cut or sawed by machine. Machined surfaces are usually absolutely level, whereas hand-cut surfaces have slight high and low areas. This is important in laminating stone because the adhesive cement must work much harder on the low areas for bonding strength. If you must level a surface by hand, use a steel-edged ruler to check the surface. By holding your straightedge against the surface of the stone, you can see the unevenness if you have an open window or bright light as a background. For surfaces where you must take off less than $\frac{1}{8}''$ of stone, a nine-point bushhammer or chisel is a good thing to use. The bushed surface, if absolutely flat, is ideal for laminating because the coarse texture holds the cement better.

128. Post-and-lintel stone construction in Pompeii utilizing marble, brick, and colored stones.

If the stones to be laminated rest snugly one on top of the other, as in a post-and-lintel structure, you can probably get away without using steel or bronze dowels. Metal dowels must be used if there is any obliqueness to the surfaces which are being laminated. If there is any chance that the sculpture can be pushed over or struck, use dowels, as this will help in keeping the stones together.

Epoxy stone cement is used in laminating stone. This can be purchased from a firm such as Granite City Tool Company in Barre, Vermont, or from any other company serving the stone industry. It is a very thick and strong

epoxy that becomes as hard as the stone you are laminating. If the stones are laminated properly, as described above, they would virtually be impossible to separate. On large out-of-door works, use stone grouting to close any edges. This will ensure that no water or freezing rain will get in between the stones. Stone grouting can be purchased from the same sources as the epoxy cement. You can continue working on your stone after the epoxy cement has set. Simply allow enough time for setting.

Combined Materials

Stone can also look well in combination with other materials such as metal, glass, wood, or plastic. Combining materials, however, requires a very exceptional sensibility to make it work. In architecture, we accept and enjoy the combining of stone, metal, and glass, but in sculpture it is more difficult. In general, I would say that the two materials must be distinct in their character and yet function visually and technically together. It is not enough to simply put them together. If you study the architectural monuments of the past, you will see that metal and stone go together beautifully. I am thinking of castles, fortresses, cathedrals, abbeys, and many other monuments. Spanish wrought iron, for example, looks marvelous with stone, as used by Antonio Gaudí, the nineteenth-century Spanish architect.

In the Gothic cathedral, the use of stained glass, lead, and stone made for one of the greatest expressions of man. The Egyptians made use of combined materials in their sculpture. Most of this was decorative and not essential to the sculpture. Eyes on portraits were made of semiprecious stones, or decorative dress may have been plated with gold or some other material. It is not new for sculptors to use a combination of materials in a work. In our times this practice has been tried by the Bauhaus school in Germany, the cubists in France, Picasso in particular, and by some American sculptors. Naum Gabo was one of the first in our times to combine metal, plastic, and wire forms. Archipenko, Picasso, Gargallo, and Julio González were sculptors who successfully combined various materials. When using stone, there are a variety of ways to attach other materials. Besides laminating, you can drill holes, make joints, or bolt material onto the stone. The principles of laminating described above hold true for attaching wood or metal to stone. I would not, however, recommend epoxy cements alone to hold material together. Always use a mechanical bond such as a dowel or bolt to hold forms together. This will ensure that the epoxy cement is reinforced and will not separate from the surface.

Some of the younger sculptors in America such as James Wines and John Buchman have combined materials. Wines worked with cement and iron, and Buchman with stone and steel. Iron and steel, because of their great tensile strength, can support and even suspend a large weight in stone. The

effects can be dramatic if handled with taste. This way of handling com-
bined materials is more exciting to me than using another material for deco-
rative effects. In any case, the combination of materials should warrant the
effort that goes into making it possible. If the sculpture is not made more
exciting by combining materials, I would leave the stone by itself.

129. *Opposite page.* **"Luke Havergal, Luke Havergal" by
James Buchman. Granite and steel, 1974—15′6″ height.**
Photo by artist, courtesy Sculpture Now, Inc.

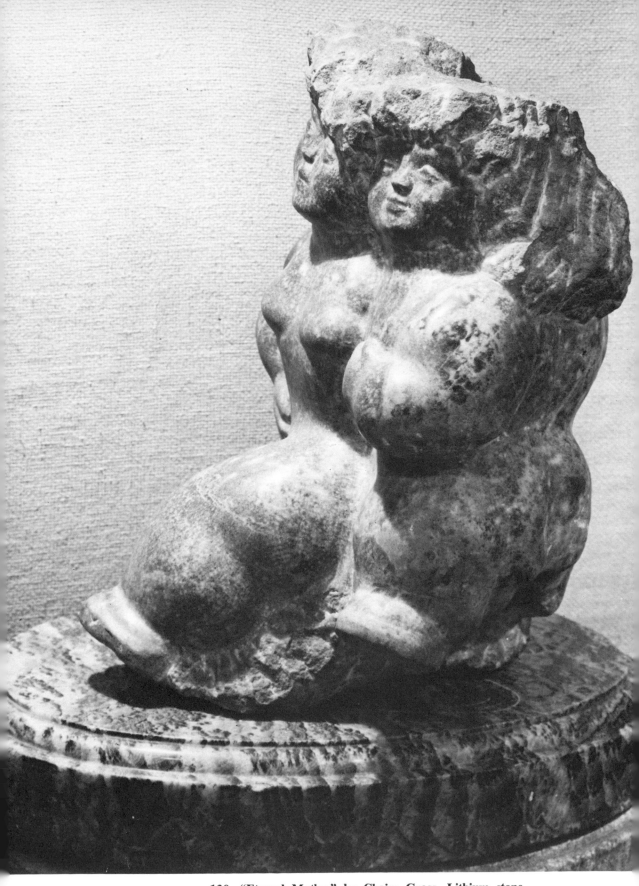

130. "Eternal Mother" by Chaim Gross. Lithium stone, 1945—28″×17″. *Photo by Arnold Eagle.*

GALLERY OF STONE SCULPTURE

131. "Owl" by Cleo Hartwig. Painted limestone—9″ length. *Photo by Walter Russell.*

**132. "Levi" by James Buchman. Granite and steel, 1975—
9′6″ height.** *Courtesy Sculpture Now, Inc.*

133. "Macrocosme et Microcosme" (detail) by Yasuo Mizui. French limestone, 1967—266′ long. *Photo by artist.*

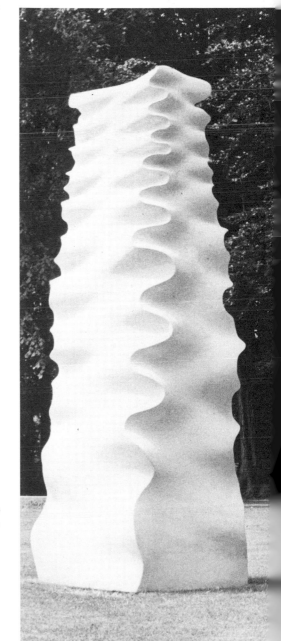

134. "Flamme Blanche" by Yasuo Mizui. French limestone, 1975—3′ × 3′5″ × 9′2″. *Musée de Sculpture à Middelkerke, Belgium. Photo by artist.*

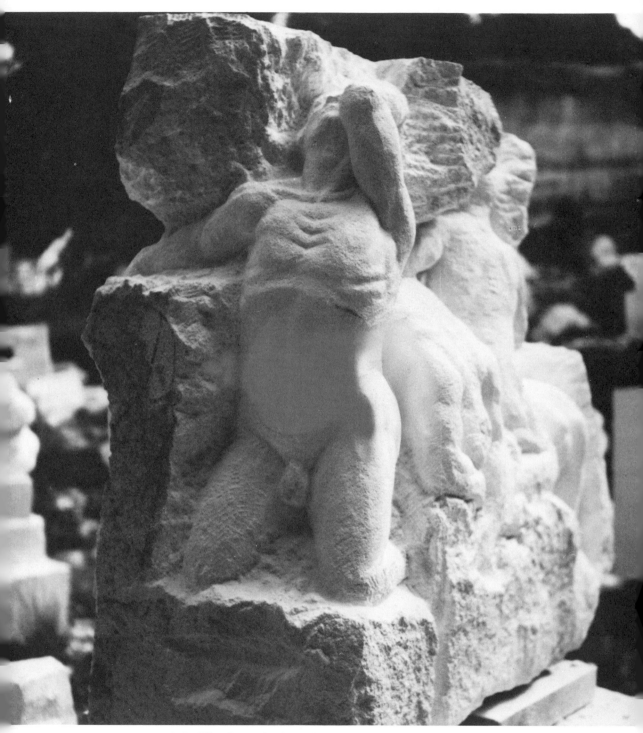

135. **"Condemned Figures" by author. French limestone,** **1977—7′ × 5′ × 4′.** *Photo by Barbara Ellen.*

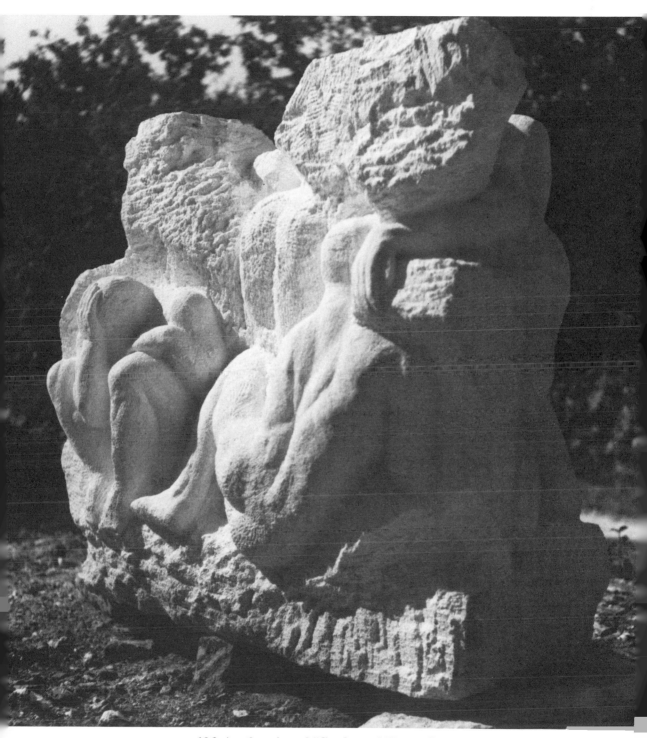

136. Another view of "Condemned Figures."

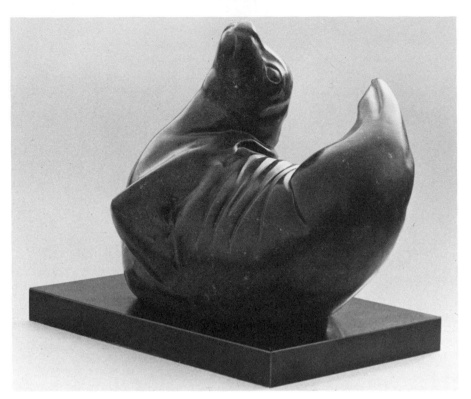

137. "Joie de Vivre" by Jane B. Armstrong. Vermont Radio black marble, 1976—approx. 20″ length. *Photo by Robert T. Armstrong.*

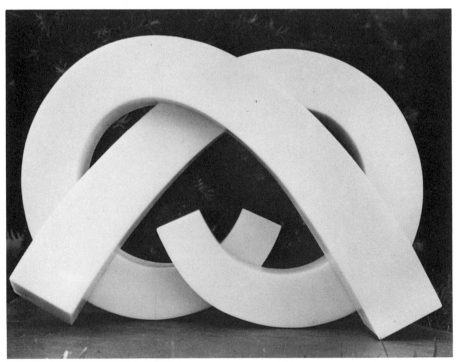

138. "Enfolding Forms" by Legh Myers. Carrara marble, 1971—11¾″×17″×6½″. *Photo by Hess Commercial Studio.*

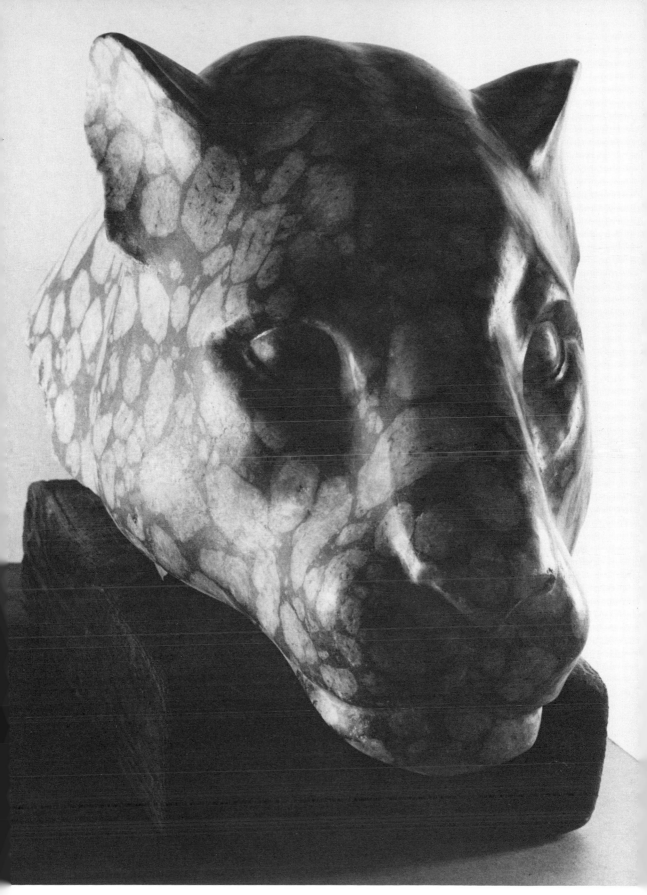

139. "Leopard" by James Wasey. Leprodite stone (green and yellow)—life-sized. *Photo by Jane Wasey.*

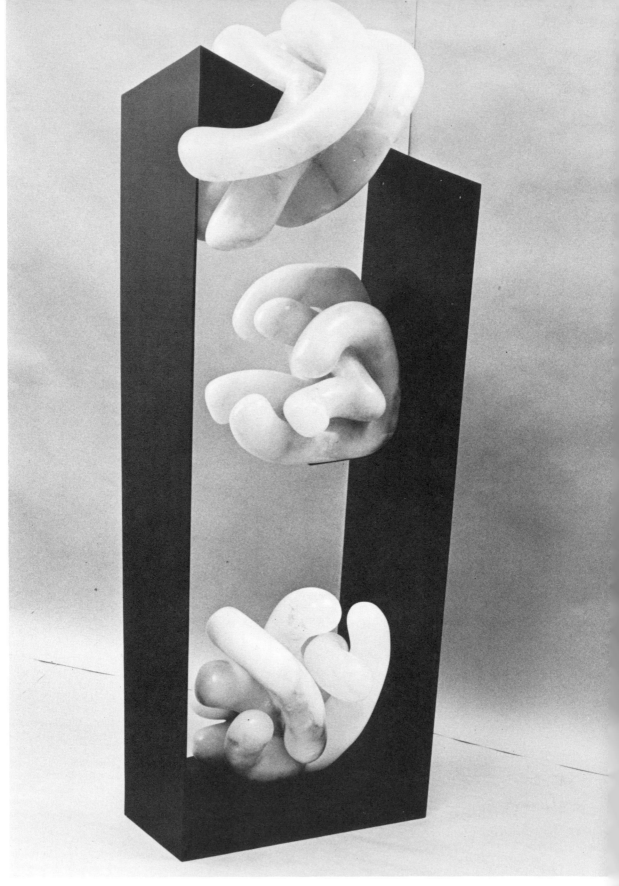

140. "Alabasters in Steel Frame" by Mashiko. 57″×17″×23″. *Photo by Thomas Ha*

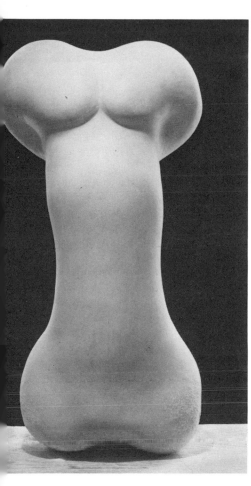

**141. "Aspiration" by Lily Landis.
Greek marble—2½′ height.**
Photo by Walter Russell.

142. "Fountain" by Pat Diska. Stone—approx. 11′ height. *Photo by artist.*

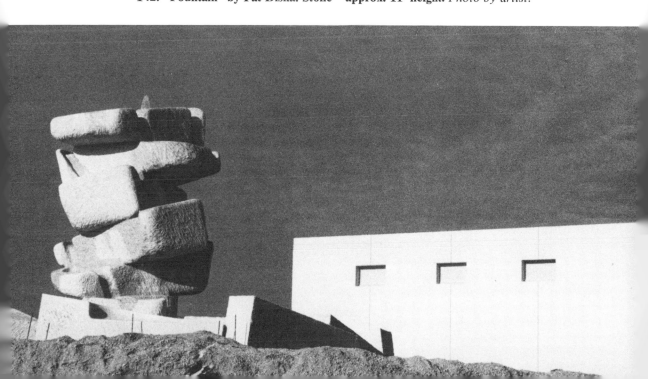

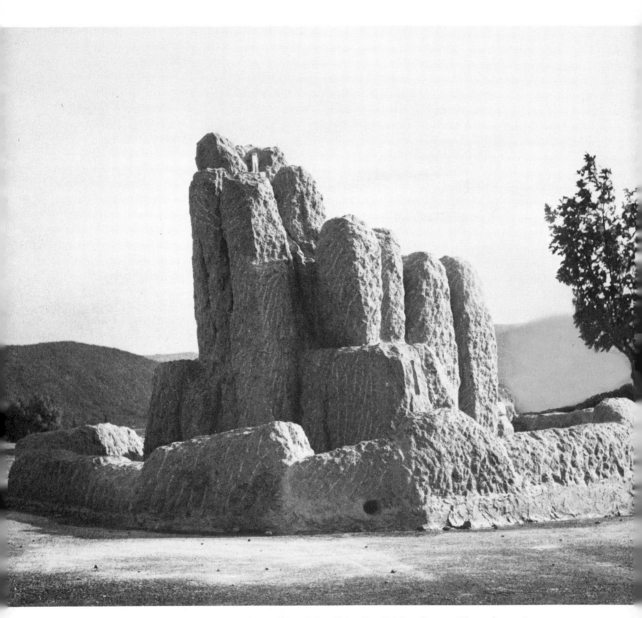

143. **"Reflection of Les Mees" by Pat Diska. Stone.** *Photo by artist.*

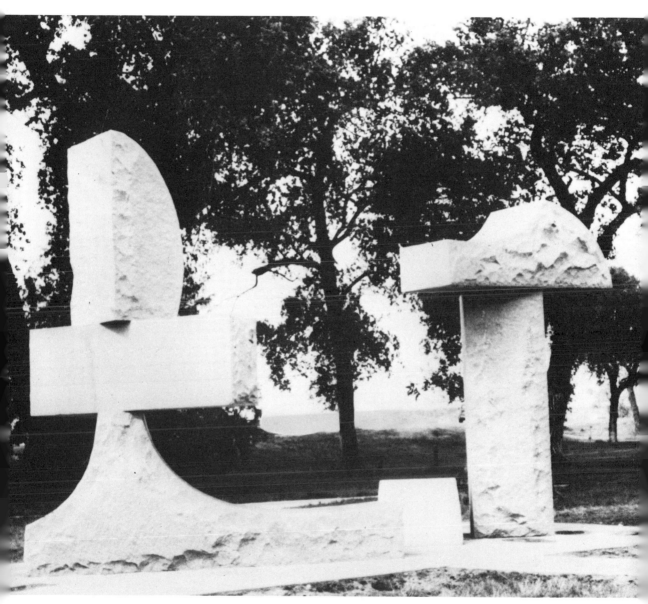

144. "Nebraskan Gateway" by author. Granite—15′×18′×35′. 1976 Bicentennial Project.

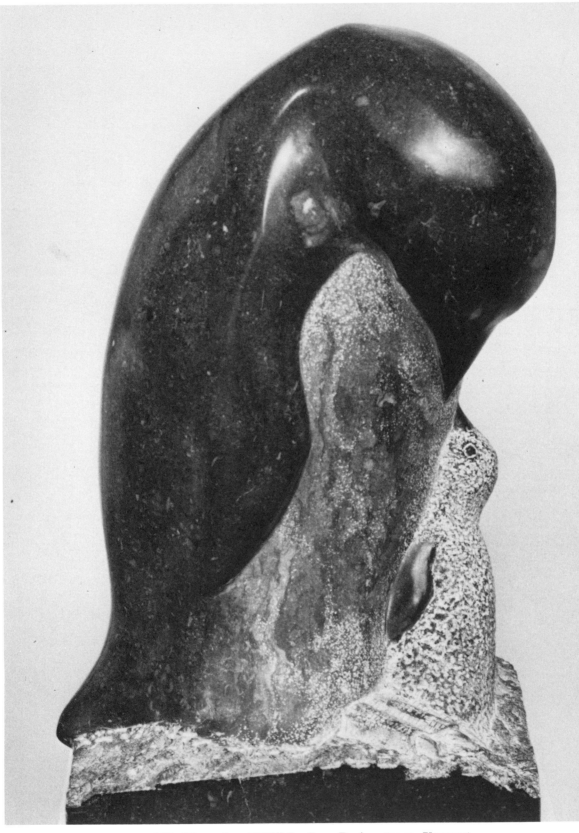

145. "December Child" by Jane B. Armstrong. Vermont
Radio black marble—approx. 26″ height × 12″ × 14″.
Photo by Robert T. Armstrong.

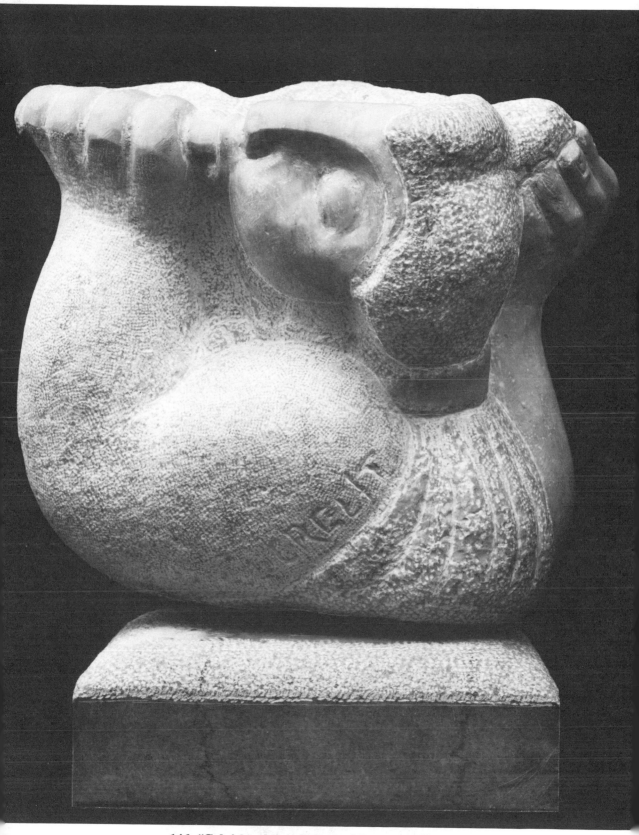

146. "Gabriel and Angel" by José De Creeft. Russian flint alabaster, 1974—24½″×22″. *Courtesy: Kennedy Galleries, Inc. Photo by Taylor & Dull, Inc.*

**147. "Estuary" by Lorrie Goulet. Tennessee marble, 1971
—32″ height.** *Courtesy: Kennedy Galleries, Inc. Photo by
Taylor & Dull, Inc.*

**148. "Vortex" by Lorrie Goulet. Green serpentine stone,
1973—21″ × 24″.** *Courtesy: Kennedy Galleries, Inc. Photo
by Taylor & Dull, Inc.*

FOUR

METAL WORKING

Metal sculpture has been and probably still is the characteristic medium of the twentieth century. The oxyacetylene process has made this possible because of its relative ease and speed in joining two metals. Although metal has existed for many centuries, it has been only in our times that metal sculpture, and especially steel welding, has been widely practiced by many artists. In Europe, the Bauhaus school, which included such men as Walter Gropius, Moholy-Nagy, Le Corbusier, Naum Gabo, Antoine Pevsner, and others, demonstrated that materials such as metal, glass, and plastic could be used in architecture and sculpture. Picasso, Gargallo, and Julio González also contributed greatly to the advance of welded steel sculpture. The influence of these innovators spread to the United States, where new ideas are generally welcomed. David Smith, Theodore Roszak, David Hare, and Seymour Lipton are only a few of the first sculptors whose work showed this influence for steel welded sculpture. In Europe, Caesar, Mirko, and Reg Butler continued the interest that Picasso and González awakened.

For the purposes of this chapter, metal sculpture will be divided into two sections. The first section will discuss sculpture that can be fabricated by cutting with shears and snips, and joined by sheet metal screws, rivets, and soldering. (Soldering is the joining of two pieces of metal by means of a melted alloy.) The second half will discuss the more advanced techniques of brazing, oxyacetylene welding, arc and heli-arc welding, and fabrication of more complex forms. (Welding is the fusion of two pieces of the same metal by melting and then mixing the adjoining edges.) It is important that beginners learn to work metal with simple tools, materials, and techniques. When they have mastered these, they can then attempt the complex techniques of metal working. The "simple" techniques are difficult enough, as anyone who has tried to soft-solder copper or brass will attest.

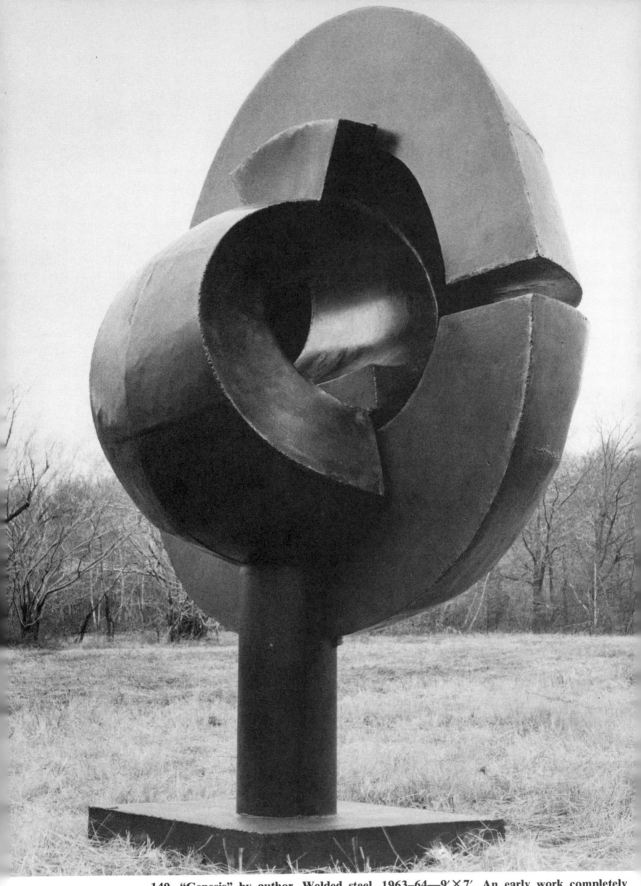

149. "Genesis" by author. Welded steel, 1963–64—9′×7′. An early work completely made and wrought by hand, using the oxyacetylene method.

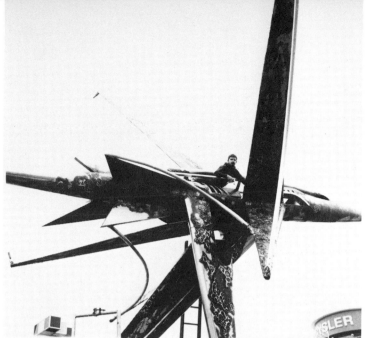

150. "Flight" or "Forms in Transit" (detail) by Theodore Roszak. Aluminum, 1962—48′ × 56′. A powerful public sculpture by Roszak that shows the diversity of textures. *Photo by artist.*

The Vital Role of Expression Through Sculpture

If your temperament is emotional and impulsive, I would advise you not to invest in expensive machinery. Purchase good hand tools and welding equipment, and have on hand a huge supply of scrap metal. Working with and cutting these pieces would probably be your technique; this is closer to direct painting, which is a give-and-take method. You would probably be interested in various nonferrous metals (ones containing no iron) such as copper, brass, Monel, and nickel silver. The sculptors of the fifties, such as Smith, Roszak, Lipton, Ferber, Hare, and others were basically of this emotional outlook, creating as they worked, while the sculptors of the sixties and seventies were and are more calculating. They relied upon a planned method of work and could therefore make use of the expensive machinery needed for large pieces. Donald Judd, David Von Schlegell, Robert Morris, Larry Bell, George Rickey, and many others reflect the preoccupation with finished surfaces and meticulous craftsmanship. Superb craftsmanship has always been part of the tradition of great sculpture, but although it is a desirable quality by itself, craftsmanship alone cannot ensure that the finished piece is a work of art.

In our times, craftsmanship often hides the lack of content and feeling. Attractiveness and seductiveness of polished surfaces has become a desirable quality leading often to banal and unoriginal forms. Rodin's "Balzac" figure was ridiculed by the critics as being a snowman or mud pie, and many nineteenth-century academic sculptors criticized Michelangelo's unfinished "Slaves" for their sketchiness and roughness. While I admire

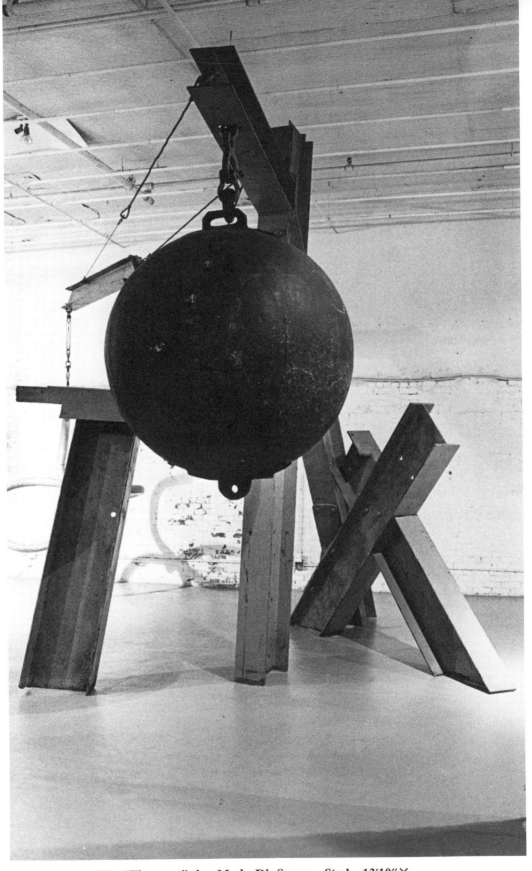

**151. "Thataway" by Mark Di Suvero. Steel—13'10" ×
19' × 13'9". Industrial and found objects are used here to
make a forceful statement.** *Courtesy Sculpture Now, Inc.*

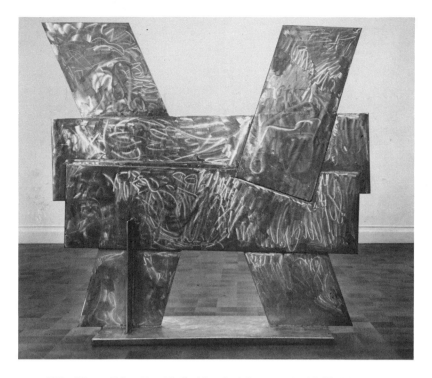

152. "Becca" by David Smith. Stainless steel, 1965. The polishing grinder is used here to create the swirling textures of light. *Courtesy Metropolitan Museum of Art.*

craftsmanship, I admire more the expression of deeper feeling because it is closer to what art is about. Content is what form expresses. In his excellent book *The Shape of Content,* Ben Shahn decried the sacrifice of content to form. Artists in recent times have accepted as their goals the perfection of form. The psychological, historical, religious, philosophical, or individual aesthetic experience has been eliminated. Utilitarian sculpture is popular because it looks well in bank lobbies, offices, decorators' shops, etc. Some galleries and even museums begin to look more like gift shops selling polished artifacts than places where one can find serious art. Much sculpture today can entertain because it can move, be plugged in, or light up, and perhaps this is what America wants, but an artist must satisfy his own sense of beauty and truth, even if it goes against the grain of society. There is great pressure upon artists in the world today, especially in America, to conform to accepted standards (by critics) of artistic relevance. Works by sculptors are often included or rejected not by quality, but by style. Often an excellent work in an outmoded style is rejected for one which is deemed "in," although it may be mediocre. There is a kind of "philosophy of progress," as if art is progressing toward some final and predetermined goal, in which only those works which resemble this predetermined look have any merit. This attitude has contributed to the drying up of painting and is presently hurting sculpture.

The sculptor must acquire a very broad range of material, technique, and experience. No ideas should be predetermined as being unworthy. Any idea,

any material, any subject, is suitable for becoming art. The problem of our times is who will determine the development of art—the artists or the art critics and historians? In the short range, the critics will win because they have influence over the museums, galleries, and the media. They will starve out, reject, and ignore the artist who is true to himself and favor those they can manipulate. In the long view of things, the true artist has a better chance, but even in the short view of things, the true artist possesses the unimaginable joy of creating solely for himself. He will pay the price for being true to himself but will think it is worthwhile. Until artists begin to work for themselves, there will be no vitality in sculpture or painting. The early pioneers of sculpture in our country had at first little support and some died in poverty and neglect. Today things are better for sculptors, although it is still difficult. Freedom of expression, however, must be won back again.

Metal sculpture, and particularly welded sculpture, was an experiment and breakaway from neoclassical concepts of sculpture. The early works of Smith and others are rough and even crude, but they have vitality. The excellent craftsmanship has been gained today through the elimination of vitality and the replacement of intellectual involvement. There is a great deal of knowledge to assimilate now. There are many more techniques, materials, and ideas, but never enough of individual courage.

As a sculptor you must decide for yourself what is really helpful in the scientific area. Some sculptors I've seen are overly concerned with technique, and they become gadget conscious. One of the important functions of an artist is to constantly assert his humanity, even if it means rejecting technology. This is important not only to the artist but to society. The creative artist in the performance of his work reasserts those values that are important, if not essential, to the survival of mankind. Values such as imagination, culture, education, and ideas are nurtured by society's artists, not by its technicians. The artist, consciously or not, accepted or not, leads the way even for technology. Indeed if it were not for our painters, sculptors, playwrights, musicians, authors, and composers, our twentieth-century mechanized society would be a totalitarian state wherein man would be a function of technology. The danger now, at least with modern sculpture, is that many sculptors are "playing with new toys," or to put it more discreetly, are involved in new technological techniques at the expense of their individuality.

There is a sameness or anonymity to much work being produced today, which is not necessarily bad in itself, but worse, there is a lack of content, and therefore there is boredom. This is not necessarily the fault of our artists, because with the emergence of abstract art and the development of technology, there has not been time left to find out who we really are. I've always felt that technology should serve man, not by appealing to his appe-

tite to acquire more material things, but by helping him find out who he is. If as a sculptor you find that heli-arc welding better expresses your ideas, fine; you have found a valuable tool. However, if you do not have ideas or feelings, why do you want a heli-arc? This tool then becomes a toy, something to play with rather than use for expression.

Play certainly has its place in the creative process, but ultimately only a high seriousness of intent can produce an art of meaningful content. We are now at the stage of playing. There are a few sculptors who are not afraid of content and do express themselves forcefully, but most established museums prefer to exhibit the toys. It is safer for the museums to do this now, but in the near future this must change. For over twenty years, most major museums have been exhibiting an art of abstract form, pleasant to behold but not meaningful as an emotional aesthetic experience. With all the exclamations from museum directors and critics proclaiming the "greatest since" or the "newest thing," how much has been of lasting value? The promotional techniques of big business when applied to fine arts weaken society's moral fiber. One cannot "promote" Rembrandt or Cézanne. Genius is to be recognized, not promoted for profit or fame. The artist must concern himself with that which lasts and not with transitory or superficial values. The creative drive is not satisfied with money or fame, it is only appeased momentarily after creative effort, and then starts over again. When Donatello was given a large vineyard as a gift, he returned it to his benefactor saying he had no time for it.

Technology can give us many things, but it cannot give us ourselves. It can in fact swallow us up in its power to make life easy. A certain amount of difficulty keeps us fit and keeps us in tune with reality. Reality is not a big red machine speeding down the highway with blazing lights and stereophonic sound. The artist is one who still enjoys a walk, who can listen to the wind or observe an insect.

Joining Metal with Screws and Rivets

I encourage you to first work in metal without the welding process. It is, after all, possible to do fine works in metal through soldering, brazing, and hammering, or what is known as "repoussé." (Repoussé is the art of hammering metal into forms.) You can also join metal through riveting and sheet metal screws. By working in metals without welding, you can avoid a stereotyped way of thinking about metal. The great metal workers of the past, such as the Spanish and Italian wrought-iron workers, made suits of armor, decorative iron railings, and architectural details without the welding process. It is the metal or the shape of the metal which is important, not the way it may be joined. There now exists a great mystique about welding which I would like to dispel. Welding is for joining metal, and is only one method of doing it.

The works of Alexander Calder, for the most part, are not welded but are joined through bolts. A younger sculptor, David Von Schlegell, uses rivets and sheet metal screws to construct his huge works. By working with these other techniques, you can acquire a knowledge and discipline which will prepare you for the welding process. Soldering, for example, would teach you the basic skills of joining metal cleanly.

153. Drill bit.

Like wood screws, sheet metal screws can be purchased in many hardware stores and come in a variety of standard sizes. To pass a sheet metal screw through metal, you must drill a hole through the metal which is *smaller* in diameter than the threads of the screw. The hole should be the same diameter as the inner body of the screw.

The teeth of the screw will thread the metal as you screw it through the hole. Two sheets of metal can be joined this way by drilling a hole through the two sheets and passing a screw through them. When screwing through two sheets of metal, you must make sure the metal is sandwiched together tightly. Use a C-clamp or metal vise to squeeze the metal together.

In riveting, drill a hole slightly *larger* than the diameter of the rivet body, but smaller than the head. The metal must be sandwiched together in the same way as for sheet metal screws. Pass the rivet through the hole, making sure the rivet does not extend more than the thickness of the combined sheets. In order to "upset" the rivet (hammer the end flat), you must back the head of the rivet with a metal block, anvil, or some heavy steel object which can be hammered against.

154. Upsetting rivet.

Hammer the end of the rivet until it becomes flat and spreads into an even circle over the surface of the metal. If it is done correctly, this will make a strong joint. Almost all metals can be riveted this way and you can join dissimilar metals without the concern about the correct joining rod you would have in welding. You could not, for example, weld aluminum to steel or copper; you *could* rivet these two together in the manner described above. I do not recommend riveting stainless steel unless you need only a few rivets. It is very difficult to drill holes through stainless steel and you could easily

spend hours trying to drill a dozen holes, not to mention the number of drill bits you could burn up. Stainless steel is also the most difficult metal to cut because it is extremely hard. You must use power machinery to cut stainless steel. For joining, use either welding or silver solder. Stainless steel is gener-

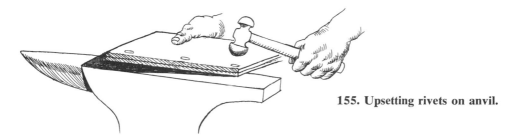

155. Upsetting rivets on anvil.

ally cut with a cut-off wheel or power shears and snips and, if thin enough, a bench cutter will also work. You will need the following materials to work with sheet metal screws and rivets:

Electric drill (¼″, ⅜″, or ½″—reversible drill preferred)
Drill press (optional)
Set of high-speed steel drill bits
Cutting oil
Metal hand blocks (purchase at auto supply stores)
Anvil (or piece of railroad track)
Plumber's hammer (2 pound)
Assorted sizes of rivets and sheet metal screws
Screwdrivers (hand, electric, and brace and bit)
C-clamps, vise grips
Metal vise

156 and 157. Bench cutter is used to cut sheet metal usually not heavier than No. 14 gauge.

158. "Variation Within a Sphere, No. 10: The Sun," by Richard Lippold. Gold-filled wire—11′ × 22′. This fine work is made of gold wire that was soldered or brazed. *Courtesy Metropolitan Museum of Art.*

The Soldering Technique

It is inexpensive to solder, requiring only a good soldering copper, solder, and some copper, brass, pewter, lead, or tin. The following is a list of the necessary equipment for soldering, all of it available at a large hardware store:

Electric soldering copper (heavy duty)
Roll of No. 32 copper sheeting
Soldering flux and metal file
Wire brush and steel wool
Sal ammoniac bar
Tin-snips
Quick clamps and small C-clamps
Strong worktable, topped with firebrick or asbestos.

159. Electric soldering copper.

Buy an electric soldering copper with a large head. Small soldering coppers are very limited and are usually used for soldering thin copper wire. When working with copper sheets, for example, you will need to preheat the soldering area before the solder will flow. When metal is too cold, the solder will ball up and roll off the metal. Copper, as well as most nonferrous metals, conducts heat rapidly. You must therefore apply enough heat to the soldering area before you can apply the solder. Soldering is not easy. Conditions must be made just right and they can easily be spoiled. A dirty soldering copper or dirty metal or carbonizing of the metal surface can prevent you from soldering at all.

Before trying to solder two pieces of metal together, practice working with solder by trying to make it flow on the copper. Wire-brush or rub steel wool on the surface to be soldered. This will clean the metal. Have your soldering copper heating (it takes about twenty minutes to heat properly) and press the hot tip of the copper to the cleaned surface. Rub the hot copper tip all along the area to be soldered. When the soldering tip becomes dark or black, clean it with the metal file. A black soldering tip will hinder your work by trapping the heat instead of conducting it to the metal. When the copper is sufficiently hot (it will darken) "tin" the soldering copper by rubbing it on the sal ammoniac bar and pick up some solder on the tip. Before soldering, apply the flux to the heated area and follow this by melting the

solder from the soldering copper. The solder should quickly run and spread into the fluxed area. If the soldering area becomes dirty, clean with the wire brush or steel wool and start all over again until you get the solder to flow. The thicker the metal to be soldered, the more heat will be required. You can practice soldering the other nonferrous metals in the same way. The various metals will behave in slightly different ways from copper and you will learn these through experience. I have never found it practical to solder aluminum. Aluminum is a great conductor of heat and the process of soldering it has not been adequately perfected. Riveting or sheet metal screws are best for joining aluminum parts.

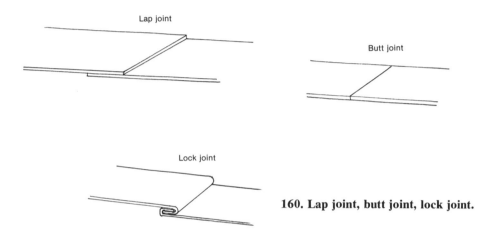

160. Lap joint, butt joint, lock joint.

Joints for Soldering

The lap joint is the easiest one to solder and is much stronger than the butt joint. Butt joints are not recommended where stress is a factor. The lock joint is the strongest of joints but is more difficult to achieve unless a metal-bending brake is available. This is a machine which can bend metal to various angles and is used in metal machine shops. A lock joint can be

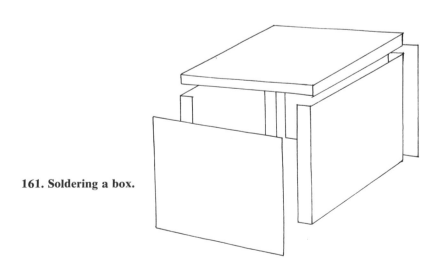

161. Soldering a box.

hammered into shape if the metal is soft or thin enough. The entire joint is heated and fluxed and the solder should flow throughout the length of the joint.

Illustration 161 shows soldering a copper box using lap joints. The lap joints are soldered on the inside of the box. Carefully plan the box and measure all sides. The lap joint must be bent at a 90 degree angle; otherwise the box will not be square. Use C-clamps to put four sides of the box together first, before you solder. In this way, you can check whether the box is square. Make any necessary adjustments to these sides. Proceed to "tack" these sides together. To tack means to place a small spot of solder every two or three inches apart on all sides before running a continuous flow of solder. First, tack each end at the corners, then the center of the metal. This will hold the metal sides together whereupon tacks can be soldered every 2 or 3″ depending upon the size of the box.

Remember that all joints and seams for soldering must be tightly fitted, clean, and properly prepared as described at the end of this section. The thinner the soldering joint, the stronger it will be. The solder should run in between the metal joints (sometimes called "sweating"). Avoid loading on solder to reinforce a joint because in most cases this will not work. Solder, which is made of lead and tin (50 percent each) has little tensile strength; therefore if it thinly flows in between tight joints, it will be much stronger. Later, I will discuss the making of various shapes and the different kinds of joints needed.

The following is a list of fluxes for soft soldering:

Metal to Be Soldered	Flux	Chemical Name of Flux
Brass	Cut acid*	Zinc chloride
Copper	Rosin	Colophony
	Sal ammoniac	Ammonium chloride
Zinc	Cut acid	Zinc chloride
Galvanized iron	Raw acid (Muriatic acid)	Hydrochloric acid
Tin	Rosin	Colophony
Tinplate	Cut acid	Zinc chloride
Pewter	Rosin	Colophony
	Tallow	
Nickel	Cut acid	Zinc chloride
Silver	Cut acid	Zinc chloride
Aluminum	Special fluxes by various manufacturers	

 * Cut acid is a term used when water is added to zinc chloride, making it slightly acid and usable for most ordinary soldering. It is

also called "killed acid" because zinc chloride is made by adding zinc, a little at a time, to hydrochloric acid until it stops eating the zinc; the acid is thus "killed" or "cut"; hence the name. This should be done in the open air and kept away from flames or an explosion will result. Muriatic acid is also called raw acid.

162. Gas furnace.

If you have the proper work space, you can install a soldering furnace. This is a versatile tool to have because in addition to heating and soldering copper, it can be used as a small forge for making, repairing, and tempering tools. A soldering copper (see illustration 159) with a large four-faced tip and wooden handle is used for the soldering and is heated in the furnace. In this instance, the flame of the furnace is used to heat the copper tip. Make sure the flame is blue, not yellow, and that the copper tip is not overheated. Rainbow colors show up when the copper tip begins to overheat. If the tip spoils, dip the copper point into a solution of zinc chloride (see chart on page 141) and then melt solder on the faces and wipe with a heavy dry cloth. You can also rub the point in drops of solder on a block of sal ammoniac or in powdered rosin. This will clean the tip. Make sure the copper tip stays bright and that the metal to be soldered is free of grease, rust, and oxide (black surface). The solder will not stick to a dirty surface. The surface must be cleaned by rubbing with steel wool or a wire brush, followed by washing in a warm solution of water and mild soap. Rinse thoroughly and wipe dry. A

**163. "Goat" by author. Lead, copper, and brass, 1959—
18″ × 24″. Use of soft solder over sheet copper.**

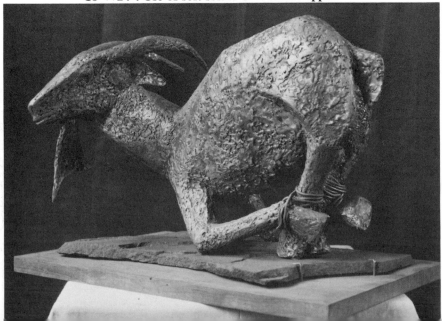

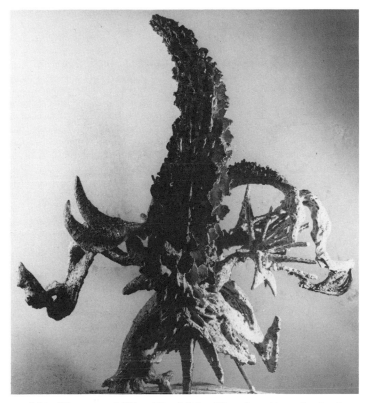

164. "Spectre of Kitty Hawk" by Theodore Roszak. Steel, brazed bronze, and brass, 1946–47. A work full of energy and vitality. The entire piece, made of steel, was brazed over with nickel silver. *Collection, Museum of Modern Art. Photo by artist.*

clean surface, however, immediately begins to oxidize, making it impossible to solder. Put on a coating of flux (refer to the chart) and this will remove the oxide from all nonferrous metals.

Brazing

Brazing is the step between soldering and welding and is generally used with nonferrous metals, such as brass, copper, and other difficult-to-weld metals. Whereas soldering is accomplished with an electric soldering copper or a propane-gas furnace, brazing is almost always done with a combustible gas such as propane or oxyacetylene. In jewelry, for example, brazing and silver soldering are used to attach and join low melting-temperature metals such as tin, silver, brass, pewter, Monel, nickel silver, bronze, and gold. The flux generally used in brazing comes in a variety of forms—a can of powdered flux, coated brazing rods, or a fluxing attachment on the oxyacetylene lines or hoses. As in soldering, flux cleans and etches the hot metal so that the brazing material will flow into the fluxed area.

The general principle of brazing is that a rod with a lower melting point is melted onto a higher melting-temperature base metal. Copper, for exam-

ple, would be brazed with a low-temperature phosphorous-copper rod, or nickel silver with silver solder or brass rods. These rods are designed so that they melt quickly because of their lower melting temperatures, and flow easily into a preheated area. If, for example, a base metal melts at 2,700 degrees Fahrenheit, the brazing rod should melt at 2,300 degrees Fahrenheit. In brazing, it is not necessary to achieve a melting-point temperature on the base metal, and in fact, it is highly undesirable. Brazing rod material can burn up and spatter if the base metal is too hot. It is only necessary to get the base metal to a cherry-red color for successful brazing to take place.

The many kinds of brazing rods available on the market are too numerous to name here.* Brazing rods generally come in lengths of 24″ and in diameters of $\frac{1}{16}$″, $\frac{1}{8}$″, $\frac{3}{16}$″, $\frac{1}{4}$″, etc. They come flux-coated or uncoated. Naturally, flux-coated ones work better but are more expensive.

Small works in metal can be brazed with a propane tank sold commercially in hardware stores. For larger works which require more constant heat, you can lease propane tanks from local gas suppliers. You will also need pressure gauges, hoses, and a torch to complete the outfit. These propane tanks, called cylinders, by law cannot be used in an apartment or house. Most fire laws would prohibit you from storing and using pressurized tanks in your living space, but you could probably use a garage or basement if you took the necessary precautions to prevent fire. Check with your fire

* Write to: Eutectic Welding Co.
 40-40 172nd St.
 Flushing, NY 11358

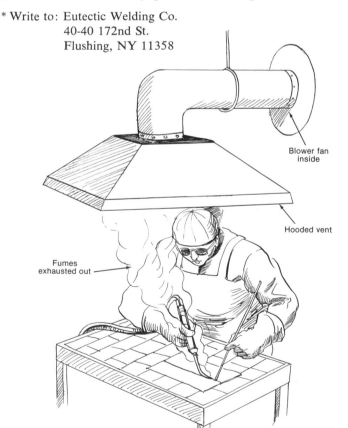

Blower fan
inside

Hooded vent

Fumes
exhausted out

165. Propane tank.

department. Clean up all flammable materials (most people seem to hoard these in their basements) such as old furniture, newspapers, mattresses, or oil and gas, if it is stored in your garage. Put sheet metal down on a wooden floor, or asbestos,* and cover your worktable with firebrick, metal, or asbestos. Keep available a garden hose which can be quickly turned on, or invest in a fire extinguisher. You must do the same if you have an attic, loft, barn, or any kind of studio which could burn.

To braze nonferrous metal, heat the metal with your propane torch, making sure your flame is a blue color. The metal, if it is copper, brass, Monel or nickel silver, will darken as it becomes hot. If you are not using a flux-coated rod, you can mix your powdered flux with water into a paste and paint it on the metal. The heat from the flame of your torch will turn the flux to a shiny glasslike substance which will receive the brazing material evenly. The brazing material should flow quickly into the heated area. On most nonferrous metals, the brazing material acts so rapidly that you may not see it flow. As in soldering, cleanliness and proper heat are required to get a good braze.

If you are brazing steel, you may need an oxyacetylene welding outfit, especially if you are using a heavy-gauge steel. You can use a propane torch on thin metal (from 22 gauge to 16 gauge), but as heavier gauges are used, more propane would be required to reach a high enough temperature to allow brazing to take place. The steel must become a cherry-red for brazing, as mentioned before. Use the flux in the same way for steel as you would for nonferrous metals.

For all surfaces to be brazed, sheets or pieces of metal must be tightly clamped or put together, and the brazing material should be made to flow into these tight spaces. A properly brazed surface is very strong and will hold up for many years or even indefinitely, under certain conditions. Sculptors like Lipton and Roszak (see illustration 164) used brazing to cover the entire surface of their sculptures, thus achieving a modeled surface. This kind of surface can be wire-brushed or ground down with a disk grinder. In this kind of brazing, the oxyacetylene outfit must be used because of the great amount of heat that is required. I would also recommend that a flux attachment be used with your welding outfit. This will save you from having to use canned flux and purchasing expensive flux-coated rods. Better results are achieved in brazing with the flux attachment, the work becoming cleaner and more consistent. Flux residue (which is a glasslike substance left after the brazing has been done) must be chipped off with a chipping hammer or metal chisel. Use eye goggles when chipping flux off because it is hard and very sharp. Wire-brushing is also used to remove hardened flux but is not as effective as a chipping hammer.

Powdered borax can be used as a flux in brazing, soldering, and welding. Borax is used in the home as a cleaning agent, but if sprinkled on the metal,

* Asbestos is considered cancer-producing.

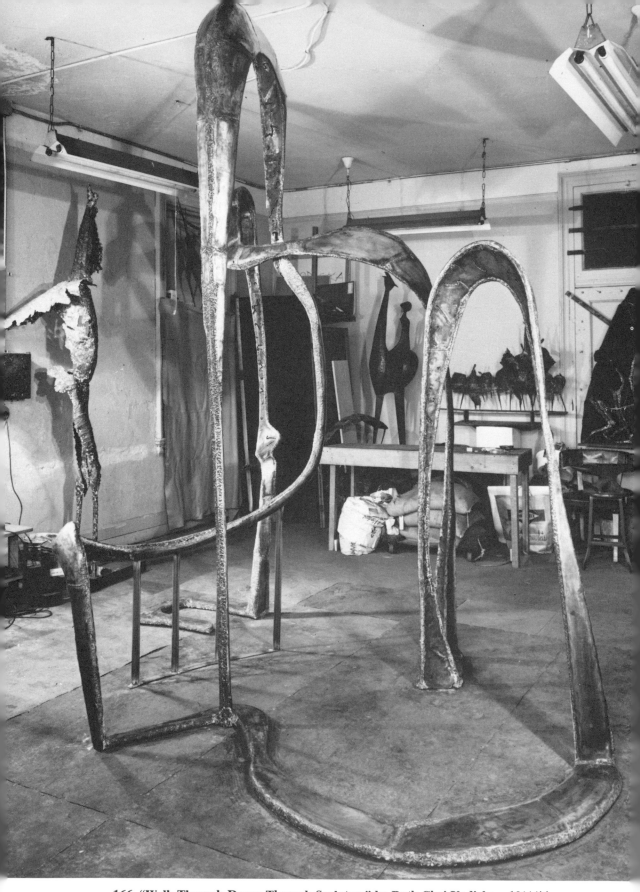

166. "Walk-Through-Dance-Through Sculpture" by Ruth Chai Vodicka—10½′ ×
10½′ × 6′. **A loft studio used for welding.** *Photo by Walter Russell.*

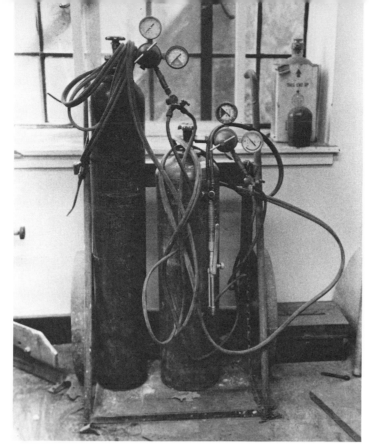

167. Oxyacetylene tanks, hoses, and torches. *Photo by Lou Sgroi.*

it works well as flux. Today however, with the great range of brazing and welding rods, special fluxes have been developed for specialized results. There are many alloys, or combinations of metals, where borax can be used; otherwise, the proper flux must be used for brazing.

Welding

Whereas soldering and brazing depend upon metal flowing *onto* a surface, welding depends upon melting the base metal to attain fusion through a molten state. The base metal must reach a hot enough temperature in order to form a "puddle," an area where the metal becomes molten. This area or puddle should be about the diameter of a dime, and must travel continuously in a straight line across the steel sheet or seam. With a little practice you should be able to move the puddle from one end of the metal to the other in a straight line without ever losing the molten flow. If you have worked awhile with copper and soldering, you will be much better prepared to start welding than if you've never touched metal.

In this medium of metal work, the biggest problems one faces in getting started are finding a school to learn to weld and obtaining a place to set up a welding studio. In my opinion, the first part of the problem is easy: to learn

welding, simply take a short course in any technical school or community college that has a welding program. Three or four classes in oxyacetylene welding should teach you enough about the technique and equipment for you to purchase your own welding apparatus. You should also buy a book on welding (see "Books for Further Reading") and read about the safety precautions as well as all the technical data concerning oxygen and acetylene gases.

The second part of the problem—*where* to weld—is more difficult. In a city like New York, fire regulations are extremely severe and even though you may have a loft, garage, or warehouse, you must first get a permit from the building department and another from the fire department. It is much easier in the rural areas where all you need is a small storage building or garage to house your equipment and where these fire regulations are not so stringent. Precautions must still be observed, of course, for welding in a barn full of hay is dangerous. Welding demands a thorough knowledge of safety precautions, common sense, and familiarity with the equipment. In my many years of teaching, I've seen students do strange things with potentially dangerous tools, such as lighting a cigarette with the welding torch, or the student I remember who came in late and threw his leather jacket on the worktable where a hot piece of metal was cooling, leaving a huge hole in his garment. Do not attempt to repair the gas tank on your automobile, or cut an oil tank in half that you may have found in a junk yard. Most safety precautions are simple common sense. As a general rule, you should have a flame proof worktable and nothing flammable within 30′ of the work area.

Among the many materials and techniques that must be known to a metal sculptor are the different kinds of welding operations. In addition to the oxyacetylene method, there are the electric arc welding method, often called "stick welding," and heli-arc welding. For the electric arc method, an AC or DC electric current runs from the welder directly through a steel rod (electrode) to create the weld. In the heli-arc method, an inert gas (usually argon or helium) is used to surround the electric current and protect it from the impure atmosphere.

One must be thoroughly instructed in the use of welding machines. It is fairly easy for an institution to buy this kind of expensive equipment whereas it is a major financial problem for most individuals—another reason for taking courses at a nearby school. Many art departments that I've visited on the East Coast had all three welding techniques available— oxyacetylene, electric arc, and heli-arc welding. The welding industry is constantly expanding and developing newer and better methods. For example, 3″ thick stainless steel can now be cut with a nitrogen gas flame; this works in much the same way as oxyacetylene cutting. There are now a great variety of electric welding machines and heli-arcs which are wire-fed through the nozzle: this eliminates the old-fashioned welding filler rod. For-

tunately, the welding industry promotes its products by an enormous expenditure in advertising catalogs which are available free upon request. Salesmen who are knowledgeable in these products will give you the information you need. Many companies will even send welding demonstrators to schools or put on "welding exhibits" in their plants. This is an excellent way to keep abreast of new developments in this fast-growing industry.

Metals and How to Weld and Cut Them

METAL	WELDING METHODS	CUTTING METHODS
Mild steel	Oxyacetylene, electric arc, heli-arc	Oxyacetylene burning, or electric shear
Cold-press steel	Oxyacetylene, electric arc, heli-arc	Oxyacetylene burning, or electric shear
Stainless steel	Electric arc, heli-arc, silver braze, phos-copper braze	Electric power shears, power saw-bench shear
Cor-ten steel	Oxyacetylene, electric arc, heli-arc	Oxyacetylene burning, or bench shear
Cast iron	Oxyacetylene, brass braze, heli-arc	Power saw
Galvanized steel	Brass or phos-copper braze, heli-arc*	Electric power shears or power saw
Lead sheet	Soft solder or lead solder	Metal hand shears
Copper sheet	Soft solder, brass or phos-copper braze, silver solder, oxyacetylene, heli-arc	Metal hand shears, power shears, saw-bench shear
Brass sheet	Brass braze, silver solder, heli-arc, oxyacetylene	Electric power shear, saw-bench shear
Bronze sheet	Brass braze, silver solder, heli-arc, oxyacetylene	Electric power shear, saw-bench shear
Monel	Brass braze, phos-copper braze, oxyacetylene, heli-arc	Electric shears, saw-bench shear
Aluminum	Heli-arc, oxyacetylene	Electric shears, saw-bench shear
Nickel silver	Silver solder, phos-copper braze, heli-arc, oxyacetylene	Electric shears, saw-bench shear

* Zinc-coating on galvanized steel sheet will burn and spatter when fusion welded, letting off toxic fumes.

METAL	WELDING METHODS	CUTTING METHODS
Bronze casting	Heli-arc, oxyacetylene, silver or phos-copper braze	Electric hand saw, power band saw, band saw
Brass casting	Heli-arc, oxyacetylene, silver or phos-copper braze	Electric hand saw, power band saw, band saw
Monel casting	Heli-arc, oxyacetylene, silver or phos-copper braze	Electric hand saw, power band saw, band saw
Stainless steel casting	Heli-arc, silver braze, electric arc	Power band saw
Aluminum casting	Heli-arc	Electric hand saw, power band saw
Silver casting	Soft solder, lead solder, silver solder	Electric hand saw, power band saw, band saw
Lead casting (pewter)	Soft solder, silver solder	Electric hand saw, power band saw, band saw

Basic Equipment of Fusion Welding

A standard set of welding equipment can be purchased from most welding supply companies. These sets range greatly in price and quality, but when you play with fire, you should have good equipment. Basic welding sets will include the regulators for the oxygen and acetylene tanks, a pair of hoses with fittings, a welding torch and set of welding tips, and a cutting attachment, goggles, striker, and work gloves. (See illustration 167.) Some companies may add or subtract one or two items from this list, but this is what you will need. Prices currently average about $200.00 for this set, but will probably increase in the future. The pressurized tanks that store the oxygen and acetylene are leased from the welding supply company. Make sure that your oxygen and acetylene regulators fit the threads on the tanks. If not, ask the company for an adaptor or find a company that has tanks that will fit your regulators. The tanks come in two or three sizes and you will have to leave a deposit on each tank you have. If you intend to do a great deal of welding, lease the large tanks. A demurrage charge is due for every day you keep each tank over thirty days. This can be considerable, so if you intend only to experiment with welding, lease the smaller sizes. For a school or a welding shop where four or five people may be welding at the same time, it is best to install a piped system. In what is called a manifold system, tanks are stored outside and gases are piped in. This is safer, more economical, and will give more space in the work area. Consult your welding supplier about this system.

In addition to the above equipment, you will need a metal worktable with firebricks, a machinist's vise, and an anvil. The necessary hand tools would include deep-throated C-clamps, quick clamps, long-handled pliers, and vise grip. There are many ways to use these few tools, and it is most important to learn how to make one tool do many things rather than getting another tool. A tool, however, should not be misused. C-clamps should not be used for hammering, for example, but there are ways of clamping work with C-clamps that can surprise you. I've used C-clamps to help me weld a steel

168. Machinist vise and C-clamp.

sphere by slowly squeezing sheets of steel over a steel framework. (The steel must first be cut and hammered.) Pressure by the C-clamps allowed me to construct an excellent spherical shape (see illustration 169). By heating the metal slightly from the inside surface, I got the metal to bend easily into the direction of the heat. As your work becomes more sophisticated, you will acquire more tools. Electric drills, hand grinders, polishing equipment, and electric cutters are all tools that you must be prepared for by using the simpler tools first. Learn to do one thing well before moving on to the next step.

The tanks you lease from the welding supplier consist of pressurized oxygen and acetylene, the former tank being taller and often painted green, while the other is shorter and often painted black. When your tanks arrive, it is a good idea to check the tank for leaks before the delivery man departs. Some companies are careless about the condition of their tanks, and you can save much time and frustration by checking them when they first arrive. Open and close each tank quickly by turning the valves. This is called "cracking" the tank, and is done to blow away any dirt so that it will not enter the regulators that are to be attached. Then attach the regulators, making sure that each handle or knob on the regulator is screwed *out* in a loose position. This is the off position, which will prevent the gas from going into

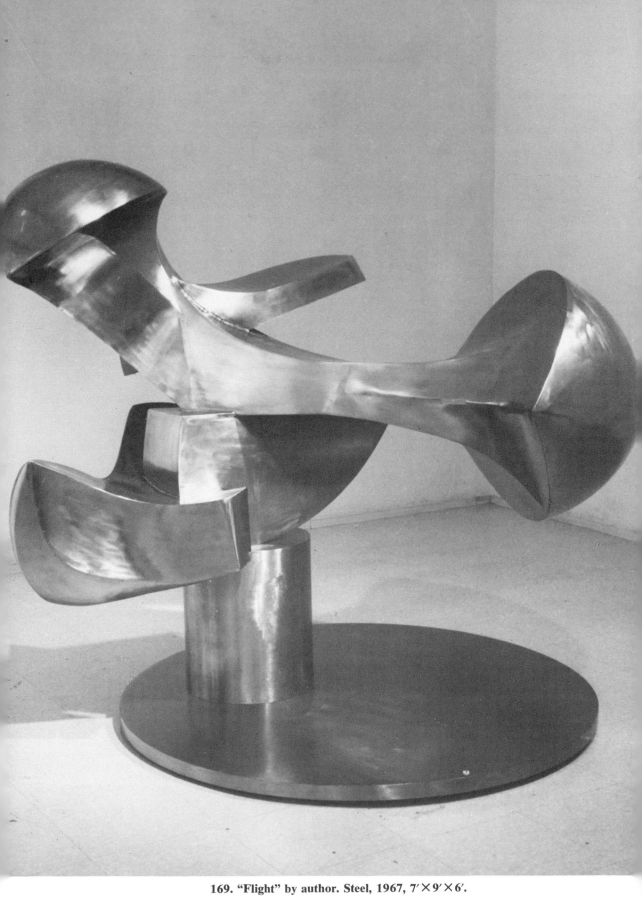

169. "Flight" by author. Steel, 1967, 7' × 9' × 6'.

the hoses. When opening either tank, whether for cracking the tank or when the regulators are being attached, make sure no one is nearby who could be hit by a sudden jet of oxygen. The great pressure within the tanks could possibly break the rubber diaphragm of the regulator and the force of the escaping gases could hurt you or someone standing close-by. If there is a leak in the fitting on the tanks, it will show up as soon as you turn on the tanks. Should you hear or smell the acetylene, turn the handle of the tank off and tighten the octagonal screw of the regulator that attaches to the tank. If you still hear or smell escaping gas after you turn on the tanks again, the tank is probably faulty. Turn it off again and give it back to the delivery man or call up the supply company. If everything is in order, you can proceed in your welding operation.

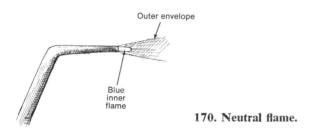

170. Neutral flame.

Operating the Torch

First examine your hoses and welding torch. Check that all the fittings and knobs are tight. When you turn on your welding torch, turn on the acetylene first and then strike the friction sparker, making sure you do not get a lot of black sooty smoke billowing out when the acetylene ignites. Increase the acetylene pressure on your torch and this will stop most of the black smoke. Slowly turn on the oxygen valve. You must get a "neutral" flame, which is blue in color. Turn on the oxygen until the long stem of the flame becomes a small, short blue flame about ¼" to ½" long. If you use a two to one mixture of oxygen to acetylene, you will get the best possible flame. Generally, ten pounds of oxygen to five pounds of acetylene are used for most fusion welding. Avoid excess oxygen in your flame because it will burn up the steel and weaken your welds. If pitting occurs on the surface of your welding, this might be caused by too much oxygen in the flame. Make the necessary adjustments until the flame is exactly right. The flame should not touch the steel but be approximately ⅛" to ¼" away from the surface. The welding tip should be held at a slight angle to the steel and be slowly rotated clockwise. The angle will also ensure the proper amount of preheating to the welds.

Types of Flames

A sparker is used to ignite the torch. First turn on the acetylene valve and ignite the escaping acetylene gas. You will notice a very long outer envelope of flame which is yellowish orange in color. Increase the oxygen until you get a small blue flame. The point at which the large yellowish orange envelope becomes the small blue flame is called a neutral flame. About 95 percent of oxyacetylene welding is done with the neutral flame. The acetylene is the first valve to be shut off when the welding torch is turned off. After the acetylene is turned off, close off the oxygen valve. Remember this rule: acetylene is first turned on, and first turned off.

You can get various size neutral flames with the same welding tip before it becomes necessary to change to another tip. Practice getting a small neutral flame. Then try getting a large neutral flame. If you get a lot of popping, hissing, or small explosions, this is usually because the flame is not strong enough. Increase the amount of gases used with the valves on your torch. If your flame blows out and you hear a squealing sound in the welding tip, turn off the oxygen and acetylene valves. This is called a "flashback." Flashbacks occur when the tip is dirty, or the base metal is too rusty, or if there is foreign matter on the base metal such as paint or zinc coating. Welding-tip cleaners should be used to clean out the small orifice of the welding tip. Tip cleaners are perforated wires in various sizes that fit the various sized holes of the welding tips. The outer surface of the welding tip should also be kept a bright copper color. Do not allow it to become black because this also causes flashbacks.

An excess of oxygen in the flame results in an "oxygen" or "oxidizing flame." This flame has a very sharp point to it, accompanied by a louder hissing noise. The color of the oxidizing flame is slightly purplish instead of blue. Oxidizing flames are generally used in bronze welding and bronze surfacing. A more strongly oxidizing flame is used in fusion-welding brasses and bronzes.

An excess of acetylene in the flame creates a slight acetylene "feather," a third conical envelope between the inner neutral flame and the other large envelope. This third or intermediate cone is of a whitish color. The "excess acetylene flame," called also a "carburizing flame," is used in welding certain alloys. During the welding of iron or steel, the excess acetylene flame will tend to remove oxygen which may be present from iron oxides, which has also caused this flame to be known as a "reducing" flame. (When oxygen is removed from a chemical compound like iron oxide, it is said that the iron oxide has been "reduced" to iron.)

When you feel confident with igniting the welding torch and getting the neutral flame, you can practice getting a puddle, which is the term used for the heated area on the steel which becomes molten. Using the neutral flame, heat a piece of steel (about 12 gauge) by keeping the flame approximately

⅛″ from the steel surface. Rotate the welding tip in a small clockwise circle until you see that the red-hot metal becomes molten. By keeping a slight angle to the welding tip, move the molten area or puddle across the steel surface in a straight line. Remember to keep the welding tip rotating and to keep the puddle or liquid state continuous. Fusion welding depends upon keeping the liquid state constantly moving. If the puddle is lost, two pieces of steel cannot fuse together. This is also true of using a filler rod on the weld or puddle.

On a piece of steel, practice making straight rows of puddles across the surface. Examine each row and see whether you managed to keep the puddle rows constant. If you burned through the steel surface, you either had too much heat or you were moving too slowly. Puddles make a shiny surface, and if there is a dull-looking area in your rows, you have either moved too fast or you're not using enough heat. Adjust your speed, rotation, welding tip, and working pressure until you achieve a consistent surface of even rows.

Having successfully completed the puddled rows, you are now ready to add the filler rod. A filler rod, or welding rod, is simply a rod of steel used to add extra steel to a welded area. Steel welding rods come in standard sizes and are commonly coated with copper. These rods are usually 3′ in length and come in ¹⁄₁₆″, ⅛″, ³⁄₁₆″, and ¼″ diameters. Generally, welding filler rods for oxyacetylene welding do not come flux-coated because fluxes are not necessary for fusion welding. These rods come copper-plated to protect them from rusting.

Oxyacetylene Cutting

Impossible as it may seem to many laymen, steel is cut with oxygen in combination with heat. The cutting torch or attachment is larger than the

171. Cutting tip.

welding torch or tip. Increased oxygen (and often acetylene) is necessary, demanding extra parts in the cutting torch.

In cutting steel, the base metal must be heated by the torch to a dull red, and then the trigger for oxygen is engaged, sending a jet of oxygen through the hot metal. The oxygen "burns up" the steel, creating an intense concentration of heat that causes a separation of the metal sheet if the cutting

torch is traveling across from one side to the other. The flames of the cutting torch must not touch the steel, and a slightly more vertical position of the tip to the metal must be maintained than in the welding procedure.

The oxygen reading on the regulator must be doubled or even tripled (to twenty or thirty pounds) when cutting. If the flame or cutting tip is too large, the cut steel will reweld right behind the cutting tip. The correct size tip must be used for the cutting operation. If the cutting torch is moving too slowly, it will also cause rewelding. As in welding, the cutting torch should move from right to left along a determined path at a steady pace. A straight metal bar or T-beam can be used as a guide. Avoid moving the cutting torch back and forth; practice until the torch is steadily moving in one direction and separating the steel. This will take some practice on scrap steel. A compass attachment is available for cutting circles.

Cutting steel causes many sparks and flying scraps of hot steel. Great caution must be maintained if cutting is taking place overhead. Be sure to wear a work hat, eye goggles, protective clothing with a high collar, and work gloves or welding gloves with long cuffs. Equally important is to ensure that flying sparks do not travel to high places such as shelves where flammable materials are stored. Caution must be constantly maintained in your work habits.

Cutting steel with the oxyacetylene method is probably the fastest and most inexpensive way to do this operation. Trying to cut a 1″ thick piece of steel with a power saw for example (such as a band saw) would require twenty or thirty times more effort and time than the oxyacetylene method. Power tools are also limited to one or two types of cut, which is not true of the oxyacetylene technique. Thick pieces of steel such as railroad tracks, or solid bars of steel 6″ by 6″, can be given a "carved" effect with the cutting torch. The pressure used on the regulators must be set as high as ten pounds acetylene and thirty-five or forty pounds oxygen. Another great advantage is that cutting can take place in any direction that a sculpture may demand. You could not cut a solid steel bar such as a 6″ by 6″ with a power band saw unless you invested thousands of dollars into an industrial Sawzall or brought the bar to a factory that had one. The cost of doing this would be the equivalent of using three to five sets of oxygen and acetylene tanks. Power band saws are also limited to the depth of throat of the saw. A 14″ band saw, for example, is limited to cutting only 14″ from the saw blade to the arm. Oxyacetylene cutting can also leave very exciting textures and surfaces. A serrated surface is created when cutting through the steel. A gouging tip can be used for taking shallow grooves out of thick steel. Many thick pieces of steel can be cut and then welded together. If you work this way, however, many sets of oxygen and acetylene tanks can be used quickly. You would be using three or four tanks of oxygen for every tank of acetylene. It would be wise to lease the large tanks in this case.

The cutting torch can also be used to cut patterns out of a sheet of steel. These patterns can be linear or large geometric or organic shapes, which are curvilinear. A sheet of steel can also be cut so that only a small part still joins the steel together. These loose parts which are still joined can be bent or twisted manually, breaking the flat plane surface. Parts can be cut from one piece of steel and joined to another. As you can see, there is great flexibility with the cutting torch.

Fabricating a Form

The term "fabrication" is the technical name commonly accepted in machine shops or welding factories for the process of making something from steel. Phrases such as "cost of fabrication," or "process of fabrication" refer to the process whereby a product is put together a certain way, either by hand or machine, and the steps are taken into account when the total product is finished. A jet-propelled airliner is a complicated process of fabrication involving not only cost of fabrication, but sequence of fabrication. There is also the term "fabricating material" and a worker is called a "fabricator," not referring to one who lies (as a professor I once knew thought), but to one who physically carries out the operation.

To fabricate a form, then, means to put together a form, volume, or shape out of metal. A cube is easily fabricated by using six equal squares and welding each edge to another at a 90 degree angle. With a little practice, almost anyone can fabricate a cube in steel, but the excitement of sculpture comes from using other shapes that are more asymmetrical or or-

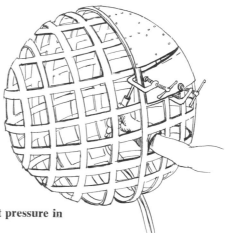

172. Constructing a steel sphere. C-clamps exert pressure in direction of flame inside.

ganic. Fabricating an egg or spherical form is more complex (and more exacting), presenting many more technical problems than a cube.

In almost all cases, organic forms must be fabricated by the following steps:

1. Weld an accurate steel framework.
2. Cut and tape down cardboard or some stiff material over the framework.
3. Trace each cardboard shape onto the sheet steel, and cut it out with the cutting torch.
4. Fit and hammer the steel pieces, and fit them onto the framework.
5. Tack down each steel piece onto the framework.
6. Weld all the seams.
7. Grind and finish all the seams.

Each of these steps must be accomplished carefully, and attention to detail is very important. A crooked framework, for example, will result in a crooked form, or if the cardboard fitting and cutting is not done properly, distortion in the metal can occur. As mentioned above, C-clamps can be used to squeeze the steel shapes onto the framework.

In butting each sheet into the others, be careful not to cause overlap or to fit them too tightly so as to distort the metal. A ⅛″ gap between each sheet

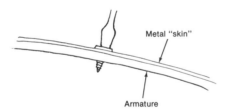

Metal "skin"

Armature

173. Sheet metal screws.

is desirable. Wherever possible, spot-weld the sheet from inside to the framework. The framework should be made well in order to offset the distortion that heat causes in metal. I recommend ½″ by ⅛″ steel strapping for shapes under 2′ in any dimension, and heavier strapping for pieces over this, depending on the size. For large works over 5′, buttressing, ribbing, and bracing are necessary to hold the framework tight and strong.

Sheet metal screws, screwed through the sheets into the framework, help in positioning each steel shape. These screws can be used to help adjust the steel shapes by lowering or raising them a turn or two. When the shape is properly adjusted, tack the steel to the framework in between the screws and later remove the screws. Fill the joints and screw holes with welding.

Electric arc welding, which I'll discuss later, should be used on large works instead of oxyacetylene. Grind down the welds so that the continuity of the curved surface is not interrupted. Use first a hard disk grinder to

rough the weld down, then use a flexible disk to model the weld to the curved surface. If you grind too low, build the weld up again by rewelding. Your first efforts may be crude, but in time you should be able to fabricate a very good-looking spherical shape.

One further word about putting on the last sheet, after all the surface has been closed in and you may have a bit of a problem: generally, you cannot get a C-clamp in position to squeeze down the metal. Rely on longer sheet metal screws, or press down with a level bar of steel.

Arc-Welding

Arc-welding has many advantages over oxyacetylene welding as well as some disadvantages. The greatest advantage is that heavy gauge steel and steel plate can be welded in a fraction of the time and cost that they could with oxyacetylene. Another advantage of arc-welding is that there is a minimum of metal distortion because there is little or no preheating required. This is ideal for fabricating an egg form as described before. The only disadvantage of arc-welding is that cutting cannot be done with arc, although someday, I believe, that will be possible.

174. Ground clamp.

Arc-welding utilizes a current of electricity which runs around a complete circuit. This current melts off the tip of the rod or electrode and creates the weld. Electrodes are steel rods which are flux-coated and are generally shorter than the welding rods for oxyacetylene. There are no pressurized tanks for arc-welding. A transformer, covered with a metal box having two heavy electrical hoses, is called the electric welder. One hose is a ground clamp and is clamped directly to the work, or to a metal table holding the work, and the other is the electrode holder.

There is a turn-on switch on the front surface of the welder. In addition, there are inserts to receive the electric hoses (or lines). Some electrical welders have four inserts, one set for a high amperage output, and another set for low amperage. Other welders may have as many as twelve inserts for the electric hoses which offer a varied combination of amperage power. Most welders, however, have a handle which can be revolved to control a sliding arrow which sets the amperage desired. Thus, you can set the voltage at 100 amps, or 150 amps, and so on. Most welding for sculpture utilizes amperage between 100 amps and 175 amps. Amperages above 175 would be

used on solid sections of iron and steel such as railroad tracks, or solid 3″ diameter bars.

It is important that an electric welding helmet is used for arc-welding. Do not use goggles for arc-welding. The dark glass in oxyacetylene goggles will not protect your eyes from the ultraviolet rays of the electric sparks. In addition, you can receive severe skin burns on your face without proper protection. The entire body must also be protected by work clothes and a welding apron, as well as welding gloves.

After the ground clamp has been attached to the metal sculpture or 'metal table, turn on the switch of the welder. A fan in the rear of the welder will go into operation to keep the welder cool. Pull your welding helmet down and strike an arc with the electrode in the holder. This action is similar to striking a match. By sliding or scratching the electrode tip against the metal, you will cause an electrical arc to jump from the tip to the metal. Keep the electrode tip about ⅛″ from the metal. This will take practice. The tip of the electrode will melt away, making the electrode shorter; therefore, the electrode must be sent downward and forward to make the weld. A half circular movement is made with the electrode tip. This movement must be made regularly, leaving an even-rippled look on the finished weld.

A hard glasslike flux will cover the finished weld and must be chipped off. Use a chipping hammer (supplied by welding companies) to remove the flux. Cover your eyes with working goggles because the hard flux flies in all directions when struck. Wire-brushing also helps to remove the remaining flux. Do not weld over flux-covered welds. Always remove the flux before rewelding.

Never have anyone watch you while you are arc-welding. Their eyes can become damaged by ultraviolet rays. The welding area must be covered with a heavy asbestos curtain to protect bystanders from even reflections from the electric arc. When the electrode is melted down to 2″ or less, a new electrode must be inserted into the holder. The flux will let off many fumes which must be eliminated with an industrial window fan.

Types of Electric Welders

There are various types of electric welders on the market, but two basic categories concern us here. There is the AC welder, called "straight-stick welder," and the AC/DC combination welder.

It would be best to purchase an electric arc welder with an AC and DC capacity. The higher cost of this kind of machine over an AC welder is offset later if you intend to use a heli-arc air-cooled attachment. Heli-arc is a system that uses an inert gas such as helium or argon to protect the welds. Although the heli-arc attachment is air-cooled instead of water-cooled, most sculpture (other than aluminum), even of large dimensions, can be welded

with this limitation. To use a heli-arc attachment, the electric welder must have the DC current capacity. The heli-arc attachment consists of the regulator for the helium or argon gas tank, an electric cable, hose, and welding gun. If you intend to weld mostly stainless steel or nonferrous metals such as aluminum on a large scale, look into the water-cooled unit. You will, of course, make superb welds with this welding machine. It is one of my principles, however, not to invest heavily in large expensive machinery if it can be avoided. This is why I favor the air-cooled system, which is an attachment to the AC/DC welder. Large machinery takes up valuable floor space and should be used often and kept in good repair. The sculptor's development is often very changeable, and you may find that you no longer need the large machines you purchased. You could resell your equipment, but try to buy machinery which is flexible and adaptable to many situations. There are situations when a large machine is absolutely necessary, but use your judgment in these matters. The costs of maintaining and operating large machines are high, especially for the water-cooled heli-arc welder. The gases for heli-arc welding have doubled in price recently, as have all pressurized gases.

The technique of heli-arc is a combination of arc and oxyacetylene welding. An arc is struck in the same way as it is in straight-stick welding, but a flow of argon or helium gas surrounds the arc, protecting it from the air and environment. The flow of gas is controlled with a lever attached to the welding gun. In the case of the water-cooled system, a foot rheostat controls the amperage to be used. The inert gas surrounding the arc keeps the weld free of contamination so that the welds are shiny in appearance. For aluminum welding, heli-arc is the best method. The air-cooled attachment system cannot be used for aluminum welding unless a high-frequency unit is also attached. This is an expensive piece of machinery and if you weigh the relative cost factors, it would probably be better to purchase the water-cooled system for aluminum welding. For art departments or art schools, a water-cooled system is preferable because of the various demands made by many art students.

Metal Finishing

The term "metal finishing" in industry has a specific meaning which has to do with the preparation of metal for polishing and plating. In sculpture, this term is more general in its application and may or may not have anything to do with polishing or plating. "Finish" in sculpture means *appropriate surface to the form or idea.* An "unfinished" marble slave figure by Michelangelo is as finished as a polished bronze sculpture by Brancusi because the surface finish is appropriate to the idea of the artist. In the former case, textured and rough surfaces are in harmony with Michelangelo's inter-

175. "Formation III" by author. Chrome-plated steel, 1966 —39″ × 22″. A nickel silver-plated work. *Photo by William Brevoort.*

est in violent movement, or what is referred to as "contrapposto." Brancusi on the other hand found smooth polished surfaces best for expressing his interest in geometrical forms. In both these cases, the surfaces are appropriate to the forms or ideas.

Today, contemporary sculpture finds itself with an incredible variety of finishes. New chemicals, paints, and materials have made this possible. We will discuss some of the older as well as the newer kinds of finishes. First, however, we will discuss the preparation of metal for polishing. Finishing metal is a whole science in itself. In general, a rough surface is ground so that it becomes smooth and glossy. If you intend to make a polished work, do *not* start with scrap steel unless it is very clean. Start with smooth and even glossy metal. The following is a list of basic materials and machines for grinding and polishing: These can be purchased at metal finishing supply houses included in the list of suppliers at the end of the book.

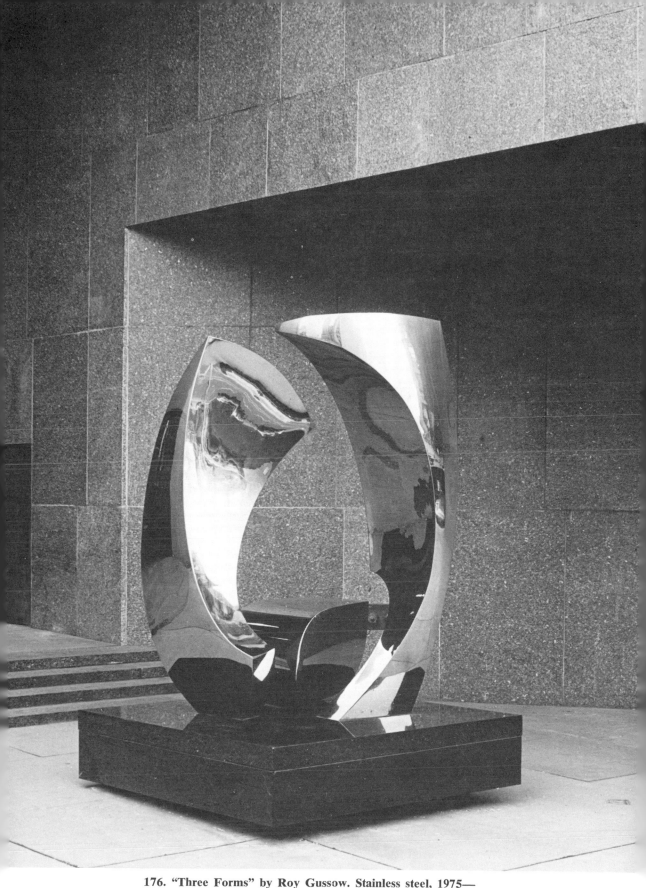

**176. "Three Forms" by Roy Gussow. Stainless steel, 1975—
10′ height.** *Manhattan Family Court, photo by Dan Brinzac.*

MACHINE	FUNCTION	REMARKS
Electric high-speed hand grinder—7″ diameter	Grind off welds	Both hard grinding disks and flexible disks can be used. Carborundum wheels can also be used. Wear goggles and face respirator when grinding.
Electric small high-speed grinder (4″ diameter disks)	Smooth out welds and hard-to-get places	Light grinder is easier for control
Flexible shaft grinder (5′ shaft)	Grind surfaces with sewn cotton wheels of 6″ diameter	Carborundum grit is glued to cotton wheels with fish or horse glue applied hot. Double boiler is used to melt glue.
Electric buffers and polishers	Grinding, buffing, polishing small parts	Small work is held in hand and pressed against stationary buffing wheel.

High Polish or "Bright" (Mirror Surface)

Metal must be ground with soft sewn cotton wheels glued with Carborundum grit starting usually with No. 60. (Higher numbers are finer grits.) All scratches must be ground away and a finer grit, No. 80 or No. 100, is used on a new wheel to grind away the No. 60 grit surface. This process is repeated until No. 220 grit is reached. Each grit must be sequentially finer (No. 80, No. 100, No. 120, No. 150, No. 180, No. 220). After No. 220, use either jewelers' rouge, chrome compound, or copper compound in brick form. Compounds are spread on the surface of the clean cotton wheel while it is in motion. Then press the cotton wheel to the surface of the metal, using long parallel strokes. The surface will become reflective. Copper, brass, bronze, chrome, and high-grade steel will become mirrorlike.

For chrome plating, this entire process, eliminating only the last step of compounds, is necessary. There are other complications with chrome plating, because the metal is submerged in tanks of solution during the plating process. A sculpture which is fully enclosed will float and cannot be plated; therefore openings must be provided to allow the sculpture to sink and then to drain out again when raised. On welded sculpture, it is imperative that welded seams be perfect—otherwise the solution will leak through and cause discoloration. The solution can even break open a seam if it is not welded strongly enough. On large or heavy works, a clamping device must be provided to allow a chain hoist to submerge and raise the sculpture from

the tank. This is usually done underneath the work where the surface is not visible.

Plating is usually done in three steps. First, a coating of copper is electroplated to the metal and polished. Then a coat of nickel silver is electroplated and polished, and lastly, chrome or hard chrome is electroplated and polished. On a complicated sculpture with many angles, the last step of chrome plating may not be possible. Platers have explained to me that the chrome does not "throw" into the deep corners, so you may have to decide to stay with only the nickel silver surface, which is quite beautiful in itself. Nickel silver, however, will tarnish and you must keep it polished, or have it clear-lacquered or enameled, sprayed, and baked.

Stainless steel sculpture can be polished as described above and will come up to a beautiful bright mirrorlike surface and need not be plated. Grinding and polishing stainless steel, however, is much more difficult and tedious than grinding any other metal. Use polished sheet stainless steel to begin with and keep surfaces covered with heavy paper. Manufacturers of polished sheet steel usually have paper glued to surfaces which can be peeled off. Remove paper where you intend to weld to avoid burning and

177. "Forged Form" by William Nettleship. Forged steel plate with nickel plate. *Photo by the artist.*

discoloration on the metal surface. The welding should be done with heli-arc welding to avoid spattering of flux or contamination of the weld, which can ruin the stainless steel surface. There is also less grinding with heli-arc because the weld can be melted in flat to the surface of the metal. Carefully grind down the weld with either the light hand grinder or the flexible shaft grinder with the cotton wheels. The welded edge must go through all the grits until you arrive at the bright, mirrorlike surface of the sheet. Chrome compound will work well on stainless steel. The chrome compound is a white brick and works well on bronze and brass as well.

Blacksmith Oil Finish

Scrap steel or rusted metal can be finished with a "blacksmith" finish. Excessive rust should be wire-brushed off first. Heat the metal with the oxyacetylene torch until it becomes dark or almost black, not red. Paint motor oil on the blackened surface with a throwaway brush. The oil will burn and smoke. Be sure to use exhaust fans to remove fumes. Apply more flame until the oil is completely burned off and the surface looks dry. Go over the entire sculpture in this manner repeating this process two or three times until a fairly even blackness is achieved. Absolute black color evenness is impossible, but after the metal has cooled, black shoe polish or Butcher's Wax can be applied and rubbed. A rich warm surface is achieved with the burned oil, creating a slight film on the surface of the metal. The burned oil becomes oxidized and helps protect the metal from further rust unless it is left out of doors all year round.

Brazed Surfaces

In the section on soldering and brazing, I mentioned that brazing has been used to cover the surfaces of sculpture. A surface not unlike a cast bronze surface can be achieved with bronze or brass brazing. This is a long and tedious process, but a surface of extraordinary richness can be developed. On large surfaces, use flux-coated bronze or brass rods on a fluxing attachment to the oxyacetylene lines. This will make the work easier and cleaner. A heli-arc welder can also be used for brazing. Spools of brass, bronze, or nickel silver wire can be brazed in this manner, eliminating the necessity of stopping and starting. Remember that the metal must be brought only to a dull red appearance for brazing to take place. As the job is almost completed, you will notice that more heat is required to braze. This is because the already brazed surfaces are conducting heat throughout the surface. The completed brazed surface can be wire-brushed or ground with a hand grinder. Roszak ground down brazed surfaces to achieve light-catching flat pellets. Lipton left the brazed surfaces as "modeled" surfaces.

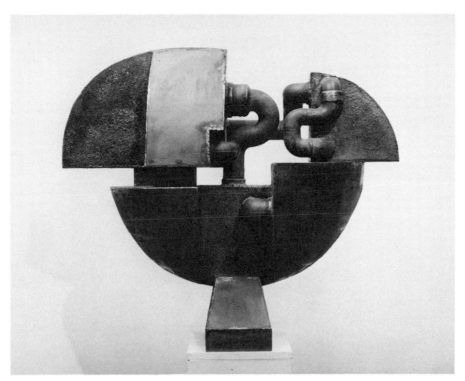

178. "Spherical Division I" by author. Welded steel, 1966. Use of blacksmith oil finish. *Collection Whitney Museum.*

179. "Sea Form" by author. Hammered and welded copper, 1959—18″ × 24″. Copper sections were brazed together with brass rod.

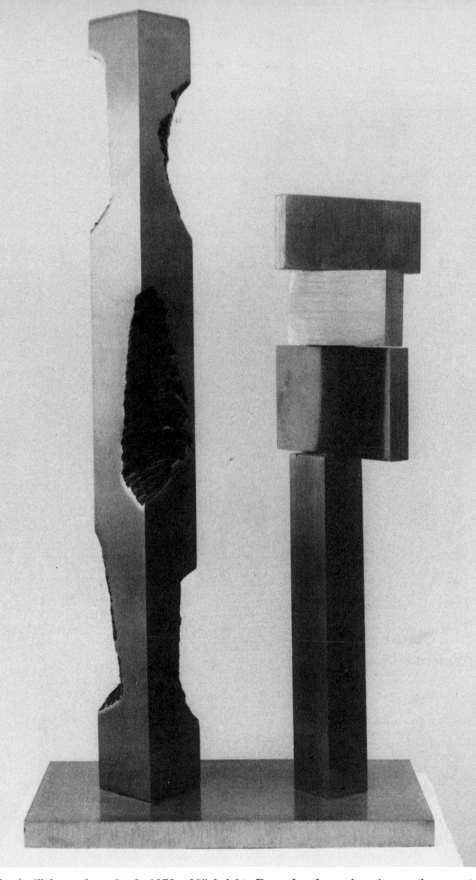

180. "Sentinel" by author. Steel, 1973—20″ height. Example of gouging tip creating serrated surfaces.

Brazing over steel will not ensure waterproofing if the sculpture is left out of doors. The steel will rust through hundreds of pin holes not possible to cover with brazing. For out-of-door sculpture, use Monel, brass, copper, or any nonferrous metal to begin with, except aluminum. If the entire sculpture is made of nonferrous metal both in the underneath structure and brazed surface, it will assume a patina similar to that on bronze cast sculpture. Caution must be exercised when brazing because fumes can make you sick. A well-ventilated studio with an exhaust fan is necessary. If the studio fills up with fumes, wait until the fan has cleared the air, or install a stronger fan. Working directly under a vent is best. See the soldering and brazing sections.

Cut Surfaces

The cutting torch can be used on steel to create textures. Narrow slices through the steel can create a lacelike effect. As mentioned before, a gouging tip can be used on the cutting torch. Long shallow or deep channels can be gouged out with this tip as well as other kinds of textured surface.

The blacksmith finish looks particularly well on this kind of surface. Other finishes can be achieved with power grinders such as the flexible disk which David Smith utilized. The disk will create a swirl effect which on stainless steel or aluminum destroys the flatness of the surface, giving it an illusion of depth. Sometimes this is not desirable because the texture tends to break up the solidity of the surface too much. The cotton wheel imbedded with Carborundum grit gives a pleasant soft-brushed or satin finish which is especially beautiful on brass, copper, and aluminum.

Hammered Surfaces

Hammering with a ball peen hammer gives a beautiful texture and was popularly used on copper and lead. Saul Baizerman did most of his sculpture by hammering out figures in copper and lead. This technique is both a sculpturing technique and a finishing process. He worked on asphaltum pitch surfaces so that the copper or lead could stretch. The asphaltum surface is made of pitch, tallow, and plaster of paris, the last two ingredients being added to the pitch when it is heated for melting. The pitch is then reheated and poured into a framework suitable for the size of metal to be hammered, or as is commonly called repoussé. The metal is worked from behind first. The thickness of the metal and the desired relief projection are crucial to the hammering process. Thin hard metal cannot be pounded into high relief without danger of cracking. The metal must also be annealed, that is, heated, to allow the metal to soften. The front of the sheet is placed upon the pitch and the hammering is accomplished from behind when the

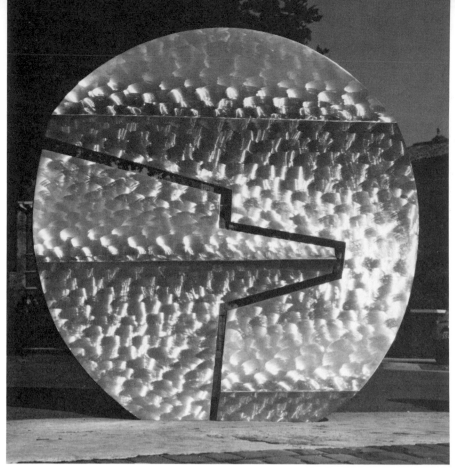

**181. "Disco" by Peter Chinni. Stainless steel, 1973—5′.
The light-catching rhythms were created with a metal
sanding disk.** *Photo by Raffaele Baldi.*

pitch has cooled. A little talc will help prevent excessive sticking to the
pitch. The sheet is then turned over and the back is placed down on the
pitch to allow working the relief from the front. Turpentine and kerosene
are used to clean off the pitch.

Sandbags are also used to hammer metal on, but this can become un-
wieldy on a large sheet. A strong wooden framework can also be used to
frame a sheet of metal. You must firmly sandwich the metal all around by
clamping it between two frames of wood. Hammering on this kind of sur-
face, however, can be deafening and your ears must be protected with
earplugs or airfield earmuffs. Constant hammering causes the metal to be-
come brittle and rigid. Annealing softens the metal by relieving the stresses
in the metal, thus hammering can resume. Copper should be heated until a
dark or rainbow color appears. Lead should not be heated excessively as it
has a low melting point and gives off toxic fumes. The malleability of lead
allows a much lower temperature for annealing to be effective. Lead has lit-
tle tensile or ductile strength and too much heat can cause it to collapse.
Malleability has to do with the property of stretching and shaping, while
tensile strength or durability has to do with the ability of the metal to sup-

port itself when projected into space. Thin lead wire has little tensile strength but high malleability, while steel wire has high tensile strength but low malleability. Aluminum can also be used for repoussé sculpture, but be sure to buy a soft alloy, not a hardened sheet. Steel, brass, bronze, and Monel sheet can also be hammered, but all these have a high percentage of ductility. The harder the metal, the more often annealing is necessary. Sheet lead for this reason has been most popular for hammered sculpture. Lead can be hammered into forms completely in the round, and large pieces can be filled inside with materials such as reinforced polyester resin (fiber glass) or with cement if weight is desired. José de Creeft hammered some superb over-life-size heads from sheet lead. Saul Baizerman hammered marvelous figures in very high relief and in the round from sheet copper and lead. The peening method, in which one hammers with the ball or chisel-shaped end of the hammer head opposite the face, leaves a beautiful texture on the metal which reflects light and gives vitality to the forms.

Baizerman solved an old problem of bas-relief most successfully. Previously, most bas-reliefs, whether used for architectural purposes, or for coins, plaques, etc., seemed to me artificial. Figures seemed cut out and glued to a background. The relationship of figure space and surrounding space in most cases was too arbitrary. The Renaissance sculptors such as Ghiberti and Donatello introduced illusionistic (perspective) space into their bas-reliefs. This innovation, however technically brilliant, seems to me a misuse of sculptural bas-relief. A painted illusion on canvas is very different from a sculpted illusion in bronze or stone. The surface of a painting does not intrude with illusionistic rendering, whereas the surface of marble or bronze, even if only a few inches deep, is always vividly apparent. There is a dichotomy or misuse of the material in sculpture when rendering landscapes, cityscapes, etc. In painting, color and value, independent of perspective, can render deep space, but this is not true of the sculptural mediums. When applied to architecture, bas-reliefs depicting deep space create a "hole" through the facade. One of the great achievements of Indian art during the Vedic Age (200–700 B.C.), and afterward in the Age of Buddhism (500 B.C.–300 A.D.), was the ability of the architect and sculptor to create monuments of simplicity and power. Sculptors adorned the outer facades, creating a rich surface of light and dark, yet the whole of the architecture was kept intact. A sculpted perspective rendering would not even be seen in such a monument. Baizerman was closer to the Buddhist sculptors in his use of bas-relief than he was to the Renaissance, however much he loved the human figure. It is also interesting to note that Rodin avoided perspective in his "Gates of Hell," preferring to let the figures become enveloped in an amorphous background of abstract form. Michelangelo, in a letter to Benedetto Varchi states: "I say that painting seems the better to me the more it tends toward RILIÈVO, and RILIÈVO appears the poorer the

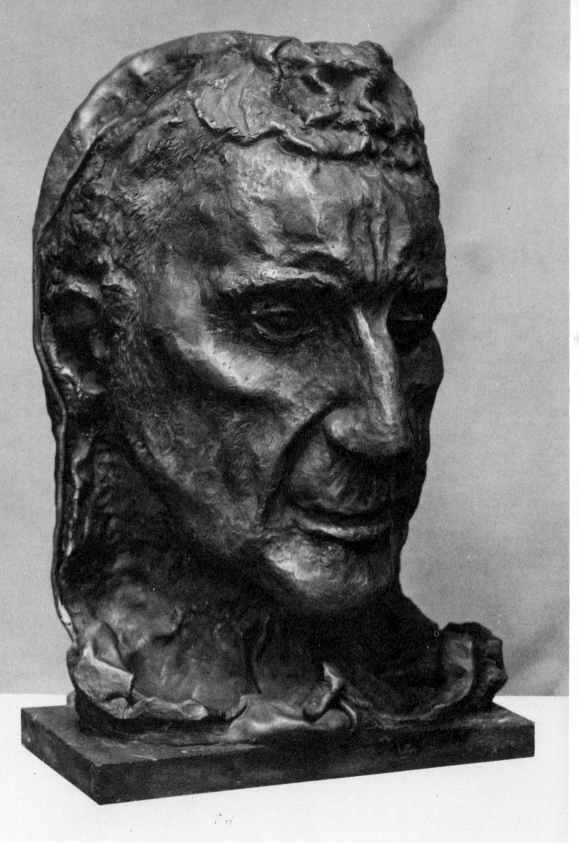

182. "Renaissance" by José de Creeft. Beaten lead, 1974—20″ height × 9″ width. High degree of realism is achieved with this beaten lead sculpture. *Courtesy Kennedy Galleries, Inc. Photo by Taylor & Dull, Inc.*

more it approaches painting."* Bas-relief means to raise from a low surface, and when this feeling of unity between background and figure is achieved, the sculptor has expressed the true character of bas-relief.

Forming Metal

In my experience with forming metal, I have used and have seen several power machines which can shape heavy-gauge steel into many forms from machine casings to metal bowls. This is a versatile piece of equipment. One of these machines is the trip-hammer. The trip-hammer was used a generation ago by blacksmiths, metal forging companies, and related industries for many types of operations. Trip-hammers come in various sizes and capacities and are measured in terms of ton force. A five-ton hammer means one which has the capacity of five tons of striking power. The jaws on a trip-hammer are supplied with a male and female die for making bowl shapes. Drop forgings can also be done on a trip-hammer with a die made to reproduce some object such as a particular piece of machinery. This, however, is not practical for a sculptor, because drop forging is essentially a stamping technique used for reproduction.

The pneumatic hammer powered either by electricity or an air compressor can also be used for forming shapes in sculpture. Simply insert a solid piece of tool steel in the pneumatic handpiece and you have a vibrating hammer. Make sure the tip of the steel has a rounded end like a peen hammer. The metal can be hammered on pitch or in a frame, as described previously. Various hammer head shapes can be made which can be used in the pneumatic handpiece. Be sure that the shaft of the steel shapes fit into the handpiece easily. You can make your own by hammering steel shapes with the welding equipment.

All hammered metals must be heated after a certain amount of hammering has taken place. Metal becomes stiff and rigid, and built-in stresses are created through hammering which must be relieved through annealing. Copper, brass, and steel should be heated until dull red. Great care must be taken with lead, aluminum, and silver because these metals melt at a low temperature. These metals should not be heated until dull red and would in fact collapse before such a temperature was reached. One test of readiness for these metals is to rub the heated surface with softwood. Pine, for example, will burn when the metal is hot enough. For annealing lead and silver, use propane gas instead of oxyacetylene because the lower temperature of propane burning is safer. Take a scrap piece of lead or silver and heat it until it melts. A large sheet, of course, would not melt so quickly, but you will get an idea of how the metal behaves.

Many cooking utensils in the restaurant business such as pans, pots, and other vessels, are made through spinning. A flat sheet of metal is mounted

* Charles de Tolnay, *Michelangelo* (Princeton University Press, 1943).

183. Deep throat hammer.

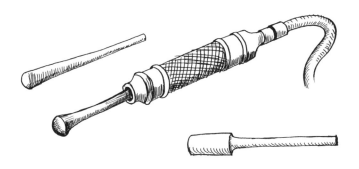

184. Pneumatic handpiece.

onto a motorized revolving arm, and while the metal is spinning, pressure is applied with a wooden form to shape the metal. Tank heads for large oil storage tanks are also made this way and the steel is shaped cold in sizes up to 31′ diameter. These shapes can be made upon order and make wonderful forms for welded sculpture. These tank-head shapes can be ordered from an illustrated catalog. The Brighton Corporation of Ohio makes large tank heads. Metal spinning on a smaller scale is done in New York and New Jersey and other industrial cities.

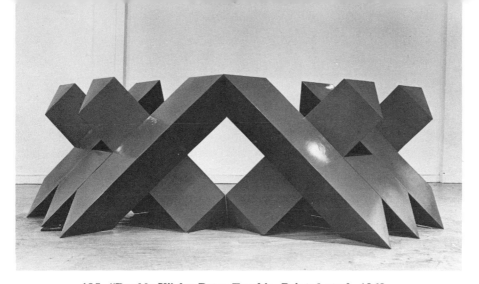

185. "Double-X" by Peter Forakis. Painted steel, 1968—5'8" × 10' × 10'. Module sculpture employs color successfully. *Courtesy Sculpture Now, Inc.*

Painted Metal Sculpture

The popular use of steel for out-of-door sculpture necessitated the use of paint as a preservative for sculpture, but it is also an enhancement to its aesthetic quality. There are many industrial paints available today such as the plastics (epoxy, acrylic, ployurethane, and polyesters) and the latexes, flat enamels, glossy enamels, and lacquers. All these paints can be brushed, rolled, or sprayed, and some, like the enamels, can also be baked onto a surface.* Paints work best when a proper preparation ground is first applied, but there must be compatibility between ground and final coat. This is especially crucial for out-of-door sculpture where the elements of weather can be hazardous in their effect on the sculpture.

The best paints for large out-of-door sculpture are the plastics, such as epoxy and polyester. Marine supply stores carry these paints in a wide assortment of colors, and they are expensive. Epoxy paints are available in most good paint stores. I've found that Rustoleum red paint makes an excellent ground for epoxy paint. Rustoleum is used as a preparation on iron and steel gates, railings, bridges, etc. The paint is made of iron oxide, and fish oil is used as the carrying vehicle. I've had several sculptures last well over five years out of doors and close to ten with this formula.

Baked enamels are also very good and have a life expectancy of three to seven years. The enameled metal is placed in a heating oven reaching temperatures of 300 to 400 degrees. Infrared lamps are also used to bake paints over metal. Many automobile body repair shops use rows of infrared lamp heat to bake and dry painted surfaces. High-temperature baked enamel (used on old bathtubs, sinks, basins, etc.) makes a very durable surface.

Lacquers are very beautiful and are the best for spraying and for achiev-

* Du Pont has recently developed a sprayed and baked technique called Imron. Imron refers to both the paint and the technique.

ing color blending or "feather edging." Lacquers can also be somewhat transparent. It is important to prepare a ground or primer first before spraying lacquer. Grounds are available in automobile supply stores, as is the lacquer. Lacquer can also be brushed on with a soft wide brush. This is difficult to do because lacquer dries quickly and you cannot brush over lacquer without ruining the surface. Japanese lacquer-masters could paint large flat trays in seconds, leaving no brush marks. Spraying is also difficult because lacquer as well as enamel can run, leaving streaks on the surface. Practice spraying it on large scrap steel sheets first. The distance of the spray gun from the surface, the speed over the surface, the pressure used, and the nozzle opening of the spray gun are the crucial elements for successful spraying. The surface should look wet when spraying.

I do not recommend using latex on metal. Latex is excellent for the more porous and absorbent materials such as wood, plaster, and cement. It can also be used as a primer ground on these materials for oil-based paints and plastic paints. For cement, however, masonry paint is best, especially when fine sand is added.

The newer paints such as the clear polyurethanes that are sold under various trade names are excellent for wood. Varnishes such as Valspar protect wood outside. There are also other protective coatings for wood which was discussed in the chapter on wood.

Color in Sculpture

Historically, painted polychromed sculpture has existed for centuries. Prehistoric man and early civilizations such as the Egyptians and Greeks painted their sculpture as well as their architecture. There is no doubt that color or hue greatly changes a sculpture when its natural material is covered over. Fortunately, the paint on Egyptian and Greek sculpture has worn off over the centuries. There is nothing more beautiful than marble, granite, or basalt, and the test of the greatness of this sculpture is exemplified by its being stripped of its colored coating. Modern sculpture will similarly be put to the test, except that unpainted steel will completely rust away in twenty to fifty years, depending on environmental conditions. We are not concerned with permanence today, but color should be used to enhance the meaning of sculpture and not to mask its faults.

Primary colors are used by many sculptors on large steel sculptures. The rich reds, blues, and yellows accent the sculpture and complement the surroundings. Light and shadow fall gently and beautifully over painted surfaces. Mixed color (secondary hues—attained by adding yellow to blue to get green, for example) also works well if handled by a sculptor of sensitivity. I used a spray gun in the early sixties to blend one hue into another on large steel surfaces. Areas can be taped off and sprayed, leaving a hard edge against the soft mixed color areas.

An interplay between three-dimensional form and painted illusionistic form can be created and can add great interest to the work. Form, however, must be of primary importance in sculpture because excessive color manipulation can destroy a three-dimensional harmony. A successful sculpture can be spoiled by the wrong use of color. Some of the best painted sculpture was done with shapes which were already painted. These are called "found objects," and include such objects as car body parts. Dubuffet has utilized painted surfaces in sculpture. Ultimately, sculpture and painting can be very similar since they are only different instruments which play the same kind of music. Many contemporary painters, Willem de Kooning, Ellsworth Kelly, Jules Olitski, and others, have done some fine works in sculpture. David Smith, Theodore Roszak, and Tony Smith, just to mention a few, are also excellent painters, as was Jacques Lipchitz. The art public and critics, however, are more reluctant to accept paintings by sculptors than sculptures by painters. I do not believe that sculptors make worse painters than painters make sculptors. Sculptors who paint generally express qualities that painters do not. Michelangelo is the perfect example of a sculptor who expressed this quality. Even today, Michelangelo's frescoes are criticized for being sculptures in paint. Perhaps this is true, but the vision and greatness of his soul stands today as it did during the sixteenth century.

Installation of Metal Sculpture

A certain amount of engineering ability is necessary to install a metal sculpture on a site. If you do not have this ability, it would be wise to consult a licensed engineer, especially if the work is to be put in a public place. Every installation demands a different solution, but in general, metal sculpture is much lighter than stone, cement, or cast bronze works, and therefore must be bolted down to the site. One of my large works on temporary display near Central Park was blown onto Fifth Avenue during a wind storm even though it weighed two tons. Being a temporary installation, it was not bolted down. It took most of the Parks Department personnel to put it back. Not only can strong winds move a large metal work, they can even destroy it. Aluminum sculptures are particularly susceptible to being damaged by wind. Large works should have a 4' deep reinforced concrete foundation underneath where bolting is possible. Bolts can be predetermined by making a template of plywood or masonite which masks off both the sculpture and its foundation.

There are other methods for securing a sculpture to its site. Male-female slip joints are excellent. A larger inside diameter tube slides over a smaller outside diameter tube in this kind of joint. This method is also used for large works which can be disassembled. There are notch joints which also work very well, and which the Japanese used extensively in wooden beam

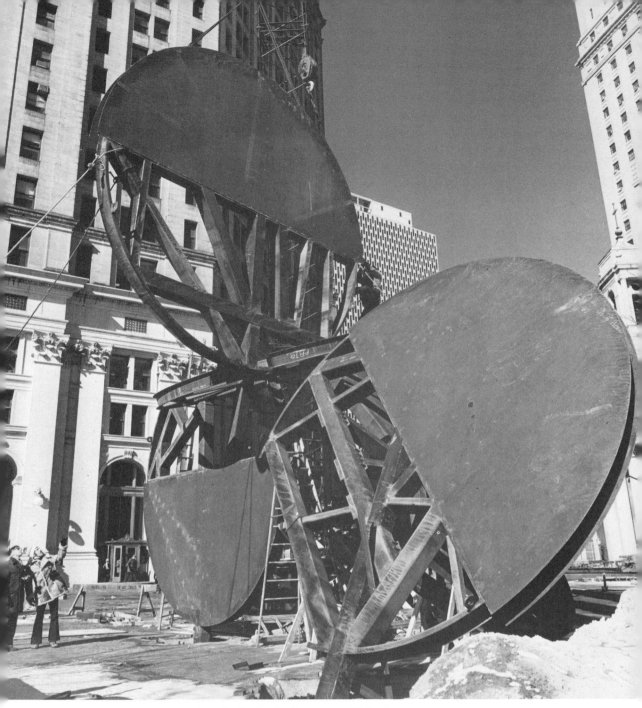

186. "5 in 1" (Police Plaza, Civic Center, New York City) by Tony Rosenthal. Cor-ten steel, 1974—42′ length × 32′ height × 28′ width. This monumental work is being both installed and fabricated onto the site. *Photo by Bethlehem Steel.*

187. *Opposite page.* "Confluence" by Hans Van De Bovenkamp. Brushed aluminum, 1976—40′ height. Forty-foot-tall sculpture was anchored to site by a deep metal column, and twenty tons of concrete. *Photos by Dan Ladely.*

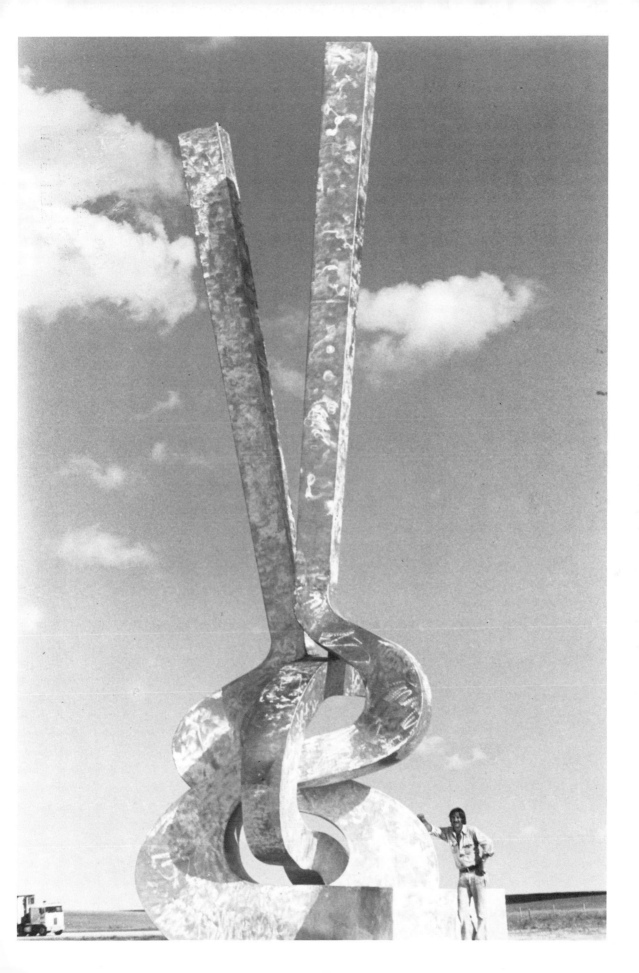

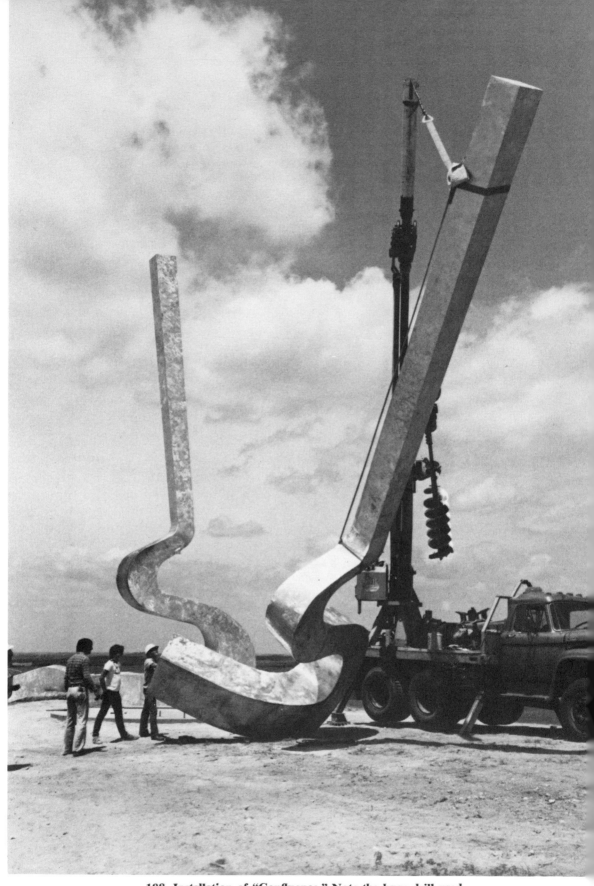

188. Installation of "Confluence." Note the huge drill used for installing underground column.

189. Notching.

construction for their architecture. All these devices must be made accurately because a mistake can cause money to be lost. Joints of any kind should be constructed as part of the sculpture and then later put into place on the site. The welding of joints can cause the metal to become unaligned, and enough tolerance must be available for these joints to work. Too tight a fit is usually not practical. Very tall sculptures should have a rod extending down into the ground for at least one-third of their total length and extending up inside the sculpture for at least one-half their total length. If this is not possible, then the sculpture should be heavily weighted or attached to a great weight. The point here is that wind, even a twenty-mile-per-hour wind, has unbelievable force. Metal sculpture should not be installed on windy days. I've seen many men trying to hold down large sections of sculpture, and this is always hazardous for them as well as for the sculpture. In Nebraska, I installed a forty-ton granite sculpture on a windy day and the wind was able to rock one block of stone weighing twelve tons while it was being lowered with a crane. Had this sculpture been made of metal, it would have been impossible to install the work. The point to all of this is that when sculpture becomes a public work, all precautions for the safety of the public as well as the sculpture must be considered.

It is also a good idea to make a small-scale model of your work and try to work out the mechanics of installation. These are the basic elements of sculpture installation:

1. Sculpture must rest firmly and be anchored to the ground.
2. Anchoring can be in the form of a concrete pad and foundation, or with deeply driven piles made of treated wood, metal, or cement.
3. Sculpture must be attached to the concrete foundation or piles with bolts, slip joints, or any acceptable joint approved by a consulting engineer.
4. Assemblage of sculpture on the site should not be dangerous to workmen or spectators.
5. Proper equipment such as cranes, forklifts, etc., should be handled by experts.
6. Assemblage of sculpture in close quarters, such as a courtyard or a city square, should be planned in advance to protect property as well as sculpture.
7. Final installation should result in a work that cannot be blown away or destroyed by strong winds.

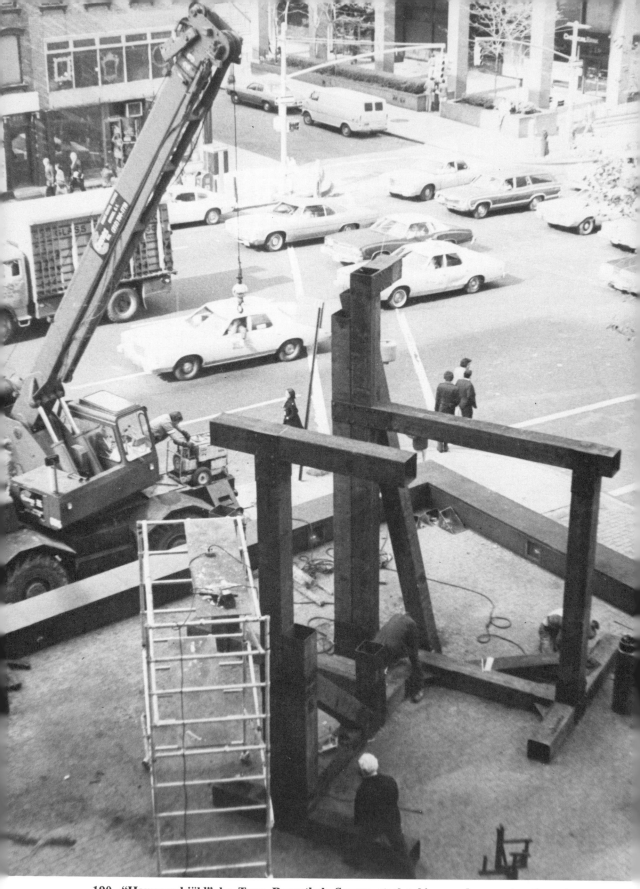

190. "Hammarskjöld" by Tony Rosenthal. Square steel tubing, under construction at Dag Hammarskjöld Plaza, New York. Rosenthal utilizes notching and bolting to assemble large out-of-door sculpture. *Photo by artist.*

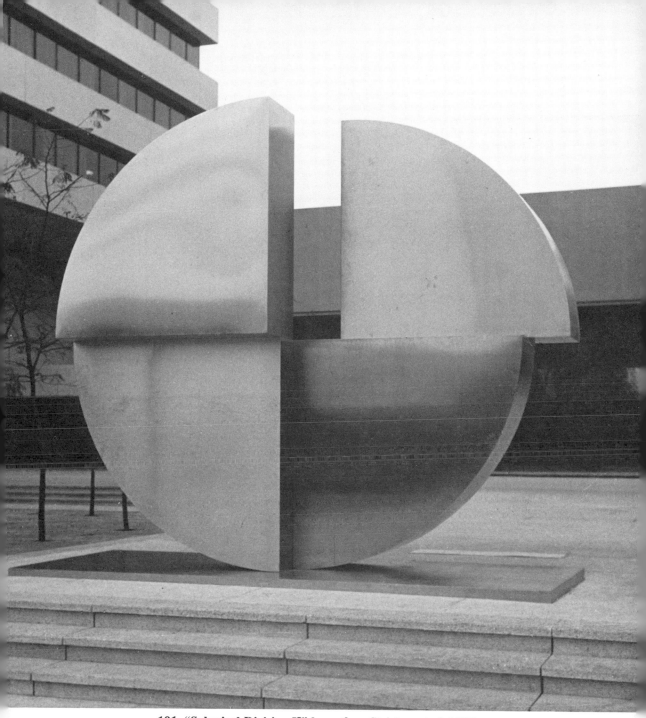

**191. "Spherical Division II" by author. Stainless steel, 1975
—13′ diameter. Path Transportation Building, Jersey City,
New Jersey. Large stainless steel sculpture is tangent to
its site by use of two square columns welded to under-
ground railroad stations at Journal Square, Jersey City.**
Photo by Lou Sgroi.

GALLERY OF METAL SCULPTURE

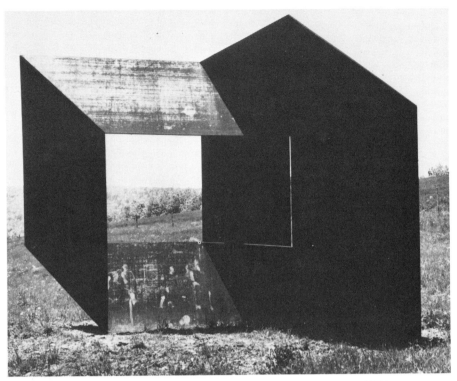

**192. "Troika" by Charles Ginnever. Cor-ten steel, 1976
—13′ × 6′ × 20′.** *Courtesy Sculpture Now, Inc.*

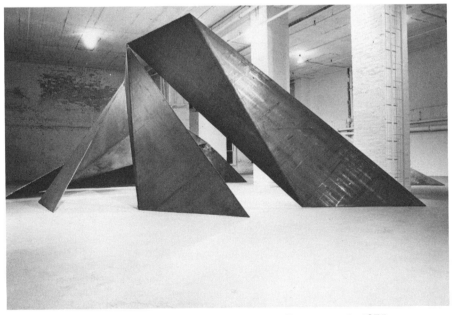

**193. "Daedalus" by Charles Ginnever. Cor-ten steel, 1975
—10′8″ × 30′ × 21′.** *Photo by Max Hutchinson, courtesy
Sculpture Now, Inc.*

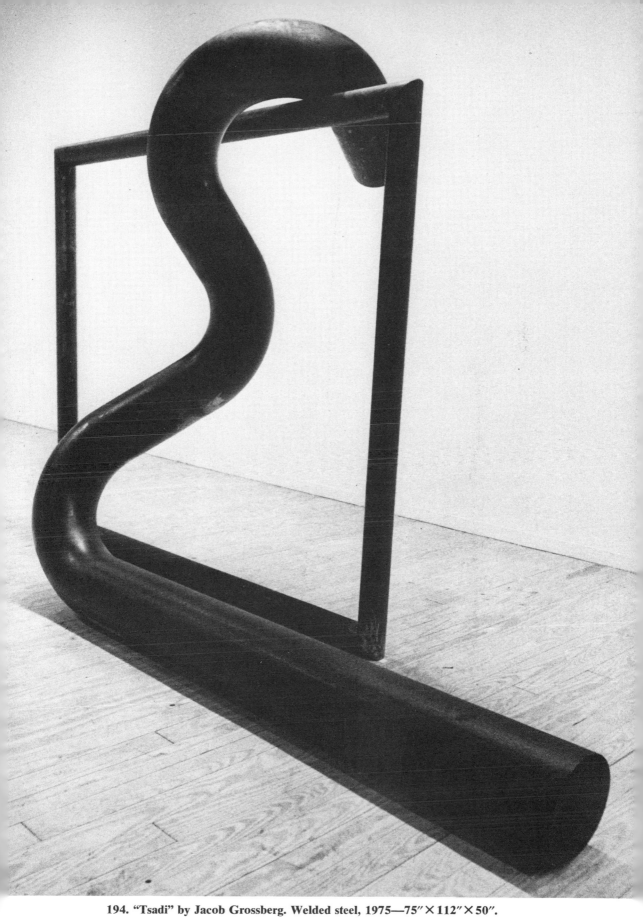

194. "Tsadi" by Jacob Grossberg. Welded steel, 1975—75″×112″×50″.
Photo by Max Hutchinson, courtesy Sculpture Now, Inc.

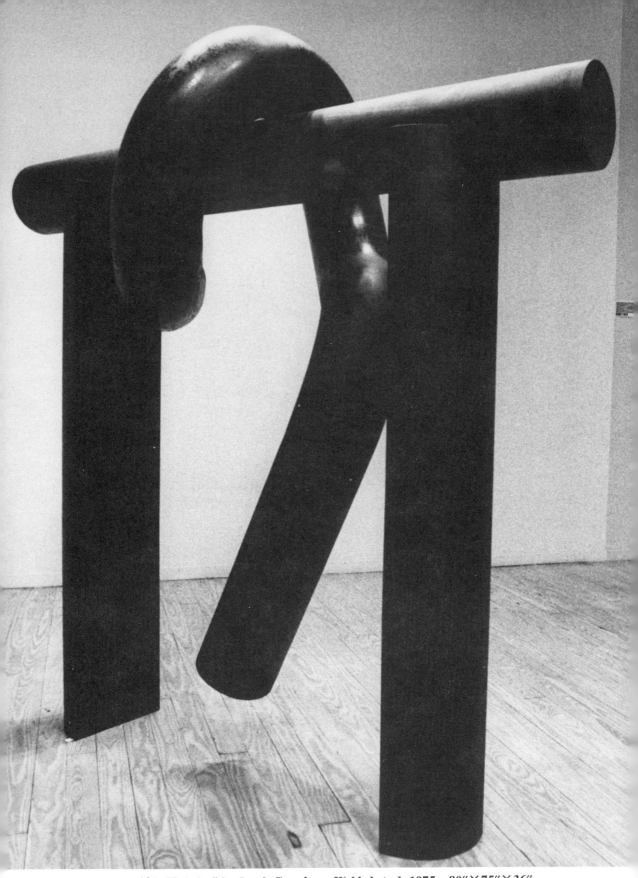

195. "Solstice" by Jacob Grossberg. Welded steel, 1975—80″×75″×36″.
Photo by Max Hutchinson, courtesy Sculpture Now, Inc.

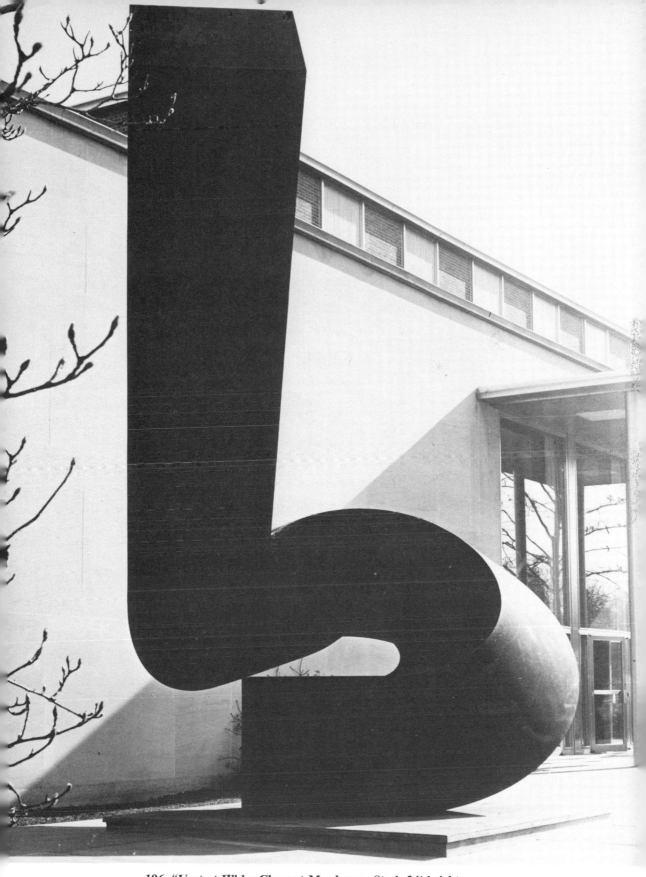

196. "Upstart II" by Clement Meadmore. Steel, 24′ height.
Collection Princeton University. Photo by artist.

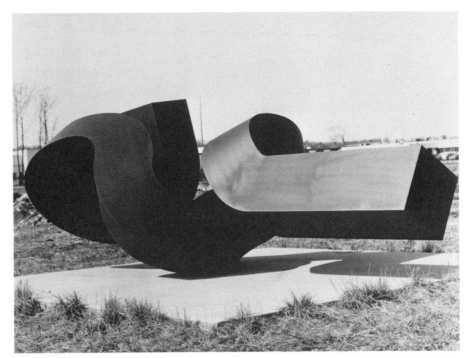

197. "Out of There" by Clement Meadmore. Aluminum, 1974—6′6″ × 9′6″ × 16′8″. *Photo by artist.*

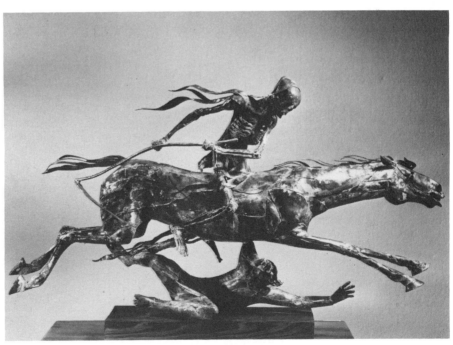

199. "Apocalyptic Rider" by Nina Winkel. Copper, 1963— 20″ × 32″ × 9″. *Photo by Otto E. Nelson, courtesy Sculpture Center.*

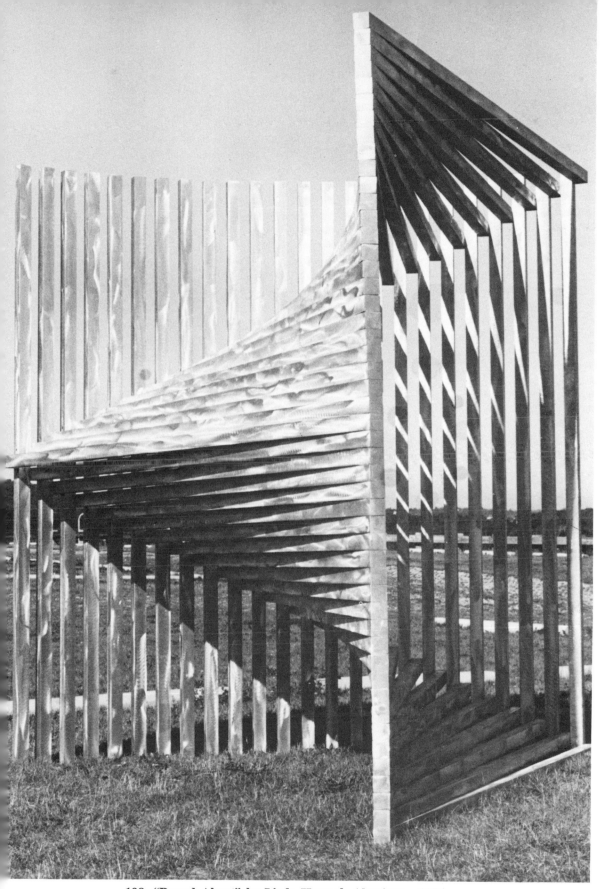

198. "Round About" by Linda Howard. Aluminum, 1976—
8′×8′×8′. *Photo by artist, courtesy Sculpture Now, Inc.*

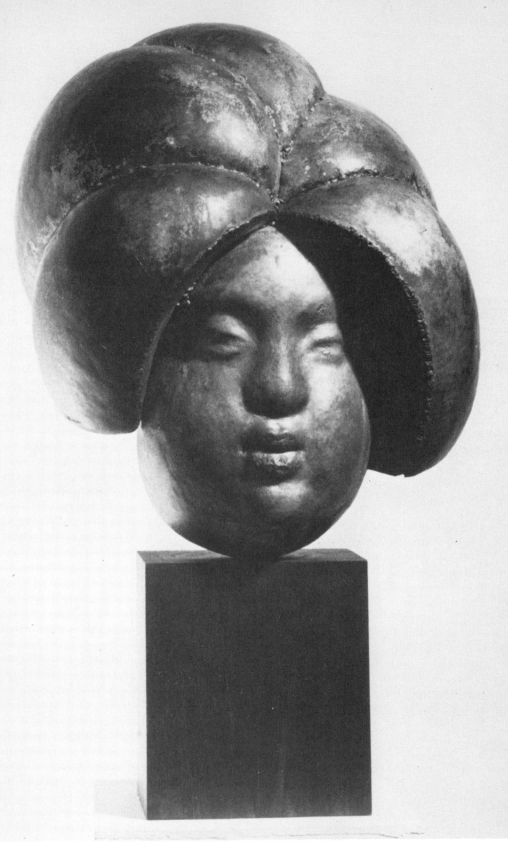

200. "Kwan Yin III" by Juan Nickford. Hammered and welded copper—30″ height. *Photo by Jene Nickford.*

201. "Mooring" by Harvey Weiss. Welded brass, stainless steel cable, 1975—28″ × 27″ × 19″ and 17″ × 15″ × 10″. *Photo by artist.*

202. "Highway" by Helen Beling. Cor-ten steel—72″ height ×50″ width×12½″ diameter. *Photo by artist.*

**203. "Morning Sun" by Jean Woodham. Welded bronze—
5′×5′.** *Commissioned by General Electric Credit Corp.,
photo by Scott D'Arazien.*

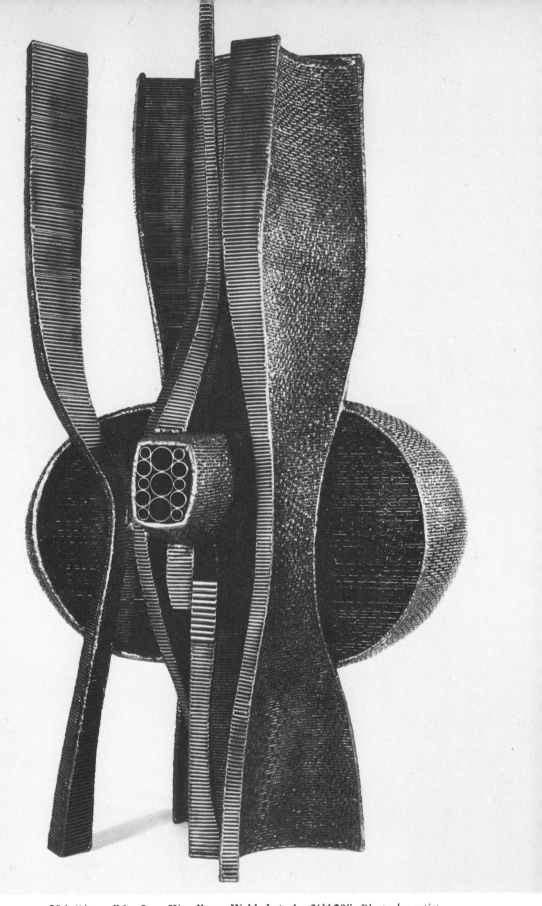

204. "Argus" by Jean Woodham. Welded steel—3′ × 20″. *Photo by artist.*

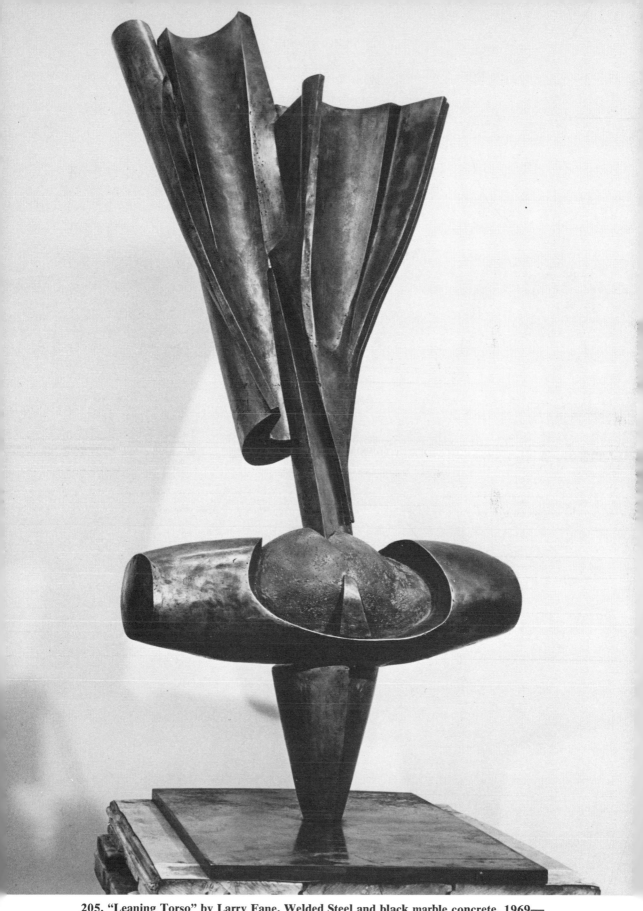

**205. "Leaning Torso" by Larry Fane. Welded Steel and black marble concrete, 1969—
62″×29″.** *Collection De Cordova Museum, photo by artist.*

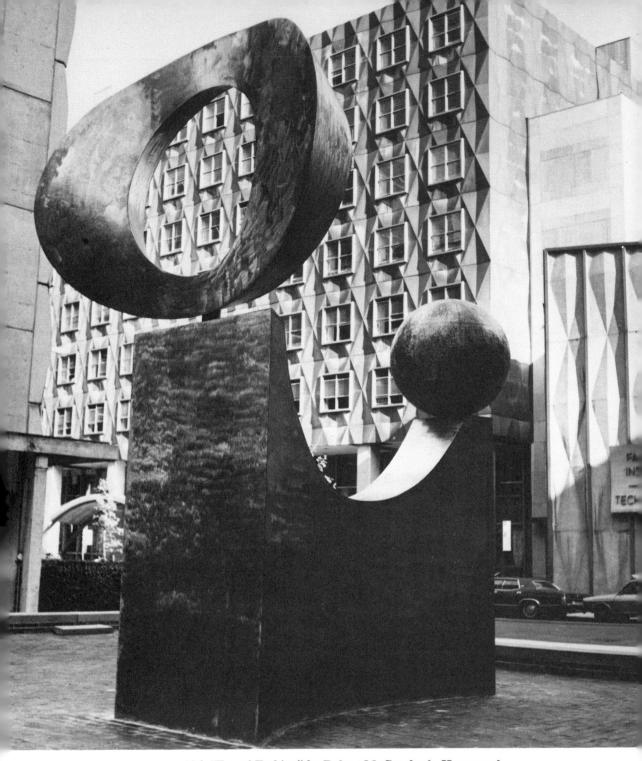

206. "Eye of Fashion" by Robert M. Cronbach. Hammered and rolled sheet brass, 1976—18′ × 12″ × 11″. *Photo by Martine Gilchrist.*

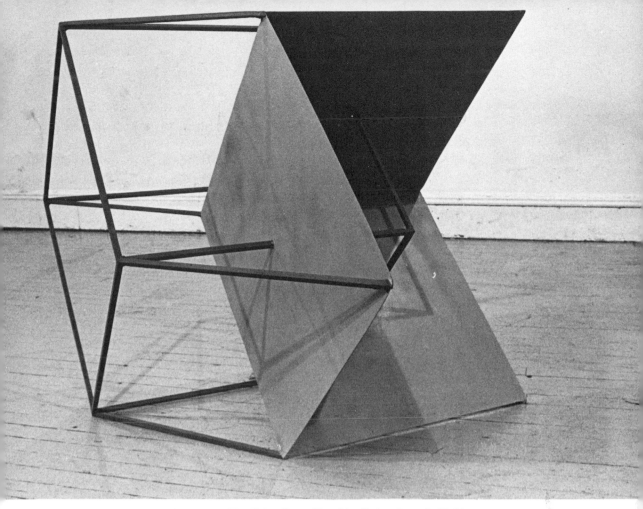

207. "Mock Two" by Peter Forakis. Painted steel, 1966—
3′×3′×3′. *Courtesy Sculpture Now, Inc.*

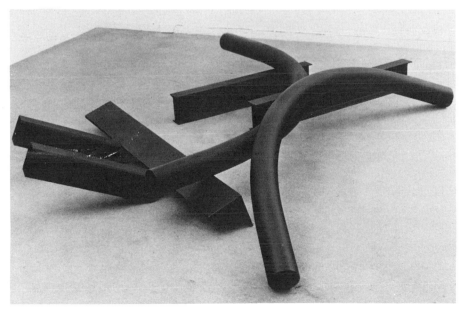

208. "Two Sweeps" by Brian Wall. Painted steel, 1975—
2′×8′×12′. *Courtesy Sculpture Now, Inc.*

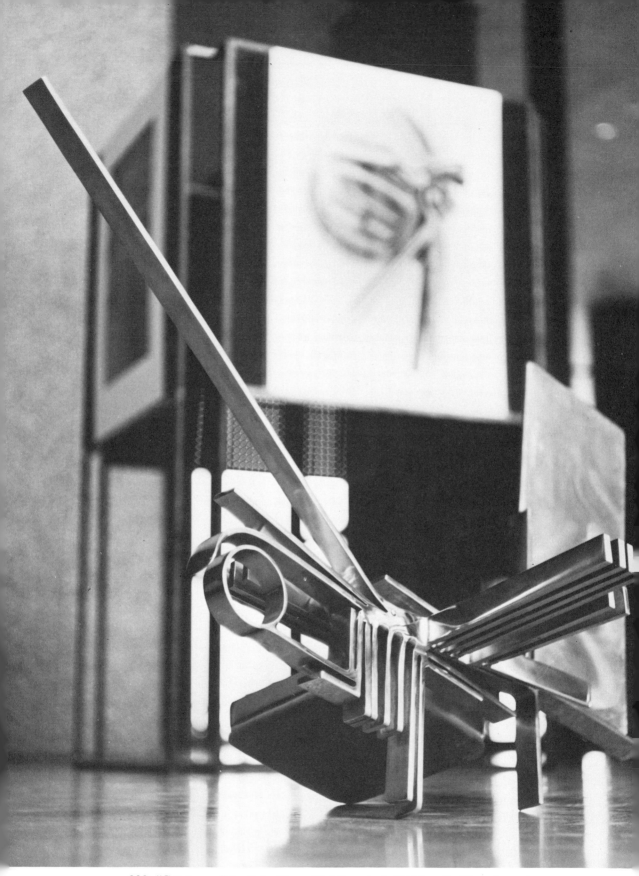

209. "Crustacean" by Zeke Ziner. Stainless steel, 4½′ length. *Photo by artist.*

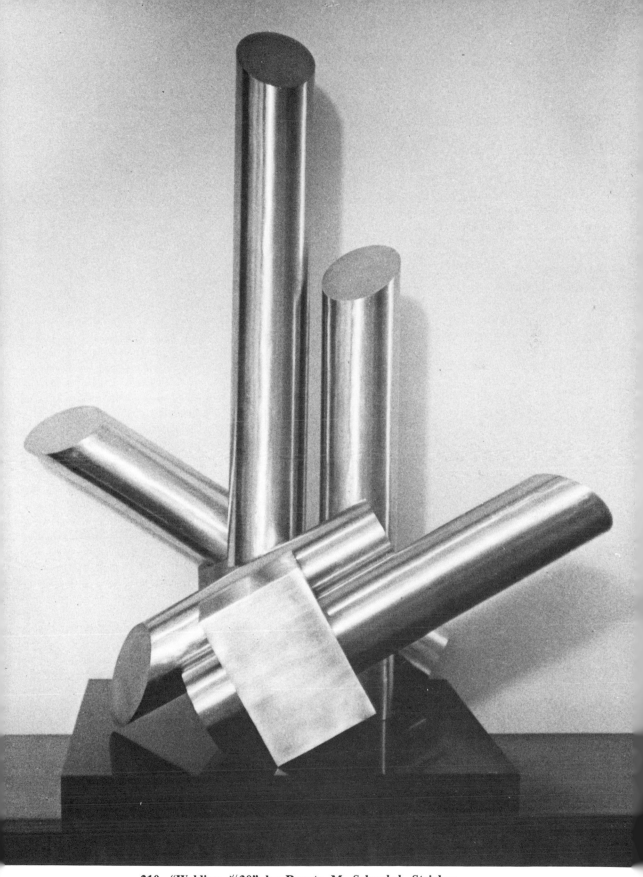

210. "Welding ⚒30" by Renata M. Schwebel. Stainless
steel—39″×33″×20″. *Photo by artist.*

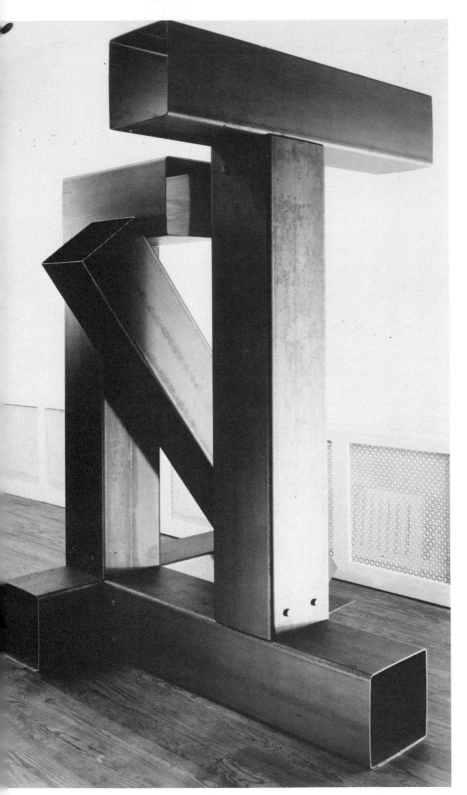

**211. "T-Square" by Tony Rosenthal. Structural steel, 1976
—76″ × 56″ × 46″.** *Photo by artist.*

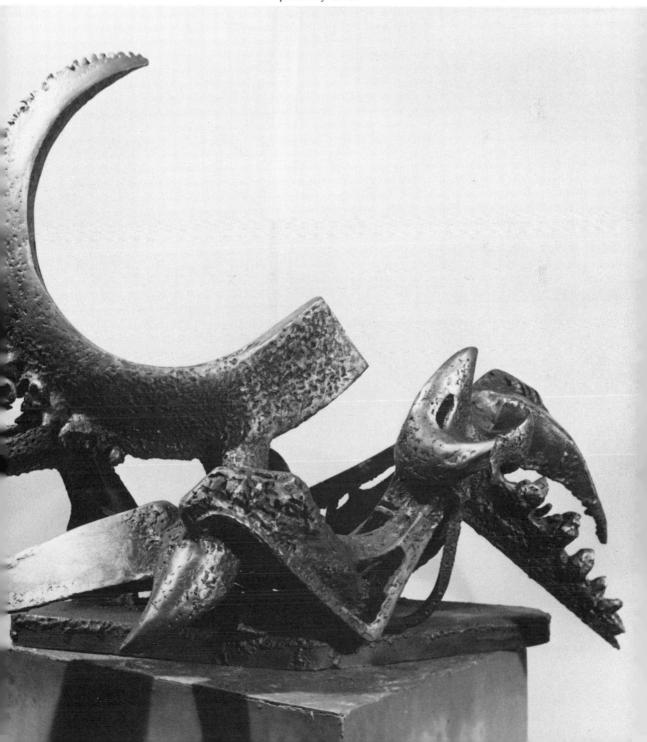

212. **"Recollection of the SW" by Theodore Roszak. Steel, 1948—40″ × 54″.** *Collection Art Institute of Chicago, photo by artist.*

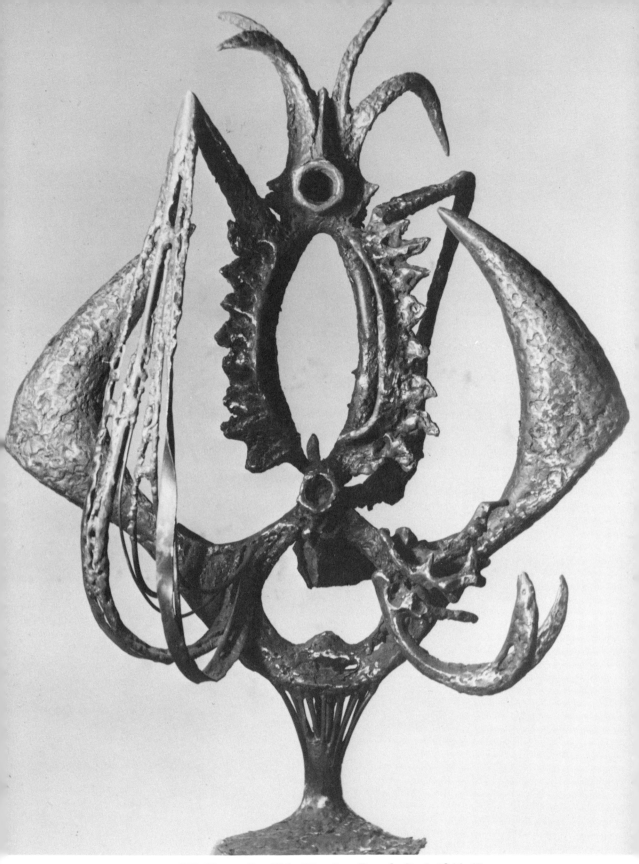

213. "Invocation I" by Theodore Roszak. Steel, 1946–47— 24″×18″. *Collection Hirshhorn Museum, Washington, D.C., photo by artist.*

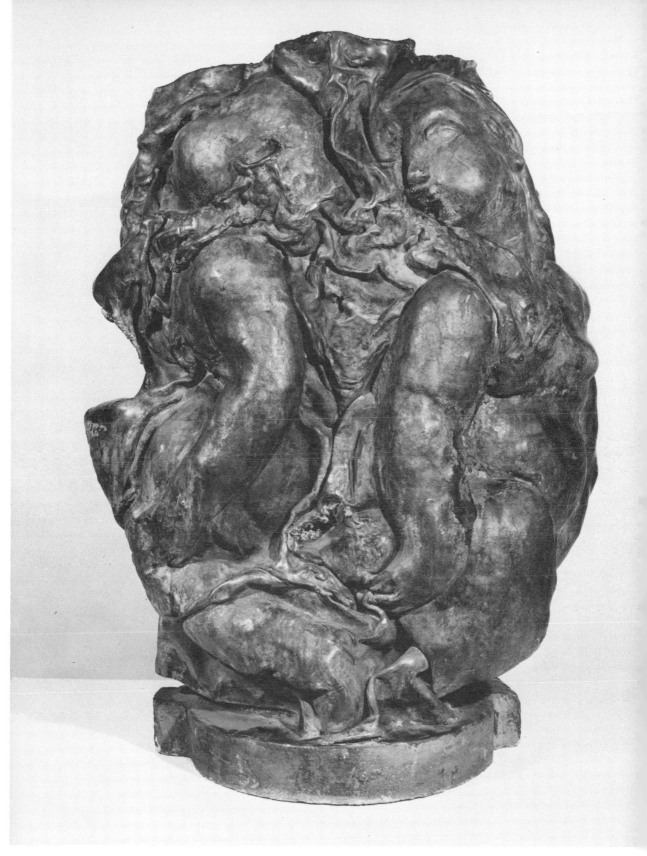

214. "Dancing Children" by José de Creeft. Beaten lead, 1961—32″×23″. *Courtesy Kennedy Galleries, Inc. Photo by Taylor & Dull, Inc.*

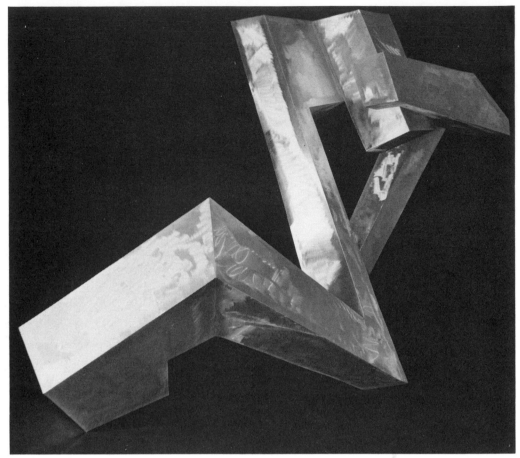

215. "Z-Love" by Bill Barrett. Aluminum, 1974—8′×10′. *Photo by Victor Tanaka.*

216. "Let the Sun Shine" by Nat Werner. Welded type-writer parts, 1973—3½′ height. *Photo by John Kender.*

**217. "Varoomb Shhh" by Ronald Bladen. Steel, 1974—
60′ × 5′—10′ × 47′.** *Courtesy Sculpture Now, Inc.*

218. "Concretion" by author. Welded cast iron and steel, 1963—5½′ × 4′. *Collection Silvermine Guild of Artists.*

219. "Interlocking Forms" by author. Steel, 1967—6′ × 5′ × 4′.

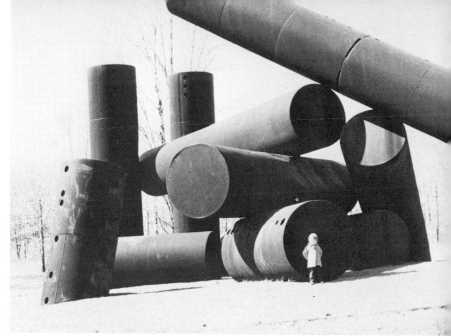

221. "Adonae" by Alexander Liberman, 1971. *Storm King Art Center, Mountainville, N.Y.*

220. "Phoenix" by Priscilla Pattison. Brass, 6¼′ × 12′ × 4⅓′. *Photo by artist.*

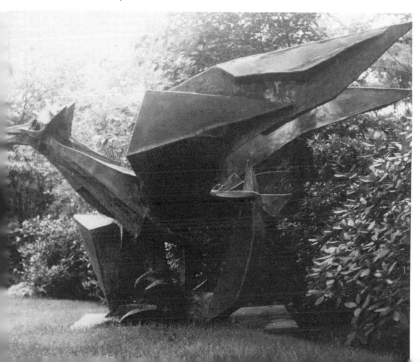

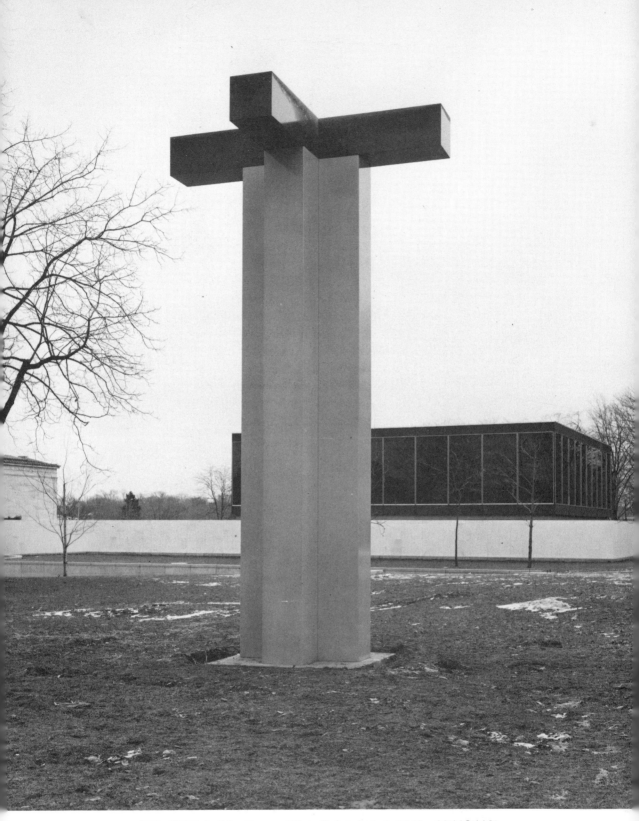

222. "Wildrice" by Lyman Kipp. Painted steel, 1968—22′ × 9′ × 9′.
Collection State of New York Albany Mall, photo by Greenberg-May Prod. Inc.

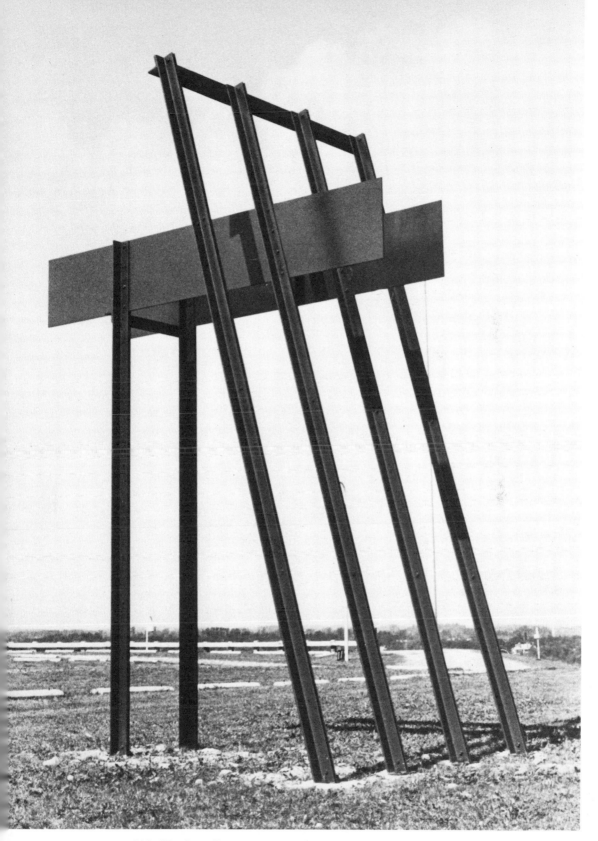

223. "Lockport" by Lyman Kipp. Aluminum, 1977—18′ × 12′ × 10′6″.
Storm King Art Center, Mountainville, N.Y., photo by artist.

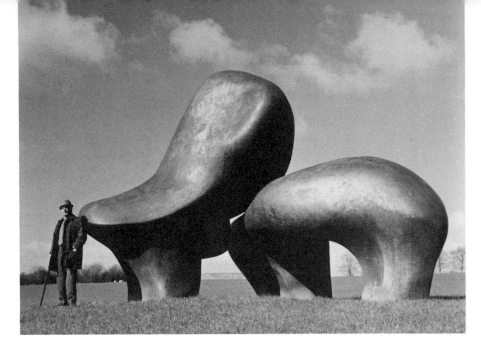

224. Henry Moore with "Sheep Piece." *Photo by Raymond Spencer Co.*

225. Gating a wax form.

226. At white heat temperature, a foundryman places his asbestos-covered arm into the crucible.

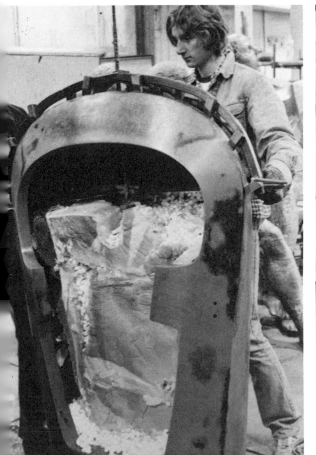

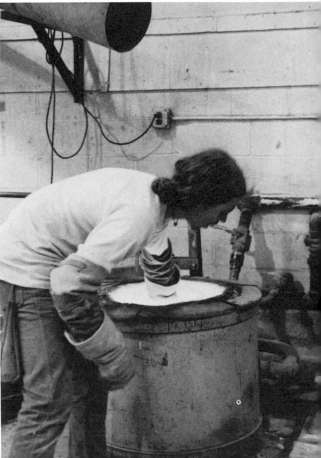

FIVE

BRONZE CASTING

Bronze is an alloy made of 90 percent copper, 5 percent zinc, and 5 percent tin.* There are many other combinations of bronze alloys which are utilized by the sculptor according to his needs. Nickel, aluminum, silver, or manganese, when melted in with the molten bronze, will result in a lighter colored cast. A pale silvery quality can be achieved by using only 5 to 10 percent of these metals. These metals will also give the bronze greater malleability, while zinc, for example, will result in a less ductile casting. Phos-bronze (containing phosphorus) is a red-colored bronze.

Bronze has great tensile strength and is a permanent outdoor medium. If left outside for a period of years, it will turn green and black, adding to its rich coloring or patina. If other chemicals are applied to bronze, the coloring can change to blue, red, brown, and copper. This is usually done in the bronze foundry, or by the sculptor in his studio. Bronze continues to be an important sculptural metal today, as it was in the past.

Bronze casting has undergone some changes in recent years since its development some five thousand years ago. The Egyptians as well as the Chinese developed the sand casting technique, which is still practiced widely today. Centuries later, during the Renaissance, the lost wax method was developed. There have been refinements with these techniques, as well as the use of new materials for mold making. During the past twenty years, ceramic shell casting, lost Styrofoam casting, and centrifugal casting have been developed. New metals, such as aluminum and stainless steel, are now also cast; they were unknown a century ago.

All casting depends upon one basic principle: namely, to fill a negative mold made from the original model. The mold can be made of sand, plas-

* United States Standard Bronze: 90 percent copper, 7 percent tin, 3 percent zinc.

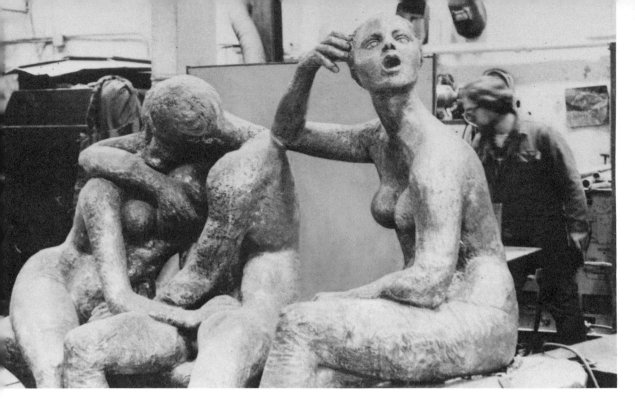

227. Over life-sized figures sit in the foundry unaware of the workers around them. *Photos by T. Fisher.*

ter, rubber, glue, metal, ceramic, clay, or whatever you like, but these materials are used to make a negative impression of a positive form. If, for example, you pressed your thumb in clay or wet sand, the shape of your thumb would be left in the earthen material, which we would call a mold. If the mold were filled with molten bronze or just plaster, we would call this the "cast," and a perfect reproduction of your thumb would be created. Molds must be made of material fine enough to reproduce the most intricate detail, and yet be strong enough to hold and contain the cast material inside. When the casting material is bronze, the mold must be made specially to further withstand the great heat of the metal and the pressure of escaping fumes and gas.

The Sand Casting Method

The first attempts at casting bronze many centuries ago were crude and rough by contemporary standards. The sand used then was coarse and control over the temperature of the molten bronze had not been perfected. When fine sand which had qualities different from other sands was discovered in France, sand casting techniques became more sophisticated. This sand, called French Sand, could be tightly packed and would reproduce details as fine as a fingerprint.* In the sand casting technique, a mold made of French Sand is made over the sculptor's model. The sand is packed around

* French Sand is composed of clay, silica, and alumina.

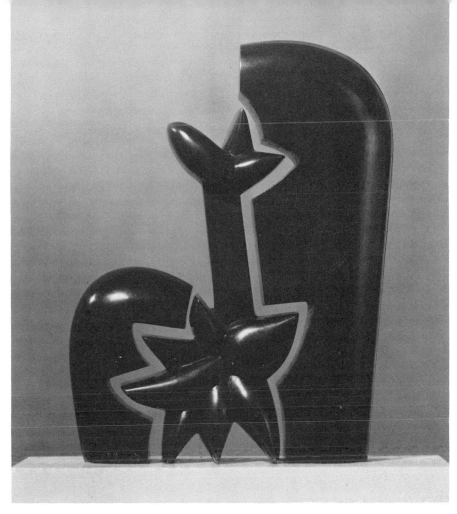

228. Peter Chinni's "Nascita I" 40″ height, 1975. Chinni does much of his casting in Italy and this work is an example of fine casting. *Photo by Raffaele Baldi.*

the sculptor's model in metal boxes called frames. The metal boxes can be stacked one on top of the other to allow for models which are taller than the metal boxes. These metal forms can be clamped together to make a very large mold. A layer of 3 or 4″ of sand is spread in the box and the model is carefully laid on top of the sand. Generally, the back is laid facing down into the sand first, if it is a figurative work.

The model, which is generally made of plaster, is painted with several coats of shellac. This seals the sculpture and does not allow moisture to be absorbed through the sand into the plaster. Talc is dusted over the sculptural model, and acts to separate the mold from the sand. Some foundries used graphite instead of talc for the mold separator. Now more sand is tamped tightly around the plaster model, covering the entire backside. The French Sand holds together so well that sections made from this sand will retain their shape even when moved.

A piece mold is easy to make from French Sand. It is basically a three-dimensional jigsaw puzzle that is made over the sculptor's model. Each

piece of the mold must be made carefully so it will pull away from the model easily. After tamping, the sand is made smooth and the edges are carefully trimmed with a knife. The remaining uncovered section of the plaster model embedded in the sand is then again dusted with talc. Another metal frame is added to the first and more sand is tamped into place over the remaining part of the plaster model. If many sections of mold are made, each piece must be dusted with talc to ensure separation from the neighboring section. A third frame is placed over the second metal frame and is clamped or bolted to the other two. This frame is filled with sand and is tamped holding the underneath sand sections in place. The entire mold is then inverted in order to remove the initial layer of sand in which the model was orignally placed. After removal of this original layer, the piece mold is made to take care of the backside of the sculptor's model. This in turn is also covered with another layer of sand holding those sand sections in place.

Now the process of disassembling the metal frames and sand sections of the piece mold begins. The frames removed, the sand sections are then reassembled in the empty frame without the sculptor's plaster model. We now have a three-dimensional jigsaw puzzle (the piece mold) without the plaster model.

The pouring feeder, vents, and channels are now cut into the sand. The feeder channel, being the largest groove cut into the sand, will have the smaller vents connected to it to allow for the flow of the molten bronze to all areas of the mold as well as for the escape of gases and fumes.

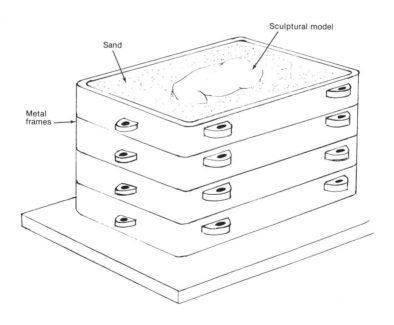

229. Metal frames used for sand casting method.

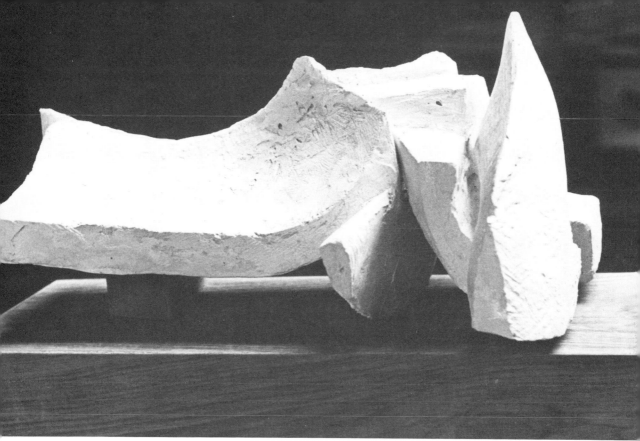

230. "Fragment" by Harvey Weiss. A plaster study for a larger piece in bronze, 1974. *Photo by artist.*

Upon completion of this stage, the mold is closed and held in place by the two large sections on either end of the mold. The mold is placed in an oven and allowed to dry and harden. The inner core is made of the same French Sand or fine sand, and is made to conform to the surface of the mold. The inner core is suspended by wires or iron pins, which penetrate the core as well as the mold.

While the mold is in the oven, the molten bronze is being prepared in the crucibles at a temperature of about 2,000 degrees. The bronze is poured into the mold by way of the cut channels into the space between the mold and inner core. The mold is allowed to cool overnight and the sand is removed from the solidified bronze cast. The inner core is shaken out and the feeders and vents now cast in bronze are cut off. The bronze is then cleaned with either nitric acid or by sandblasting. These vents and gates are then finished by "chasing" tools and files. The cut off vents are blended in with the bronze sculpture and finally colored or patinaed. (See the section on "Patina.")

Lost Wax Casting

There are three major methods of casting bronze using the lost wax technique. They are, in order of historical development, direct wax, solid invest-

ment core casting, and ceramic shell casting. In each case, the underlying principle is similar: The wax sculpture is embedded in a mold, the mold is baked at a high temperature, melting the wax, and bronze is poured into the mold, taking the place of the wax. Each of these three basic steps has innumerable minor steps which are essential to the preparation of bronze casting.

Direct Wax

Direct wax is the most creative technique for bronze casting. There are two dominant methods of direct wax working. One is to model or construct wax as you would clay or plaster. The wax is then prepared with the addition of vents and feeders, covered with mold material, and burned out for bronze casting. The other method is to model soft warm wax over a prepared investment form (see "The Solid Investment Core"—the next section) which is sculpted to be almost a finished sculpture, but which allows the thickness of the bronze cast to be modeled in wax. For example, a portrait bust can be modeled in investment material and completed to look like the finished portrait. Then, a ¼" layer of wax is modeled over this investment material, and it becomes the finished portrait. Bronze pins are driven through the wax into the inner investment, also called the "inner core," and

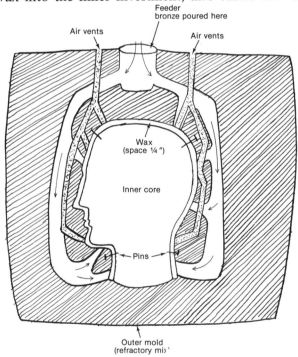

231. Casting mold.

an outer investment mold, which engages the protruding bronze pins, is made over the wax. The necessary gates and feeders are attached to the wax first.

The advantage of direct wax modeling is that it gives greater involvement and flexibility to the sculptor. He works on his sculpture to the final stage just before it is cast, instead of on a plaster model which is reproduced by the foundry in wax. The process is more creative than the usual "touch up the wax" technique, where almost any foundryman can accomplish this task.

The first obvious step in direct wax modeling is to buy the wax you need for modeling. There are several kinds of wax available. The following is a chart of available waxes and their recipes:

Wax	Add		
Beeswax	Paraffin	5–10	parts
10 parts	Rosin	3–5	parts
	Oil (Motor)	1	tablespoon

This formula is a softer wax, good even in warm weather.

Beeswax	Carnauba	3–5	parts
10 parts	Paraffin	3–5	parts
	Tallow	3–4	parts

This formula gives a hard, strong wax.

Many foundries and sculptors use a petroleum product called Microcrystaline wax. This is a synthetic product produced by such companies as Mobil. There are now many smaller companies producing microcrystaline wax under various trade names. It is available in a dark brown color, as well as in yellow or off-white. This is an excellent wax which is relatively inexpensive compared to beeswax. Microcrystaline wax can be softened by adding a little motor oil (usually one tablespoon per quart of wax), or it can be hardened by adding carnauba. It is, however, very workable as it comes from the manufacturer. This wax can be softened by heat, using either an infrared heat lamp or a double boiler. It can also be directly melted down in a pot over heat and painted onto an investment form. In this manner, hot wax can be painted on with a brush to the desired thickness. (Over a core, use a colored inner coat of wax to ensure proper thickness. It is easier to judge thickness of the wax with two different colored layers.) It can also be poured into flat sheets ¼″ thick and later shaped into sculptural forms.

To pour wax into sheets, you must make a plaster of paris bat or casting square (see illustration 233). Take a ¼″ piece of masonite measuring 12″

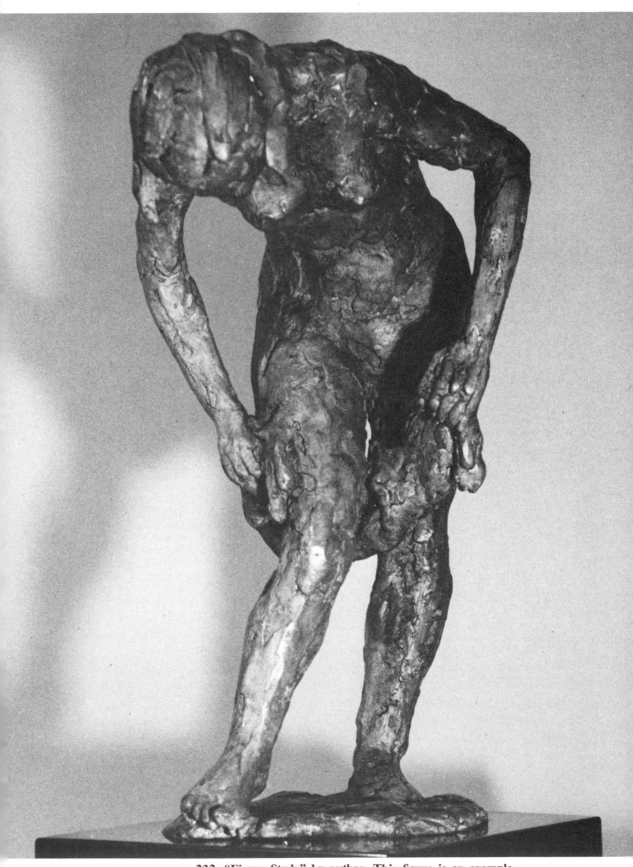

232. "Figure Study" by author. This figure is an example
of direct wax modeling. It was cast into bronze.

by 18". Bevel the edges, then sand them, so that the smooth surface of the masonite has the smaller dimension. This will be the side that faces up. Nail a frame which is 4" wider and longer than the masonite, or that measures 16" by 22". Secure this frame and the masonite to a perfectly flat surface and check this with a level. The frame should be about 1½" high. Apply a mixture of Vaseline and motor oil to the inside of the frame and surface of the flat table and masonite. Pour in plaster of paris so that it completely fills the frame to the very top. As the plaster thickens and just before it sets hard, usually in ten to fifteen minutes, scrape the surface with a flat metal bar using the frame edges as a guide. Allow the plaster to set for thirty minutes. Carefully remove the wooden frame. Gently rap the flat surface all around the plaster form and use a little water to break the suction. This should cause the plaster to become free of the table. Turn the plaster form over and gently pry out the masonite along the edges. Any serious chips can be replastered. You are now ready to pour hot wax into the sunken square of the plaster form from which you've just removed the masonite.

Check again that the plaster form is perfectly flat, otherwise the wax sheets will not be uniform in thickness. First pour a little water into the plaster rectangle. This acts as a mold separator to the wax. Never throw water into hot wax, as this will cause spitting and sputtering. After you've wet your plaster form, pour the hot wax into the sunken rectangle, making

WOOD FRAME AND MASONITE TO POUR PLASTER

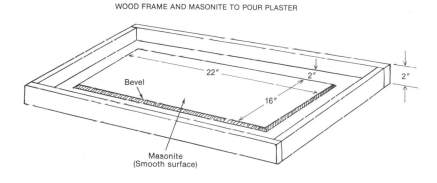

PLASTER BAT FOR POURING WAX SHEETS

233. Plaster bat for pouring wax sheets.

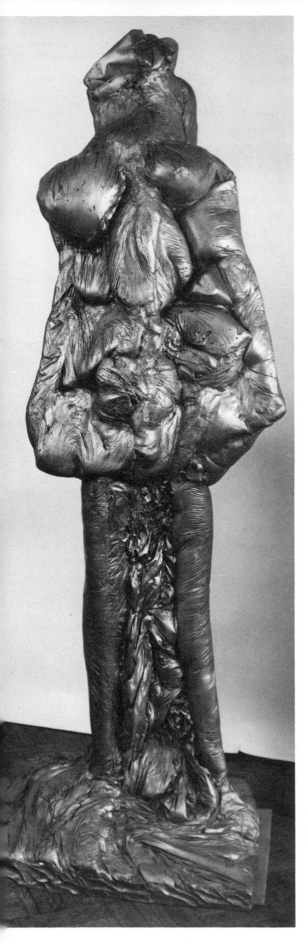

234. "Pisana" by Ezio Martinelli, 1965, is an extraordinary achievement of casting from polyurethane-covered forms into bronze. *Photo by Geoffrey Clements.*

sure the entire surface is covered and filled to the edges. Once it's filled, allow the wax to cool for fifteen minutes. It should be smooth and easily removed from the plaster bat. You can float these rectangular forms in a large basin of cold water for further cooling. The plaster bat can be used for innumerable sheets of wax. Simply remember to wet the bat with water before each pouring.

These sheets can be laid over the investment form to achieve the ¼″ thickness necessary for the bronze foundry. The wax can then be modeled with softer wax and worked with wax tools. Wax tools are made of steel, not wax, and are used hot so as to shape the surface. A very smooth surface can be achieved by rubbing the wax with a cloth soaked with turpentine or kerosene. Do not use gasoline because of the great danger.

The wax sheets can also be cut into shapes with a knife and joined with a hot tool or soldering iron. The wax pieces must be held together for a few seconds so that the soldered wax has a chance to solidify. A hot plate can be used to heat several wax tools at once. An alcohol lamp is also used for this purpose. If a spoon-shaped piece of copper is wrapped around a soldering iron, this makes a fine hot tool to work the wax. It may also be necessary to use balsa wood supports for large complicated direct wax sculptures. These ¼″ thick pieces of balsa wood can be removed before bronze casting, or can be cast with the sculpture and later cut off. The balsa wood will easily burn out in the burn out oven. Very thin or delicate forms can be supported with this balsa wood. A copper wire can also be used as an armature for the wax. After the burn-out, any remaining copper in the mold will fuse with the molten bronze.

The Solid Investment Core

If you intend to directly model wax over a core, go to the foundry that will be casting your work and have them give you the formula they use for their investment material. Many foundries frown upon casting into molds they have not made. If, however, you are using their formula, or even their material, they may be more agreeable to doing a direct cast for you. Investment molds for bronze casting must have properties different from the normal plaster mold. The great heat of bronze (2,200 degrees) and the gases it emits can cause a normal plaster mold to disintegrate or explode. Investment molds therefore must be made with ingredients which can contain this heat and allow gases to escape.

The inner core inside the wax sculpture is part of the mold and is made of the same material as the outer core. Some of the ingredients added to plaster of paris to form these molds are: earth clay, often called grog, pulverized quartz, asbestos, silicone sand, and crushed and pulverized brick. All of these substances resist heat and hold the plaster of paris together.

These ingredients are first mixed dry and are generally used in a 50 percent ratio to the plaster of paris. A typical formula is:

Plaster	2 parts
Asbestos*	1 part
Crushed Clay Grog	1 part

These are mixed in a large container and applied with a spatula. If they're used for the inner core, the core must be thoroughly dried before the wax is built up over the surface. Remember that wax will not adhere to a wet surface. Small investment cores can be placed in an oven at a low temperature (180 degrees) for several hours. Allow large cores to air dry, or if a large oven is available, heat the core in the oven for several hours. The purpose is to dry out the mold enough for the wax to adhere to the surface. Later, in the burn-out oven, the core will be thoroughly baked and dried.

No metal must be used in the inner core, or if it is, it must be easily removable because it must be removed before placing in the burn-out oven. A portrait bust can have a pipe supporting it, but this must be removed. Newspapers can be wrapped around the pipe before the core is built and this will allow the pipe to be pulled out. The newspaper will easily burn and cause no damage to the core.

Another core formula is:

Plaster	4 parts
Silica Flour	3 parts

This will make a strong mold or core which has sufficient porosity. This formula is also good because when applied over the wax modeling, it will pick up the details. A stiff brush should be used to ensure that this substance is covering all of the surface.

After the wax modeling is completed, the bronze pins driven into the inner core, and the outer mold completed, the mold is placed in the burn-out oven. The foundry would have attached the necessary gates and feeder.

In the burn-out oven, the wax is melted away, leaving an empty space. The inner core is held in position by the bronze pins. All the water and moisture is evaporated from the mold. All of this takes hours, days, or even two weeks, depending on the size of the mold. A funnel is placed in the feeder hole and is strongly attached to the mold. The molten bronze, which is being heated in a crucible, must be poured through this funnel and into the mold. The bronze is poured when the mold is hot to ensure against solidification of the metal during pouring. The bronze will solidify in minutes when in the mold, but must be allowed to cool for hours before handling can

* Asbestos gives off poisonous fumes when heated.

235. The melting furnace. *Photos 235–247 by T. Fisher, courtesy Tallix Foundry, Inc.*

236 and 237. Mixing investment material.

occur with safety. Generally, an overnight cooling is sufficient. The outer core is then smashed off with a hammer. The gates and feeder are cut off from the main mass of the bronze cast and the inner core is shaken and scraped out. Most foundries clean the bronze cast with sulfuric acid solution or sandblasting. It is important to clean out the inner core; otherwise, discoloration of the bronze may occur.

The bronze is now ready for filing, chasing, and finishing. The remaining parts of the gates are ground down with rotary files or Carborundum stones. Fine files and chasing tools are used to blend in the gate attachment to the surface of the bronze. Holes or small pits are bronze welded and ground down and finished. Heli-arc welding is best to weld bronze casts. Bronze, as

239. Sandblasting bronze.

238. Placing bronze ingot into furnace.

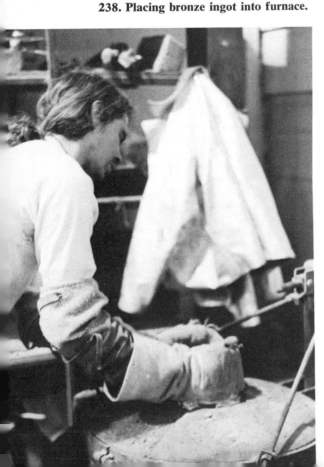

a conductor of heat, would consume a great amount of oxygen and acety-
lene if they were used.

Patina

After the bronze cast is thoroughly finished and found satisfactory by the
sculptor, it is ready for patina or polishing. For polishing, refer to the sec-
tion on "Metal Finishing" in the chapter on "Metal Working."

To patina a bronze simply means to color it. Bronze will naturally turn
color if left outside, but this process can be done quickly by the sculptor or
bronze foundry. Chemicals are mixed with water and applied to the bronze,

240. Welding bronze. **241. Filing off bronze gates.**

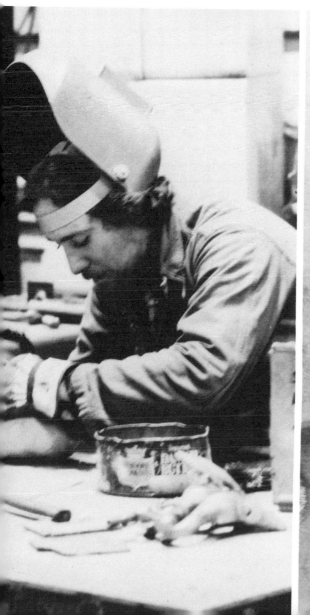
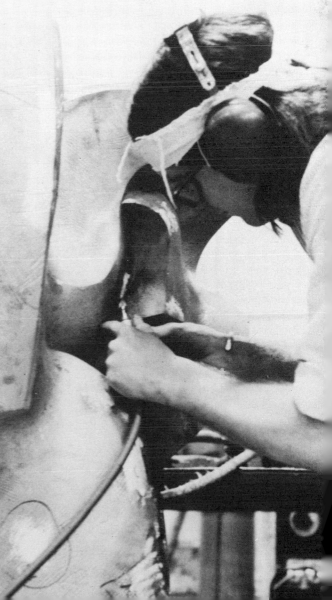

which is heated with a torch. A propane blowtorch is generally used, and the chemical solution is applied with a round brush. The color must be built up to a solid consistency with many applications of heat and chemical solution. The following is a chart for color and chemicals.* (All measurements are approximate; slight variations only vary the intensity of the color.)

Blue

Sodium Hyposulfite	60	grams	The metal should be dipped
Nitric Acid	4	grams	into the solution, if possible
Water	1	quart	

Yellow Green

Sodium Thiosulfate	1	gram	The metal should be dipped
Iron Nitrate	8	grams	into the solution, if possible
Water	1–1½	quarts	

Brown

The same as above recipe, but brush until brown appears.

Antique Green

Cupric Nitrate	40	grams	Heat
Ammonium Chloride	40	grams	bronze and
Calcium Chloride	40	grams	brush on
Water	1	quart	

Matte Brown

Barium Sulfide	1	ounce	Heat and
Potassium Sulfide	1	ounce	brush onto
Ammonia	2	ounces	surface
Water	1–1½	quarts	

Green

Ammonium Chloride	7	grams	Heat and
Copper Acetate	8	grams	brush onto
Water	1	ounce	surface

Light to Dark Brown

| Ferric Nitrate | 1 | teaspoon | Heat and |
| Water | 16 | ounces | brush onto surface |

Brown to Black

Antimony Sulfide	2	grams	Heat and
Sodium Hydroxide	4	grams	brush onto
Water	16	ounces	surface

Purple—Early stage of following recipe is purple.

* Courtesy City Chemical Corp., N.Y.

Light Green

Sodium Chloride	5	grams	Heat and
Ammonia	4	grams	brush onto
Glacial Acetic Acid	4	grams	surface
Ammonium Chloride	5	grams	
Water	1	quart	

Antique Green

Copper Sulfate	12	grams	Heat and
Ammonium Chloride	2	grams	brush onto
Water	8	ounces	surface

Black

Copper Carbonate	2	grams	Heat solution to a boil.
Ammonium Carbonate	4	grams	Bronze should be immersed
Sodium Carbonate	1	gram	and solution stirred.
Water	1	quart	

Green

| Cupric Nitrate | 1 | teaspoon | Heat bronze and |
| Water | 16 | ounces | brush onto surface |

Antique White

| Bismuth Nitrate | 2 | teaspoons | Heat bronze and |
| Water | 8 | ounces | brush onto surface |

Verde

Copper Nitrate	1	gram	Immerse bronze into
Ammonium Chloride	1	gram	solution until dull
Calcium Chloride	1	gram	green appears
Water	1	quart	

Golden Yellow

Sodium Thiosulfite	¼	ounce	Heat the solution
Ferric Nitrate	2	ounces	to a boil and immerse
Water	1	quart	bronze

Blue

Potassium Sulfide	15	grams	Heat bronze and
Ammonium Chloride	200	grams	brush onto surface
Water	1	quart	

Deep Rust Red

Copper Nitrate	48	grains	Brush to surface for
Sal Ammoniac	48	grains	color. Dip into diluted
Calcium Chloride	20	grains	nitric acid solution
Copper Sulfate	10	grains	(1 part to 8 parts water)

Oxalic Acid	10	grains	for ¼ hour. Remove,
Water	4	ounces	wash, and dry.

Blue Green

Copper Sulfate	5	ounces	Dip the bronze into the
Cupric Acetate	5	ounces	solution
Copper Carbonate	5	ounces	
Water	1–1½	quarts	

Brown to Black

Antimony Sulfide	2	ounces	Heat liquid and apply
Sodium Hydroxide	4	ounces	
Water	1	quart	

Brown to Black

Ammonium Sulfide	1	teaspoon	Heat the bronze and
Water	8	ounces	brush onto surface

Brown to Black

Potassium Sulfide	few crystals		Dissolve a few crystals into
Water	16	ounces	half quart and heat bronze
			and brush onto surface

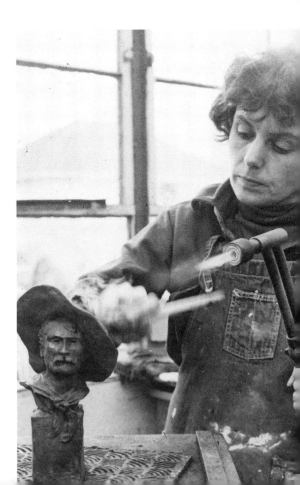

After the color has been developed on the bronze surface, several applications of wax polish heighten the color further. Paste wax is generally used and even shoe polish has been applied by some sculptors and foundries. To a clear paste wax, such as Butcher's Wax or Johnson's Paste Wax, color can be added directly into the wax by mixing in a little dry color or oil color. Buffing between each application of wax polish will give a transparency to the patina and a life to the bronze which is beautiful. Rodin bronzes have been done in this manner, as well as the bronzes of Renaissance sculptors.

242 and 243. Painting bronze—both heat and acids are used to color bronze.

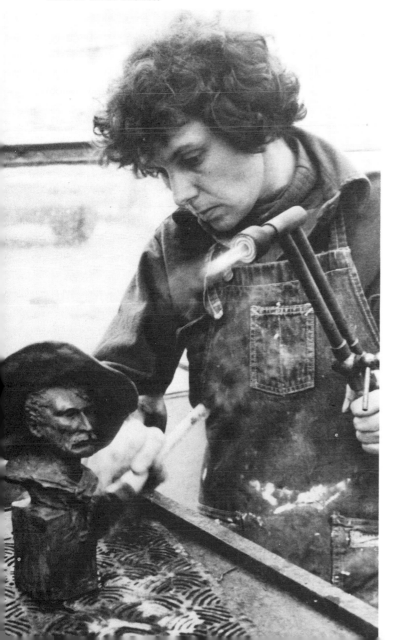

244. Ceramic shell and silica sand covering.

Reproductive Molds

Up to now, we have discussed direct wax modeling for bronze casting, but many sculptors do not work directly in wax. They usually work in clay and then cast their work into plaster. After finishing this plaster sculpture, they send it to the bronze foundry, where they may not see it again until after casting. The foundry goes through the lengthy and costly process of making a rubber or glue mold over the original plaster model. The purpose of making a flexible or reproductive mold is to cast a wax duplicate of the original plaster. This kind of mold is also used to make more than one cast. Once a rubber or glue mold is made, many cast waxes can be made from it. Rubber is better than the glue mold because it lasts longer and has greater strength and heat resistance. Glue molds are a misnomer because often they are made of gelatin and are also referred to as gelatin molds. From a gelatin mold, only five to seven waxes can be made before the gelatin loses its reproductive qualities. On the other hand, fifty to a hundred waxes can be made from a rubber mold, depending on the size and details of the original plaster model.

The wax is either brushed into the mold until it is ¼″ thick, or the mold is completely filled with hot wax and allowed to cool. As the wax cools, the outer edges that touch the mold solidify first; when sufficient thickness is attained, the remainder of the wax, which is still liquid, is poured out. This leaves a hollow shell of solidified wax inside the rubber mold. The same technique is used in ceramic casting and is referred to as "slush casting."

The wax is carefully removed from the flexible mold and is touched up or further developed by the sculptor. At this point, the gates, vents, and feeders are added to the wax casting. This step is important because the gates must be attached so as to allow the easy fill-up of the cast from the bottom up. On a figure, for example, the feet would fill up first and the head last, if the feeder is attached to the top of the head. Many figures are poured

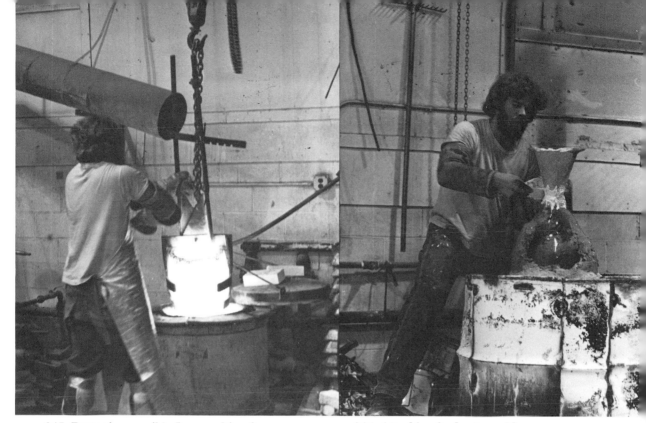

245. Removing crucible from melting furnace. **246. Attaching feeder to mold.**

upside down, but the principle remains the same: The bronze cast fills from the bottom upward. Wax tubes are used for the gating and venting system. These, of course, will melt away later during the burn-out stage. After the gates and vents are attached, the inner core must be developed in the hollow wax.

In ceramic shell casting, the wax with gating systems is submerged in a liquid ceramic material (zircon flour and water base) called the precast. This liquid ceramic substance fills both the inside and the outside of the mold. The ceramic-covered wax is then coated with silica sand both inside and outside.

The wax-covered form is left overnight to dry and harden. The thin shell

247. Pouring molten bronze into feeder.

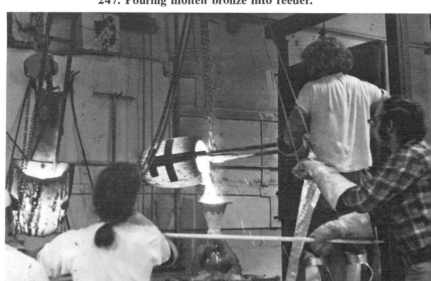

must then be dipped several times in an alcohol-based ceramic material (alumina and silica solution with alcohol) and covered with silica sand after each dipping. Each coat must dry for a half hour before redipping. When the mold reaches its final thickness, it is exposed to the fumes of ammonia, which harden the mold. The mold with the wax inside is now ready for the burn-out (or autoclave) oven which will melt away the wax and bake the mold hard, at 1,800 degrees maximum. A ceramic cone is cemented to the feeder of the mold just before the bronze is ready to pour. The baking of the ceramic mold turns it to a hard material capable of retaining the heat of the molten bronze. Molds for pouring should be 600 degrees. As in solid plaster mold casting, the ceramic mold is broken off after casting, the gates, vents, and feeder are cut off, and the bronze is finished. In ceramic shell casting foundries, the bronze casts are cleaned by sandblasting or with an acid bath of full-strength heated caustic soda. Sandblasting units can be purchased in many styles from the companies listed in the appendix of suppliers at the end of the book.

Care of Bronzes

The maintenance of bronze sculpture depends upon several factors. Most important, of course, is whether the bronze is left indoors or out. Outdoor sculpture requires more care and maintenance, but bronze sculpture can be left to turn a beautiful green patina. This green color is a result of oxidation of the bronze with the atmosphere and will last for decades. If a black polished patina is to be preserved on an out-of-door bronze sculpture, an annual cleaning and repolishing would be necessary. Depending upon the condition of the bronze, a detergent solution would clean the bronze of grime and dirt. If this is not strong enough, a solution of muriatic acid (10 percent) would clean off tough grime and dirt. Be careful with acids, making sure to wear eye goggles, gloves, and work clothes. Use steel wool or a steel brush to clean off the grime.

Thoroughly wash off all detergent or acid with plenty of water. This is important because if it's not washed off, trapped acid will continue to eat away at the bronze. After the bronze is dry, the surface can be rewaxed. Use a hard wax, such as Simoniz, or add some carnauba to Butcher's Wax. Apply several coats of wax over the surface and buff each coat to a high luster.

A polished mirror surface in bronze cannot be maintained out of doors for very long. Even indoors, cleaning and polishing are necessary every two to three weeks to keep the mirrorlike finish. Polished bronzes can be sprayed with a clear lacquer or enamel, which can be baked on. Out of doors this will not prevent tarnishing, and once the bronze tarnishes, the baked clear enamel will have to be removed in order to repolish the bronze. This is a difficult task. Indoors, the baked clear enamel would last consid-

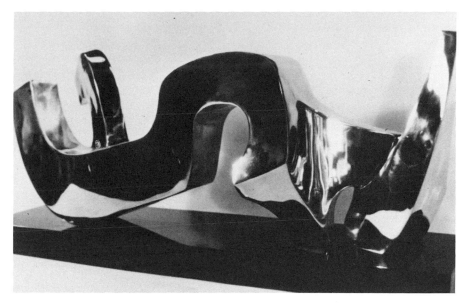

248. "Maja" by author, 1978—36″ × 12″. This polished bronze was cast by the sand casting method, which gives a denser cast to the metal. A brighter finish is possible with the denser metal. *Photo by T. Fisher. Collection of Samuel Greenbaum.*

erably longer and would be worthwhile doing. It would be best to have a professional paint-sprayer do this job for you.

Setting Up a Small Foundry

Most schools, universities, individuals, or groups can easily set up a small foundry capable of pouring fifty to a hundred pounds of bronze. A moderate-size room, basement, garage, or studio is needed. Ventilation is important, and an industrial window fan is required. The floor should be dirt, at least half of it, in preference to wood or cement.

The following are the necessary tools and pieces of equipment:

Furnace or Kiln—can be easily made from steel plate and high-fired ceramic bricks, or purchased.

Melting Furnace—can be made of steel plate, high-fired brick, and refractory cement. This furnace should be made to house the crucible, so it should conform to its shape.

Crucible—purchase from foundry supply company, or a good used one will do. Buy only big enough for your needs.

Tongs—come in various sizes, but a two-man tong is necessary to pour 50 to 100 pounds of bronze. Can be made or purchased.

Pyrometer—to measure heat and should be purchased from foundry supplier.

Wax—see wax formulas in section on "Direct Wax."

Plaster of paris—200 pounds to begin.

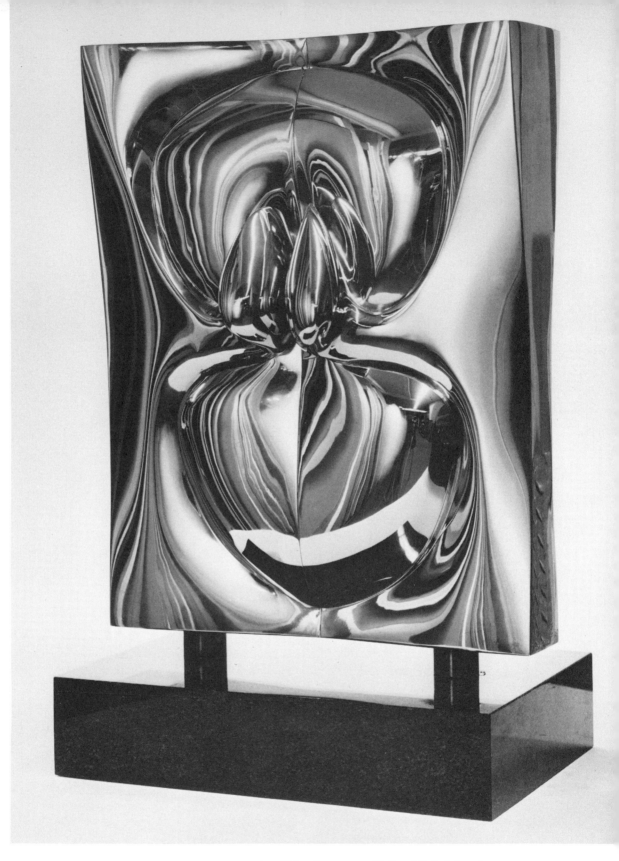

249. "Instant" by Aldo Casanova, 1969—30′ height. An Op-Art quality is achieved through this extraordinary finish. *Collection of Whitney Museum of American Art, photo by Geoffrey Clements.*

251. Burn-out oven.

252. Fireproof clothing.

Silica (sand or flour)—purchase from foundry supplier, 100 pounds to begin (see section on "The Solid Investment Core").

Asbestos apron, gloves, helmet, goggles—purchase from foundry supplier. Buy at least two sets of each.

Flexible shaft grinder—purchase.

Chasing tools—can be made from tool steel or purchased from supplier.

Metal cutters and hack saw—for cutting off gates. Purchase from hardware store.

Welder—heli-arc is best. (See section on "Welding.")

Chemicals for patina—see section on "Patina."

Wax—Simoniz, Butcher's Wax, etc.

Other tools would include those hand tools and power tools that most schools or sculptors would already have. Buy some ceramic funnels from the foundry supplier.

250. Melting furnace. *Photos 250–254 by T. Fisher, courtesy Tallix Foundry, Inc.*

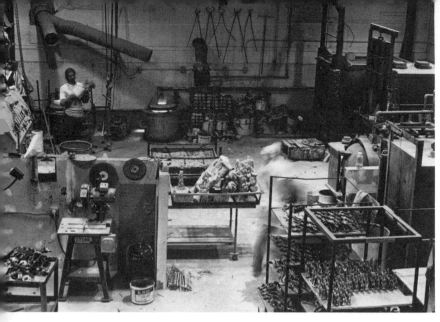

Placement of the Foundry

The burn-out ovens and the melting furnaces with the crucibles should be in the same general area. These would most likely be fueled with propane gas, which you buy from a local gas supplier. He will also tell you what size to use for your gas pipes, valves, and fittings. By keeping all the heat equipment together in the foundry, you will save time, energy, and money.

Keep the mold-making area away from the bronze-pouring area. Designate this as the plaster area. The plaster, as well as any liquid rubber or gelatin, should be stored in a dry place.

Mold making requires concentration and has its own particular set of problems.

254. Gating system.

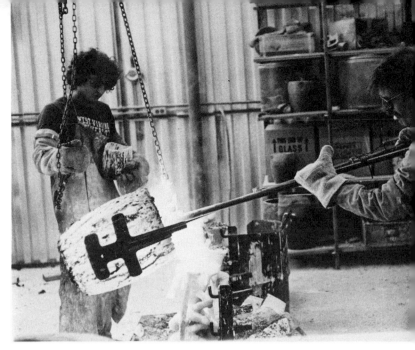

255. Pouring bronze. *Photo by T. Fisher, courtesy Tallix Foundry, Inc.*

The wax-working area should be as far away from the hot area for obvious reasons. It should be adjacent to the mold-making area. As waxes are poured in the mold-making area, they should be easily available for touching up.

Investment cores and molds can be adjacent to the wax-working area, but not close to the hot furnace area. Here the waxes are cored and the outer investment is built up over the wax and necessary gates and vents.

An outside area is best for smashing off the investment mold, raking out

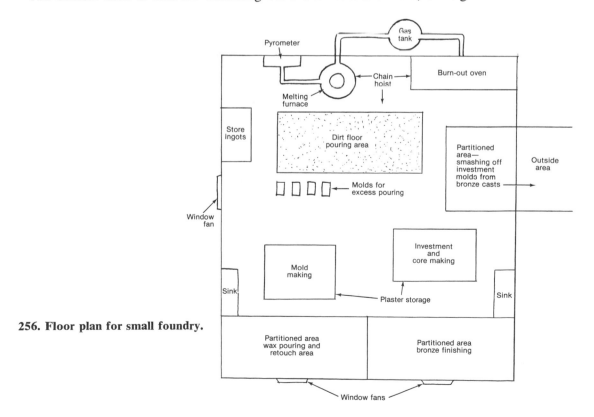

256. Floor plan for small foundry.

257. Stainless steel ingots. *Photo by T. Fisher.*

258. Bronze ingots. *Photo by T. Fisher.*

**259. Jon Bogle's "Module One Structure One," 8′ height.
This work is a great feat of casting.** *Photo by artist.*

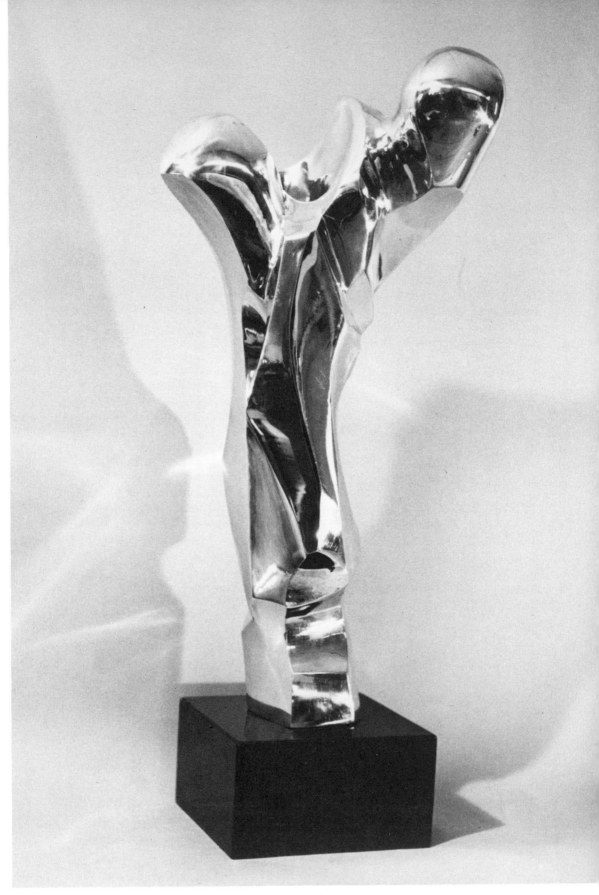

260. "Growth" by author is an example of yellow bronze that can be polished to a high luster.

the inner core, and for cutting off the gates. This is usually a very messy job that can easily spoil the operation of the entire foundry. If it is not possible to do it outside, a partitioned area would work well.

The finishing area should be off by itself, away from plaster dust, furnace fumes, and melting wax. The finishing tools must be kept clean, as should the cast bronzes. The patina area can be close by, or even in the same area. Mounting bases, waxing, and other types of finishing work can also take place in the final area.

Original models and molds should be carefully stored and numbered. Paint corresponding numbers on models and molds, and even record them in a book. In a relatively short time, many molds can be stored away.

On page 237 is a general floor plan of a foundry:

The bronze metal can be purchased in ingot form—solid bricks of metal—from a smelting firm. It is possible to buy copper, brass, and bronze from a scrap metal dealer, but be sure that the metal is clean and not attached to other metals, such as iron or steel. Other metals should be cut off from the bronze, brass, or copper body. When the bronze is in a molten state in the crucible, slag, carbon, and foreign matter will float to the top. This must be scraped off with a long-handled metal scraper. Be sure to wear asbestos protective clothing when approaching a white-hot crucible full of bronze.

Aluminum Bronze

You can experiment with other metals melted into your crucible of bronze. The addition of 5 percent to 10 percent aluminum will lower the melting point of the bronze and also lighten the color. A temperature of approximately 1,500 degrees will melt this bronze. Remember that bronze should not be poured into a cool mold because that would chill and solidify the bronze before the mold was completely filled. This could cause serious gaps in the casting, as well as cracks. Aluminum bronze is very gassy, so you should be sure that the venting system is made to provide for the easy escape of these fumes. The outer mold core can be made a bit more granular with the addition of grog or crushed brick, which will also allow for the escape of gases.

Aluminum is excellent for out of doors because it resists corrosion. It will turn a dull gray color, which is not very pleasant, but this can work very well on certain types of works. Aluminum bronze, however, will not turn gray because of the high percentage of copper (90 percent). Castings in aluminum bronze should be cleaned by sandblasting, or with a dilute solution of lye (sodium hydroxide). Lye is an extremely powerful acid and even the fumes can cause discomfort. Use great care in handling lye, especially when adding it to water.

In 1856, the price of aluminum was about $90 per pound; in 1928, $.24

to $.26 per pound. Aluminum is second among metals in malleability, sixth in ductibility.

Pure aluminum is often used in castings, as well as for direct works in welding and hammering. Aluminum is only one-third the weight of iron or steel. The melting point of pure aluminum is relatively low (1,220 degrees Fahrenheit) and an alloy can be made by adding another metal such as magnesium. Aluminum is difficult to finish because high-speed rotary files or grinding disks tend to "glaze" or become saturated with the aluminum. The use of tallow is a great help in grinding and polishing aluminum. Sometimes the metal will "drag," that is, the surface can become slurred or bumpy. A slower speed or more tallow should correct this problem. The best way to weld aluminum is with a heli-arc welder (see the section on "Types of Electric Welders"). The air-cooled system cannot be used unless there is a high-frequency attachment. Aluminum can be polished to a mirrorlike surface, but it cannot achieve the mirror surface of bronze or stainless steel. It will quickly dull.

A pearl-like surface can be achieved by heating the surface and applying a dilute solution of oxalic acid. This surface becomes very hard and protects the metal for years, even out of doors. Aluminum is often electroplated with brass, but the life of this covering is limited out of doors, depending upon location and environment.

Brass

If more zinc is added to copper (from 20 to 25 percent), the result is called brass. Sometimes a small percentage of tin is also added (2 percent) but the color of this alloy is a light yellow or golden one. Brass is harder, more tensile, and less malleable than bronze. The zinc is volatile, causing the alloy to fume and spit when being welded or cast. Brass, however, takes a very bright finish and wears better out of doors than does bronze or aluminum. It is used extensively for plumbing hardware for this reason. "Yellow bronze" is a form of brass. "Red bronze" has less zinc added to the copper than ordinary brass. Brass as well as bronze can be cut on a band saw using a metal blade with three to six teeth per inch. I personally find that six teeth cut better than three teeth, which industrialists officially list as correct. This is also true for aluminum.

Stainless Steel

Stainless steel is a relatively new material for casting. In the commercial steel market, stainless steel is available in sheets, plates, beams, and many other forms. The casting of stainless steel requires some extra steps in the casting and finishing process. The melting point of stainless steel is about 1,700 degrees, but the metal is poured at 3,000 degrees. An induction fur-

nace is used to melt the steel, and the mold must be heated to a temperature of 1,500 degrees. The heated mold ensures that the molten stainless steel flows throughout the entire form. A mold that is too cool could cause solidification of the flowing metal too soon and cause gaps in the casting.

Nickel and chromium (from 11 to 18 percent) are added to steel to form stainless steel. Stainless steel is harder than ordinary steel, does not rust, and can be polished to a mirrorlike finish. Grinding and polishing stainless steel (see "Metal Finishing" section of Chapter Four) is far more difficult than finishing bronze. Stainless steel, however, can be placed out of doors. Even a polished work will require little maintenance. Stainless steel will not tarnish, and requires only dusting or washing dirt from the surface.

Lost Styrofoam Casting

Within recent years, Styrofoam has been extensively used by sculptors for casting into metal. Styrofoam dissolves when in contact with heat, and herein lies the idea of "lost Styrofoam casting." The two steps of burning out and pouring are combined in Styrofoam casting; that is, the Styrofoam remains in the mold until the molten metal is poured. The molten metal then dissolves the Styrofoam and completely fills all the space previously occupied by the Styrofoam. These two processes happen instantaneously.

The advantages of the technique lie in the low cost of casting, as compared to lost wax, or even sand casting. No rubber molds need be made. Up until now, lost Styrofoam has been cast in sand molds. Many foundries have been reluctant to make solid investment or ceramic shell molds over Styrofoam, but one or two are now showing more willingness to do this. Fifteen years ago, I could only find commercial foundries willing to cast from Styrofoam. The charges were based upon the weight of the sculpture and not its complexity, but now all this has changed.

The Styrofoam is placed in a sand mold with attached feeders, vents, and

261. "Jeu De Boules" by Pat Diska, 2½′ height. Cast iron. This is an example of a lost Styrofoam casting. The Styrofoam was cut with saws, knives, then burned with a propane torch and soldering iron. *Photo by artist.*

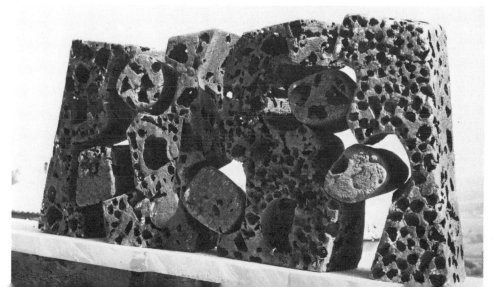

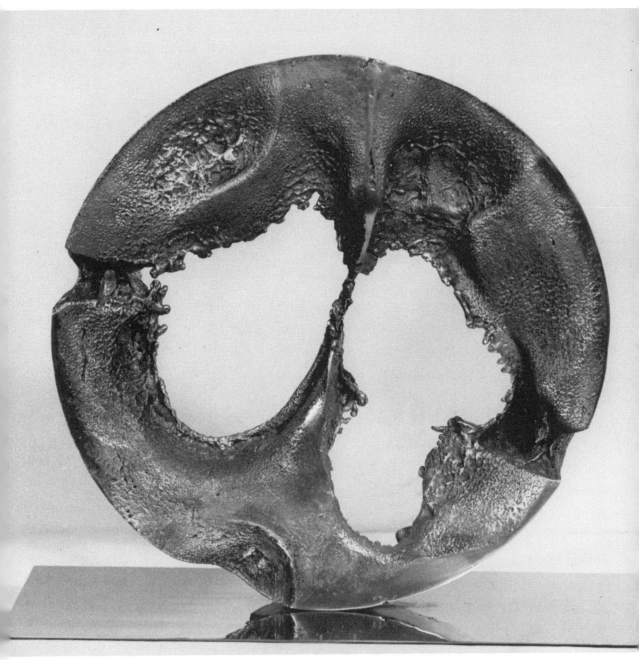

262. "Open Circle" by author. Using a 1″ thick slab of Styrofoam, a 12″ diameter circle was cut and later burned with a propane torch. The work was cast in aluminum and finished with a high-speed wire brush.

gates, as they are in normal casting. The gating is also made in Styrofoam, unless it is cut out of the sand, as is usual in sand casting. Styrofoam releases a toxic gas and caution is necessary when working with this material. Styrofoam is an expanded plastic, with each air compartment full of gas. (See chapter on "Plastics," section on "Rigid Foams.") Even sawing through Styrofoam releases this gas, so ventilation is extremely important.

Generally, simplified forms lend themselves best to Styrofoam, but detailed works can be made using a dense Styrofoam. Styrofoam can be cut, sawed, and glued into a construction, and then cast into metal. A hot wire or small torch is also used to achieve other kinds of forms and textures. The sculptor Diska, from southern France, used Styrofoam in this manner and has made some remarkable works.

The disadvantage of lost Styrofoam is that castings are solid, not hollow, as they are in lost wax. A solid small work in bronze can easily weigh fifty to a hundred pounds. In some cases, it is possible to hollow out the Styrofoam and fill it with core material. Aluminum is often used in casting because of its lighter weight. Lost Styrofoam casting is an exciting way to work, despite its limitations. Foundries in this country have been slow and reluctant to accommodate the artist, but one can hope that perhaps this technique will become more practical in the future.

GALLERY OF BRONZE SCULPTURE

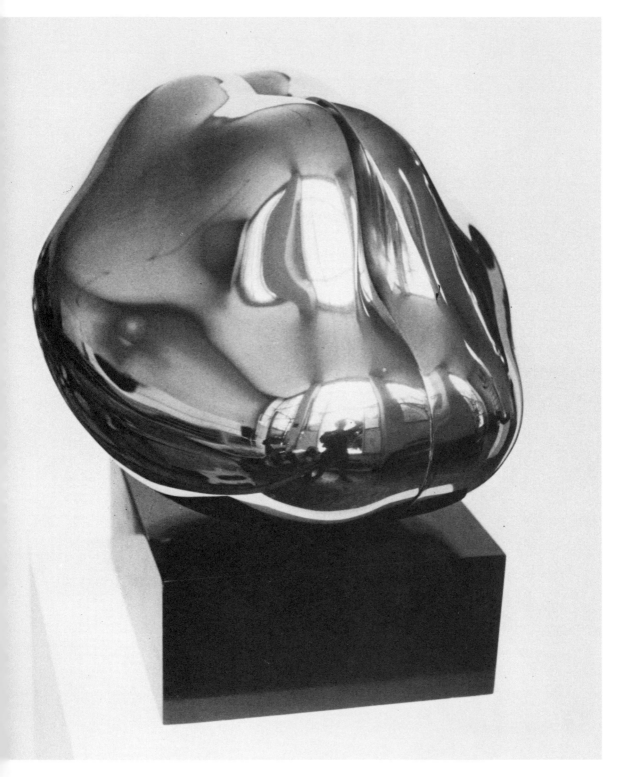

263. **"Present" by Aldo Casanova. Bronze, 1969—14″ height.** *Photo by artist.*

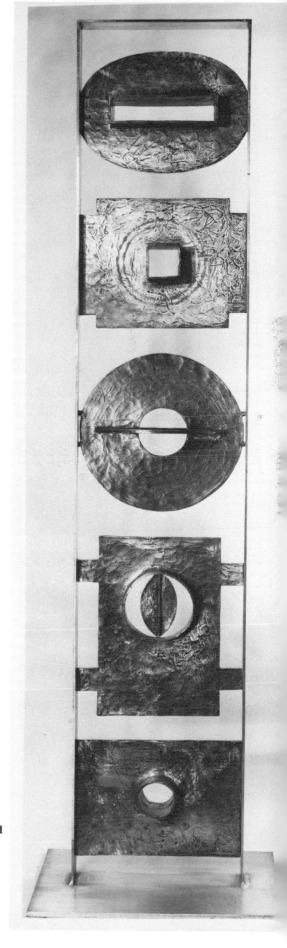

264. "Centotaph ⚌2" by Dorothy Dehner. Bronze and aluminum—7' height. *Photo by Walter Russell.*

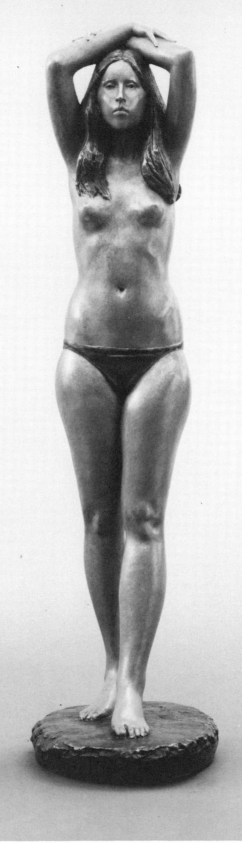

265. "Bather" by Lloyd Glasson. Bronze, 1975—30″ height. *Photo by David Allison.*

266. "Crag" by Ezio Martinelli. Bronze, 1961—7'6″×30″×
24″. *Collection, Guggenheim Museum, photo by artist.*

267. "Cythera's Dream" by author. Bronze, 1975—44″ × 24″ × 28″.

269. "Brush Hollow Beach" by Sidney Simon. Unique bronze—2′ and 3′ figures. *Photo by artist.*

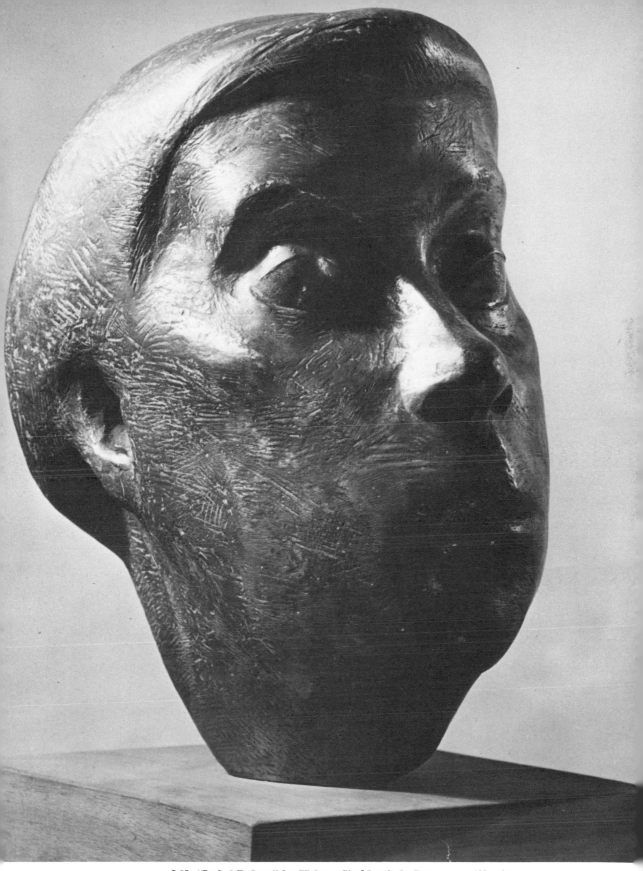

268. "Isabel Bolton" by Helena Simkhovitch. Brass, over life-size.
Courtesy of Whitney Museum of American Art. Photo by J. Schiff.

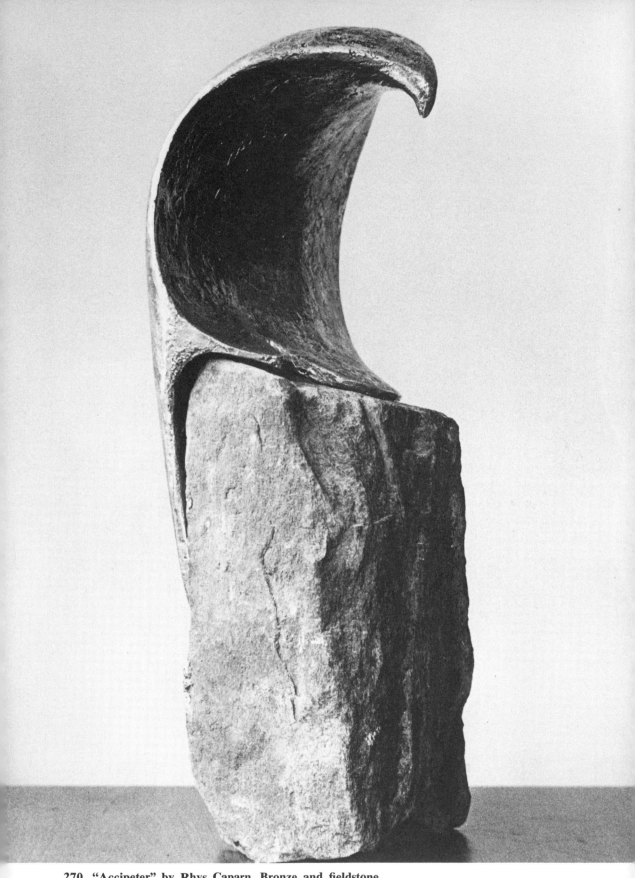

270. "Accipeter" by Rhys Caparn. Bronze and fieldstone, 1969—22″ height. *Photo by Budd.*

271. *Opposite page.* **"Lover's Rite" by Peter Chinni. Bronze—31″ × 10″.** *Photo by artist.*

272. "Urban Man" by Zeke Ziner. Cast tin—24″ height. *Photo by artist.*

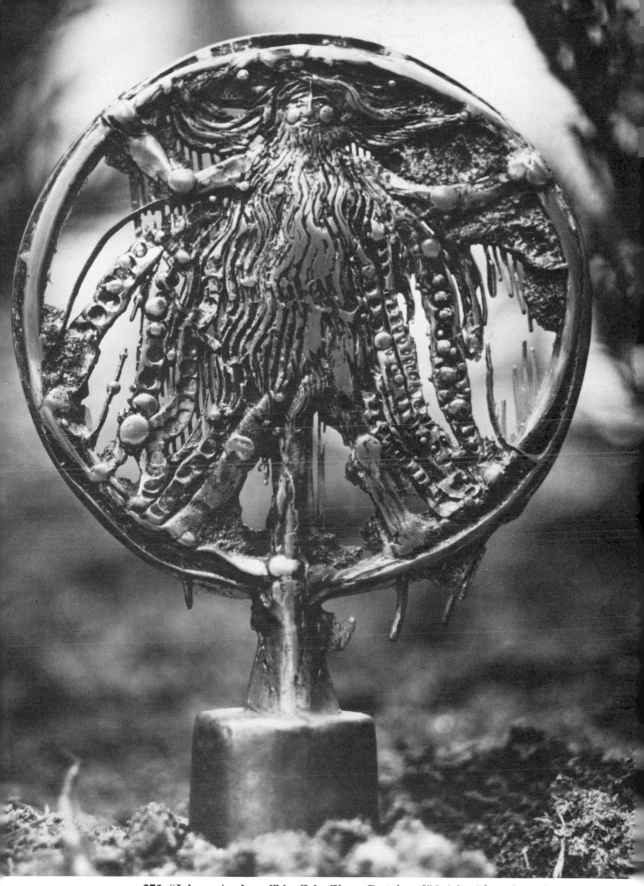

273. "Johnny Appleseed" by Zeke Ziner. Cast tin—6″ height. *Photo by artist.*

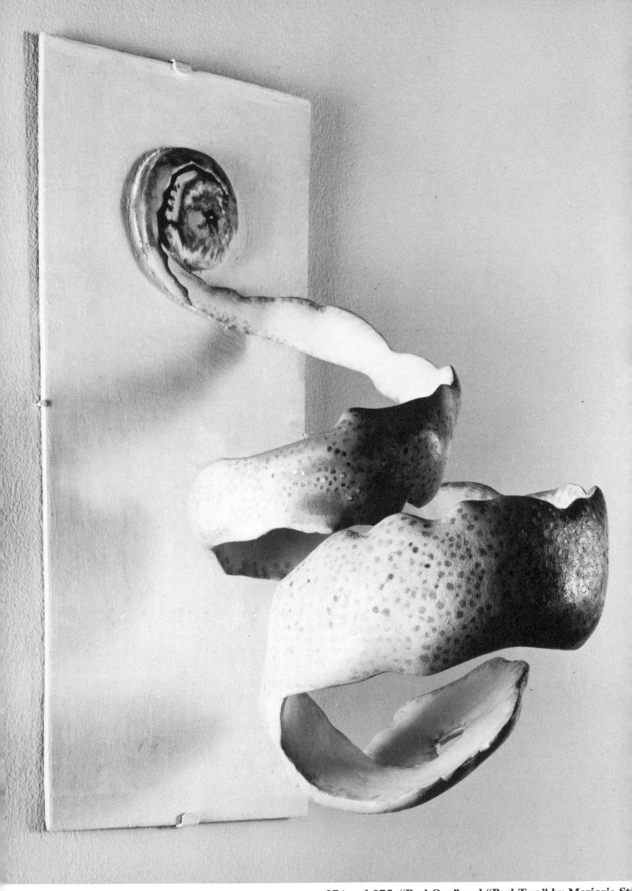

274 and 275. "Peel One" and "Peel Two" by Marjorie St
Bronze, aluminum, 1976, 1977. *Photos by B. Davies.*

276. "Revolving" by Louis Shanker. Bronze, 1966—12″ height. *Photo by W. Rosenblum.*

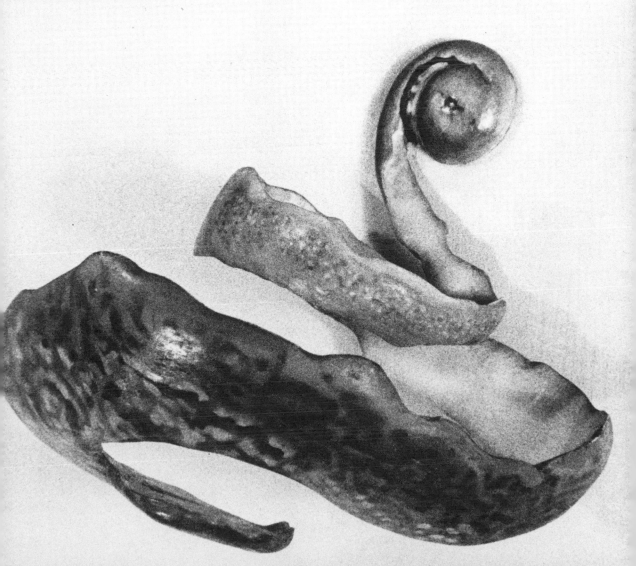

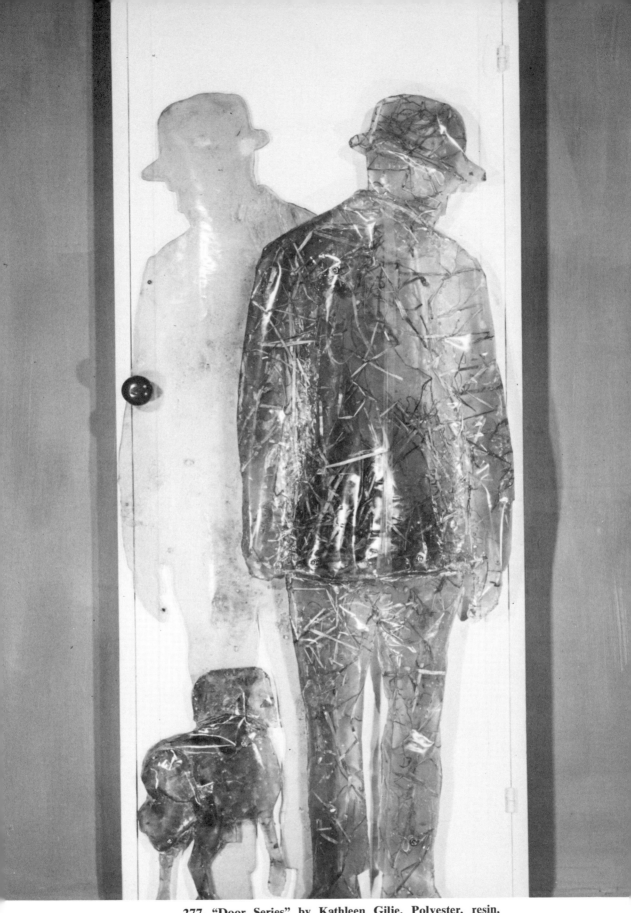

277. "Door Series" by Kathleen Gilje. Polyester, resin, 1973—76″×32″. *Photo by artist.*

SIX

PLASTICS

The word plastic simply means to form, mold, or shape, but it is used today to mean a substance which is made synthetically from organic compounds. These compounds are produced by polymerization and can be hardened with either heat or a catalyst for various commercial uses. The most popular plastics are acrylic, Lucite, epoxy, and polyester resins. Plastics also cover all the foam materials such as Styrofoam, urethane, silicones, and polyurethane. Foam plastics can be flexible or rigid, each having its distinctive advantage. Polyurethane foam can be sprayed over various forms as well as into molds. Plastic foam is commercially used as home insulation as well as in decorative interiors. The sprayed method is good for building large works because polyurethane is strong and light.

Plastics are very much a part of our modern environment. Probably no modern material is as versatile. Plastics can be transparent, opaque, colored, or made to resemble any material. They can be used as a finished product or as a substructure for cement, plaster, or reinforced resins. Silicone can be used for making molds over any material including the human body. Figures are cast and colored to resemble human details such as skin, hair, and clothes. The flexible foams can be twisted and bent into shapes and cast into other plastics. Plastic can be purchased in blocks, sheets, rods, tubes, or in various industrial shapes such as plumbing pipes. The polyester and epoxy resins can be poured into molds, or made to spread like butter over forms. Castings or constructed shapes can be sanded and finished to an incredible brightness, or made to resemble a weathered material. Acrylic sheet can be sawed with a power saw and glued (fabricated) to form enclosed volumes. Transparent colored sheets can be laid one over the other creating an illusion of depth and color change. Cast shadow and lights are

created with colored plastic windows or transparent forms. In short, just about anything can be done with plastics.

Health Hazards

Caution must be exercised when working with plastics. People who have respiratory ailments should consult their doctors before working with plastic. Vapors and plastic dust can be dangerous and even fatal to many people. The work area or studio should not be near or part of the living area. A powerful exhaust fan should be installed and a good dust mask purchased. If, however, nausea, vomiting, or excessive tiredness occurs, stop work immediately. Styrene vapors can be fatal to very young children, as well as to yourself. An exhaust fan will clear the air. A fire extinguisher is also necessary because plastics can be highly flammable. Protective work clothing is necessary as well as proper gloves. Rubber and plastic gloves can be used for many operations and will protect the hands from absorbing plastic elements through the skin. Sculptors whom I've known personally have become extremely ill because they were not protected from dust and fumes. I know of several sculptors whose health is permanently damaged and who cannot work with plastics any longer.

If, however, the correct procedures are followed, plastics can be one of the most stimulating mediums to use. Knowledge of the materials and caution in working habits will ensure many years of productive work.

Using Resins—Polyester and Epoxy

Polyester and epoxy resin are both liquid plastics which harden with the addition of a catalyst. Epoxy resin is stronger and more expensive but it is more unpredictable in the setting process. Polyester seems to set under more variable conditions whereas epoxy requires a more controlled room temperature. Think of those resins as you would of plaster or cement. Additives and fillers can be mixed with the resins. You can use sand, aggregate or clay, asbestos powder, cabosil (powdered plastic), or anything you may want to bond together. These additives and fillers decrease the amount of transparency and also reduce shrinkage. The appearance of resin can change from that of a synthetic material to one that looks organic and natural, such as stone, clay, or metal. When bronze powder is added to resin, it forms Bonded bronze, which resembles cast bronze somewhat. Bonded bronze does not have the weathering quality of cast bronze. The natural patina of cast bronze does not occur with Bonded bronze and no one knows how long Bonded bronze would last out of doors.

Plastics are relatively new and have been used only recently for major sculptural works. All materials go through chemical and structural changes

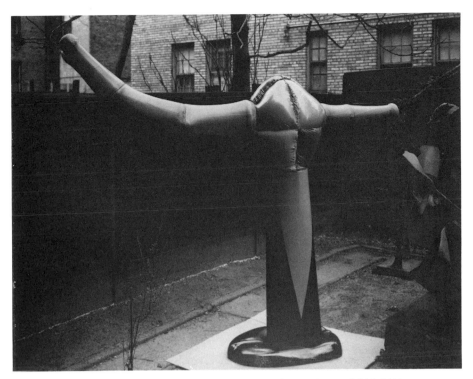

278. "Fossil" by Ezio Martinelli, 1969—6′ × 9′ × 2′. Martinelli combines sewn polyester with metal in this surrealist image that seems to have arrived from another world. *Photo by artist.*

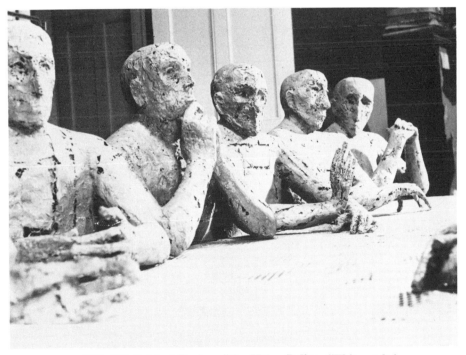

279. "Unfinished Business" by Helen Beling. "This work is built directly over a screen armature. Aluminum powder was mixed with polyester and reinforced with fiber glass. *Photo by Craig Hodgetts.*

over a period of years. Some of these changes are quick while others are slow. Wood, for example, will rot and disintegrate, steel will rust and fall apart, aluminum will oxidize and pit, even stone will crack and weather. The early resins discolored when exposed to sunlight, but no one really knows how long a major work in plastic will last. Most sculptors would probably not be too concerned about their work lasting for centuries, but a general knowledge of the life expectancy of a material is valuable. Art history has shown that the works which were done hastily or experimentally have been destroyed by time. Many works of Leonardo, Degas, Gauguin, Picasso, and others are in a sad state of repair.

In addition to fillers and additives, polyester and epoxy resin can be applied over or soaked into fiber glass cloth. This gives great strength to resin and is advantageous for forming expanses of thin shapes. Small boats and cars are made of reinforced fiber glass. A sculpture can be constructed over a metal armature in the following way:

Bond and shape metal rods or tubing into the desired design. Rods and tubes can be attached by welding or binding, using burlap strips soaked in plaster of paris. The burlap strips are wound around the overlapped rods and allowed to harden (usually in ten to fifteen minutes). Use quick-set plaster for armature construction. After the framework has been constructed, metal screening can be formed, shaped, cut, and attached to the rods or tubes. Use hardware cloth or ¼" wire screening for medium to large works. The screening is tied to the framework with soft steel wire. The completed armature should be well made and strong, being a work of art in itself.

Cut the fiber glass cloth into squares, usually 4" by 4" depending upon the size of the sculpture. Be sure you cut enough squares to cover the entire surface you are working on. Embedding polyester or epoxy resin into fiber glass by hand is a slow and tedious task. The fiber glass squares will float on the surface of the resin and several squares will stick together. Use a flat tray (a painter's roller pan is good) and impregnate the squares either with a brush or by pushing them under the resin. Wear polyurethane disposable gloves and work in a well-ventilated area with an exhaust fan. Lay up the impregnated fiber glass squares over the armature making sure each square touches the next. Use the fiber glass to reinforce the rod and tube connections. The squares can only be put on top of horizontal surfaces and will fall off if applied vertically or upside down. After hardening, the sculpture can be turned over for the covering of its other surfaces. It is not necessary to cover both sides of the screening unless the screening is visible. When the entire armature is covered with reinforced fiber glass, you should have a strong light-weight shell. Further applications of reinforced fiber glass will build thickness to the walls of the sculpture. Additives and fillers can be used with the resin to make it buttery or moldable for hand build-up. This

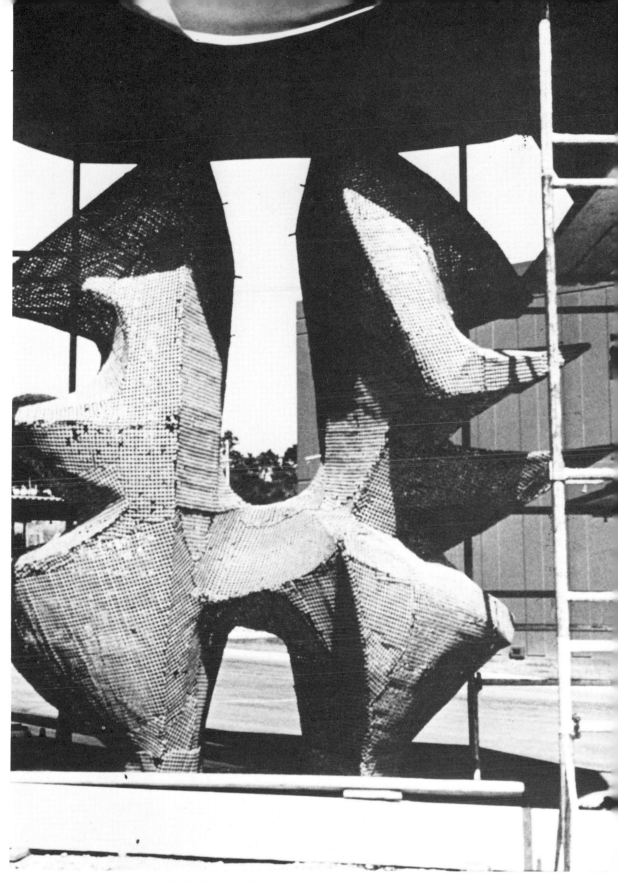

280. Plaster is being sprayed over the metal armature.

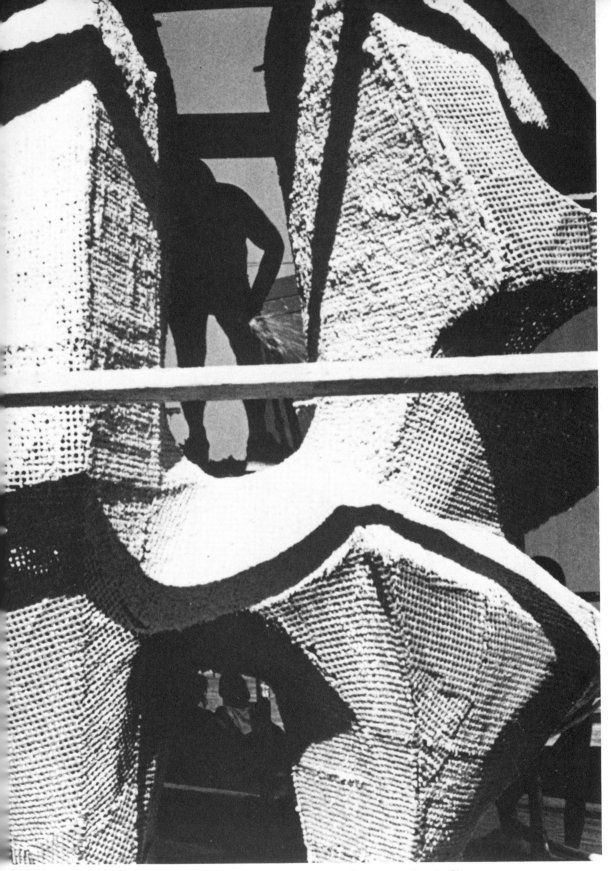

281. After the forms are developed in plaster that is 2″ thick, epoxy resin is applied to a thickness of ¼″.

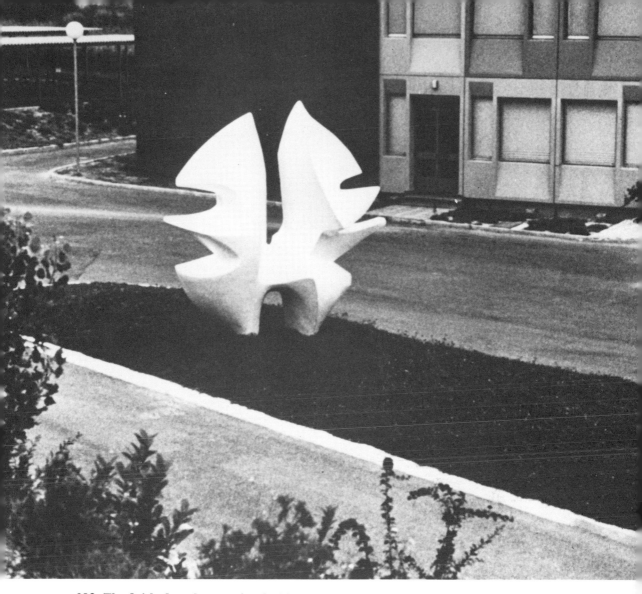

282. The finished work was painted white with several coats of epoxy paint. By Pierre Gerard. *Photos by Romain Recubert.*

technique is similar to plaster of paris construction. Use cabosil or asbestos in the resin to make it viscous. In this state, it can be applied to vertical surfaces. If too much cabosil or asbestos is added to the resin (over 50 percent), the resulting mixture will be weak. Add only enough to make the resin stick to vertical surfaces without running. When working with cabosil or asbestos, use a good dust respirator over your face as well as protective clothing; asbestos has been linked to cancer.

The forms and surfaces of the sculpture which are built with the resin in this manner will result in an extremely durable and strong material. Color can be added to the resin by simply mixing the same amount of color each time. Color can be purchased in marine supply stores or from suppliers of

plastic materials. Inert powdered pigments can also be used as a coloring agent. Mars black, Venetian red, rottenstone, potassium oxide, as well as other inert colors can be mixed with the resin for color. Color as well as additives must be added to the resin before the catalyst is added. Remember that the catalyst is always added last. This will ensure enough time for working the exact mixture you want.

The Catalyst

Adding the catalyst (hardener) to polyester and epoxy is an exacting operation. Each polyester and epoxy has its own catalyst and it is usually best to follow the directions of the particular producer. There are, however, various conditions you must be aware of. Temperature and humidity play an important role in the successful hardening of resin. Epoxy is especially sensitive to temperature and more catalyst may be required for setting in temperatures below 65 degrees. If epoxy does not set, heat may be applied. A hot-air blower or infrared lamp or some kind of heating appliance may be used. Do not use an open flame because of the danger of combustion with the resin. Too much catalyst in polyester resin can cause the resin to smoke, fume, and crack. When pouring thick sections of resin, use less catalyst. Heat build-up while hardening can cause the resin to crack. If the resin begins to get very warm, place the resin in a cool spot. Do not move the resin if it has already started to gel because this can distort the form. If the resin continues to overheat, use less catalyst or consult the company for advice.

Some of the epoxy resins which are yellowish in color can be made almost crystal clear by adding a 1 percent solution of Perox Blue Whitener.

Tools for Plastic

Both polyester and epoxy resin can be cut, sawed, sanded, and even carved. Basically, the same kinds of tools used for woodwork and metal can be used for resin and most plastics. There are a few variables in working plastic. Sawing, sanding, and drilling can burn the plastic if too high a speed is used. Generally a slower rpm on your power tools works better for plastic. Using wax or tallow as a lubricant also helps in the drilling and sawing of plastics. These can be purchased in an industrial hardware store or from a metal finishing supplier. Sears, Roebuck has a good hardware department for a sculptor's needs. Eye goggles and work gloves must be worn when drilling or sawing plastic. Plastic can shatter and fly in all directions, hurting someone nearby. Such operations can be done in a caged-off area if working in a classroom studio or where other people are present. Children should not be around when work with plastics is going on.

Sanding plastic is especially dangerous because of the very fine dust that

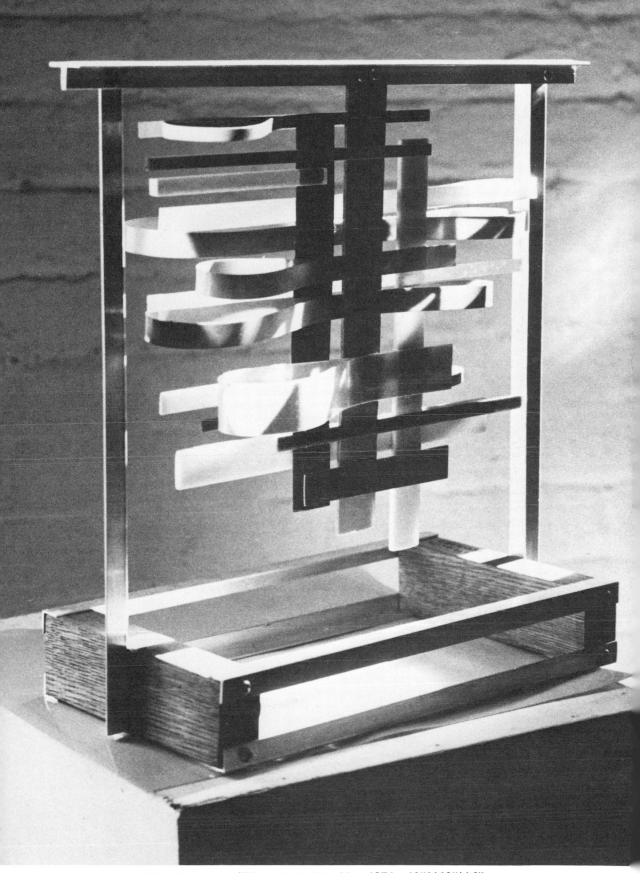

283. "Crossway ⚹7" by Anita Weschler, 1974—13″ × 13″ × 6″.
An example of a sculpture where some of the same tools were used for plastic, wood,
and metal. *Photo by Marjorie Gilbert.*

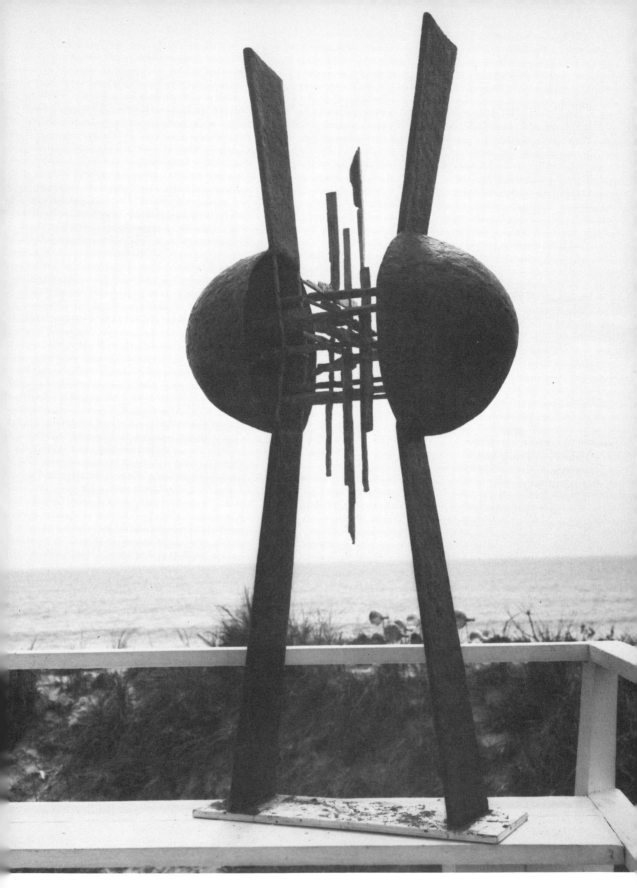

284. "Dynamics" by Lily Landis, 9′ height. Epoxy, resin, and ground brass. Here plastic is constructed and modeled, taking on some of the qualities of a welded steel sculpture. *Photo by Mike Elliot.*

can be breathed in. Wear a good respirator as well as safety goggles. Work clothing will have to be washed after every session of sanding. Plastic dust is very difficult to brush off of clothing. As with welding, a strong exhaust fan is necessary to clear the air. Try to sand near the exhaust fan to minimize dust or vapor build-up. Sanding plastic is done by starting with the coarse grits and working toward the finer ones. If sanding by hand, use emery paper. Use a flexible fiber disk if sanding with an electric drill or sander. When sanding with a power tool, do not overheat the plastic because the material will begin to "pull." This is the plastic becoming flexible again and reforming itself toward the direction of the sanding disk. If this happens, sand this area by hand or use less pressure on the tool. Plastic and resin can be sanded down to grit No. 600 and buffed to a high gloss with wax. For a satin or dull finish, simply finish sanding at desired grit. Paraffin or beeswax can be mixed in with resin which will also dull the surface.

When drilling through thick resin or plastics, use a vise or clamping system to hold the work stationary. A blade drill bit which is used for wood will also work for resin. Apply the pressure slowly and stop if you smell burning. Use tallow or wax for lubrication. Flat acrylic sheet can be cut on a table saw using a fine tooth circular saw blade. If using a band saw, use a ten to fourteen tooth per inch blade for cutting. A variable speed band saw has the advantage that you can slow it down by changing the drive belt on the pulleys. All sawing should be done while wearing eye goggles and work gloves.

We've discussed making a resin construction over a metal framework. Another way of working resin or acrylic is to cast blocks or shapes. Blocks can be made by pouring the resin into a prepared box. The box can be made of plywood, metal, masonite, or any rigid material, but a mold separator must be used. Coat the inside of the box with paraffin mixed with motor oil or Vaseline. Wood should first be sealed with several coats of shellac. The box should be tight (sealed with plastelene) so that no resin can leak out. The mold should come apart easily after the resin has set. Use wood screws for a wooden box or mold. A silicone mold can also be used. Silicone is a rubberlike substance which can peel off a form like a glove from a hand. I will discuss silicone molds and piece molds in more detail later.

After pouring the resin blocks or shapes, you can saw the forms into smaller units. These can be sanded or drilled and then rejoined. A construction in solid plastic is very exciting because of the transmitting of light from one form to another. The blocks can be joined by using the same material for the adhesive, in the case of the resins. For joining acrylic blocks, make sure the surfaces are perfectly flat. A table belt sander is useful for this purpose. An acid is used for bonding the acrylic. Usually an eyedropper is used to apply the adhesive acid to the joint. The blocks must be first set

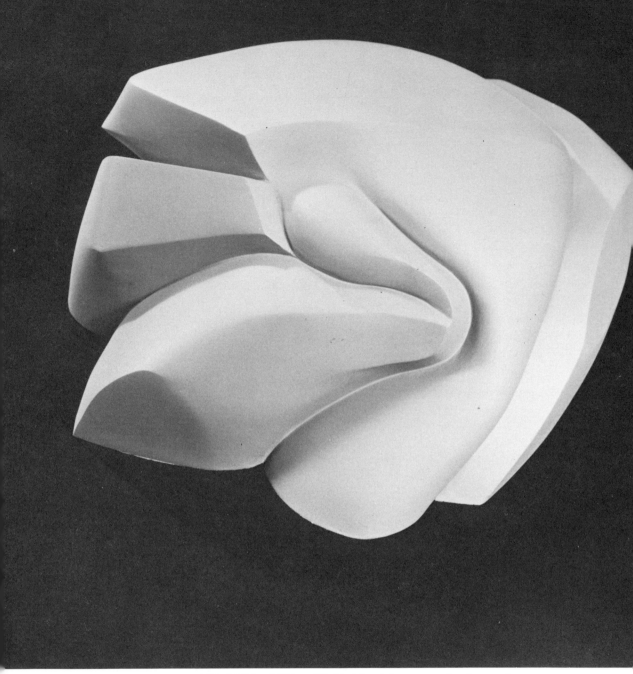

285. "23" by William Nettleship. A fine example of organic forms in plaster and epoxy. *Photo by artist.*

together perfectly, and then the acid is applied. There is also a bonding adhesive for acrylic called PS 30, but this requires twenty-four hours of setting whereas the acid adhesive is almost instantaneous. This acid adhesive (ethylene dichloride, according to the chemist) is a solvent which runs along the edges of the plastic fusing the two parts together. The eyedropper is used for application of the solvent. This is usually done in seconds, but the glued pieces should remain in position for several minutes undisturbed.

Acrylic is commercially available in sheets, tubes, rods, domes, and other industrial shapes. In sheet form it comes covered with a protective paper which is firmly adhered to the surface to protect it during sawing. Once the paper is removed, however, great caution must be taken in keeping the acrylic from getting scratched or marked. All sawing and sanding should be done while the paper is still adhered to the acrylic. Scratches can be removed from the acrylic sheet using a buffing wheel and compound. Use a soft sewn cotton wheel with little pressure or slow speed. These are the same type of cotton wheels discussed in the section on polishing metal. (See list of suppliers for sources.) The principles are the same for both plastic and metal, but a slower rpm is necessary for plastics. A foot rheostat for the flexible shaft grinder is most helpful because of the ability to slow down when necessary. Foot rheostats can be purchased from machine suppliers or even industrial hardware stores. Keeping acrylic clean and free from dust, which is attracted through static electricity, is accomplished by spraying an antistatic cleaner. A vacuum cleaner is very helpful in getting rid of plastic dust.

Acrylic is highly transparent and many artists take advantage of this quality. A favorite way of working acrylic is to fabricate a transparent box which incorporates other objects or pieces of plastic inside. Many decorative materials are available for the internal construction, which can range from motorized elements to industrial patterns. Neon tubing and fluorescent lighting have been incorporated in acrylic boxes. All these attractive elements, however, must be constantly maintained, otherwise much of the excitement of a transparent work is lost. Neon lights burn out, motors stop, plastic eventually fades, seams open so that unless strict maintenance is adhered to, the destruction of plastic work is swift.

Rigid Foams

The best use of plastics is in the form of rigid foams. Large blocks of Styrofoam or polyurethane foam can be purchased or made and can be used in several ways. All of these ways have one thing in common; they are used for support or for casting into other materials. The one exception is the covering of rigid foam with an epoxy coating. Rigid foam can be shaped with a Shur-form rasp, a saw (keyhole saw is best), a hot wire cutter, a sharp, serrated knife, or by flame (beware of toxic fumes).

LYNN MAYO AT WORK

286. The mold is multi-layer fiber glass (mat and woven roving), finished on the inside with a gel coat. It was cast over a varnished plaster positive. Several coats of Butcher's Bowling Alley Wax are applied and buffed before casting.

287. Casting. Fiber glass mat is cut to fit the inside of the mold and a layer of resin and a second coat of resin applied. Safety equipment: chemical respirator, surgical gloves.

288. Assembling mold. Safety equipment: chemical respirator, surgical gloves.

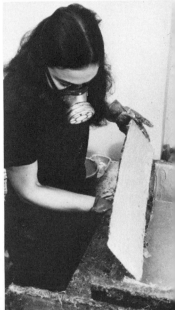

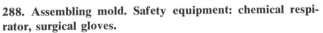

289. Trimming cast with saber saw, carbide blade. Safety equipment: face shield, respirator, work gloves.

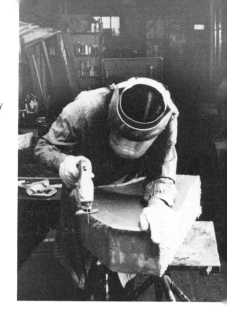

290. Sanding cast (belt sander). Safety equipment: face shield, respirator, work gloves. Smock is all Mayo wears—the sanded particles penetrate any fabric and itch "like mad" to quote the artist; "After sanding, I drop smock and run like mad for the showers!"

291. Finished work: "Right of Passage"—resin and fiber glass. As shown at Storm King Art Center, spring 1976. Assembled from mold-cast sections, surfaced with grog and vermiculite.

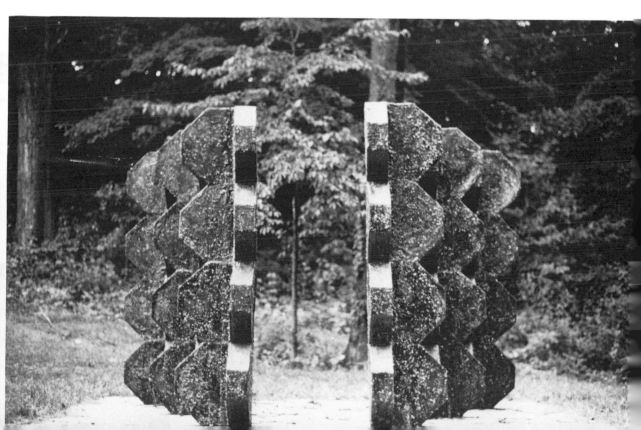

Foam can then be sanded and parts can be built or joined through gluing. Rubber cement works best for gluing parts, but the glued surfaces must be flat to ensure full contact of each surface. Dry mounting works best for gluing rigid foam. Spread an even layer of rubber cement on both surfaces to be glued. Allow several minutes for the rubber cement to dry. Once it's dry, carefully position and press the forms together. If done correctly, the forms will not come apart. Dowels of wood, plastic, or metal can be inserted for further strength, but should not be used if metal casting is to be used.

Lost Foam Casting

Finished rigid foam can be cast into any high temperature metal. The foam sculpture is set in a sand mold and tightly packed with sand all around. Vents and a feeder, also rigid foam, are made on the piece. Molten metal is poured into the sand mold. As the hot metal comes into contact with the foam, the foam evaporates, leaving the metal to take its place. I've termed this process the "lost foam method" for want of a better name because it is similar in idea to the lost wax method of bronze casting. The lost foam method has some advantages and disadvantages. One advantage is that this method is relatively inexpensive compared to the lost wax method of bronze casting. Many commercial foundries do Styrofoam casting into metal. The disadvantage of lost foam casting is that each work is cast solid. A cube of Styrofoam, for example, would become a solid cube of bronze, aluminum, or iron, which would be extremely heavy. Styrofoam and other foams can of course be hollowed out, or fabricated from thin (¼") foam sheet, and although sculpture will tend to be heavier than in the lost wax method for bronze castings, much weight and cost of material can be cut down.

The important thing when doing lost foam casting is to find a foundry willing and cooperative to take a little extra time in casting your more complex forms. Foam which has been hollowed out must be filled with casting sand. Often, complex works must be cut into parts and cast separately. Later the parts can be welded together, but you must find a foundry which will do this well, even if you must pay for this service. Many production-type foundries will not deviate from what they are doing and will give you either bad service or none at all. Most commercial foundries charge according to the weight of the casting, but a very complex piece may be charged differently. From the contemporary point of view, the advantages of lost foam casting far outweigh the disadvantages. Rigid foams can be made into a great variety of shapes and forms, all of which can be further worked directly in the metal casting, and finally be welded together into sizeable works. Most commercial foundries will cast in bronze and aluminum. Some will cast iron and other metals, but it is difficult to find a foundry that will cast in all these metals.

Rigid Foam as a Support for Cement, Plaster, and Synthetics

Rigid foams such as Styrofoam have great strength although they are very light. A cubic foot of Styrofoam will easily support your own weight without collapsing. If a cubic foot of Styrofoam were covered with a 1″ thick layer of cement on all sides, you would have a strong and durable form. The foam should be coarse for good adhesion with the cement, whose surface can be finished smooth if desired. For very large out-of-door works, the cement should be thicker than 1″. Contraction and expansion due to heat and moisture can cause the cement to crack. A 2 or 3″ thick surface of cement on a 10′ high sculpture, for example, should hold up very well. A supporting armature may be necessary depending upon the design.

A general principle of good structure in sculpture is that a stronger armature is required if the form is made thinner. Armatures are usually made of metal although wood is sometimes used. Metal, such as iron rods or screening, has great tensile strength which is able to support another material such as plaster or cement. If polyester resins are used in combination with fiber glass cloth over a metal armature, the tensile strength of the sculpture is greatly increased. Plastics have excellent tensile strength. It is possible to make large expanses of thin forms such as domes and spheres and still have the form remain under 1″ in thickness.

If you wanted to make a cement sculpture, you would make such an armature as described above. The metal screening should be the type used for cement construction, which is called "diamond cut mesh." This is especially suitable for large works. With a well-made armature of diamond cut mesh, you need not make the cement very thick and therefore the sculpture can be much lighter in weight.

Diamond cut mesh can also be attached to the Styrofoam. The cement is then troweled over the mesh which is supported by the Styrofoam. The mesh would minimize shrinkage and cracking. When covering a large work with cement, manipulate the work so that cement is always troweled on the upside surface. After the cement has hardened, the work can be turned again. Pay particular attention to the edges and make sure none of the cement falls away from the surfaces. Loose parts should be broken away and patched with the same cement mixture. Wet the area with water before patching. Edges and continuing surfaces must also be wet before fresh cement is applied to hard cement. When troweling cement, use a mason's metal trowel with serrated teeth on one side. Press the cement firmly into the screen mesh or Styrofoam. Cement should not be watery; it should be firm when troweled on. Keep the cement damp by spraying a fine mist of water over the surface. Windex bottles are good for this. Do not expose the cement to the sun. This will cause it to dry too quickly and result in a weak setting. Cover the cement with a plastic sheet (the type used by dry cleaners is fine). This will keep the moisture in and result in a harder set. A high

temperature refractory cement such as Cement fondu, ferro cement, or alumina silica cement works best because of the adhesive qualities of these cements. The cement can be built up to a great thickness by making sure to allow the underneath surface to set hard and be thoroughly wet before you apply fresh cement. Better adhesion occurs when the underneath surfaces are left rough instead of smooth. Various sands, gravels, and aggregates can be mixed in with the cement. Crushed stones ⅛" screen grit, or white sand, or vermiculite can be mixed with the cement.* Vermiculite is a plastic grain which will result in a lighter weight cement mixture. Garden shops and nurseries sell vermiculite. Cement can be finished when hard with masonry tools, rasps, or grinding disks. The cement should be allowed to harden for eight days before finishing with masonry tools. Color can be added to cement with dry inert powders such as lampblack or Venetian red. A cement mixer is also a must if such work is to be done.

Plaster of paris can also be applied over rigid foam. Because plaster is weaker than cement, use a hard setting plaster such as industrial plaster, superfine casting plaster, or Hydrocal. Dental plaster is also excellent for covering rigid foam, but is usually limited to small works because of its high cost. For large works, or added strength, burlap squares should be cut (4" by 4") and soaked into the plaster. The burlap squares can then be hand laid on top of the horizontal surfaces of the rigid foam. As in the cement construction, the work can be turned when the up surfaces have set hard. Wet the set plaster with water before applying fresh plaster. The burlap squares should be touching or slightly overlapped. After setting, the plaster can be built up to any desired thickness. Make sure each set layer is thoroughly wet with water before applying fresh plaster.

Plaster of Paris

Plaster is made from a calcium stone (calcium sulfate) which is burned and ground into a powder. A paste is made when water is added to the plaster powder. Plaster is produced and supplied throughout the United States and Europe. Most building supply companies have plaster. Gauging plaster is a coarser and weaker form of plaster. It is good enough for certain rough studies, but for sharp finished surfaces, superfine casting plaster, sometimes called art plaster, or industrial plaster is best. The Knickerbocker Plaster Company in New York supplies most of these plasters.

Plaster-covered rigid foam is very light and not suitable for out of doors. It is excellent for making sculpture models to be shipped to bronze foundries or stone carving quarries. Henry Moore uses Styrofoam to make full-scale models which are cast or carved in foundries or quarries.

* Cement mixture is usually three parts sand to one part cement—add desired amount of aggregate.

Epoxy and Polyester Resin Covered Foam

The resins can be used to cover rigid foams. Be sure to use a resin that does not attack the surface of the rigid foam. For a list of different resins and their applications, see "Types of Resins and Molding Compounds, with Applications" later in this chapter. Polyester resin will attack many types of Styrofoam. Use epoxy resin as a first coat on the Styrofoam. Polyester can then be applied over the epoxy, which protects the Styrofoam. This is advantageous because polyester is half the cost of epoxy. Fiber glass soaked with resin can be hand laid over the rigid foam. Fillers and additives as well as color can be added to additional layers of resin. For finishing resin, see the section on "Tools for Plastic."

Other Uses of Rigid Foam

A mold can be made directly over rigid foam. This can be a plaster waste mold, piece mold, or flexible (rubber or latex) mold. A casting can be made in any material once the mold is made. Use a mold separator (green soap, Vaseline, silicone) on the rigid foam before plaster is applied to the surface.

Rigid foam can itself be the mold into which another material is poured. The foam can be sawed and glued into a boxlike form which is prepared and filled with cement, plaster, or resin. A hot wire cutter can be used to make complex curved surfaces which can also be filled with various material. Plain or carved Styrofoam pieces may be cut with an electrically heated wire. Inexpensive sets are available commercially, but a handyman or hobbyist can make his own. Using the hot wire takes a bit more practice than cutting with a saw or knife, as the hot wire melts and shrinks the foam. The foam is fed into a chrome nickel wire (silver ni-chrome). The diagram shows how to build a hot wire cutter. A transformer and control switch is connected to an electrical wire which is held taut by the galvanized pipe at top and a metal rod under the wooden platform or base.

A burned surface can be filled with any material. Remember that you are working in reverse when using rigid foam as the mold. A hole or concavity in the foam will become a projection in the cast (concrete, plaster, etc.). For a three-dimensional cast from rigid foam, construct a strong box in either Styrofoam sheet (2" thick) or plywood (¾"). Glue foam shapes inside the walls of the box including the top surface. Taper the forms so that they will come away from the casting material easily without undercuts.

Close the box (use screws if it's plywood, plaster-soaked burlap if it's Styrofoam). Once the box is closed, turn the box upside down so that the open bottom is up. What you see inside is the negative of your cast. The projections of the inside walls will become depressions or concavities in the cast.

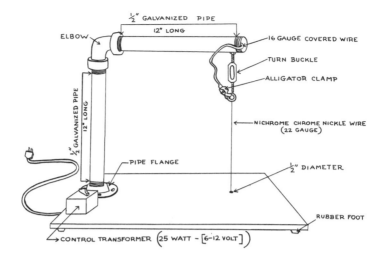

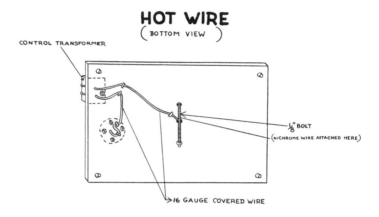

HOT WIRE
(BOTTOM VIEW)

292. Hot Wire. *Diagram courtesy Snow Foam Products, Inc.*

Filling the box is no easy task, especially if the box is over 3′ tall. Slush casting is necessary.

Slush casting consists of revolving the mold around to allow the casting material (plaster, etc.) to attach itself to the inside walls as it sets and thickens. This requires some knowledge of the casting material. For example, plaster takes between ten and twenty-five minutes to thicken before it will not flow. This means that within that time limit, you can revolve the mold to build up the inside walls with the casting material. The mold may require two or three sessions of slush casting to build to the required thickness. Castings should not be made too thick and heavy and should be reinforced inside with plaster-soaked burlap or metal screening.

Each technique for filling the mold has its own problems, but the casting

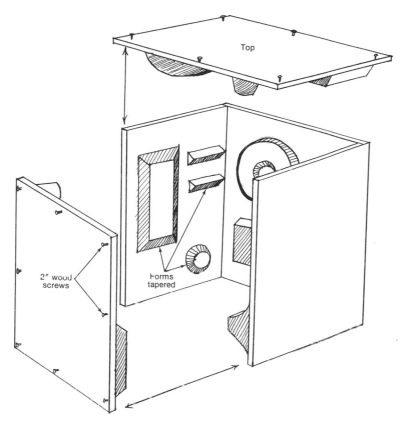

Top

2" wood screws

Forms tapered

293. Plywood box for reversible casting. Bottom remains open. When box is screwed closed, turn box over and fill with plaster, cement, or resin.

material should also determine how you fill the mold. For a plaster cast, slush casting would be the best technique. Have someone help you fill the mold. You will need to move the heavy mold around, and someone will have to prepare the buckets of plaster for you to slosh in the mold. Pour in a bucket of plaster slowly in one corner until the bucket is empty. This will break air bubbles and push trapped air away from pockets in the form. Slowly revolve the mold so that the plaster runs into all corners and crevices of the internal forms. On a large mold, it may be necessary to lay the mold down to fill each side. Do not fill the box solid with plaster as this will result in an extremely heavy cast. Build the internal sides to a 1" thickness and reinforce with plaster-soaked burlap, or wire screening (¼"). The mold can be opened once the plaster has passed the warm stage in its setting. For delicate details in the cast, allow the plaster to set for one hour.

Open Mold

For filling the mold with cement or resin, use the "open mold" method. The chart at the end of this section includes resins for open mold fabrication. Open mold casting is that method which fills each section of the mold separately while the casting material is still soft. This method depends upon precise timing because if the separate sections harden before they are closed, you can ruin the mold and casting. In the case of plaster, it would be wise to add a retardant to prevent fast setting. A plaster retardant is sold commercially by masonry suppliers, or you can add one tablespoon of vinegar to a bucket of plaster, which will slow down the setting time.

The separate sections of the mold must be squeezed together when the plaster is soft but not liquid. Try to ensure that the separate sections are attached by pressure and by tamping the outside mold with a soft (rubber or wood) hammer.

Cement must be tamped or pounded into the mold with a piece of wood. The sides of the box are filled separately, making sure that sides do not collapse or overlap the edges of the mold. When using cement, you have more control of timing because cement sets slowly. When the cement gets firm (but not hard), put the mold together. Stand the four sides close to each other (you will need one or two extra hands for this). If firm enough, the cement should not fall away from the box. Mix a loose (cream) mixture of cement and gently paint onto the edges of the cement cast which will come together when the mold is closed. The mold can be squeezed together by using wood screws, or furniture pipe clamps. You should see the loose mixture of cement ooze from the corner edges inside the mold when the mold is squeezed closed. Add more cement to the corners inside the mold to ensure total adhesion of each side to the other. The top side, which is on the bottom during filling, is also attached to the four sides in the same manner. Use a long wooden spoon to reach inside the mold. The inside of the cement cast can be reinforced with ¼″ metal screening, diamond cut mesh, or ½″ reinforcing bar. Allow the cement to set and cure for twenty-four hours. Keep the cement moist by covering the mold with sheet plastic. If possible, keep the mold closed for three weeks for further curing and hardening.

When later the mold is opened, use water to break the vacuum created between the cement cast and the mold. The sides of the mold should come off easily. Any rigid foam stuck in the cast can be cut with a sharp knife and pulled out piece by piece. Lacquer thinner or acetone will also dissolve Styrofoam, if it will not come out manually. After all the foam has been removed, clean the cast with soap and water. A mild detergent will remove most surface discolorations and oil. Some sculptors use oxalic acid to clean cement, followed by a thorough rinsing with water. Cement cleaner can be

purchased in hardware stores. The success of any cement casting depends on how well the cement was tamped into the mold. Cement should not be poured like plaster because too much water will weaken the setting and curing of cement. The cement should be gritty and coarse in texture before being tamped.

Cement can be filed, ground, or even carved after it has set and hardened for twenty-eight days. A Carborundum stone can be rubbed over the cement with water. This will grind the cement, leaving an even-textured surface. For a smoother finish, sanding disks and emery abrasives can be used in the same way as they are for limestone and marble.

Rigid foam or Styrofoam can also be cut with a hot wire cutter into curved surfaces (see illustration 292). If thick blocks of foam are used for cutting these curved surfaces, the foam can be used as the negative mold into which to pour any desired material. Rigid foams can be made into many forms and shapes, all of which can become the negative mold for casting other material.

Very large castings in cement or resins are possible using Styrofoam or rigid foams as the negative mold. Take a block of Styrofoam and either cut or burn a depression or hollow into the surface. This depression should be lightly coated with Vaseline. Fill the depression with cement, plaster, or resin. Be sure not to use a resin that will attack the foam. Allow ample time for setting and hardening. Remove the hardened material and you will have a cast. Such a method can be used for intricate designs. This technique is particularly adaptable to architectural wall reliefs.

Types of Resins and Molding Compounds, with Applications

On the following pages, charts are provided that show the various types of polyester resins, polyester molding compounds, epoxy resins, and polyester resins specifically designed for open mold fabrication. These charts would be very helpful in choosing and ordering the specific type of material most suitable for the work you are planning. Some of the information, especially on the first chart, is fairly technical and cannot be fully explained here. Those who wish a complete explanation of the chemical makeup of each type may contact Reichold Chemicals, Inc. at the address in the back of the book.

POLYESTER RESIN*

Resin Type	Catalysts	Description	Application
SUPEROX 700	MEK Peroxide	60% MEKP† in DMP‡	General polyester resin catalyst.
SUPEROX 704	MEK Peroxide	60% MEKP in DMP	Polyester curing at low temperatures.
SUPEROX 722	MEK Peroxide	60% MEKP in DMP	Rapid cure in clay pipe seal applications.
SUPEROX 723	MEK Peroxide	60% MEKP in DMP, Red Color	Catalyst identification in spray-up.
SUPEROX 725	MEK Peroxide	60% MEKP in DMP	Designed for use with polyester gel coats.
SUPEROX 729	MEK Peroxide	Special reduced flammability MEKP	General polyester resin use.
SUPEROX 731	MEK Peroxide	Special proprietary MEKP in DMP	Unique polyester curing requirements.
SUPEROX 738	MEK Peroxide	Special proprietary MEKP in DMP	For use with water-filled polyesters.
SUPEROX 705	Benzoyl Peroxide Paste	55% BPO Paste in BBP	Elevated temperature polyester cure.
SUPEROX 706	Benzoyl Peroxide Paste	50% BPO Paste in BBP	Elevated temperature polyester cure.
SUPEROX 742	Benzoyl Peroxide Dispersion	40% BPO Dispersion in Plasticizer	Elevated temperature polyester cure.

* Courtesy Reichold Chemicals, Inc.
† MEKP—Catalyst.
‡ DMP—Additive compound that accelerates the action of the compound.

POLYLITE® CLEAR CASTING RESINS*

RCI Code†	Gel Setting Time‡ (minutes)	Description
32-032	25–35	Extreme clarity, acrylic modified.
32-033	20–25	For encapsulation of metallic objects. Excellent clarity.
32-035	20–25	Resistant to thermal cracking. Adaptable for color matching. Excellent clarity.
32-037	10–15	Premium resin. Fast curing in the cured state. Refractive index similar to glass. Good hot strength.
32-039	8–12	Excellent clarity and color. For decorative embedments.

* Courtesy Reichold Chemicals, Inc.
† Reichold Chemicals, Inc. Code
‡ 100 grams, 25° C, 1% Superox® 700

POLYLITE® RESINS FOR SPECIAL APPLICATIONS*

RCI Code†	Viscosity CPS	Promoted	Type	Description	End Use
31-402	4000–6000	No	DAP Modified	Not available.	MMD molding.
31-822	2000–4000	No	Monomer-free	Vehicle for pigment grinding.	Pigment pastes.
31-830	600–900	No	Flexible IPA	Resin exhibiting outstanding toughness.	Adhesives, blending.
31-851	300–450	No	Flexible	General purpose, low viscosity.	Blending.
31-866	100–150	No	Flexible	High elongation, accepts high filler loading. Low shrinkage.	Clay pipe seals.

* Courtesy Reichold Chemicals, Inc.
† Reichold Chemicals, Inc. Code

RCI Code	Viscosity CPS	Promoted	Type	Description	End Use
32-180	50–150	Yes	Water-fillable	For emulsification with water in casting applications.	Decorative casting.
32-344‡	250–300	Yes	Resilient	For open mold casting with fillers.	Furniture parts, decorative casting.
32-345‡	300–400	Yes	Resilient	Dual promoted for BPO/MEKP curing.	Autobody patching compounds.
32-356	200–300	Yes	Flexible	Designed for fast gel/cure with fillers.	Furniture parts, decorative casting, adhesives.
32-357	200–300	Yes	Resilient	Designed for fast gel/cure with fillers. For general purpose open mold casting.	Furniture parts, decorative casting.
32-358	400–500	Yes	Resilient	Designed for fast gel/cure with fillers. For use with structural embedments.	Furniture parts, decorative casting.
32-367	400–475	Yes	Resilient	Promoted for use with BPO, exceptional stability.	Autobody patching compounds.

‡ Available on West Coast only.

RCI Code	Viscosity CPS	Promoted	Type	Description	End Use
32-516	2700–3700	No	Rigid	Light stabilized. For reduction with styrene or methyl methacrylate.	Fiber glass panels.
32-738	150–250	Yes	Surfacing	Non-wax, non-air-inhibited coating resin.	Furniture finishing, clear coatings.
32-773	600–800	Yes	Resilient surfacing	Non-air-inhibited for impact resistant surfacing.	Boat covering, protective coverings.
33-773	500–800	Yes	Resilient surfacing	Thixotropic version of 32-773.	Coatings applied to vertical surfaces.

POLYLITE® POLYESTER MOLDING COMPOUNDS*

RCI Code†	Color	Description	Application
30000-1	Black	Glass and mineral filled.	For compression- and plunger-molded parts having outstanding electrical properties and low water absorption.
30000-2	Gray		
30001-1	Black	Glass and mineral filled.	For plunger- and injection-molded parts having outstanding electrical properties and low water absorption.
30001-2	Gray		
30001-3	Blue		
30002-1	Black	Cellulose filled.	Excellent moldability with low specific gravity and excellent electrical properties. Fast cure.
30003-1	Black	Glass and mineral filled.	For compression and plunger molding with improved impact strength.
30003-2	Gray		

* Courtesy Reichold Chemicals, Inc.
† Reichold Chemicals, Inc. Code

EPOXY RESINS CHART*

Type	Recommended Resin/Hardener	Ratio in Grams	Pot-Life Set Time at (77° F)	Comments
Polyamide (37-612)	100 (Grams) Resin	60–85 (Grams Hardener)	50–70 minutes at room temp.	General purpose resiliency and adhesion.
Polyamide (37-625)	100	45–70 "	110–130 minutes at room temp.	Moderately fast reactivity.
Polyamide (37-640)	100	35–60 "	150–180 minutes at room temp.	Versatile polyamide, moderate viscosity.
Modified Amines (37-605)	100	31 "	25–35 minutes at room temp.	Low viscosity, moderately long pot-life.
Modified Amines (37-614)	100	26 "	12–15 minutes at room temp.	Excellent general purpose.
Modified Amines (37-622)	100	19 "	25–30 minutes at room temp.	General purpose low viscosity, wide use range.
Amido Amines (37-620)	100	50–100 "	120–150 minutes at room temp.	Low viscosity, extremely versatile.
Amido Amines (37-630)	100	35 "	35–45 minutes at room temp.	Combines best properties of amido amines and amines.

*Courtesy Reichold Chemicals, Inc.

POLYLITE® POLYESTER RESINS FOR OPEN MOLD FABRICATION*

RCI Code†	Type	Description
31-000	General purpose	Medium reactivity base resin.
31-001	General purpose	Low reactivity base resin.
32-037	Clear casting	Air-inhibited, suitable for surfboard laminating.
32-739‡	Laminating	Light stabilized, for surfboard laminating. Excellent color.
32-740‡	Laminating	Light stabilized, non-wax, light color surfboard laminating resin.
33-031	Laminating	Excellent cure in thin sections.
33-049‡	Laminating	Rapid wet-out, controlled exotherm spray-up resin.
33-067	Laminating	Longer gel version of 33-072, color change upon catalyzation.
33-071	Laminating	Fast gel, fast cure version of 33-072.
33-072	Laminating	Exceptional wet-out. Low exotherm. Color change when catalyzed.
33-081	Laminating	Exceptional wet-out. Longer gel version of 33-072.
33-084	Laminating	Fast wetting, low exotherm. Designed for use in warm climates.
33-086	Laminating	Fast wetting, controlled exotherm. Designed for ambient temperature variations.
33-089‡	Laminating	Excellent wetting, controlled exotherm spray-up resin. Non-wax.
33-092‡	Laminating	Fast wetting, controlled exotherm spray-up resin.
33-401	Tooling	Resilient version of 33-404.
33-402	Tooling	IPA-modified laminating resin for mold making. Good hot strength.
33-404	Tooling	Slower gel, slower cure version of 33-402.
33-770	Laminating	Resilient, impact-resistant, medium viscosity lay-up resin.

* Courtesy Reichold Chemicals, Inc.
† Reichold Chemicals, Inc. Code
‡ Available on West Coast only.

Using Plastics and Chemicals Safely

Artists and crafts people throughout history have had to contend with safety and health problems inherent in their materials and/or fabrication processes. Plastics are no different. If you are uncertain as to what to do or how to do it, don't do anything until you have spoken to an instructor or expert. Some common sense precautions:

1. Work in uncluttered area away from others.
2. Remove all jewelry, neckties, etc., and button up clothing. Tie back long hair. Wear clean protective smock or apron and long-sleeved, high-necked shirts, and shoes with soles and heels that grip.
3. Keep plastics and chemicals away from heat and open flame. If improperly used or stored, some materials may present a fire hazard. Disposable containers should be used. Working surfaces should be covered with polyethylene film, which is disposed of after use. Use disposable towels for clean-up. Garbage should be removed from the premises regularly. Do not smoke when using these materials. Keep a fire extinguisher available. Keeping containers closed also prolongs the shelf life of materials.
4. Some plastics, particularly epoxies and fiber glass, can be irritating to skin. It is recommended that disposable gloves be worn to avoid skin contact. If contact does occur, the affected area should be washed thoroughly with soap and water. Hand cream is recommended to restore natural oils. If irritation occurs, call physician.
5. Avoid breathing vapors and dust. Find alternatives to aerosol sprays, i.e., brushing, dipping, etc. Working area must be well ventilated. A large room with a good passage of air is essential; open the windows, and use ventilators and fans. With adequate ventilation, the concentration of toxic vapors in the air will be reduced to a safe level—despite the presence of relatively strong odors. Wear proper respirator if ventilation is poor. When cutting, filing, or sanding, always use a dust mask and face shield. Vacuum after working.
6. Avoid eye contact. Plastic dust and fumes are damaging to eyes. It is recommended that protective glasses or face shield be worn at all times when machining or mixing any chemicals and plastics. If materials are splashed or rubbed into eyes, flush with water for fifteen minutes. Call a physician at once.
7. Do not take internally. Harmful or fatal if swallowed. These materials must not be used near food or kitchen areas. They must never be stored in food containers or in the kitchen refrigerator. Hands should be thoroughly washed before eating or smoking. In event of an accident, call a physician at once.
8. Keep all materials out of reach of children, who should not be allowed into the workroom. It is recommended that a locked cabinet or closet be set aside for the storage of plastic materials and chemicals whenever they are left unattended.

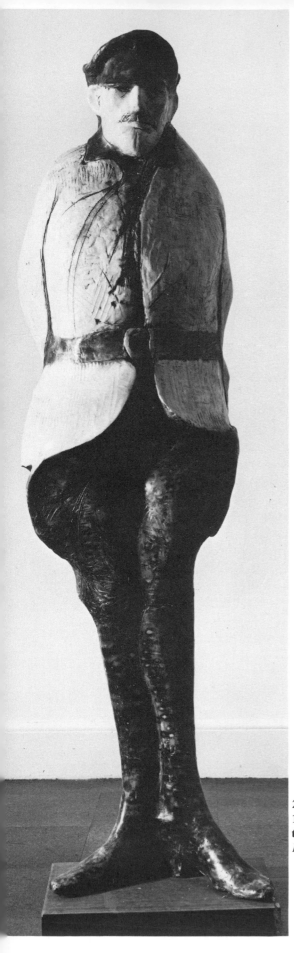

294. "Cavalry Officer" by Frank Gallo, 1965—66″ × 18″×14″. The sense of human personality, even caricature, comes through in Gallo's sculpture. *Photo by Rudolph Burchhardt.*

295. "Man in Newspaper" by Kathleen Gilje, 1973—
42″ × 42″. Polyester resin, plaster of paris, powder pig-
ment. Kathleen Gilje brings a great sense of mystery of the
human condition to her work as well as some humor.
Photo by artist.

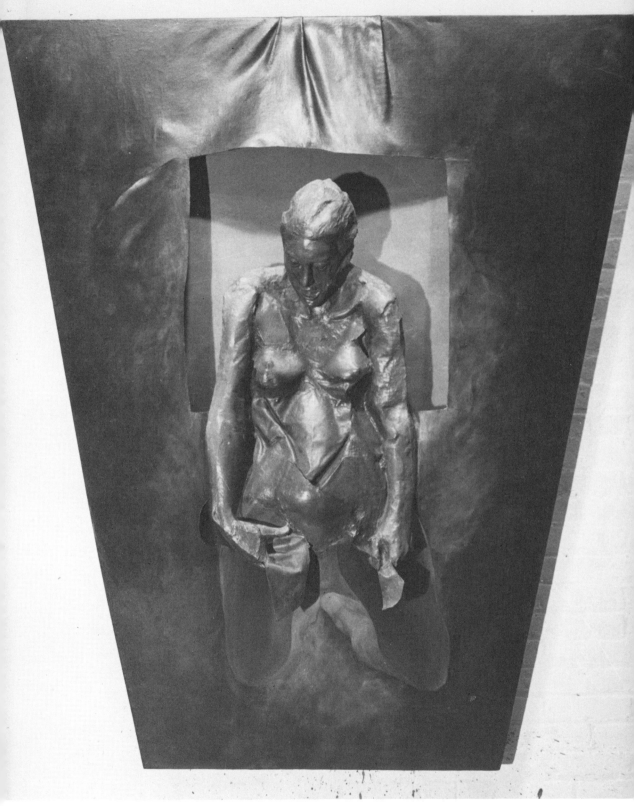

296. "Day" by Margot Krasne, *60″ × 69″.* **Canvas, fiber glass, acrylic. Krasne's sculpture aspires to the heroic statement.**

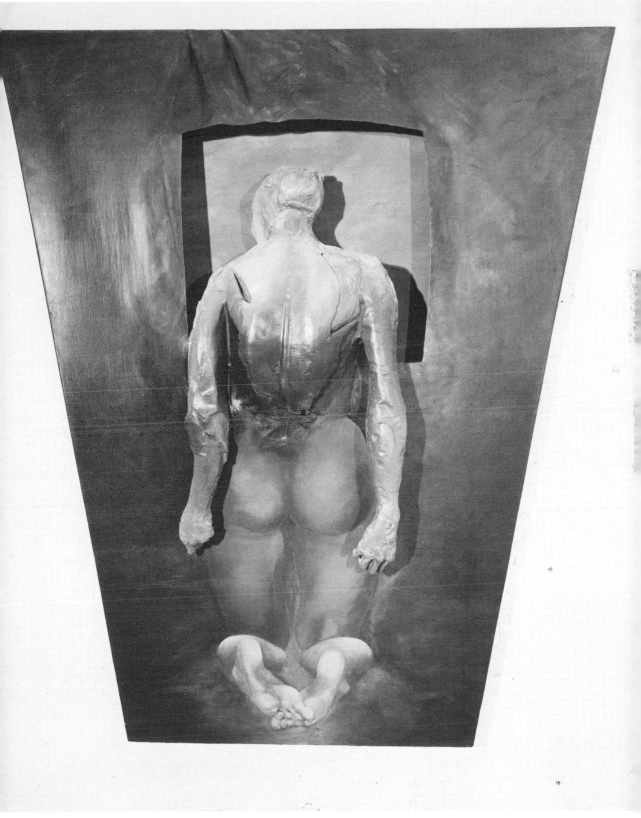

297. "Night" by Margot Krasne, 60″×69″. This figure combines the flat (illusionary) parts very successfully with the three-dimensional.

Thoughts on Plastics in Art

Plastics as a sculptural material have great versatility but lack the feeling of warmth, permanence, and tactility found in natural materials. It is true that all sculptural mediums are temporary and are subject to the devastating corrosion of time and environment, but whereas stone, bronze, and wood often improve with age, plastics seem to lose their crystalline charm. Works by early sculptors in plastics, such as Gabo, have become faded and dull. Surfaces of paintings done in the early nineteen-sixties by leading American painters using plastic paints such as acrylic have also darkened and faded. In the Art Institute of Chicago, I was struck by the appearance of the contemporary American painting, which looked dirty, faded, and dull, whereas in the nearby galleries, paintings done three or four hundred years ago looked fresher and brighter, as if they had just been painted.

Plastics reflect our contemporary taste for transition or change. Our shifting value system finds its expression well in plastics, yet we often criticize our "plastic society" as having little value. We live in a temporary world of images and other sensations that appeal to us immediately. Lasting power and values seem to be difficult to fit into the American system. We produce specialists in all areas of the arts and sciences who are vital one moment and forgotten the next. At the moment, we are witnessing the crumbling of our plastic value system. This is all to the good, but these necessary changes have not yet been accepted by our cultural leaders and institutions, which want to continue the game of novelty. Much visual culture or art is made for entertainment, or has a limited intellectual appeal. The great universal themes of earth, nature, love, and religion have mostly been discarded for an eye-catching commercialism that we try to call art. Plastic has been used extensively toward this goal.

One cannot blame the material for this lack of depth, but in our times, the material is indicative of our value system. Great art has always aspired to the universal, if not the eternal. Not that artists wanted their works to last forever, but the great ones wanted to express deep and lasting feelings. The Rembrandts, Masaccios, and Michelangelos still have great meaning today. I do not believe that we should be trapped by these past images, but neither should we fool ourselves into elevating much contemporary work to the status of art. Art which lacks depth is soon discarded and forgotten, but art which deals with humanity seems to interest us. The problem of materials such as plastic is not a technical one, but one of aesthetics and values. I often feel that the true spontaneous feelings of artists are sublimated in a sea of technical information and chemical charts. It is a little like having your lover analyzed and tested before you respond to his or her affections.

Perhaps it is possible for someone to use plastics in a way that does ex-

press humanity. Up till now, most of these works have been brilliant expressions of design and decoration but void of feeling. Frank Gallo (whose "Cavalry Officer" is shown here) is one notable exception who involves himself with the human condition. Most young artists embarking upon a career in sculpture, I think, should be aware of the whole problem of materials and their potential use, or lack of it, toward expression.

Cleverness is boring, as has been proved today. Depth of feeling, vision, and humanity are always new, but also rare. There have been societies wherein these values have been cherished, such as ancient India, Egypt, China, as well as Greece. We in our times seem to be the deviants and exceptions to the rule. The process of change toward humanism will be slow and painful but it has already started.

GALLERY OF PLASTIC SCULPTURE

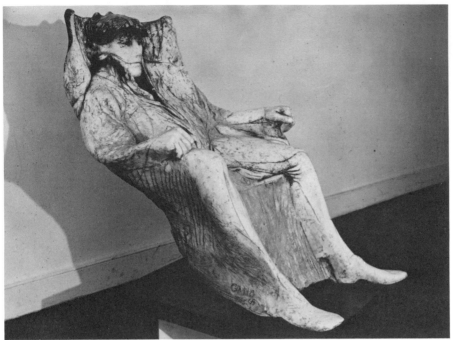

298. "Man in Rocker" by Frank Gallo. Epoxy, 1965—
37″×32″×38″. *Courtesy Graham Gallery.*

299. "Ancient Song" by Robert I. Russin. Granite in
polyester. *Photo by Adele Russin.*

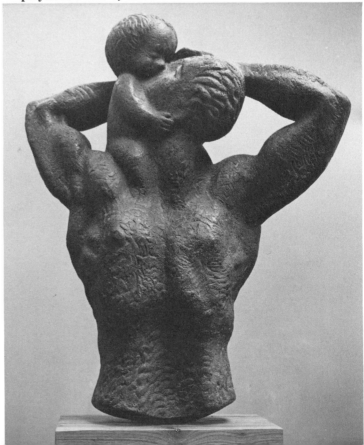

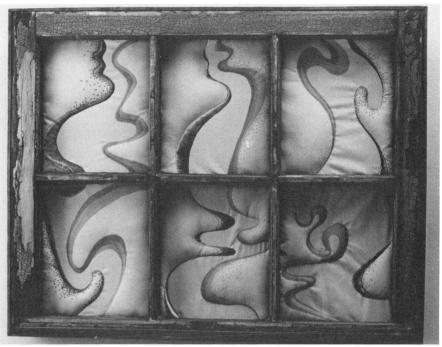

300. "Variations on a Theme" by Jene Nickford. Wood, fabric, polyester fiberfill—32½″ × 25½″. *Photo by artist.*

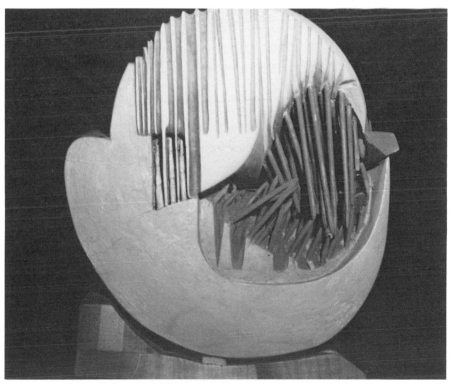

301. "Mandala II" by Wörden Day. Polyester and mixed media—12¾″ × 11¾″. *Photo by artist.*

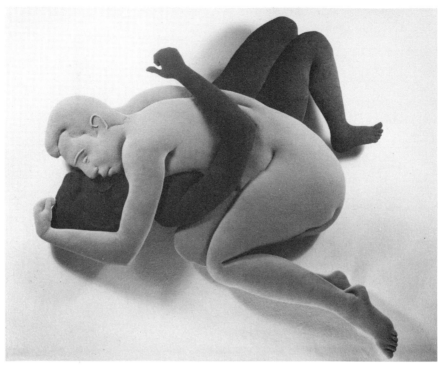

304. "Beach Scene" by Isabelle Borgatta. Knit textile over tempered masonite—5′ width. *Photo by Otto E. Nelson.*

303. "Wall Sculpture" by Dorothy Dehner. Plexiglas—30′ × 9′. *Photo by Great Southwest Industrial Park.*

302. "Widow" by Helen Beling. Polyester resin, bronze powder, fiber glass—5′. *Photo by W. Rosenblum.*

305. **"Birthstone ╪4" by Sidney Simon. Marbleplast, 1976 —70″ × 42″ × 36″.** *Photo by artist.*

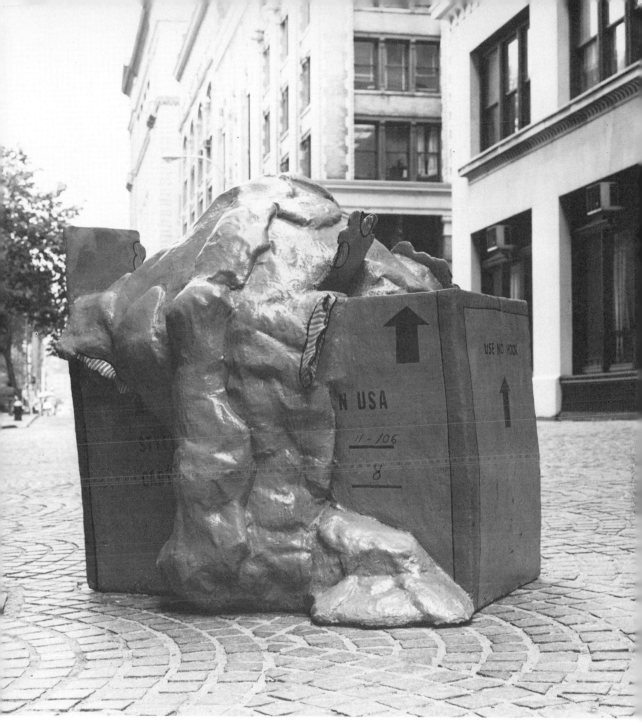

306. "Big Box" by Marjorie Strider. Fiber glass, paint, 1973—6′ × 7′ × 5′. *Photo by J. Robinson.*

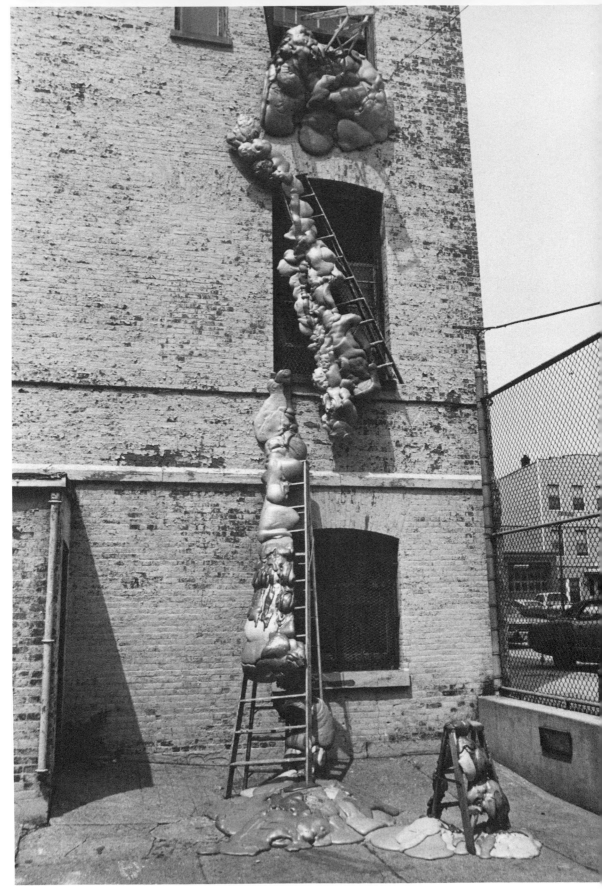

307. "P.S.I." by Marjorie Strider. Urethane foam, 1977.
Photo by J. Robinson.

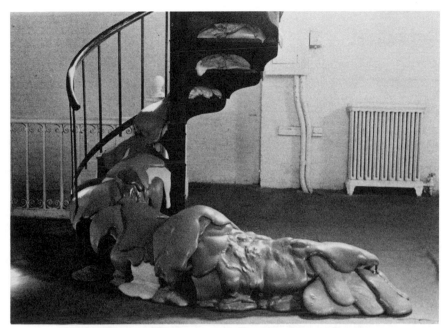

308. "Spiral Staircase" by Marjorie Strider. Fiber glass, paint, 1977. *Photo by J. Robinson.*

309. "Dream Cow Boy" by Kathleen Gilje. Polyester resin, plaster of paris, gouache, 1976—54″ × 57″. *Photo by artist.*

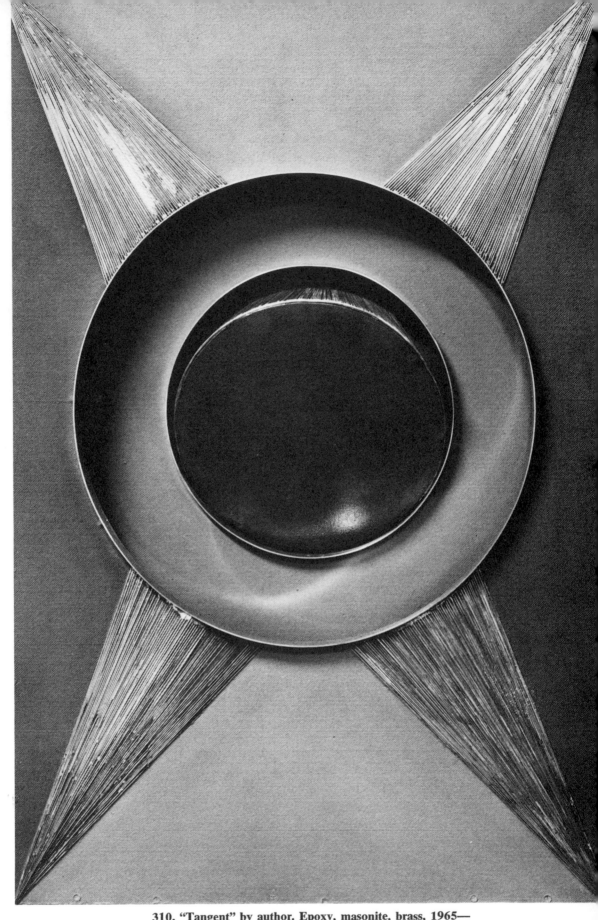

**310. "Tangent" by author. Epoxy, masonite, brass, 1965—
4′×2′6″.** *Photo by William Brevoort.*

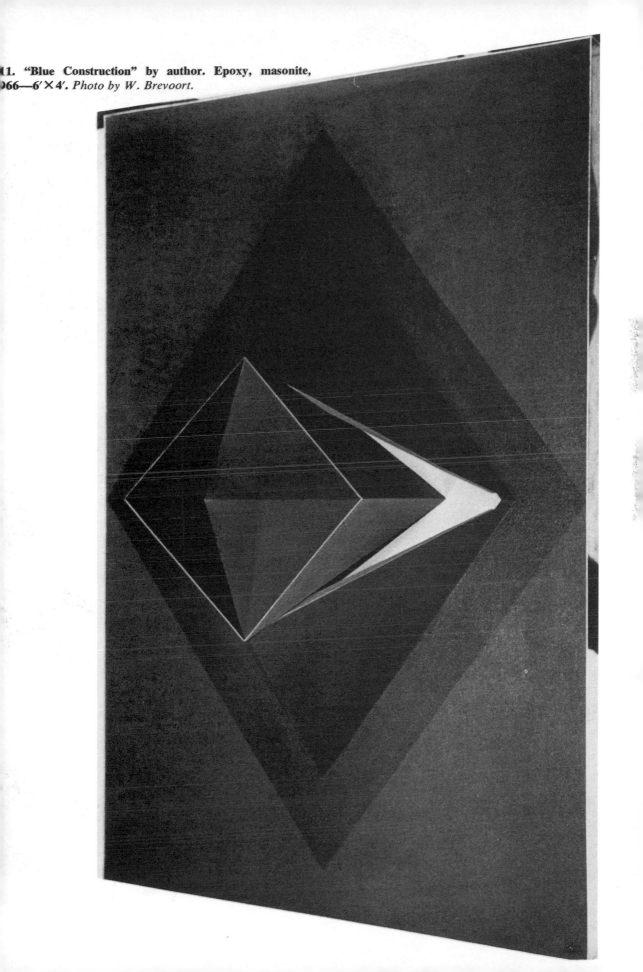

11. "Blue Construction" by author. Epoxy, masonite,
1966—6′ × 4′. *Photo by W. Brevoort.*

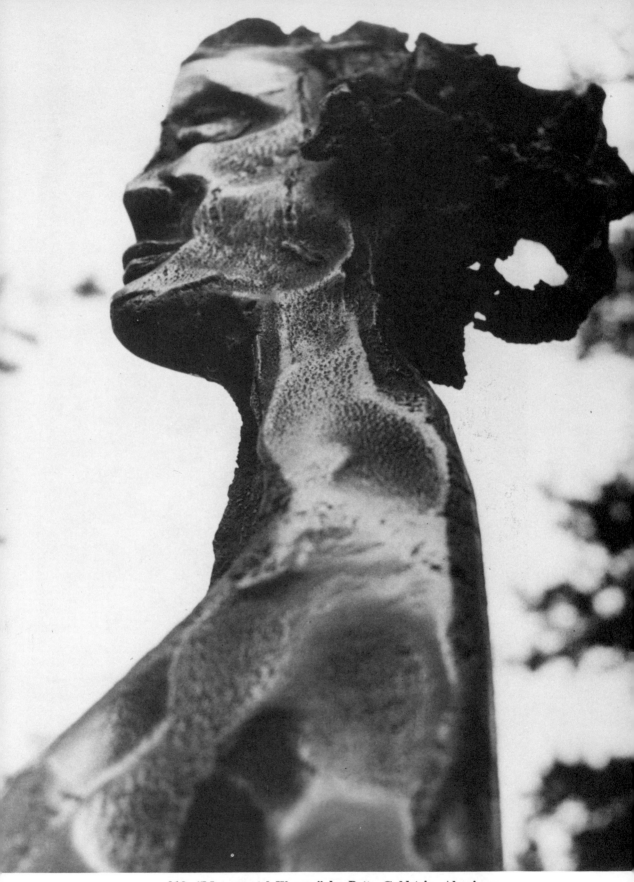

**312. "Monumental Woman" by Betty Goldstein. Aluminum
cast from Styrofoam, 1975—9′ × 9″.** *Photo by Steven Schnur.*

AFTERWORD

One point of this book is that art (emotional and intellectual need) creates technique. It is true that new inventions and materials make new art possible, but usually the intellectual environment is ready for these new developments. Welded sculpture is one example of this phenomenon. There are dozens of new techniques in the technological field which are adaptable for artistic purposes. Some artists are using computers, scanners, electromagnetic fields, holograms, chemistry, and other scientific innovations. No doubt some very interesting art forms will develop from these techniques, but at the present moment, the general climate for these new forms is not encouraging. The public has been bombarded with an avalanche of novelties and has had little time to assimilate the new forms and is suffering "novelty fatigue." It is, however, important for the artist to continue experimenting.

Another point of this book is to encourage experimentation. Technique will change and someday another book will have to be written, but the problem will remain the same. Where is art in relationship to technique? It is no longer a simple matter to state that art is a question of the "Why," whereas technique is a question of the "How." The "Why" and the "How" have become intricately interwoven, and it is sometimes almost impossible to separate by this difference.

There are the old master techniques which must be learned, not only for technical groundwork, but for a spiritual and artistic foundation. The sixties and seventies in America have largely discouraged this traditional groundwork, but there is now a return to these basics as we enter the eighties. The basics should not be interpreted as merely the techniques of drawing, modeling, etc. The basics have to do with a profound reexamination of ourselves, art, humanity, and the world. What is basic is really human. Technique is to

serve this end. A great artist can be technically very poor indeed, but most of them have been brilliant virtuosos. The incompetent (by academic standards) great artists—Cézanne, Van Gogh—are rare individuals and pay a great emotional price.

It is hoped that in this age of "doing your own thing," young artists realize there is much to learn from an artist of experience. Young students should not feel that their personalities are going to be crushed by learning from another. Unfortunately, in our times, there are many teachers who are most interested in spreading their own philosophies and thereby winning disciples, and they put the needs of their students last. An advanced artist cannot teach art at the level that he is working. He must go back to the problems he faced when he was his students' age. If he cannot do this, he should not teach. In fact, many advanced or great artists could not teach for this reason.

Teaching is enjoyable because of the experience of shared growth on the part of the student and teacher. The sense of shared accomplishment is true teaching. Teaching by rote or memory separates student and teacher. The teacher must relive the struggles and experiences of the student as he did when he was young. He relives this in the classroom or studio. His experience guides the student through pitfalls, failures, and successes. He never commands or dominates the student to merely assert his own personality.

As mentioned in the preface of this book, technique is a question of possibilities. The more ways you know of doing sculpture, the more choices you have. It is my hope that this book has inspired you to have the courage to experiment.

Bibliography on Plastics, Sculpture, and Mold Making

I. *General Plastics*

Baird, Ronald J. *Industrial Plastics,* South Holland, Ill.: Goodheart-Wilcox, 1971.

Bowman, Ned A. *A Handbook of Technical Practice for the Performing Arts,* Norwalk, Conn.: Scenographic, 1973.

Dubois, J. Harry, and John, Fred W. *Plastics,* New York: Van Nostrand, Fifth ed., 1974.

Dubuffet, Jean. *Edifices,* New York: Museum of Modern Art, 1968.

Hohauser, Sanford. *Architecture & Interior Models,* New York: Van Nostrand, 1970.

Hollander, Harry B. *Plastics for Artists and Craftsmen,* New York: Watson-Guptill, 1972.

A Plastic Presence, Milwaukee Art Center, Vols. 1 and 2., 1969.

Modern Plastics Magazine, New York: McGraw-Hill, monthly and annually (Encyclopedia).

Newman, Thelma R. *Plastics as an Art Form,* Radnor, Pa.: Chilton, Revised ed., 1969.

———. *Plastics as Design Form,* Radnor, Pa.: Chilton, 1972.

———. *Plastics as Sculpture,* Radnor, Pa.: Chilton, 1974.

Restany, Pierre. *La Plastique dans l'Art,* Monte-Carlo: Editions André Sauret, 1973.

Richardson, Terry A. *Modern Industrial Plastics,* Indianapolis: Howard W. Sams, 1974.

Roukes, Nicholas. *Sculpture in Plastics,* New York: Watson-Guptill, Second printing, 1969.

———. *Plastics for Kinetic Art,* New York: Watson-Guptill, 1974.

Simonds, Herbert R., and Church, James M. *Concise Guide to Plastics,* New York: Van Nostrand, Second ed., 1963.

The Society of the Plastics Industry. *Plastics Industry Safety Handbook,* New York: Cahners, 1973.

The Society of the Plastics Industry. *SPI Printed Matter,* New York: Cahners.

Swanson, Robert S. *Plastics Technology,* Bloomington, Ill.: McKnight & McKnight, 1965.

II. *Acrylics*

Bunch, Clarence. *Acrylic for Sculpture and Design,* New York: Van Nostrand, 1972.

Cherry, Raymond. *General Plastics,* Bloomington, Ill.: McKnight & McKnight, Fourth ed., 1967.

Fabrication of Plexiglas, Philadelphia: Rohm & Haas Co. (Free.)

Plexiglas Design and Fabrication Data, Philadelphia: Rohm & Haas Co. (Free.)

Zahn, Millicent. *Plastics Craft,* New York: Van Nostrand, 1974.

III. *Embedding*

Harden, Cleo F. *How to Preserve Animal and Other Specimens in Clear Plastic,* Healdsburg, Calif.: Naturegraphy Co., 1963.

Lutz, E. L., Sr. *Plastic Embedding and Laminating,* Redlands, Calif.: Natcol Labs., 1960.

IV. *Fiberglass*

Cobb, Boughton, Jr. *Fiberglass Boats,* New York: Yachting, 1969.

Lannon, Maurice. *Polyester and Fiberglass,* North Hollywood, Calif.: Gem-O-Lite Plastics Co., Eighth ed., 1969.

Lubin, George, Editor. *Handbook of Fiberglass & Advanced Plastics Composites,* New York: Van Nostrand, 1969.

Oleesky, Samuel, and Mohr, Gilbert. *Handbook of Reinforced Plastics of the S.P.I.,* New York: Reinhold, 1964.

Panting, John. *Sculpture in Fiberglass,* New York: Watson-Guptill, 1972.

Reinforced Plastics & Guide to Hand Lay-Ups, etc. Toledo, Ohio: Owens-Corning Fiberglass Corp., 1970.

Steele, Gerald. *Fiberglass-Projects and Procedures,* Bloomington, Ill.: McKnight & McKnight, 1962.

Suggestions on How to Mold a Small Fiberglass Reinforced Boat, New York: Owens-Corning Fiberglass Corp.

V. *Mold Making*

Benjamin, William P. *Plastics Tooling,* New York: McGraw-Hill, 1972.

Chaney, Charles, and Skee, Stanley. *Plaster Mold and Model Making,* New York: Van Nostrand, 1973.

Clarke, Carl Dame. *Facial & Body Prosthesis,* Batter, Md.: Standard Arts Press.

————. *Molding and Casting,* Batter, Md.: Standard Arts Press, 1946.

————. *Prosthetics,* Batter, Md.: Standard Arts Press, 1965.

Gleave, J.A.E. *Moulds and Casts for Orthopaedic and Prosthetic Appliances,* Springfield, Ill.: Thomas, 1972.

Kenny, John B. *Ceramic Sculpture,* Radnor, Pa.: Chilton, 1953.

Kowal, Dennis, and Meilach, Dona Z. *Sculpture Casting,* New York: Crown, 1972.

Design, Construction & Maintenance of Reinforced Plastic Hand Lay-Up Molds, Toledo, Ohio: Owens-Corning Fiberglass Corp.

VI. *Plaster & Cement*

Auerbach, Arnold. *Modelled Sculpture & Plaster Casting,* New York: T. Yoseloff, 1961.

Bleck, Eugene E., and others. *Atlas of Plaster Cast Techniques,* Chicago: Year Book Medical Publishers, Second ed., 1974.

Wagner, Victor H. *Plaster Casting for the Student Sculptor,* London: Alec Tiranti, 1970.

Wolfe, Gay. *Plastercraft Handbook,* Chicago: U. S. Gypsum Co.

VII. *Polyesters*

Bick, Alexander F. *Plastics Projects and Procedures with Polyesters,* Milwaukee: Bruce Publishers, 1962.

Lawrence, John R. *Polyester Resins,* New York: Reinhold, 1960.

Books for Further Reading

On the Human Figure:
Barcsay, Jeno. *Anatomy for the Artist,* Budapest: Corvina, 1956.
Bridgman, George. *Constructive Anatomy,* Pelham, N.Y.: Bridgman Publishers, 1920.
Gray, Henry. *Anatomy of the Human Body,* Philadelphia: Lea & Febiger, 1942.
Peck, Stephen Rogers. *An Atlas of Human Anatomy,* Toronto: Oxford University Press, 1951.
Saunders, J. B. de C. M., and O'Malley, Charles D. *The Illustrations from the Works of Andreas Vesalius of Brussels,* Cleveland: World Publishing, 1950.
Schieder, Fritz. *An Atlas of Anatomy for Artists,* New York: Dover, 1947.

On Welding:
The Oxy-Acetylene Handbook, published by Linde Air Products Co., N.Y., 1943.

General:
Shahn, Ben. *The Shape of Content,* Cambridge, Mass.: Harvard University Press, 1957.

SUPPLIERS

Stone—Materials and Tools

1. TOOL STEEL STOCK
 Available from a steel distributor in
 almost any city in the United
 States.

2. CARBIDE TOOLS and other tools
 for stone carving.
 Granite City Tool Company
 Barre, Vt. 05641

 Sculpture Associates
 114 East 25th Street
 New York, N.Y. 10010

 Sculptors' Supplies
 99 East 19th Street
 New York, N.Y. 10011

3. STONE Suppliers.
 Vermont Marble Company
 Proctor, Vt. 05765

 Gawet Marble Company
 Rutland, Vt. 05701

 Lake Wausau Granite Company
 Wasau, Wis. 54401

 Puritan Granite Company, Inc.
 Elberton, Ga. 30635

 Colorado Alabaster Supply Company
 c/o Lloyd's Art Shop
 Fort Collins, Colo. 80522

 Heldeberg Bluestone and Marble,
 Inc.
 East Berne, N.Y. 12059

 Harmony Blue Granite Company
 Elberton, Ga. 30635

 Chioldi Granite Corp.
 Barre, Vt. 05641

 United Granite Sales Company
 St. Cloud, Minn. 56301

Barre Guild and Rock of Ages
Barre, Vt. 05641

Elberton Granite Association, Inc.
Elberton, Ga. 30635

Georgia Marble Company
Tate, Ga. 30177

Metal—Welding, Forming, and Finishing Materials and Tools

1. BRAZING Supplies, and other welding materials, tools.
 Eutectic Welding Company
 40-40 172nd Street
 Flushing, N.Y. 11358

 Standard welding equipment available from most welding supply companies located throughout the United States.

2. METAL FINISHERS Supplies and Plating Products.
 Jelco Finishing Equipment
 Company
 20 West 22nd Street
 New York, N.Y. 10011

 Plating Products Company
 840 Colfax Avenue
 Kenilworth, N.J. 07033

3. FORMING metal, tank heads for spinning.
 Brighton Corporation
 P. O. Box 41192
 Cincinnati, Ohio 45241

Bronze Casting—Equipment

1. SANDBLASTING Units.
 P. K. Lindsay Company, Inc.
 Nottingham Road
 Deerfield, N.H. 02037

 Johnson Memorial Company
 Meyersdale, Pa. 15552

 Granite City Tool Company
 Barre, Vt. 05641

2. FOUNDRY Equipment.
 Casting Supply House, Inc.
 62 West 47th Street
 New York, N.Y. 10036

Plastics—Materials and Tools

1. ACRYLIC sheet, rod, tube, etc., cut to size. Also acrylic tools.
 Canal Street Plastics, Inc. (Open Saturdays. Price list.)
 115 Cedar Street
 New Rochelle, N.Y. 10801
 914-698-3103

2. Same as above plus plastic FILM: Mylar, polyethylene, acetate, vinyl, high impact
polystyrene, etc. Phone for needs. Closed Saturdays.
 AIN Plastics, Inc.
 160 MacQuesten Parkway South
 Mount Vernon, N.Y. 10550
 914-698-3103

 Allied Plastics Supply Corp.
 895 East 167th Street
 Bronx, N.Y. 10459
 212-991-5200

 Amplast Corp.
 3020 Jerome Avenue
 New York, N.Y. 10468
 212-584-0200

3. POLYESTERS clear, filled, colorants. Mold Making: latex and rubbers, fillers,
releases. Foam-in-place polyurethane. Phone for needs.
 Adhesive Products Corporation. (Free literature. Use UPS.)
 1660 Boone Avenue
 Bronx, N.Y. 10460
 212-542-4600

4. Polyesters as above plus acrylic-polyesters, epoxies, fiber glass, mold-making mate-
rials and releases, Century clay, basic supplies, safety materials, books.
 The Plastics Factory. (Free catalog. Use UPS.)
 18 East 12th Street
 New York, N.Y. 10003
 212-691-6611

5. SCHOOL supplies. Plastics plus tools and equipment.
 Cope Plastics Inc. (Free catalog. Use UPS.)
 4441 Industrial Drive
 Godfrey, Ill. 62035
 618-466-0221

6. POLYESTER, COLORANTS, MOLDS, LATEX, etc.
 American Handicrafts Co. (Free catalog. Open Saturday.)
 182 Mamaroneck Avenue
 White Plains, N.Y. 10601
 914-948-5892

7. FIBER GLASS epoxies, polyurethanes, polystyrene foam blocks, marine supplies.
 Defender Industries, Inc. (Catalog $.75.)
 255 Main Street
 New Rochelle, N.Y. 10801
 914-632-3001

8. RTV SILICONE Rubbers (Dow). Distributor, but poor supply in stock, so call and order. Also full line of plastic sheet, film, resin, novelties.
 Industrial Plastics Supply Co., Inc.
 309 Canal Street
 New York, N.Y. 10013
 212 WA5-2397

9. INDUSTRIAL EPOXIES, POLYURETHANES, COATINGS, ADHESIVES, etc.
 Emerson and Cuming, Inc. (Free literature.)
 Canton, Mass. 02021

 Devcon Corp. (Free literature. Buy through distributors.)
 Danvers, Mass. 01923

10. FASTENERS, plastic.
 Product Components Corp. (Free catalog. Use UPS.)
 30 Lorraine Avenue
 Mount Vernon, N.Y. 10553
 914-699-8640

11. POWER AND HAND TOOLS, VENTILATORS.
 Sears, Roebuck. Order through Power and Hand Tool Catalog. They have retail stores throughout the country.

 W. W. Grainger, Inc. (Free catalog. Use UPS.)
 200 Clearbrook Road
 Elmsford, N.Y. 10523
 914-592-2272

 AEG Power Tools
 24-16 Jackson Avenue
 Long Island City, N.Y. 11101

 Stanley Power Tools
 119 West 23rd Street
 New York, N.Y. 10011

 Skil Corporation
 75 Varick Street
 New York, N.Y. 10013

Rockwell International
132 Lafayette Street
New York, N.Y. 10013

Black & Decker
98 Cutter Mill Road
Great Neck, N.Y. 11021

12. FIBER GLASS AND PLASTIC TOOLS.
 J. M. Thomas Company, Inc. (Free literature. Use UPS.)
 227 Highland Avenue
 Westmont, N.J. 08108
 609-858-5400

13. Discount ART SUPPLIES including SCULPTURE HOUSE products.
 Pearl Point Company (Robert Perlmutter). (No delivery or catalog.)
 306 Canal Street
 New York, N.Y. 10013
 212-962-2470

14. SCIENTIFIC, INCLUDING OPTICAL, MATERIALS.
 Edmund Scientific Co. (Free catalog. Use UPS.)
 Edscorp Building
 Barrington, N.J. 08007

15. U. S. GYPSUM products. HYDROSTONE, HYDROCAL, TUF-ART, etc.
 Knickerbocker Plaster Co., Inc.
 522 West 38th Street
 New York, N.Y. 10018
 212 LO3-5520

16. MOLD-MAKING materials. Dental alginate and CASTING MATERIAL. Velmix.
 Hebard Dental Supply
 100 Lafayette Avenue
 North White Plains, N.Y. 10601
 914-948-8080

17. ACRYLIC LACQUERS and ENAMELS, POLYURETHANE COATINGS, Body Hardware, Tools, Welding Equipment, etc.
 Goodfellow Auto Body Supply. (Industrial distributor.)
 521 Fifth Avenue
 New Rochelle, N.Y. 10801
 914-636-8000

18. POLYESTER RESINS, POLYESTER MOLDING COMPOUNDS, and EPOXY RESINS.
 Reichold Chemicals, Inc.
 525 North Broadway
 White Plains, N.Y. 10602

About the Author

Anthony Padovano started sculpting at age fourteen when his first teacher, Hy Freilicher, a professional sculptor himself, said, "Here's a block of limestone, see what you can do with it." Since then there have been many blocks of stone, marble, and granite carved into as many images as there are different stones. Not content with carving alone, Mr. Padovano worked with such sculptors as Oronzio Maldarelli, Calvin Albert, William Zorach, Theodore Roszak, and had instruction from the late Jacques Lipchitz.

Tony, as his friends and students refer to him, spent many years working as an apprentice for Robert Baillie, carving monuments. He also worked in bronze foundries, design studios, and as a welder for Theodore Roszak. His training was of the old apprentice method, not merely confined to art schools and universities. He did, however, attend Pratt Institute and later graduated from Columbia University as that school's "outstanding sculptor" (according to Oronzio Maldarelli, as quoted in the New York *Times* and New York *Daily News*).

He has been the recipient of the Prix de Rome and the Guggenheim Fellowships, the sculpture award from the Academy of Arts and Letters, and numerous other honors both public and private. His sculpture has been exhibited in many important museums and galleries in the United States. The New York *Times* refers to him as "the real thing—a sculptor with a wonderfully natural gift for the forms and methods and syntax of modern sculpture," (Hilton Kramer).

Mr. Padovano has taught at Columbia University, the University of Connecticut, Queens College, and Sarah Lawrence College, and is currently teaching at Kingsborough Community College in Brooklyn, New York, and Parsons School of Design.

INDEX